Traders and Raiders
on China's Northern Frontier

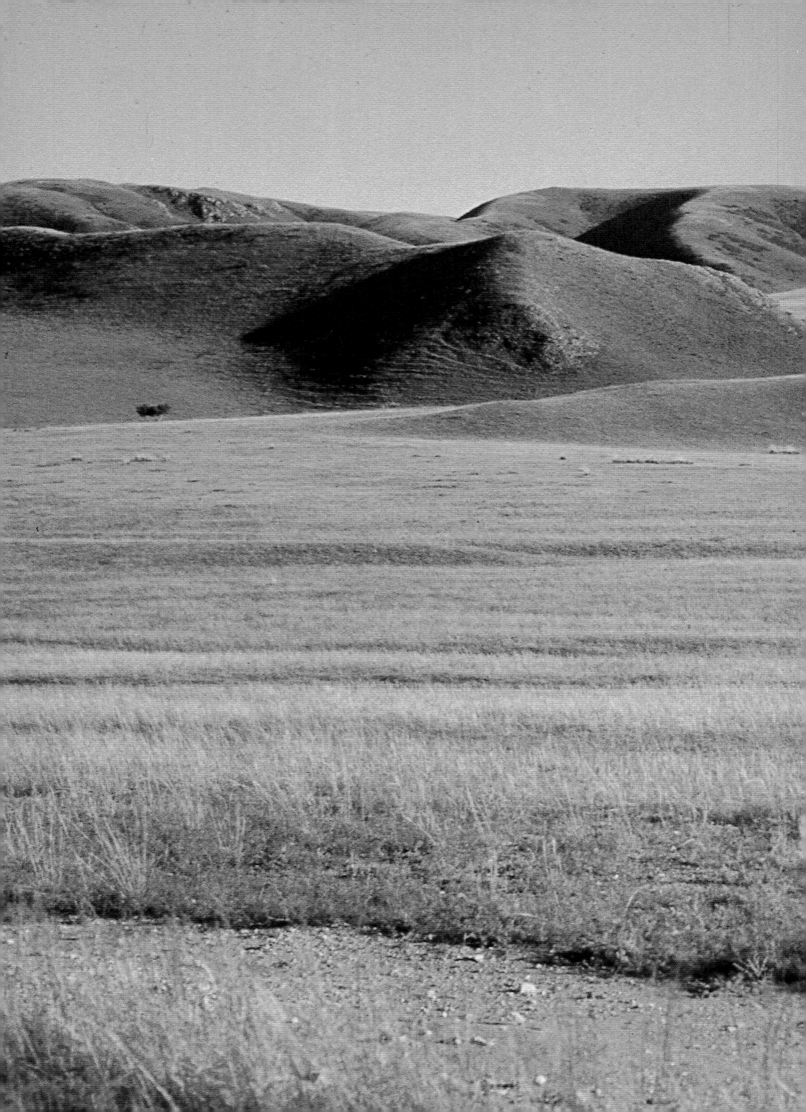

TRADERS
and
RAIDERS
on
CHINA'S NORTHERN FRONTIER

Jenny F. So and Emma C. Bunker

Arthur M. Sackler Gallery, Smithsonian Institution,
in association with the University of Washington Press

Seattle and London

Copyright © 1995 Smithsonian Institution
All rights reserved.

Published by the Arthur M. Sackler Gallery, Smithsonian
Institution, Washington, D.C., in association with the
University of Washington Press, Seattle and London, on the
occasion of an exhibition at the Arthur M. Sackler Gallery,
November 19, 1995–September 2, 1996.

Cover: Gilded cast bronze ornament, North China, 1st or 2d
century A.D. The Therese and Erwin Harris Collection. See no.
77, p. 155.

Back cover and frontispiece: Grasslands of Xilingole, Inner
Mongolia

Library of Congress Cataloguing-in-Publication Data
So, Jenny F.
Traders and raiders on China's northern frontier/Jenny F. So
and Emma C. Bunker.
p. cm.
Includes bibliographical references and index.
ISBN 0-295-97473-7
1. Decorative arts—China—History—To 221 B.C. 2. Decorative
arts—China—History—Ch'in–Han dynasties, 221 B.C.–220 A.D.
I. Bunker, Emma C. II. Title.
NK1068.S596 1995
745'.0931—dc20

95–18910
CIP

Credits
Photographs by Robb Harrell, except as noted; frontispiece:
James Reardon-Anderson; maps and final drawings by Patricia
Condit; fig. 1: Freer Gallery of Art Photograph Reference
Collection, FGA/AMSG Archives, Smithsonian Institution; figs.
2–4, 18, 23–25, 35b, cat. figs. 71.1, 95.1, 96.1, 104.1: Emma C.
Bunker; fig. 5: Mrea Csorba; fig. 6: Carl Whiting Bishop Papers,
FGA/AMSG Archives, Smithsonian Institution; fig. 9: © Royal
Ontario Museum, Toronto; figs. 13, 29, cat. figs. 47.2, 49.
detail, 52.1, 52.2: drawings by Erwin Harris; fig. 19, cat. fig.
99.1: Therese and Erwin Harris Collection; figs. 26, 30:
Jeannine Davis-Kimball; fig. 28: © Museum of Far Eastern
Antiquities, Stockholm; fig. 32: an anonymous collector; cat.
fig. 10.1: Dr. and Mrs. George Fan; cat. fig. 12. details: drawings
by Walters Art Gallery; cat. fig. 22.1: Jin Fengyi, Cultural
Relics Research Bureau, Beijing; cat. fig. 30.2: Harvard
University Art Museums; cat. figs. 41.1, 62.1: Freer Gallery
of Art, Smithsonian Institution; cat. fig. 56.1: drawing by
Richard Kimball

The paper used in this publication meets the minimum require-
ments for the American National Standard for Permanence of
Paper for Printed Library Materials, Z39.48-1984.

Contents

Foreword

I T IS A GREAT PLEASURE FOR THE ARTHUR M. Sackler Gallery to present *Traders and Raiders on China's Northern Frontier.* This book and related exhibition are the result of recent studies centering on intercultural contacts between the ancient Chinese and the tribes to their north. Chinese and non-Chinese artifacts are exhibited and illustrated side by side and discussed in light of the most recent archaeological discoveries. Old assumptions are re-examined and either discarded or reaffirmed, but always with the intention of clarifying the character of cultural exchange between these ancient neighboring cultures and the effects of trade, intermarriage, and warfare on the appearance and production of both everyday and luxury goods. Perhaps most important, and for the first time, the contributions of each group are rightly recognized as of equal significance.

This book and exhibition could not have been accomplished without the enthusiasm and dedication of the collectors, in particular Terri and Erwin Harris, who generously loaned their treasures and allowed the authors to study them for an extended period of time. Jenny F. So, curator of ancient Chinese art at the Sackler Gallery, and Emma C. Bunker, research consultant at the Denver Art Museum, whose special interest is the art of the northern tribes, conceived the exhibition and brought it to fruition. They bring extraordinary expertise to this examination of ancient encounters on China's northern frontier. We hope their book and exhibition on this long-misunderstood Asian cultural arena will encourage further investigation of the many new ideas and questions presented here.

Milo Cleveland Beach
Director, Freer Gallery of Art
and Arthur M. Sackler Gallery

Acknowledgments

Since objects in western collections formed over many decades constituted the starting points of our research, our first expression of gratitude goes to the individuals and institutions who collected and cared for them and provided the opportunity for us to study and publish their treasures. To Terri and Erwin Harris, we owe special thanks for encouraging us to embark on this joint venture and allowing us unlimited access to their collection. Erwin Harris's insight as a collector, his keen observation, and his skilled draftsmanship became an invaluable asset when he kindly agreed to supply drawings for some of the objects presented in this book.

We also thank W. Thomas Chase, Paul Jett, and Janet Douglas of the Department of Conservation and Scientific Research, Freer Gallery of Art and Arthur M. Sackler Gallery, for thorough examinations of many objects and much technical advice; Pieter Meyers, Conservation Department, Los Angeles County Museum of Art, for help with casting techniques; Lily Kecskes, Freer and Sackler Gallery Library, and John Stucky, Asian Art Museum of San Francisco Library, for help in research and reference materials; and Robert Bagley, Princeton University, for his close reading of the manuscript and many welcome comments and suggestions.

Over the years, our colleagues in China have generously shared the results of their most recent archaeological activities with us. We are particularly grateful to Wu En, deputy director of the Institute of Archaeology, Chinese Academy of Social Sciences; Han Rubin, Institute of Historical Metallurgy, University of Science and Technology, Beijing; Jin Fengyi, Beijing Cultural Relic Research Bureau; Zheng Shaozong, director of the Hebei Institute of Cultural Relics in Shijiazhuang; and the husband-and-wife team of Tian Guangjin and Guo Suxin at the Inner Mongolia Cultural Relics and Archaeological Research Institute for providing access to their nation's archaeological discoveries and to the newest publications on the material.

Our North American colleagues have also brought their newest research and field findings to our attention: Mrea Csorba shared her discovery of the face on the Baifu dagger; Jeannine Davis-Kimball, Kazakh-American Research Project, Berkeley, supplied illustrations and information about recent archaeological finds at Pokrovka in the Ural Mountains of Central Asia; Miklos Érdy shared his research on early nomadic cauldrons; Bo Lawergren answered many questions on ancient plucked string instruments; Katheryn Linduff, University of Pittsburgh, kindly read and commented on earlier ver-

sions of the manuscript; and Mary Littauer gave helpful advice on chariotry and horse gear.

The cheerful cooperation of staff members of the Arthur M. Sackler Gallery contributed greatly to the pleasure and success of this joint venture. Milo C. Beach, director, gave his support and encouragement to the project from the start. Kelly Welch, assistant registrar, patiently and efficiently managed complex loan procedures; Rocky Korr and Tim Kirk in Collections Management took meticulous measurements and kept track of the objects as they were moved back and forth for examination and photography; Robb Harrell photographed many of the artifacts illustrated in the book; and John Zelenik conceived the engaging design of the exhibition.

Finally, we offer thanks and appreciation to Karen Sagstetter, editor in chief; to our editor, Ann Hofstra Grogg, for her helpful suggestions, always tactfully presented, and for her meticulous care in reading the manuscript; to Blanche X. Cheng, Chinese Art Department, for tirelessly typing and entering endless corrections for huge portions of the manuscript into the computer, and for compiling the Chinese character glossary; and to Beth Schlenoff, who was responsible for the elegant design of this book.

JFS and ECB

10

Chronology

	THE WEST	NORTHERN TRIBES
1500 B.C.		
1250 B.C.		Tribes from north and west attacked Shang, 12th–11th century B.C.
1000 B.C.		Northwestern tribes attacked Zhou, late 9th–early 8th century B.C.
		Quanrong sacked Zhou capital, 771 B.C.
750 B.C.		
	Achaemenid king Cyrus died fighting horse-riding Massagetae in Central Asia, 530 B.C.	Achaemenid invasion of Central Asia, 517 B.C.
500 B.C.		
	Alexander the Great's campaigns in Central Asia, 334–323 B.C.	Arrival of militant mounted tribes in the northwest, late 4th century B.C.
		XIONGNU in the Ordos Desert, 3d century B.C.
250 B.C.		Xiongnu driven out of Ordos Desert, late 3d century B.C.
		Maodun became *shanyü*, 209 B.C.
		Heqin policy, 198–135 B.C.
		Xiongnu drove Rouzhi westward, 176–160 B.C.
		Xiongnu forces arrived outside Chang'an, 166 B.C.
B.C./A.D.	Augustus, first Roman emperor, reigned 29 B.C.–A.D. 14	
		Xianbei on the rise, 1st century A.D.

CHINA

SHANG DYNASTY, ca. 1700–1050 B.C.

Shang capital relocated to Anyang, ca. 1300 B.C.

King Wu Ding and Consort Fu Hao, died between
 1250 and 1200 B.C.
Shang campaigns against tribes north and west of Anyang,
 12th–11th century B.C.
Shang conquered by Zhou, ca. 1050 B.C.

WESTERN ZHOU DYNASTY, ca. 1050–771 B.C.
King Wu, reigned ca. 1027–1024 B.C.

Zhou battles with northwestern tribes, late 9th–8th PREDYNASTIC QIN, ca. 821–247 B.C.
 century B.C.

Zhou capital sacked by Quanrong, 771 B.C.

EASTERN ZHOU DYNASTY, 770–221 B.C.
Zhou capital established at Luoyang, 770 B.C.

SPRING AND AUTUMN PERIOD, 770–481 B.C.

Qin capital located at Yong
 (modern Fengxiang), 677–424
 B.C.

Confucius born, 551 B.C.

WARRING STATES PERIOD, 480–221 B.C.

Mencius active, 372–289 B.C.

King Wu Ling of Zhao decreed adoption of nomadic dress, Yan capital located at Xiadu,
 307 B.C. 311–222 B.C.

DYNASTIC QIN, 246–221 B.C.
Qin conquered Chu, Zhao, and Yan, 228–222 B.C.
China unified under Qin Shihuangdi, the First Emperor, 221–210 B.C.
Linking of the Great Wall, late 3d century B.C.

HAN DYNASTY, 206 B.C.–A.D. 220

WESTERN HAN DYNASTY, capital at Chang'an, 206 B.C.–A.D. 9
Han Wudi, reigned 140–87 B.C.

EASTERN HAN DYNASTY, A.D. 25–220

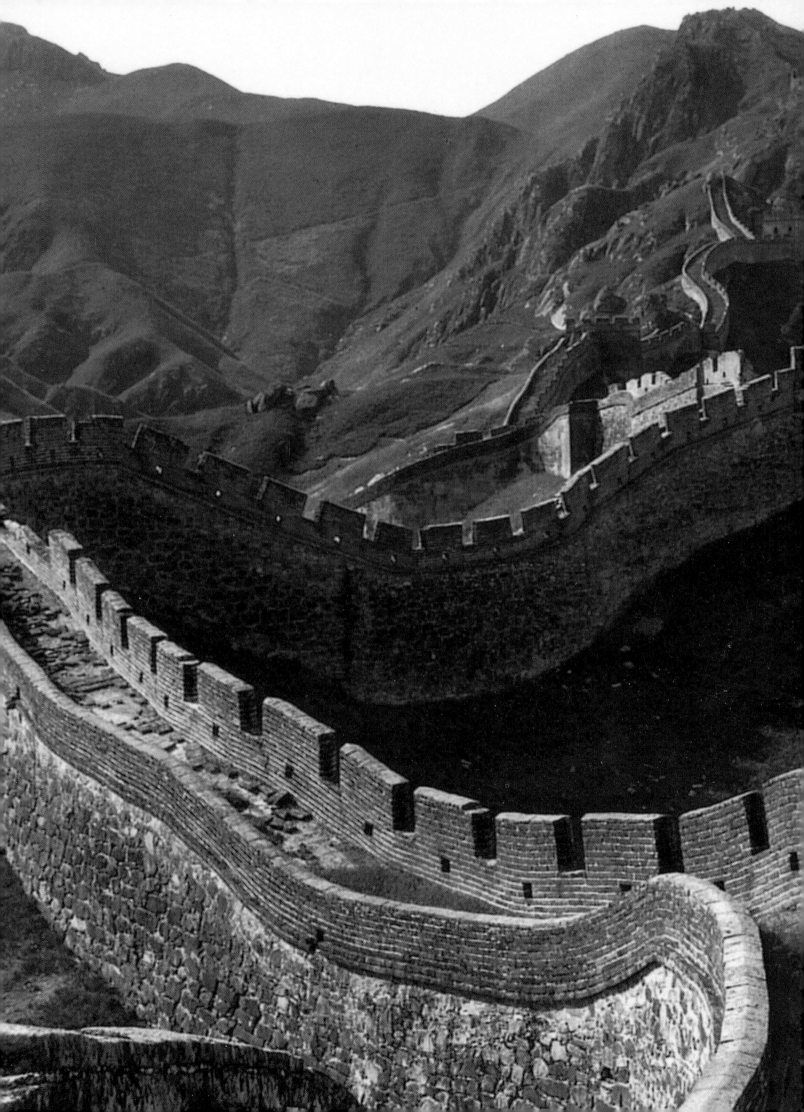

Introduction

THE GREAT WALL WINDS ALONG THE NORTH-ern frontier of China like a giant dragon guarding its patchwork of cultivated fields against the less fertile land beyond (fig. 1). Since its construction in the late first millennium B.C., the Great Wall has stood as a symbol of the cultural differences between the Chinese farmers and the non-Chinese herders and hunters who lived on the other side. The complex interrelationships of these two peoples are among the major themes of Chinese history.

In the past, the frequent encounters between the sedentary Chinese farmers and their more mobile northern neighbors were described by the Chinese in emphatically Sinocentric terms, with the non-Chinese tribes always on the receiving end of any cultural benefits. The idea that these tribes could have contributed to their culture was unacceptable and unthinkable to the Chinese. This biased point of view seriously distorted the vital role these tribes played in the development of Chinese civilization.

While dedicated research by generations of Chinese and Western scholars has produced a reasonable understanding of ancient China's artifacts, the artistic heritage of the northern tribes is among the most misunderstood in Asian history. Their artifacts have been described in a bewildering array of ambiguous terms that have no historical or archaeological basis: Animal Style, Sino-Siberian, Scytho-Siberian, steppe/Ordos, barbarian.[1] These unscientific terms obscure rather than reveal the cultural heritage to which they refer. Moreover, where they imply evidence of contact between the cultures of China and the northern tribes, there has been no consideration of how or why this contact came about.

Today, the published results of scientific excavations carried out in the People's Republic of China, Mongolia, and Russia make it possible to refer to the temporal and regional styles of the northern tribes in terminology based on fact instead of supposition. Moreover, recent excavations on both sides of the Great Wall are enabling scholars to reconstruct a plausible picture of contact and cultural exchange between ancient Chinese farmers and their non-Chinese herding and hunting neighbors. These peoples were partners in a reciprocal relationship based on trading and raiding. Their artistic creations reflect centuries of flourishing exchange that mutually enriched their cultural development.

—JFS and ECB

Note

1. The term "Animal Style" was coined by Mikhail Rostovtzeff (1929) to refer to the artistic traditions of the pastoral tribes that inhabited the Eurasian steppes during the first millennium B.C. It is now considered inaccurate because the art of the Eurasian tribes was never governed by one universal style. "Steppe," the Russian word for "grassy plains," has become synonymous with the vast belt of grasslands that stretches across northern Eurasia from the Great Wall to the Carpathian Mountains in eastern Europe. Some of the regions are not true steppe but taiga and forest steppe. "Ordos" refers only to the semidesert region on either side of the bend in the Yellow River in northwestern China.

FIG. 1. The Great Wall, north China, begun during the late first millennium B.C. and added to throughout later periods in Chinese history

EURASIA

Baltic Sea

Rome

Moscow

Mediterranean Sea

Black Sea

CRIMEA

Kelermes

Pokrovka

Trans-Siberian Railw

Ural Mountain

KAZAKHSTAN

Caucasus
Mountains

Caspian Sea

Antioch

Ziwiye

Silk Route

Ur

Red Sea

Persian Gulf

SIBERIA

Yenisei River

Minusinsk

Irkutsk

Lake Baikal

Amur River

Tuekta

Tuva

Noin Ula

Pazyryk

Bashadar

Altai Mountains

MONGOLIA

Liao River

Sea

of

Japan

yk

Alma Ata

Alagou

ORDOS

Beijing

Great Wall

Yellow River

Kunlun Mountains

Xi'an

imalayan Mountains

CHINA

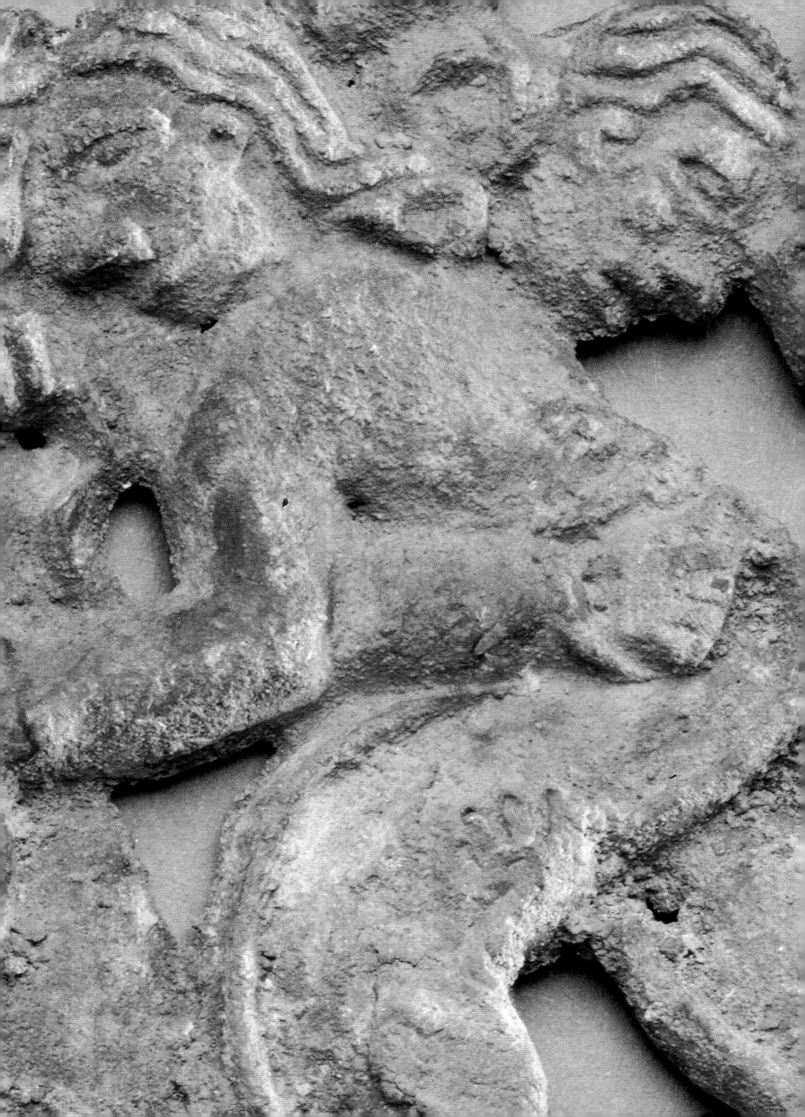

The People, the Land, the Economy

I have left my beautiful country, China,

I have been taken to the camp of the Barbarians.

My clothing is of coarse felts and furs

I can scarce force myself to swallow their rancid mutton

China—and the barbarian land,
Both are different in climate and habit.

—LADY WEN JI, *Eighteen Refrains to a Barbarian Flute,* ca. third century A.D.

SINCE THE DAWN OF HISTORY, THE CHINESE have shared their world with culturally different but complementary herding and hunting tribes in present-day north China and southern Inner Mongolia. The psychological outlook on life that emerged in ancient China was wholly and irrevocably unlike that which developed among the tribes that inhabited the northern frontier zone. Nevertheless, the cultural ebb and flow that developed between these two spheres have been mutually

Detail from plate 1, see page 22

enriching for almost four thousand years. In spite of their professed superiority and self-sufficiency, the Chinese appear to have been as fascinated with their northern neighbors and northern goods as the northern tribes were with Chinese products.

From the beginning, the northern tribes placed a greater value on animals than did their predynastic Chinese neighbors, although during the Neolithic period both lived a similar sedentary farming life.[1] Distinct differences in their material remains were already manifest by the second millennium B.C. Archaeological discoveries from non-Chinese Bronze Age sites, for example at Huoshaogou near Yumen in Gansu Province and at Zhukaigou in the Ordos Desert, in what is now the Inner Mongolia Autonomous Region, as well as sites in the northeast, have revealed metal earrings, bracelets, and other personal ornaments unrelated to Chinese Bronze Age traditions in the Central Plains, where, until the Han period, only jade was worn next to the skin.[2]

The differences between the two cultural spheres became even more pronounced during the first millennium B.C., when colder and drier climatic conditions forced the northern tribes to turn more emphatically to herding and hunting. As the economic similarities between these neighboring

groups decreased, their commercial relations increased significantly, resulting in the creation of a vast Sino-steppe consumer network that would prevail for centuries.

To evaluate the reciprocal exchange relationships between the ancient Chinese and the northern tribes, it is necessary to examine their individual cultures and the specific ecological geographies of their habitats. The livelihoods, customs, mythologies, and range of artifacts that characterize each group were to a great extent determined by ethnicity and environment. Within each geographic region, the inhabitants developed tools, weapons, ritual objects, and personal ornaments to meet specific cultural needs and an artistic vocabulary representing their beliefs in visual form that, when used as decoration, made their paraphernalia unique.

The Land and the Economy

Rich farmlands created by vast irrigation and water control systems mark the plains of north China today, including Shandong Province and the valleys of the Wei and Fen Rivers[3] (fig. 2). This fertile land between the Yellow River to the north and the Yangzi River to the south has long been considered an important center of ancient Chinese civilization. In the late Neolithic and dynastic periods, the prevailing culture was characterized by peasant-village masses under elite urban domination. The economy that developed was based chiefly on agriculture supplemented by animal husbandry and the creation of ritual paraphernalia sufficient to maintain the supremacy of the elite.

The economy of the ancient Yellow River basin was basically self-sufficient, but certain desirable commodities could be obtained only from the non-Chinese tribes in the north. Above all, the Chinese coveted the domesticated horse. Introduced into the Yellow River valley during the late Shang period to pull chariots, the horse became the all-consuming incentive for commercial relations with the northern tribes for centuries to follow.

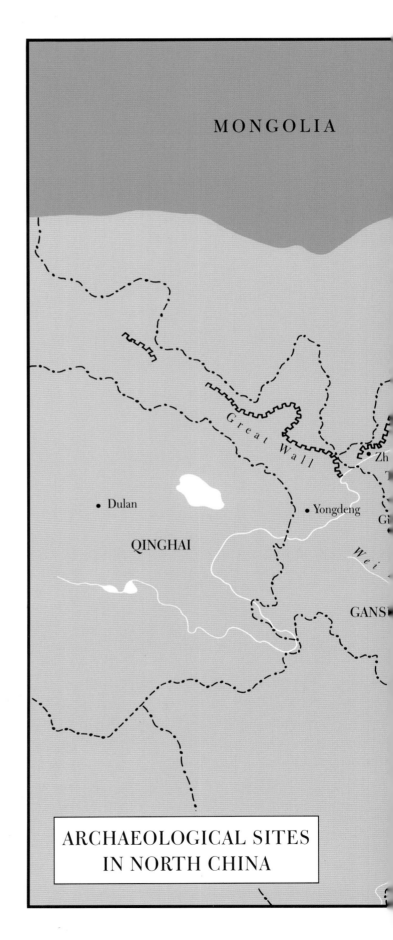

MONGOLIA

Great Wall

Zh

• Dulan

• Yongdeng

Gi

QINGHAI

Wei

GANS

ARCHAEOLOGICAL SITES IN NORTH CHINA

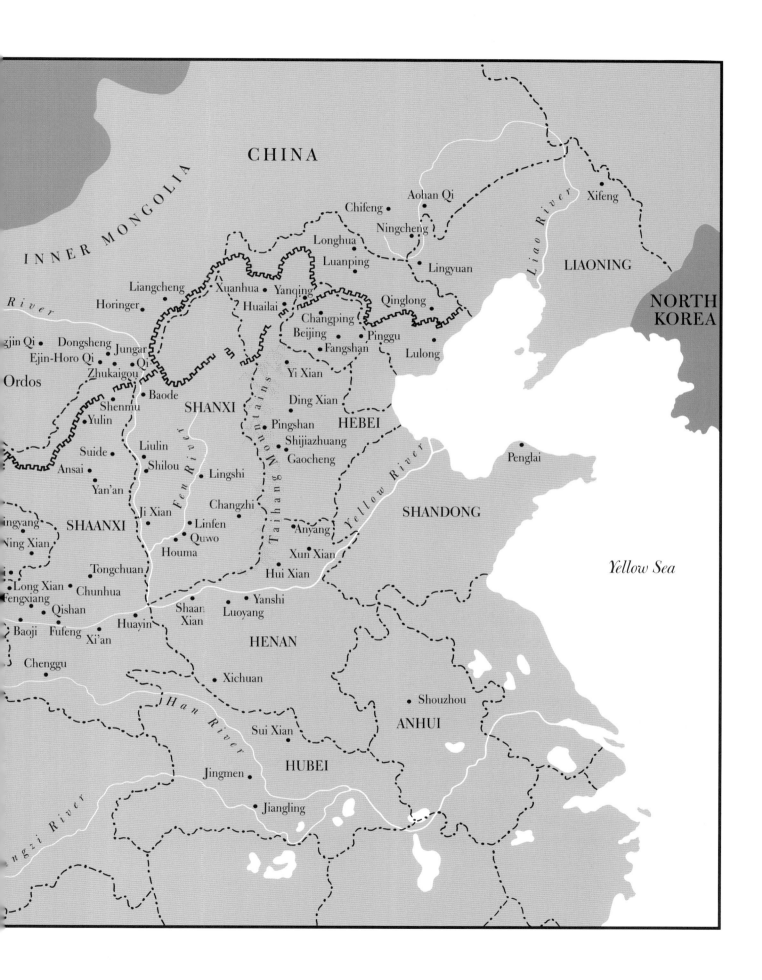

CHINA

INNER MONGOLIA

Aohan Qi

Chifeng

Ningcheng

Longhua

Luanping

Lingyuan

Xifeng

LIAONING

Liao River

Liangcheng

Horinger

Xuanhua

Yanqing

Huailai

Changping

Beijing

Fangshan

Qinglong

Lulong

NORTH KOREA

gjin Qi

Dongsheng

Ejin-Horo Qi

Jungar Qi

Zhukaigou

Baode

SHANXI

Yi Xian

Ding Xian

Ordos

Shenmu

Yulin

Suide

Ansai

Yan'an

Pingshan

Shijiazhuang

Gaocheng

HEBEI

Penglai

Liulin

Shilou

Lingshi

Changzhi

Ji Xian

Linfen

Quwo

Houma

SHAANXI

ingyang

Ning Xian

Tongchuan

Long Xian

Chunhua

Fengxiang

Qishan

Baoji

Fufeng

Xi'an

Huayin

Shaan Xian

Luoyang

Anyang

Xun Xian

Hui Xian

Yanshi

SHANDONG

Yellow River

Taihang Mountains

Fen River

Yellow Sea

HENAN

Chenggu

Xichuan

Han River

Shouzhou

Sui Xian

ANHUI

HUBEI

Jingmen

Jiangling

ngzi River

Pinggu

Lingyuan

FIG. 2. Terraced fields in
northwest China

To the north, numerous non-Chinese tribes
occupied a vast arc of marginal land extending
northeast from Gansu Province and the Ordos
Desert, through north China and southeastern Inner
Mongolia, into northeast China. In the past, this
entire northern zone was erroneously described as a
broad belt of grasslands inhabited by non-Chinese
pastoral nomads devoted primarily to harassing the
Chinese. Today scholars recognize that the region
was not ecologically homogeneous and that the early
inhabitants were not all pastoral nomads bent on
upsetting the lives of the people to their south.
Instead, the region includes grasslands, forests,
mountains, and deserts that encouraged a range of
local economic adaptations. In addition, it is di-
vided topographically by the Taihang Mountains
into western and eastern regions (see map, pp.
18–19). The northern tribes practiced stock breed-

ing, herding, livestock trading, hunting, fishing, and
agriculture, according to the local environment, and
supplemented their needs by developing strong
exchange ties with the Chinese.

The western part of the northern frontier com-
bines grasslands and plateaus. As the climate
became cooler and drier during the second and first
millennia B.C., the land became less suitable for agri-
culture (figs. 3, 4), and its inhabitants turned to
large-scale livestock raising and herding (nos. 6, 8).
Here full-scale pastoralism evolved. The patches of
semidesert interspersed throughout the northwest
area supported little of value but served as natural
barriers separating the Chinese world from Central
Asia. The main access to the northwest was through
the Gansu Corridor that stretches from modern
Lanzhou through Yumen to Dunhuang, later the
main route taken by travelers on the Silk Route that
extended from Xi'an in Shaanxi Province to the
Mediterranean in the West (see map, pp. 14–15).

By contrast, the eastern half of the northern fron-
tier includes mountainous areas, forests, and

Languages and Livelihoods

FIG. 3. *Above*. Grasslands near Huhehot, Inner Mongolia Autonomous Region

FIG. 4. *Below*. Ordos Desert, Inner Mongolia Autonomous Region

The proto-Chinese long considered themselves an important "we"-group. Even if they were not linguistically homogeneous, their early written script, dating back to the Shang period, is the predecessor of the Chinese writing system of today and, as a common writing system, bound the Chinese together over the centuries and helped them to assimilate many non-Chinese cultural elements.[4] Although spoken dialects differed throughout the various regions of China, the written language has remained consistent and until recently was a monopoly of the elite.

Ancient Chinese texts abound with references to the many non-Chinese peoples who inhabited the northern zone, but the primary concerns of the writers were geographic and political rather than cultural. By contrast, the northern tribes were not literate and left no written records to enlighten us about their cultural and commercial dealings with the Chinese. Even the languages they spoke are not known, although they were presumably not Chinese. That some northern tribes spoke an Indo-Iranian dialect is suggested by the presence of early Sinitic words that appear to have derived from Indo-Iranian stems, such as those for horse *(ma)* and wheel *(che)*.[5] This theory is reinforced by the presence of faces with Europoid features on several artifacts found at late-second- and early-first-millennium B.C. sites[6] and the recent discovery of ancient mummies

farmlands very different from the pasturelands of the northwest. In the Chifeng area of Aohan Qi in southeast Inner Mongolia Autonomous Region and in northern Hebei Province, coniferous and deciduous forests predominate. These areas were more suited to hunting and trapping than to herding. To the east the fertile soil of the Liao River valley receives enough rainfall to sustain some agriculture and domestic livestock but not large-scale herding. Hunting and trapping appear to have been important in the economy here, and fur, hides, antler, and bone—not horses—were the chief commodities traded with the Chinese. To date, there is no evidence for domesticated horses in this area before about the eighth century B.C.

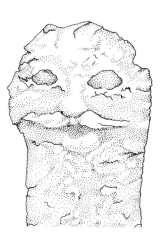

FIG. 5. Drawing of dagger pommel with face, Baifu, Changping Xian, Beijing, early 1st millennium B.C.

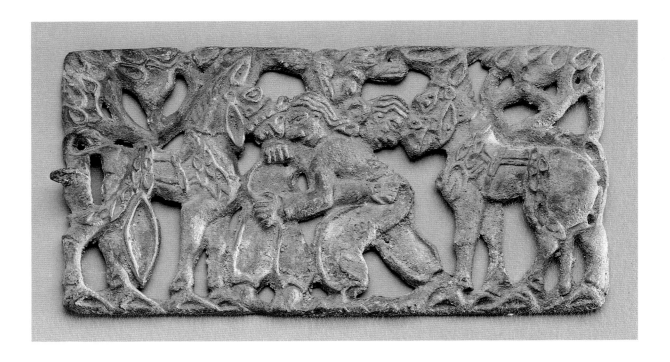

PLATE 1. Belt plaque, no. 1

with Europoid features in the sandy soil of the Xinjiang Uighur Autonomous Region.[7] Of particular interest is the recent identification of a face with a mustache and Europoid features on the pommel of a dagger excavated from an early-first-millennium non-Chinese grave at Baifu, Changping Xian, north of Beijing (fig. 5; see also fig. 15). Similar non-Chinese faces occur on a Western Zhou scabbard ornament (no. 41) and on a much later northern belt plaque (plate 1; no. 1).

In ancient China there was an enormous economic gap between the governing elite and their less fortunate subjects. The artifacts discovered in royal tombs are lavish beyond belief by comparison with the meager grave goods provided subjects and servants who unwillingly accompanied their masters in death. David Keightley has explained that ancient Chinese tradition is "permeated by . . . hierarchical social distinctions, . . . massive mobilization of labor, . . . an emphasis on the group rather than the individual, . . . an emphasis on ritual in all dimensions of life, . . . [and] an ethic of service, obligation, and

emulation" that began at birth and continued forever, even beyond the grave.[8]

The most important Chinese artifacts from the dynastic Shang and Western Zhou periods are jades believed to enhance and protect the body and bronze ritual paraphernalia that supported the political legitimacy of the aristocracy. Together the quality and quantity of the jades and bronzes used by the living and placed in graves for the dead reflected the owner's status and rank.[9] Most Shang and Western Zhou ritual jades and bronzes are embellished with zoomorphic designs that have little relationship with earthly counterparts (no. 4). One major motif is an elaborately conceived masklike image created by a fantastic, decorative combination of conventionalized shapes.

The lack of interest in the individual is readily apparent from early Chinese narrative scenes in which the main focus is nonspecific rather than specific (no. 12). There is no obvious hero. Instead, man is represented as a minor player in a lifelong drama regulated by ritual and obligation.[10] The specificity of the wrestlers portrayed on a non-Chinese belt plaque is a complete contrast (plate 1; no. 1). Although modern scholars have not identi-

fied the two protagonists, the scene represented is clearly a contest between two heroes who were certainly known in the north, where they were probably honored in the oral epics that thrived among the many tribes of the Eurasian steppes.[11]

The social organization of the northern tribes can best be described as decentralized. Loyalties were to clan and tribe rather than to a strong central authority. In a world where grazing and hunting rights were a matter of survival, kinship and tribal ties were also paramount. But the northern tribes did not build cities, and their tombs tended to be small, stocked with utilitarian articles such as a bronze cauldron (no. 10) and a few artifacts reflecting status and rank as well as a variety of sheep, horse, and cattle skulls and bones, indicating sacrifices. Status and rank were indicated by personal ornaments such as earrings, hairpins, bracelets, and rings made of cast gold and bronze, many of which are stylistically related to Andronovo types found farther west in Central Asia.[12] Status and rank were equally important in ancient China, but they were represented differently. In China, immense tombs of the elite were laden with grave goods and the bodies of unfortunate slaves. Those with the highest status were buried with breathtaking amounts of jade (nos. 25, 79) and bronze ritual paraphernalia (nos. 4, 12, 19–21, 23).

The northern tribes were neither the "happy vagabonds" nor the "howling barbarians" often pictured by city folk and isolated academics. Quite the contrary, they led highly structured although rugged lives governed by the seasonal demands of the hunting, herding, or stockbreeding activity specific to each region (nos. 3, 6). Many lived in felt tents that ultimately developed into the famous felt-covered trellis tent known as a *ger* still found today in the steppes of the Inner Mongolia Autonomous Region[13] (fig. 6). They wore coats, trousers, and prominent belts frequently hung with tools and

weapons (nos. 1–3, 5, 11) rather than the long, flowing robes of the urban Chinese (no. 12). Compared to the artifacts of the Chinese, the artifacts of the northern tribes were more portable and practical, products of a vigorous people on the go: colorful textiles, weapons, tools, horse gear, and personal ornaments frequently embellished with heraldic symbols.

The zoomorphic motifs employed by the Chinese and the northern tribes were both real and fantastic, depending upon the cultural requirements of the object's owner. The correct identification of the species of birds and animals represented can be essential to understanding an artifact. Local fauna and domestic animals frequently dictated the selection of the zoomorphic motifs and are therefore important indicators of locale and economy.[14] The wonderful prickly hedgehog on a cast-bronze finial (plate 2; no. 7) must come from northwest China

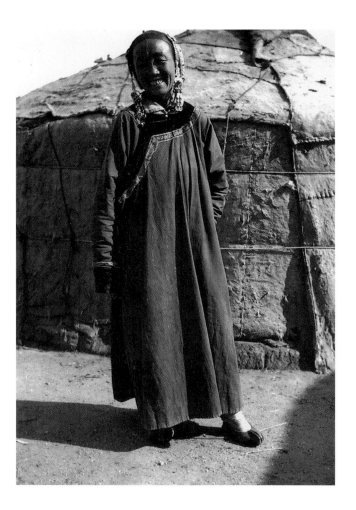

FIG. 6. The felt-covered trellis tent known as a *ger*

where these hedgehogs lived, and the plaques with camels are connected with the northwest, where camels traveled the desert highways of Eurasia during the last few centuries of the first millennium B.C. (nos. 5, 61, 88).

Trade and Tribute

A reciprocal relationship slowly emerged between these economically and culturally distinct groups in the northern frontier regions. The Chinese obtained horses, furs, hides, carpets, jade, bone, antler, and pack animals from the northern tribes, and, in return, they manufactured luxury goods for the northerners, such as silk and cotton as well as bronze mirrors (nos. 46, 68), metal belt ornaments (nos. 50–54, 56, 59, 61, 63–67), bridle fittings (nos. 47–49, 55, 60), and chariot ornaments (plate 3; no. 9). Traditionally, the Chinese have been classified as producers and the northerners as anxious con-

sumers, but only because the Chinese traded manufactured goods for raw materials, animal products, and wool carpets from the north. Barter for equivalent goods was the traditional practice among the herding and hunting tribes of the Eurasian steppes, whereas the Chinese developed metal coins during the Eastern Zhou period. The appearance of knife coins in the northern states of Yan, Qi, and Zhao may have been stimulated by a desire to produce coins that might appeal to their frontier business partners.[15]

Trade was important both to the pastoralists in the northwest and to the hunters, trappers, and farmers of the northeast. The herders needed grain for their diets because their activities did not allow for much cultivation, and the hunters and farmers may have desired Chinese silk and cotton as warm-weather alternatives to fur, felt, and leather for clothing. Chinese lacquer fragments have also been discovered in northern burials. For the Chinese, according to the *Zhanguoce* (Annals of the Warring

PLATE 2. Finial, no. 7

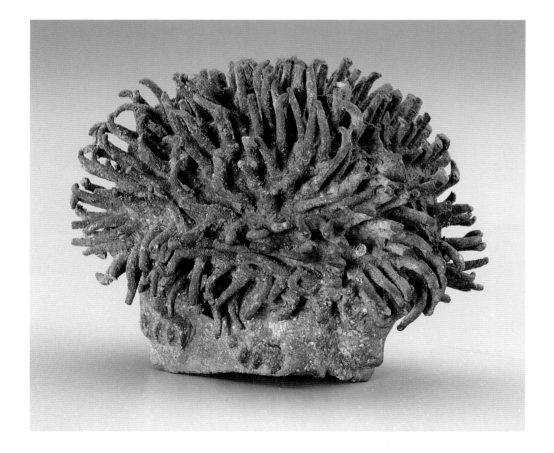

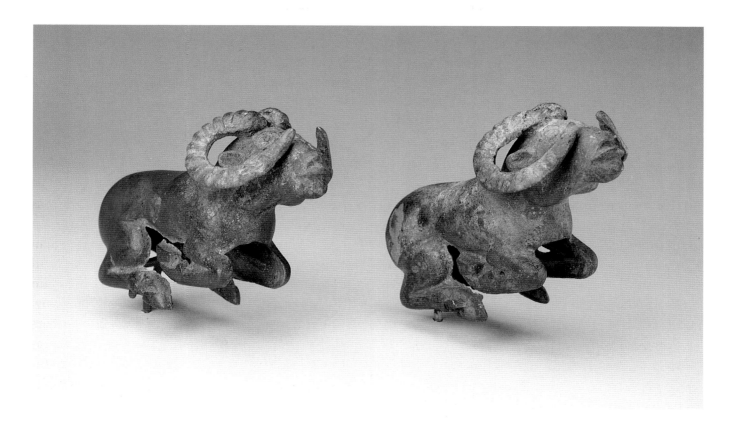

PLATE 3. Two chariot yoke
ornaments, no. 9

States), the most important commodities for the Eastern Zhou state of Zhao were "the horses of Tai [Dai], . . . the coursers of [the] Hu, . . . and the jades of the K'unluns [Kunlun Mountains]."[16] By the Han period, the list of desirable imports recorded in the *Yantielun* (Discourses on Salt and Iron) included mules, donkeys, camels, and horses of all colors and types, plus furs, rugs, carpets, and all manner of semiprecious stones.[17] A necessary commodity for the Chinese would also have been leather for horse harness, although it was never mentioned. Perhaps the need for horse harness brought skilled itinerant leather workers from the north to Chinese centers. Silk or cotton reins would have been quite useless.

Any discussion of the market situation before the Han period is limited by a lack of contextual information. The belt plaques made in large numbers by the Chinese must have been commissioned, because they could not have been acquired by northerners during casual shopping sprees at a trading post. Belt plaques carried iconographic designs that were specific to the wearer, while the type of metal employed indicated status and rank. Although the role of itin-

erant metalsmiths, both Chinese and northern, has never been addressed, there is some evidence that they did exist, as passages in the *Han Shu* (History of the Former Han Dynasty) include references to itinerant Chinese armorers during the Han period.[18]

Border markets were set up by the Han at strategic places to facilitate trade of seasonal merchandise. The time to market horses and other domestic animals was in the fall when the animals were fat and the herders had returned to their winter camps. Leather and fur were probably marketed later, after they had been cured, tanned, and softened, and wool had been cleaned and spun—tedious tasks probably performed in winter. The border markets were likely modeled on the camp markets set up by the Chinese who were guarding the Xiongnu early in the third century B.C. in northern Shanxi Province.[19] Trade with the Xiongnu was often performed under the guise of tribute, due to the Han court's

insistence on viewing itself as the superior partner in the exchange.

The Heqin policy developed by the Han early in the second century B.C. guaranteed the Xiongnu fixed annual payments of four major provisions: silk, wine, grain, and other foodstuffs; a Han princess for the *shanyü* (the Xiongnu ruler); equal status for both Han and Xiongnu; and the Great Wall as the boundary between them.[20] This policy sometimes worked and sometimes failed. If the Chinese did not open markets, the nomads would raid to acquire the goods they needed, usually in the fall when their animals were fit and the Chinese were busy harvesting their crops. Raids benefited the whole tribe, whereas trade and tribute-exchange were more beneficial to the nomadic elite.[21] By the Han period, relations between the Chinese and their northern neighbors had settled into the choice of trade or raid, a kind of "trick or treat" condition that would shape the affairs of the peoples separated by the Great Wall for centuries to come.

The Introduction of Wheeled Transport: Late Second Millennium B.C.

The most important result of contact between the ancient Chinese and the northern tribes was the introduction of wheeled transport into late Shang China (ca. 1300 B.C.). In China, transportation before this time had depended on a network of waterways: navigable rivers, streams, and canals connected by footpaths. The technology of traction and wheeled transport did not develop independently in ancient China; it was adopted from the non-Chinese tribes to the north, who had themselves acquired it from tribes living farther west in Central Asia and beyond[22] (nos. 2, 3). The remains of a spoked wheel from a wooden cart discovered at Nomhon, Dulan Xian, Qinghai Province, associated with socketed axes and knives that suggest a date around 1500 B.C., is more evidence for the introduction of wheeled transport into ancient China from the northwest and deserves further consideration.[23]

The Shang two-horse chariot was not a great war machine, as some scholars have suggested. Instead it was a prestige vehicle for ceremonial display that raised the elite above the common people and served as a mobile command platform in battle. Even the four-horse chariot of the Zhou cannot have been the main force of the army. Descriptions of chariots, both two-horse and four-horse, throughout the *Shijing* (Book of Odes), compiled around 600 B.C., refer to their spectacular demonstration of power, brilliantly colored heraldic banners with oxtail tassels, and tinkling harness bells.[24] Recent archaeology has revealed that the ancient Chinese chariot was an extremely heavy and cumbersome affair with a centrally placed axle that would have made it almost impossible to maneuver in battle.[25] The *Sunzi Bingfa* (Sunzi's Art of War), written during the mid–Eastern Zhou period, describes chariots as vehicles for officers and for carrying equipment, not combat machines:

> In ancient chariot fighting, leather-covered chariots were both light and heavy. The latter were used for carrying halberds, weapons, military equipment, valuables, and uniforms. The Ssuma Fa said: "One chariot carries three mailed officers; seventy-two foot troops accompany it. Additionally, there are ten cooks and servants, five men to take care of uniforms, five grooms in charge of fodder, and five men to collect firewood and draw water. Seventy-five men to one light chariot, twenty-five to one baggage wagon, so that taking the two together one hundred men compose a company."[26]

The earliest known evidence for chariotry in China comes from burials at Anyang dating to King Wu Ding's reign (late thirteenth century B.C.). How chariotry was first introduced into China has never been fully explained. The infrastructure necessary for successful transmission would not have been simple. A whole crew of horse trainers, drivers, veterinarians, grooms, and wheelwrights would be required to transform horses, harness equipment, and vehicles into functional conveyances. A large-scale movement of skilled workers and horse spe-

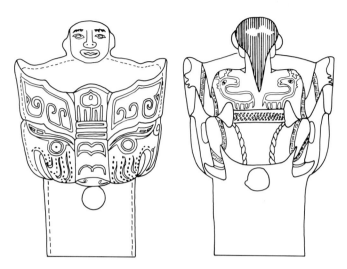

FIG. 7. Drawing of bronze chariot fitting, front and back views, Rujiazhuang, Baoji Xian, Shaanxi Province, 10th or 9th century B.C. Height 12.5 cm. After Beijing 1988, p. 403, fig. 272.1

cialists from the non-Chinese northwest into the capital at Anyang would account for the presence of many northern artifacts in late Shang tombs.[27]

It is doubtful that this specialized technology could have been obtained through warfare alone. Oracle bone inscriptions refer to the capture of chariots from the Weifang, a non-Chinese group in Shaanxi Province, but presumably the Shang had already adopted chariotry and understood the value of their spoils.[28] It is far more likely that chariotry was adopted by the Shang through some amicable exchange with one of the northern non-Chinese groups.[29] Fu Hao, Wu Ding's consort, was a woman warrior. It is possible that Fu Hao herself or some other consort belonged to one of the non-Chinese peripheral *(fang)* groups and brought chariotry to the Shang court as part of her dowry.[30] Such a marriage alliance would explain the northern artifacts among her grave goods, such as bronze mirrors, awls, and animal-head knives (compare nos. 15, 16).

Oracle bone inscriptions from the reign of Wu Ding also refer to the royal use of chariots for hunting.[31] Hunting was the sport of kings throughout Southwest Asia wherever the chariot was known

and usually took place in a royal park or game reserve. The concept of the royal hunt was apparently introduced into ancient China as an essential element of chariotry. This transfer implies more than just a borrowing of technology. It was the transfer of a whole cultural complex that included not only the horse and chariot but the idea of a royal hunt in an imperial hunting park, a concept that was to survive in China until the end of the Qing dynasty.[32] Hunting flourished in ancient China as both a ritual and an elite diversion. By the end of the first millennium B.C., imperial hunts had become grandiose ritual affairs that involved the massacre of great numbers of animals to demonstrate the "emperor's potency."[33]

The Emergence of Luxury Goods: The First Millennium B.C.

About 1050 B.C. the Shang were overthrown by the Zhou, a northern ritual bronze–using people from the Wei River valley in Shaanxi Province whose ancestry and cultural makeup are considered to be partly non-Chinese.[34] During the early centuries of Zhou rule, bronzes were cast not only for ritual purposes but to mark military victories, marriage alliances, and other auspicious events. The Zhou maintained a closer relationship with the non-Chinese tribes than did their Shang predecessors and occasionally represented northern people in their art. The man depicted on a bronze chariot fitting from a Western Zhou cemetery at Rujiazhuang near Baoji Xian, Shaanxi Province, is probably a slave or servant from the north (fig. 7). He wears typical northern clothing: trousers; a jacket, perhaps of felt, decorated with two appliquéd stags; soft boots, and a wide belt (see no. 3).

The border tribes posed a constant threat to the stability of the Zhou, who erected a series of watchtowers along their northern frontier as a defense system. These precautions foreshadow the later Eastern Zhou walls that were eventually consolidated by the Qin dynasty to form the famous Great Wall—the ultimate monument to the ongoing drama between the Chinese and the northern tribes.

By 770 B.C., the central authority of the Zhou kings had been shattered by the Quanrong, an aggressive non-Chinese people from the north who forced the Zhou to move their capital from Haojing near Xi'an in Shaanxi Province to the Luoyang area of Henan Province. The succeeding Eastern Zhou period is characterized by a rise of regional power

FIG. 8. Felt saddle cloth from kurgan 1, Pazyryk, southern Siberia, 4th century B.C. After Rubinson 1990, fig. 14a

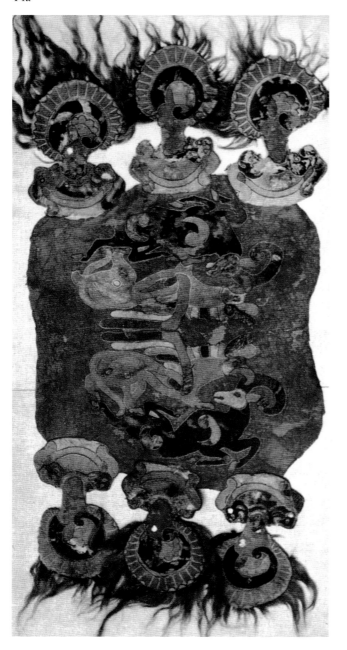

and diverse cultural traits among a large number of feudal states that owed only nominal allegiance to the royal Zhou. This regionalism appears to have fostered a close relationship between the northern tribes and the states with which they came into contact. These tribes were integrated into the economy of the northern Chinese states, especially Qin, Jin, Yan, and Zhao, and northern warriors occasionally served as mercenaries in their armies.[35]

The Eastern Zhou period was artistically one of the richest in all of Chinese history. Although descended from earlier ritual traditions, the majority of Eastern Zhou decoration was produced for conspicuous secular consumption, satisfying the ostentatious taste that emerged among the elite of the various competing regional powers. Lavishly ornamented vessels, chariotry gear, and weapons inlaid with precious metals and encrusted with jade, malachite, glass, and other colorful materials abound among grave goods.[36] In addition, bronze mirrors, a type originally borrowed from the non-Chinese tribes, began to be cast in large numbers at Chinese foundries during the late Eastern Zhou period (nos. 46, 68), and metal joined jade as a medium appropriate for personal adornment. Garment and belt hooks made of gold, silver, and bronze, enhanced by tin or gold plating, or inlaid with both precious metals and stones, became enormously popular among the Chinese (nos. 74–76, 92, 93, 97). They indicated power and wealth, not clan and rank, as did belt ornaments in the north. A fascination with color dominated the secular Eastern Zhou taste. This sudden interest in color and precious metals was inspired by contact with the northern tribes, whose love of gold and color is well documented by the brightly colored fabrics and gold-leaf appliqué decoration found in the fourth-century B.C. frozen tombs excavated at Pazyryk in the Altai Mountains of southern Siberia[37] (fig. 8).

The Beginnings of Horseback Riding:
Late First Millennium B.C.

The most important Chinese appropriation from the northern tribes during the Eastern Zhou period was mounted warfare and related horse-riding gear.[38] A comparison between the saddles and bridles worn by the cavalry horses from Qin Shihuangdi's terracotta army[39] and those excavated at Pazyryk in southern Siberia clearly demonstrates the Chinese debt to the mounted tribes of the Eurasian steppes, not only for the technology of riding astride but for the riding gear that facilitated the practice.[40]

The ancient Chinese adoption of mounted warfare has been traditionally dated to 307 B.C., when King Wu Ling of the Zhao state, in an effort to improve the military effectiveness of his troops in interstate warfare, decreed that Zhao soldiers should wear nomadic dress and ride astride in battle. There is now sufficient evidence, however, to suggest that riding astride had been practiced in the north[41] and even among a few of the northern Eastern Zhou feudal states long before the introduction of mounted warfare.

Certain horse bits found in northern Shanxi[42] and in non-Chinese tombs at Jundushan, Yanqing Xian, north of Beijing, dating as early as the sixth century B.C., were specifically designed for riding.[43] This type of bit has a jointed mouthpiece with stirrup-shaped terminal loops through which leather straps attached the cheekpieces. Bits with stirrup-shaped terminals had been in use throughout the Eurasian steppes in the eighth or seventh century B.C.[44] The earliest examples have snaffle bits and cheekpieces with three attachment holes; in the sixth century B.C., the number of holes in the cheekpieces was reduced to two. A more secure method of attaching the cheekpiece was developed by the horse-riding Scythians in the Black Sea area of southwestern Europe in the sixth or fifth century B.C., and from there the method spread eastward across the Eurasian steppes to the borders of ancient China.[45] In this new bitting system, each end of the mouthpiece terminates with a large loop through which an S-shaped cheekpiece is fitted. This type of bridle was introduced into China during the late Eastern Zhou period and can be seen on a cavalry horse from the Qin Shihuangdi burial complex[46] and on Han bits (no. 81).

The sport of horse racing, introduced into China along with mounted warfare, is first mentioned in late Eastern Zhou texts.[47] Presumably the riders were imported from the north, where horse racing is still a favored sport today.

Unification and Separation: The Qin-Han Dynasties and the Great Wall

After centuries of internecine warfare, in which the stronger states slowly obliterated the weaker ones, the state of Qin, located in the Xi'an area of Shaanxi Province that had once been the Zhou homeland, managed to unite all of China under one rule in 221 B.C. Qin's major contribution to the Sino-steppe drama was to drive the Xiongnu tribes out of the Ordos region north to the area around Lake Baikal and to create the Great Wall of China by linking up the earlier Eastern Zhou segments.

Qin power did not last long, however; after the death of the founder, Shihuangdi, his descendants lost control of China. In 206 B.C., a peasant revolt overthrew the oppressive Qin and reunited China under the more enlightened and benevolent rule of the great Han dynasty. Shortly after the formation of the Han dynasty, the Xiongnu tribes returned to the Ordos region and, under the innovative leader Maodun, united all the tribes of the eastern Eurasian steppes into one vast steppe empire that would torment the Chinese throughout the Han period.

Exchange between the Chinese and the north greatly accelerated during the Han period, sometimes under the guise of tribute and more often through border markets, as an obvious effort to keep a distance from the powerful, and sometimes aggressive, non-Chinese tribes in the north. Gradually the Xiongnu weakened as a separate entity politically and culturally, and the tribe was superseded by more

powerful tribes, effectively ending the first great nomadic empire of the eastern Eurasian steppes.

The northern tribes acted as intermediaries in long-distance trade along the Silk Route, which provided the Chinese with many of the commodities they wanted, including horses, furs, jade, and foreign exotica. The Chinese desire for horses increased dramatically during the Han period, as did the Xiongnu's taste for luxury items such as silk, lacquer, and ornate metal belt ornaments. The close relationship of the Chinese and the Xiongnu is reflected in the visual arts of both peoples.

—ECB

Notes

The epigraph is from Haskins 1963, pp. 147–48.

1. Linduff 1994b; Nelson 1994.

2. See Yang Boda 1987, no. 3; Bunker 1993, p. 27; Bunker 1994b, pp. 31, 33–35.

3. Geographic and ecological descriptions are based on Lattimore 1940; Tregear 1965.

4. Pulleyblank 1983, p. 413.

5. Mair 1990, pp. 44–46; Pulleyblank 1966, pp. 10–11.

6. Mair 1990, figs. 1–3.

7. Mair 1994.

8. Keightley 1990, pp. 50–51.

9. Bunker 1993, p. 29; Bunker 1994b, p. 31.

10. Keightley 1990.

11. Bunker 1978, p. 124; Rawson and Bunker 1990, p. 342.

12. Bunker 1993, pp. 30–31; Bunker 1994b, p. 33.

13. *Ger* is Mongolian for what is incorrectly called a *yurt,* which means "campsite" in Turkish. When the *ger* first developed is a matter of some debate. See Kriukov and Kurylev 1992.

14. See Gai Shanlin 1986, pp. 415–24, for animals represented on ancient petroglyphs throughout the Yinshan Mountains of southern Inner Mongolia; Gai Shanlin 1989, pp. 323–24, for animals represented in the Wulanchuba grasslands of southwestern Inner Mongolia.

15. Li Xueqin 1985a, pp. 385–91.

16. Crump 1979, p. 324.

17. Gale 1931, pp. 14–15. For an extensive discussion of intercultural trade during the Han period, see Yü Ying-shih 1967.

18. Swann 1950, p. 411.

19. Yü Ying-shih 1967, pp. 94–95.

20. Barfield 1989, pp. 45–46; Yü Ying-shih 1990, pp. 122–23.

21. For an extensive discussion of Chinese relations with the tribes on their borders and the division of spoils within the tribal communities, see Jagchid and Symons 1989.

22. Shaughnessy 1988.

23. *Kaogu xuebao* 1963.1, p. 41, fig. 18; for axes and knives, see p. 28, fig. 10; *Early China* 3 (1977): 91. The site is associated with a calibrated C[14] date of 2195–1935 B.C. The calibrated DFLW date was supplied by Han Rubin in an informal communication, February 1995. The object tested was a wood post, not the wooden wheel. The C[14] date, which seems too early for the axes and knives, needs further clarification.

24. Legge 1935, 4:545, 547–49.

25. For discussion of the Chinese chariot, see Creel 1970, pp. 262–68; Piggott 1992, pp. 63–71.

26. Griffith 1963, p. 72.

27. White 1956, plates 24, 22A, 36.

28. Ho P'ing-ti 1975, p. 357.

29. For discussion of the northern tribes, see Chang Kwang-chih 1980, pp. 248–59.

30. Chang Ping-ch'üan 1986, p. 136.

31. Shaughnessy 1988; Ho P'ing-ti 1975, p. 255.

32. Piggott 1992, pp. 67–68.

33. Lewis 1990, pp. 150–52.

34. Chang Kwang-chih 1980, pp. 249–51.

35. Lewis 1990, p. 271, n. 25.

36. Jacobsen 1984; So 1995.

37. New York 1980, chap. 8.

38. Creel 1965; Bunker 1983, p. 84.

39. New York 1980, plates 101–2.

40. Sun Ji 1981; Bunker 1983, pp. 84–85; Vainshtein and Kriukov 1984; Goodrich 1984.

41. See fig. 17; Rawson and Bunker 1990, p. 293.

42. *Wenwu* 1992.10, p. 72, fig. 14.

43. *Wenwu* 1989.8, p. 31, fig. 23.1.

44. Yablonsky 1990, p. 294, fig. 4.

45. Rawson and Bunker 1990, no. 223.

46. New York 1980, plates 101–2.

47. Cutter 1989, pp. 17, 19–22.

Early Trade and Contact

SECOND MILLENNIUM B.C.

EVEN BEFORE THE CHINESE OF THE LATE first millennium B.C. started constructing walls and ramparts to keep out the "barbarians" from the north and west, language and natural barriers effectively separated the people in the fertile flood plain of the lower Yellow River valley and those in the drier, rugged uplands in the middle Yellow River valley. The most important physical divide is the Taihang Mountains, extending from north-northeast to south-southwest, following roughly the boundary between modern Shanxi and Hebei Provinces. Subsequently, the Great Wall was constructed along the northern and western flanks of this mountain range. The difference in terrain and climate on either side of the mountains encouraged the development of vastly different economies in these two regions: a stable agrarian economy under increasingly organized and stratified leadership in the plains, and, on the uplands, a mixed farming-hunting-stockbreeding economy in which loyalties shifted with the strength and wealth of each tribe. These differences in economy and way of life are reflected in the material remains of the peoples of these regions.

Detail from plate 5, see page 35

Representative Types of Artifacts

The artifacts of the northern tribes reflect their occupations as hunters and herders and the hardships that accompany a mobile life. Typical metal artifacts are bronze weapons and tools with handle and blade cast as one piece: adzes for cutting wood, knives for hunting and skinning animals (plate 4; nos. 15, 16, 39, 40), and awls for working with leather.[1] For hunting and personal defense from wild animals and tribal enemies, axes (plate 5; no. 17), daggers (nos. 14, 43–45), and spearheads and arrowheads form an important part of a northerner's gear.[2] Most of these weapons and tools are reasonably small, light, and portable, so they could be carried on the body and used as the need arose. Many were designed to hang from or attach to a part of the clothing, through rings, loops, or similar devices. To control their draft animals and the horses they rode to pasture, the northerners made harnesses, bridles, and cart or chariot fittings (nos. 9, 32–36).

Complex rituals were ill-suited to the mobile life of the northern frontier, and ritual vessels like those commonly found in Chinese Bronze Age tombs are rare. The vessels that have been found are often plain and utilitarian (no. 10). Bronze mirrors, which

originated in the north, were intended for personal use but may have had magical functions as well[3] (nos. 46, 68).

Finally, personal ornaments in bronze or gold, made into earrings, armlets, and other ornamental regalia, serve as indicators of status and wealth[4] (nos. 18, 26–30). The active life of the northerners encouraged them to carry and display the evidence of rank on their persons. Worldly possessions consisted only of weapons, tools, and personal paraphernalia, and their content, degree of ornamentation, and choice of material often signified not only status but tribal affiliation.

Among the ornaments typically associated with northern bronzes, bells or jingles in slit pommels appear to be particularly favored. They top tool and weapon handles (no. 14; cat. fig. 17.1), horse and other fittings (no. 34), and occasionally even vessels and utensils. From a burial in Baode Xian in northern Shanxi Province came two tazzas whose stems contained noise-making metal pellets,[5] and a bronze pedestal from Liaoning shows two bells hanging from its underside.[6] Other jingled artifacts from

Baode include a jingle-pommeled dagger (see no. 14), small harness bells, and harness fittings capped by jingles.[7] The presence of large numbers of harness fittings from these late-second-millennium B.C. sites provides some of the earliest evidence for the importance of the horse and horse-drawn conveyances in these regions, vital to an economy based partly on seasonal migration of herds for pasture. Another fitting—a "bow-shaped" object with strongly arched arms terminating in animal-head or slit pommels with jingles—is also regarded, in spite of scanty supporting archaeological evidence, as a signature artifact of the northern tribes[8] (fig. 9). Isolated examples of harness fittings have been recovered from Chunhua Xian, Shaanxi Province, in the west[9] and in Lulong Xian, near the Hebei-Liaoning border in the far northeast.[10] More have come from royal cemeteries at Anyang.

Perhaps the most elaborate noisemaker recovered so far from a late second millennium B.C. context is a bronze bell-like object from Shilou Xian, west of the Taihang Mountains, in northern Shanxi Province[11] (fig. 10). Hollow from end to end, it has no clapper, but hanging from thirty-three loops evenly spaced in vertical rows on the exterior of the stem and body are small attachments that would

PLATE 4. Knife, no. 15

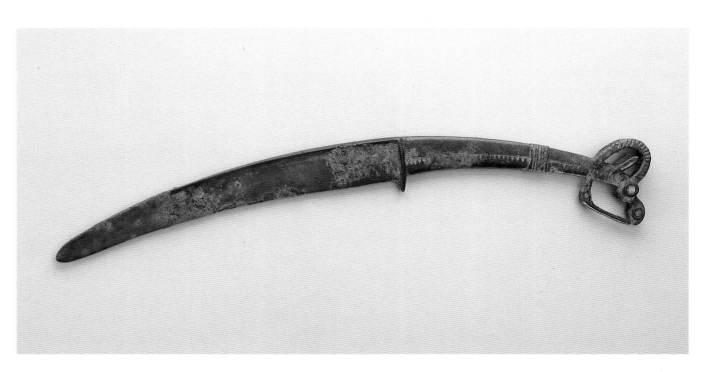

sound when they hit the surrounding surface.[12] The movable tongue of an alligator-handled implement was probably also meant to rattle when used (no. 13). Noise was no doubt useful for scaring animals during hunts and unnerving enemies in intertribal warfare.[13] Rattles and bells also figure prominently in cultures in which shamanistic rituals and some form of animism are practiced.[14] The apparent prevalence of noisemakers made of valuable, non-perishable metal in the north—and their nonoccurrence among Chinese artifacts—suggests that they played a special ritualistic role in the lives of the northern tribes.

In early northern bronzes, birds of prey and animals such as the horse, deer, goat, and ram often decorate the handles of weapons, tools, or poles (nos. 15, 16, 36–38). These animals were drawn directly from the local fauna, and certain animals were associated with particular regions (nos. 5, 7). In their renditions, the northerners enhanced the animal's special features to create highly individualized images (plate 4; nos. 15, 16). Such animal images have become virtually synonymous with the art of the northern tribes, and the intimate understanding and admiration of animals they express remain a hallmark achievement of these tribes throughout antiquity.

Perhaps to compensate for drab natural surroundings, color figures prominently in the appliquéd woolens and leather of the garments of the northern tribes, examples of which have survived from a later period (see fig. 8). Colored stones were used to accent bronze designs (plate 4; nos. 15, 16), and the rare article in gleaming gold must have commanded much admiration.

Artifacts from West of the Taihang Mountains

In the absence of written records, material remains are a primary source for documenting the existence and movement of the northern tribes in ancient times. Some of the earliest evidence for the presence of non-Chinese tribes in the north is found in an early- to mid-second-millennium B.C. context in Zhukaigou, south-central Inner Mongolia. Here bronze tools and weapons, apparently locally made, include simple ring-pommeled daggers and knives that were meant to hang by rings from the owner's waist[15] (fig. 11). Contact at this early date with the peoples who routinely carried such implements on them is suggested by the recovery of a similar ring-pommeled knife among the Chinese bronzes from the early-second-millennium site at Erlitou, Yanshi Xian, Henan Province, in the lower Yellow River basin.[16]

Such early signs of contact are, however, few and isolated. Traffic seems to have increased soon after 1300 B.C., when the Shang kings relocated their capital to Anyang in northern Henan Province. Enough northern bronze knives, tools, and fittings

PLATE 5. Ax blade, no. 17

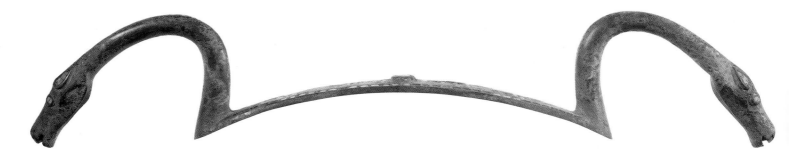

FIG. 9. Bronze bow-shaped
fitting, inlaid with turquoise,
late 2d millennium B.C.
Width 37.9 cm. Royal
Ontario Museum, Toronto

have been recovered from royal burials at the Shang
capital of Anyang to suggest that people of northern
heritage mingled with the Chinese in their capital
city.[17] These artifacts must have entered Shang
domain through trade, war, intermarriage, or other
circumstances. It has been suggested that Fu Hao,
the royal consort and military leader buried in the
late-thirteenth-century B.C. tomb at Anyang, might
have been a princess from one of Shang's *fang*
(peripheral) kingdoms given in a marriage alliance to
the Shang king Wu Ding.[18] Her many campaigns
against tribes in the north and west would also have
provided ample opportunity for the capture of war
souvenirs.[19] Oracle bone inscriptions from the early
twelfth century B.C. also record major battles
between Shang kings and tribes north and west of
Anyang, with their inevitable spoils often including
enemy captives.[20] As livestock breeders and
hunters, northerners probably paid seasonal visits
to busy trading outposts along the border to
exchange horn, bone, furs, and woolens for grain
and other goods. Since oracle bone texts reveal that
Shang kings were avid hunters, northerners who
possessed hunting skills and expertise in grooming
and training horses for chariots were probably
actively recruited to serve in the Shang court. Any of
these circumstances would have brought northern
goods and artistic ideas into Chinese territory.

The richest finds of northern bronzes, however,
remain around the fringes of late Shang domain.

Numerous graves, containing both Shang and
northern bronzes, have been excavated west of the
Taihang Mountains, in northern Shanxi and neigh-
boring Shaanxi Provinces[21] (nos. 13–17). Most, but
by no means all, the vessels appear to be of Shang
origin, while the smaller bronzes—weapons, fittings,
tools, and personal ornaments—are local types. The
Shang vessels might have been captured war booty,
buried with tribal leaders as symbols of their suc-
cessful raids into Chinese territory. The sets of late
Shang bronze vessels with different clan signs found

FIG. 10. Bronze bell-shaped
object, Caojiayuan, Shilou
Xian, Shanxi Province, late
2d millennium B.C. Height
29 cm. After Shanxi 1980,
no. 57

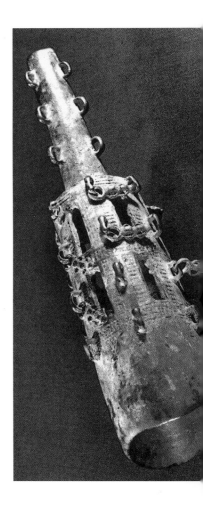

in the same grave at Jieqi, Lingshi Xian, in northern Shanxi Province, probably represent just one man's share of the spoils of war.[22] The representation of a wild ass *(Equus hemionus)* on the underside of a food vessel *(gui)* excavated from a burial at Jingjiecun, also in Lingshi Xian, suggests the vessel was made for a non-Chinese patron to whom the wild ass had a major symbolic or tribal meaning.[23]

It is significant that the richest and most varied artifacts associated with early northern tribes have been found west of the Taihang Mountains. Most of these tombs are located between the Fen River in northern Shanxi Province and the Luo River in northern Shaanxi Province, within the reputed home territory of some of Shang's most trouble-some neighbors.[24] Indeed, it has been suggested that the relocation of the Shang capital to Anyang during the late thirteenth century B.C. might have been a retreat in face of mounting pressure from the west and that the series of wars the Shang kings undertook against these tribes in succeeding reigns was an attempt to curb their advance. The battles must have been fierce. The northerners' lineup of chariots and horses so impressed the Shang that details of the confrontations were often diligently recorded in the divinations concerning these campaigns.[25] The militant nature of the western and northwestern tribes is vividly expressed in an elegant and impressive ax blade (plate 5; no. 17). To date found only in territory west of the Taihang Mountains, with related types extending as far west as Qinghai Province, the blade's elaborate shape and superb workmanship indicate that warfare was serious business to its maker and owner. It is perhaps no accident that the Zhou, the tribe

responsible for Shang's final downfall around 1050 B.C., originated in territory occupied by western tribes and also favored the chariot.

Artifacts from East of the Taihang Mountains

Toward the eastern extent of the Taihang Mountains, finds of northern bronzes contemporaneous with the late second millennium B.C. decrease dramatically in number and variety. One of the earliest indications of a non-Chinese presence came from a damaged fourteenth- to thirteenth-century B.C. tomb excavated at Liujiahe, Pinggu Xian, outside Beijing.[26] The most unusual contents of this tomb are two gold armlets, a gold earring, and a gold hairpin that have no precedent, in material or type, in Chinese contexts.[27] The tomb also contained a group of small bronze ornaments in the shape of human faces, a type that can also be associated with non-Chinese artifacts (see entry no. 18). Although the tomb structure and the bronze vessels found in the tombs are typically Shang, and it is likely that the occupant of the tomb was Chinese, the presence in northern Hebei Province of these ornamental paraphernalia nevertheless suggests local contact at a fairly early date with the northern tribes that used them.

The richest hoard of non-Chinese bronzes discovered so far dates from the late second millennium B.C. This is a group of eight bronzes recovered from a cache (not a burial) at Chaodaogou, Qinglong Xian, north of the Great Wall at the Hebei-Liaoning border.[28] Other scattered finds of bronze and gold

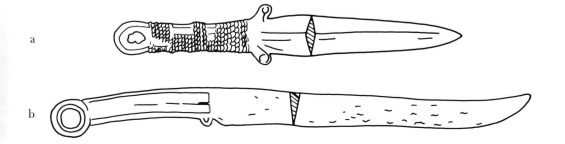

a

b

FIG. 11. Drawings of bronze tools, Zhukaigou, Inner Mongolia Autonomous Region, early–mid 2d millennium B.C. Length (a) dagger ca. 25.6 cm; (b) knife 33.2 cm. After *Kaogu xuebao* 1988.3, p. 325, fig. 29.2–3

artifacts, also mostly in buried caches, have been recovered from sites at the foot of the Great Wall, where ancient trading posts might have been located.[29] Although the finds east of the Taihang Mountains come mainly from caches, not from burials, and are far fewer in number, they occasionally include types closely identified only with the west (nos. 13, 18). These shared object types and sometimes common motifs—most significantly, the animal-pommeled knives—indicate a veneer of uniformity among lands east and west of the Taihang Mountains. The scattered finds of non-Chinese artifacts east of the Taihang Mountains probably mark temporary settlements or seasonal migrations of peoples from the west who came for trade, pasture, or hunting. It is likely that during the late second millennium B.C., the most aggressive non-Chinese tribes responsible for the weapons, tools, and ornamental regalia found throughout the north were centered in the west and northwestern regions. The northeastern frontier was probably occupied by mixed farming and hunting peoples who were content to live in reasonable harmony with their Chinese neighbors to the south.[30]

—JFS

Notes

1. Representative artifacts from the north are discussed in Loehr 1965a, pp. 773–76; Watson 1971, pp. 60–66.

2. The Siberian origins for many of these weapons and tools are discussed in great detail in Loehr 1949; Loehr 1951; Loehr 1956.

3. The possible non-Chinese origin and magical function of the mirror are discussed in O'Donoghue 1990.

4. For an account of early gold ornaments, see Bunker 1993.

5. *Wenwu* 1972.4, p. 4, fig. 4. Another jingled vessel was recovered from a burial at Taohuazhuang in Shilou Xian, Shanxi Province. *Wenwu* 1960.7, p. 51, fig. 1.

6. Li Xueqin 1985b, no. 79.

7. *Wenwu* 1972.4, p. 66, fig. 11, inside back cover, figs. 3, 5.

8. For Mongolian and Siberian examples, and a detailed discussion of the "bow-shaped" object's possible association with the chariot, see Lin Yün 1986, pp. 263–66.

9. *Kaogu yu wenwu* 1986.5, p. 14, fig. 2.14.

10. Beijing 1980a, no. 80.

11. Also published in *Wenwu* 1981.8, p. 52, figs. 19–20; the find is reported on pp. 50–53; a second damaged example was reported to have been found earlier in the vicinity.

12. Similar rattlelike attachments are also frequently found on the handles of bronze spoons from frontier sites. See *Wenwu* 1976.2, p. 94, fig. 3; *Wenwu* 1981.8, p. 52, fig. 23; *Kaogu* 1985.9, p. 489, fig. 3, where they are found hanging from the waist.

13. Lawergren 1988.

14. Eliade 1964, pp. 91, 178. Spirits are often embodied in pebbles, such as those used in the rattle pommels of northern daggers. Modern examples are the functions of noisemakers in Buddhist and Roman Catholic rituals.

15. *Kaogu xuebao* 1988.3, pp. 301–32; see also Linduff 1994b, where local manufacture of tools is supported by the recovery of an ax mold at Zhukaigou.

16. *Kaogu* 1983.3, p. 204, fig. 10.9.

17. See Chen Fangmei 1991, figs. 22–26, 28, 66–67; Beijing 1980c, plates 66.1–6, 68.1, 68.3, 75. These objects are also summarized and discussed in Lin Yün 1986, pp. 250–58.

18. See Cao Dingyun 1989.

19. O'Donoghue 1990, p. 22, suggests the same route for the importation of mirrors to the Shang capital.

20. Zou Heng 1980, pp. 279–81.

21. The bronzes from these sites are summarized and discussed in ibid., pp. 274–78; Tao Zhenggang 1983; Wu En 1985. Some of the Shanxi bronzes are illustrated in Li Xueqin 1985a, nos. 88–90; many of the bronzes from Shaanxi sites are illustrated in Beijing 1979. It should be noted that only some of the Shaanxi bronzes were associated with burials; others appear to be surface finds or caches.

22. See *Wenwu ziliao congkan* 3 (1980): plates 7–8; Lin Yün 1986, p. 240.

23. *Wenwu* 1986.11, colorplate 1. bottom, pp. 4–5, figs. 6, 8.2. Writers of the report suggested a late Shang date for the tomb and its contents; the style of the *gui* and other bronzes, however, does not preclude an early Zhou date. In any case, a late-eleventh-century B.C. date seems appropriate.

24. Průšek 1971, pp. 31–46.

25. These encounters are also thought to be one of the ways by which the chariot was introduced into China. Shaughnessy 1988, pp. 217–18, 232–34.

26. *Wenwu* 1977.11, pp. 1–8; also discussed in New York 1980, no. 12.

27. The foreign prototypes of these gold artifacts are discussed in Bunker 1993.

28. *Kaogu* 1962.12, pp. 644–45; see also Beijing 1980a, nos. 82–86.

29. See Lin Yün 1986; Bunker 1993. Some of these bronzes are illustrated in Beijing 1980a, nos. 80, 81, 87.

30. The economy and life of this region are also examined in Linduff 1994a.

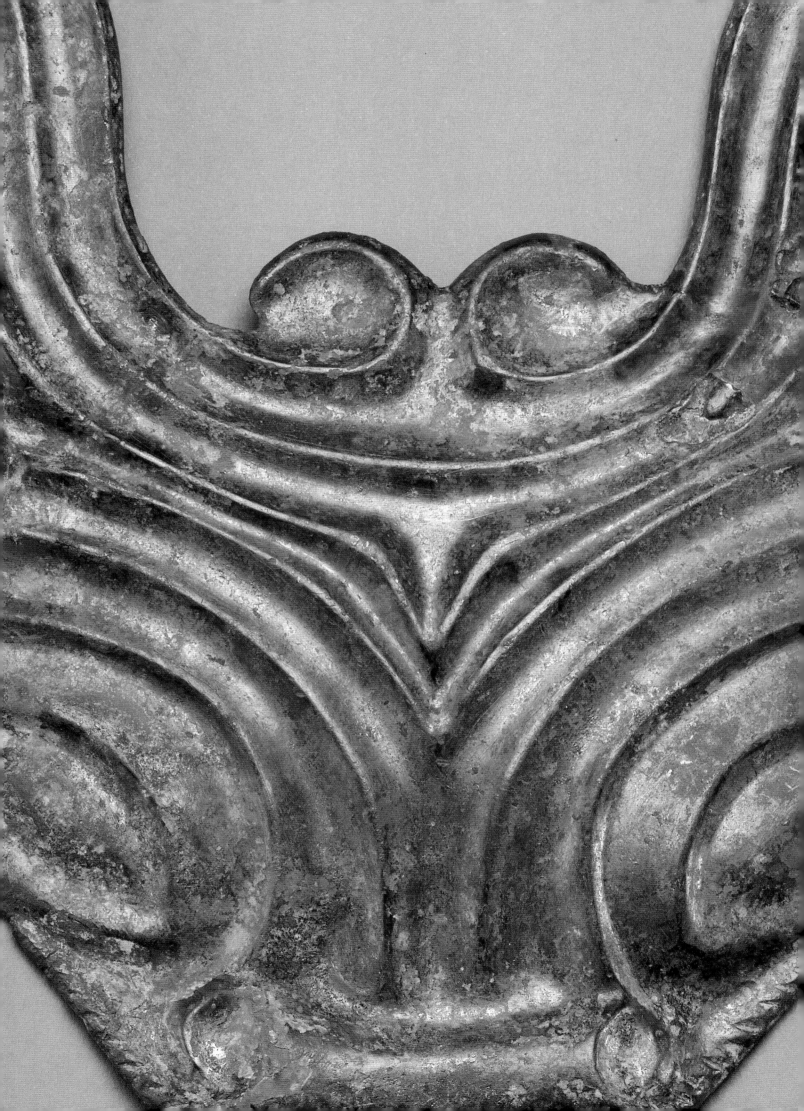

Expanded Cultural Exchange

CA. 1000–500 B.C.

THE SIMPLE MOVEMENT OF ARTIFACTS between Chinese and northern territories east and west of the Taihang Mountains that took place during the late second millennium B.C. changed markedly with the fall of the Shang kings around 1050 B.C. The conquerors, the Zhou tribe, swept in from the middle Yellow and Wei River valleys, from lands west of the Taihang Mountains where seminomadic tribes had been active. Not only did they bring a significant influx of northern influences into their homeland west of the Taihang Mountains, the Zhou kings' subsequent eastward expansion also carried northern influences to the lands east of the Taihang Mountains.

The Zhou's takeover of Shang rule magnified the levels of cultural exchange between the Chinese and the tribes in the north. Chinese ritual bronze vessels began to show northern features, while northern artifacts and personal ornaments increasingly appeared in Chinese contexts with Chinese workmanship and motifs. Abundant finds of horse and chariot fittings signified the added prominence of the horse and horse-drawn conveyances in the Zhou realm. The

turning point in China's early relationship with the north was reached with the arrival of mounted tribes in the northwest and northeast during the eighth century B.C., and a new era of vastly expanded and complex encounters began.

Bronze Vessels

One of the most obvious changes following the Zhou conquest involved bronze vessels. In contrast to finds from the late second millennium B.C., most Zhou burials contain large numbers of bronze vessels, a sign of the Zhou nobility's commitment to the highly formal, hierarchic society inherited from the Shang. Although many vessels closely follow traditional Shang conventions and decoration, others display shapes and decoration that are now recognized as typically Zhou.[1] In particular, the more prevalent attachment of small bells to vessels may have been inspired by the northerners' delight in adding jingles to their bronzes.[2]

Moreover, the shape and design of certain vessels began to reflect the mobile existence of the northerners. To carry liquid sustenance on their hunting or

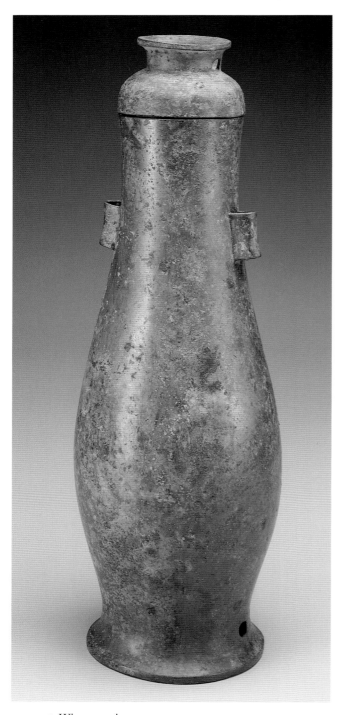

PLATE 6. Wine container, no. 19

42

goblet—just like the modern thermos bottle or camping flask. The peculiar shape of no. 20 betrays its original portable prototype—a soft leather drinking pouch typically carried by a hunter or herdsman.

If the wine containers (nos. 19–21) were modified according to the northerner's needs, the food container (no. 22) represents an unusually early prototype of a shape that in subsequent centuries came to be adopted, manufactured, and completely identified with tribes north of the border (no. 10). Later versions of the container made in Chinese workshops continued to concede to the northerners' taste—adding color with copper inlays (no. 23) or choosing subject matter inspired by their exotic fauna and activities (nos. 12, 24).

Personal Ornaments

Encountered only rarely in late second millennium B.C. contexts, personal ornaments became more common and varied following the Zhou conquest. Perhaps through prolonged mingling with northern tribes, early Zhou nobles also acquired a taste for elaborate and colorful ornaments made of horn, bone, faience, jade, agate, or other colorful stones, as signs of their high social status. Excavation of a ninth-century B.C. grave at Rujiazhuang, Baoji Xian, Shaanxi Province, revealed a Zhou nobleman and his consort buried wearing lavish beaded necklaces accented by jade animal pendants in the shape of stags and crouching felines seen in profile[3] (fig. 12; see also no. 25). These jade crouching felines are clearly related to similar ones in bronze and gold, which were made and worn on the chest as status or tribal symbols by non-Chinese tribal leaders along the northern frontier (compare nos. 26–28). Some of the earliest belt ornaments were also recovered from Zhou burials during this period (see chap. 6).

The theme of predatory animals, expressed as a snarling beast trampling a limp figure of a ram in two harness ornaments (no. 30), is synonymous with the art of the northern tribes during the late first millennium B.C. (see also nos. 50–52, 55, 56, 89–91). It is

herding excursions, northerners would have used containers girded with rope for easy transport. These rope cages were copied onto the design of bronze containers (no. 21). Furthermore, the *hu* (wine container) in no. 19 (plate 6) has a lid that, when inverted, could serve also as a drinking

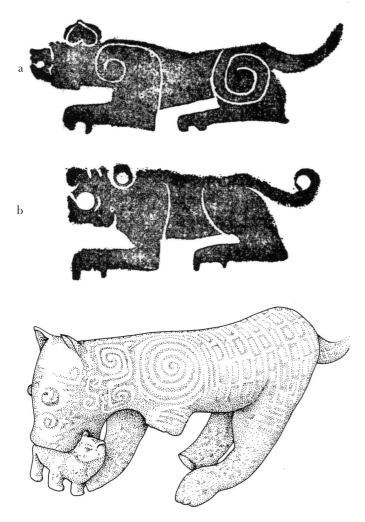

a

b

FIG. 12. *Above.* Rubbings of jade feline pendants, Rujia-zhuang, Baoji Xian, Shaanxi Province, 10th or 9th century B.C. Length: (a) 8 cm; (b) 6.5 cm. After Beijing 1988, p. 344, fig. 238.3–4

FIG. 13. *Below.* Drawing of a bronze tiger ornament, Rujia-zhuang, Baoji Xian, Shaanxi Province, 9th–8th century B.C. Length 20 cm. After *Kaogu yu wenwu* 1990.4, inside front cover, fig. 6

therefore striking to find a different rendition of the relationship among a group of ninth- to eighth-century bronzes, also recovered from Rujiazhuang, in the heart of Zhou territory.[4] Among a buried cache of four bronze animal sculptures—including a stag, a dog, a fish-shaped vessel—is a tiger holding a small animal in its jaws (fig. 13). Excepting the fish, these appear to be ornamental fittings of some kind. The tiger is rendered naïvely, devoid of ferocity, with its striped pelt described by conventionalized Chinese patterns. The subject is also more gentle, as it seems

to be carrying its cub in its teeth instead of devouring the small creature.

The contrast between this early tender portrayal and later versions, such as no. 30, reveals the northerner's awe for these wild animals and intuitive grasp of their powers. This fundamental difference in viewpoint persisted into later Chinese products in which even the same theme of animals in combat was subject to an overwhelming concern for elegance and design[5] (no. 75).

The carved bone ornament (no. 29) is a rare example of a commonly worked material that does not normally survive the ravages of time. Furthermore, its unusual hybrid character perhaps best embodies the complex circumstances that surround the Chinese and the northern tribes during the early first millennium B.C. Its form and pose suggest West Asian origins, but its decorative vocabulary is part-northern and part-Chinese, and its execution clearly reflects training in Chinese jade-working techniques.

Horse and Chariot Fittings

The third major change during the early centuries of the first millennium B.C. is the proliferation of horse and chariot equipment in burials of the ruling elite, signifying the rising importance of the horse and horse-drawn chariots[6] (nos. 31–35). Particularly striking are sets of animals with hollow bodies found in the northwestern frontier. These may have adorned the yokes of horse-drawn vehicles often used in funerary processions (plate 7; nos. 9, 31, 32). The custom of adorning funerary carts with animals was widely practiced throughout the ancient Eurasian steppes,[7] and the appearance of these objects on the fringes of Zhou territory indicates close contact with these peoples on China's western borders. The crouching felines (no. 31) betray their Chinese heritage in their pose and ornamented bodies, but the four standing does display unadulterated nomadic features and casting techniques (see entry no. 32). The imposing horned animal plaque (plate

8; no. 33) probably adorned the forehead of a horse harnessed to such carts or chariots. Elaborately caparisoned horses represent another Central Asian tradition illustrated by the extravagantly dressed horses buried with their nomadic masters in the fourth-century B.C. tombs at Pazyryk in the Altai Mountains.[8]

Other horse and harness fittings recovered in the lands encompassed by modern Gansu and Qinghai Provinces, Ningxia Hui Autonomous Region, and Mongolia beyond China's borders demonstrate the presence of non-Chinese tribes along China's far western and northern frontier (nos. 32–38). Some, like the finials and ornaments (nos. 36, 38), display West Asian connections, while others appear more closely linked to Bronze Age cultures in southern Siberia (nos. 34–37).

The Eastward Expansion: Late Eleventh–Tenth Century B.C.

As one of the principal carriers of cultural traits and customs from west of the Taihang Mountains, the Zhou also became the instruments of their distribution eastward. Soon after the conquest, Zhou's King

Wu named one of his three most powerful ministers as the duke of Yan, ruler over the territory corresponding to modern northern Hebei Province. The sudden proliferation in the east of both Zhou and northern artifacts usually encountered in the west was a direct consequence of the spread of Zhou rule.

In contrast to the isolated caches from the late second millennium B.C., many early-first-millennium B.C. finds east of the Taihang Mountains have been made in the context of burials. This phenomenon alone signifies the development of more stable and permanent settlements, replacing seasonal encampments set up for trade, hunting, or pasturing. Tombs opened in the vicinity of Beijing—at Liulihe in Fangshan Xian—contained not only traditional Zhou ritual bronzes, some inscribed with the names of dukes of Yan, but also weapons, tools, and harness and ornamental paraphernalia commonly associated with non-Chinese tribes.[9]

The most important discovery in this regard was the opening of three tombs at Baifu, Changping Xian, north of Beijing, datable through the style of the ritual bronzes to the late eleventh or early tenth century B.C.[10] The richest of the three graves excavated belonged to a woman who was evidently also an accomplished warrior, for her grave goods included a bronze helmet (fig. 14b), more than sixty bronze weapons, and large numbers of horse and harness fittings. (One is reminded that Fu Hao, the

PLATE 7. Two feline yoke ornaments, no. 31

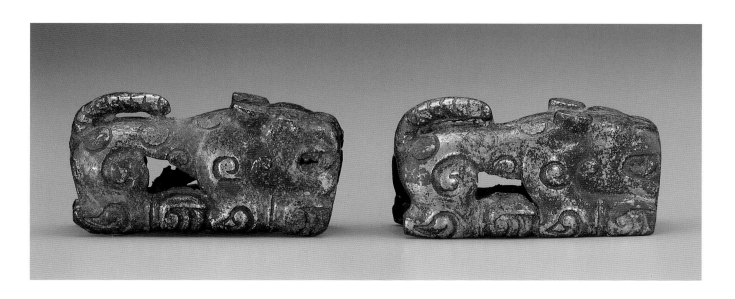

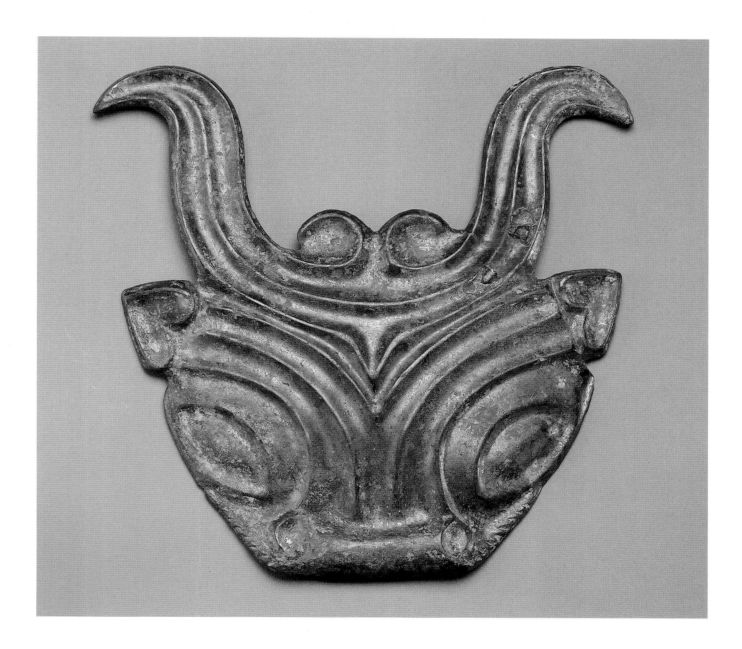

PLATE 8. Harness ornament, no. 33

royal consort whose late-thirteenth-century B.C. tomb was opened intact at Anyang, was also a noted warrior.) Although the presence of bronze vessels, elaborate chariot fittings, and fragments of oracle bones for divination reveal obvious concessions to traditional Chinese customs, most of the grave goods from Baifu suggest that the woman and her companion, buried in the adjoining grave with fewer weapons but also a helmet,[11] might have been foreigners who had adopted Chinese customs.

The military regalia of the woman warrior at Baifu—helmet and weapons—are modified versions of late-second-millennium types found in both Chinese and northern sites[12] (fig. 14). Her many *ge* (halberd) blades show greater variety and more distinct shapes than those known in Chinese contexts, while other weapons and tools—daggers and knives with animal-head or jingled pommels (fig. 15), socketed pickaxes, bow-shaped fittings, and shield ornaments—are clearly non-Chinese in origin. The few bronze vessels are practical, undecorated types, including a *hu* like no. 19 (plate 6), whose design shows northern influence.

46

The woman warrior apparently wore leather boots ornamented with more than one hundred bronze roundels, just like the boots worn by northern warriors in the late first millennium B.C.[13] It should be noted, however, that typical articles of a nomad's apparel—ornamental plaques and ornamented belts—did not form part of her lavish furnishings. Although Zhou's eastward expansion brought a uniform veneer of Zhou culture to the region (see entry nos. 19, 41), the distinctive contents of burials like Baifu suggest that peoples of non-Chinese heritage were already firmly ensconced east of the Taihang Mountains, in the area around modern Beijing, by the beginning of the first millennium B.C.

New Tribes in the East: Ninth–Eighth Century B.C.

If the Zhou kings' eastward expansion during the late eleventh and tenth century B.C. brought increased traffic and prosperity to the sleepy seasonal trading posts and scattered settlements on the eastern fringes of the Taihang Mountains, it was probably their aggressive wars against tribes west of the mountains that continued to fuel changes in the east. Detailed inscriptions on late-ninth- and eighth-

FIG. 14. Drawings of two bronze helmets: (a) from Gaohong, Liulin Xian, Shanxi Province, late 2d millennium B.C.; (b) from Baifu, Changping Xian, Beijing, late 11th–early 10th century B.C. After Wu En 1985, p. 140, fig. 4.10–11

century bronze vessels recount their battles with hostile tribes descending from northern Shaanxi and Shanxi Provinces.[14] These repeated raids into the middle Yellow River valley eventually drove the Zhou court east to Luoyang in 770 B.C. The collapse of the western stronghold of the Zhou domain put the Zhou court at the mercy of the growing ambitions of its nobles who, while pretending to protect the Zhou kings, systematically began to carve out huge territories for themselves. A vulnerable and weak Zhou court invited aggression from its neighbors on all sides.[15] Along the eastern extent of the Taihang Mountains, the eastward retreat of the Zhou court and subsequent political instability within China are indicated by the emergence of tribes with distinct characteristics from the eighth century B.C. on.

Some of the richest finds of material from these new tribes have been discovered near Nanshan'gen, Ningcheng Xian, in southeast Inner Mongolia, just across the border from northern Hebei Province.[16] Their early date (eighth century B.C.) and location in the outer fringes of the Zhou domain suggest that a significant non-Chinese population had settled along the Inner Mongolia–Hebei border at this time. Tomb furnishings from the burials in Ningcheng Xian include the occasional bronze vessel, but most are northern artifacts—bronze knives and daggers (nos. 39, 40), some accompanied by ornamental sheaths (see no. 42), personal and harness ornaments (nos. 34, 35), and, on rare occasions, gold ornaments.

Only the helmets suggest a link between these tribes and those farther west, for the helmets worn by warriors buried in the Ningcheng area are clearly descended from those recovered from earlier sites at Liulin Xian in northern Shanxi Province and at Baifu, Changping Xian, outside Beijing[17] (see fig. 14). Most of the other artifacts recovered from this area reveal the population to be closely tied to older local cultures. The people cast bronze weapons, tools, and small ornaments using stone or pottery molds like the ancient inhabitants of the region.[18] Their daggers with curvilinear blades seem to be

FIG. 15. Drawings of daggers, Baifu, Changping Xian, Beijing, late 11th–early 10th century B.C. Length 25–45 cm. After *Kaogu* 1976.4, p. 253, fig. 9

The Arrival of Mounted Tribes: Seventh–Sixth Century B.C.

As in western China, the proliferation of horse and harness fittings in eighth-century B.C. eastern graves where there had been limited evidence for a horse-based economy suggests that horses were becoming more common there (nos. 34, 35). Additional evidence is provided by the recovery from tomb 102 at Nanshan'gen, Ningcheng Xian, Inner Mongolia Autonomous Region, of a carved bone plate depicting two horse-drawn chariots and a hunter on foot aiming his bow and arrow at antlered deer[20] (fig. 16). Another object, a bronze bucklelike device from an adjoining grave at Nanshan'gen, shows two riders on horseback, one chasing a hare (fig. 17). In spite of these vivid images, it remains unclear whether these tribes rode only to herd or also fought on horseback, although their militant nature is clearly illustrated by the prevalence of bronze helmets and the variety of daggers and elaborate sheaths that accompany them.[21]

Excavations of subsequent seventh- and sixth-century burials east of the Taihang Mountains testify to a markedly different role of the horse. South of Ningcheng Xian, at Lingyuan Xian, Liaoning Province, graves have been opened to reveal individuals buried with crouching horse and animal plaques at their chests (see no. 27), some also wearing horse- and animal-shaped belt hooks at the waist[22] (see no. 96). Some of the crouching horses show circular accents at their haunches reminiscent of the ones on the tiger jingle (no. 34). The prominence of the horse in ornamental imagery suggests that, by this time, the loyal mount guiding herds to pasture and perhaps even carrying the warrior through the fiercest battles had acquired a status closely linked to its owner's. Such animal-shaped plaques and belt hooks appear frequently in seventh- and sixth-century B.C. tombs in northern Hebei Province as well, encompassing territory from Xuanhua Xian at the foot of the Great Wall[23] to Jundushan, Yanqing Xian, just north of Beijing. Both ornamental belt

characteristic of weapons used by tribes farther east and north.[19] Decorative motifs also distinguish these eastern tribes from their western counterparts. The human face on the handle of the knife (no. 39) is rendered with a naïveté that may have local roots (compare no. 18). The intertwined snakes on the scabbard ornament (no. 42) appear more realistic than the flowing floral interlace of no. 41 (plate 9).

48

PLATE 9. Scabbard orna-
ment, no. 41

FIG. 16. Drawing of bone fragment, Nanshan'gen, Ningcheng Xian, Inner Mongolia Autonomous Region, 8th century B.C. Length 34 cm. After *Kaogu* 1981.4, p. 307, fig. 6

plaques and fasteners and animal-shaped plaques worn at the chest were also favored by tribes living west of the Taihang Mountains, although local variations in animals represented and in ornamental vocabulary still distinguished the eastern and western types (see nos. 26–28, 89, 90, 94–96).

Connections between the tribes who favored crouching animal plaques and ornamented belts in northern Hebei Province and tribes farther west are also illustrated by certain common tools and weapons, especially daggers with straight blades and ornamented hilts and guards (plate 10; nos. 43–45).

FIG. 17. Drawing of bronze bucklelike fitting, Nanshan'gen, Ningcheng Xian, Inner Mongolia Autonomous Region, 8th century B.C. Dimensions not specified. After *Kaogu xuebao* 1975.1, p. 137, fig. 19.4

PLATE 10. Dagger, no. 43

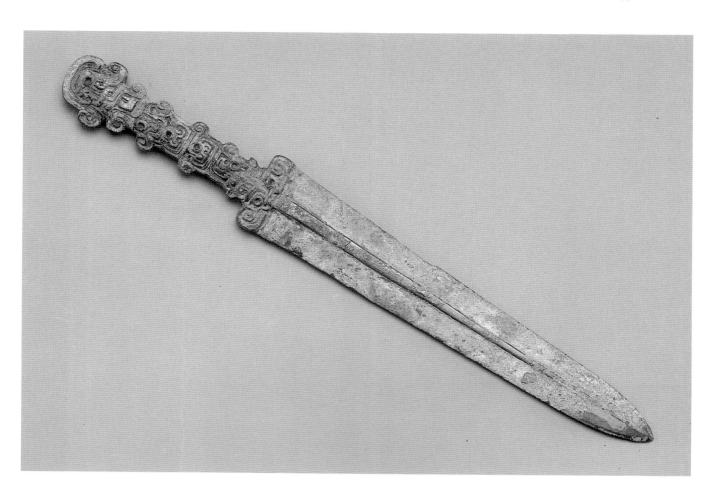

50

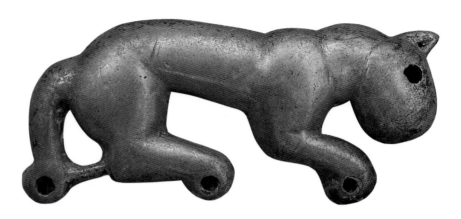

FIG. 18. Gold crouching
feline chest ornament,
Jundushan, Yanqing Xian,
Beijing, 7th–6th century B.C.
Dimensions not specified

A striking array of these daggers has come from more than five hundred graves, some perhaps dating from as early as the seventh century B.C., excavated near Jundushan, Yanqing Xian, in the hilly terrain between two sections of the Great Wall just north of Beijing.[24] The large numbers of knives, arrowheads, and daggers suggest the predominance in the area of hunting and trapping rather than herding.

In the Jundushan burials, clan and rank were also expressed by crouching animal plaques in gold or bronze worn at the chest[25] (fig. 18; no. 27). Other personal ornaments also include small animal-shaped belt hooks (no. 96), belt buckles (see fig. 35a), gold earrings, and large numbers of bronze stags, horses, and wild boars worn on necklaces, belts, and tunics[26] (no. 83). Most bridling equipment and the absence of evidence for wheeled transport indicate that horses were harnessed primarily for riding and not as draft animals.

Clearly the individuals buried in these seventh- and sixth-century graves in northern Hebei Province had more in common with their western than their eastern neighbors. They could have been members of tribes that originally lived along China's northern and northwestern frontiers and were driven from their homes by the same aggressive raiders who invaded Zhou's western territory during the eighth century B.C.[27] Their arrival might, in turn, have displaced earlier non-Chinese settlements in northern Hebei Province across the

border into Liaoning Province. In time, they penetrated south into Hebei, where they appear to have lived in relative harmony with the local Chinese population, as fifth- and fourth-century burials in Pingshan Xian, south of Beijing, continue to yield similar daggers, harness fittings, and other artifacts suggesting an easy symbiotic relationship.[28]

The small fifth-century bronze mirror (no. 46), which has a near-identical mate excavated from a Pingshan grave, perhaps best exemplifies this relationship. On the mirror's decorated back, the simple functional device of the loop was turned into a crouching bear, a familiar animal to the rugged northerner. The rest of the back is ornamented by interlaced dragons closely associated with bronzes produced by the late-sixth- to early-fifth-century workshop at Houma in southern Shanxi Province.[29] Artifacts such as this mirror demonstrate that by the fifth century B.C., the Chinese and the northern tribes had clearly lived long enough with each other to share comfortably each other's artistic styles and motifs (see also nos. 12, 24, 53, 54, 101–3). The mutual recognition—perhaps even respect—that seemed to inform relations between the Chinese and the northern tribes by the mid-first millennium B.C. was a prelude to the full-scale commercial, cultural, and artistic exchange that developed in subsequent centuries.

—JFS

Notes

1. Rawson 1990, introduction.

2. Ibid., p. 33, figs. 28, 38.7, 52.7; also Beijing 1988, plates 6, 7.3, 9.2–3, 19.

3. The Rujiazhuang finds are published in Beijing 1988.

4. *Kaogu yu wenwu* 1990.4, pp. 11–16.

5. See also discussion regarding an early-fifth-century B.C. *hu* in New York 1980, pp. 267–68, entry no. 69.

6. The role of the horse and chariot and its attendant regalia in Zhou history are discussed in Shaughnessy 1988, pp. 221–37. One of the richest finds of this material in recent years came from Rujiazhuang and Zhuyuangou in Baoji Xian, Shaanxi Province. Beijing 1988. A full discussion of the cultural complexities of these finds is beyond the scope of the present study; a preliminary examination of the cultural mixing evident in the Rujiazhuang finds is presented in Zhang Changshou 1980.

7. See Rawson and Bunker 1990, entry no. 205.

8. Rudenko 1970, nos. 119–20.

9. *Kaogu* 1984.5, pp. 405–16.

10. *Kaogu* 1976.4, pp. 246–58. C^{14} dates of 1120 ± 90 B.C. (origin of samples unspecified) are given on p. 248. These dates seem too early for the decor style of the bronze vessels recovered in tomb 2, where the woman warrior was buried, and may be of only peripheral significance for the dating of her tomb.

11. *Kaogu* 1976.4, p. 253, fig. 10.2.

12. For representative helmets from Anyang, see Li Xueqin 1985b, no. 70. For other examples, see Cheng Dong and Zhong Shaoyi 1990, nos. 2.88–93. Anyang weapons are illustrated in *Kaogu* 1976.4, plate 2.3, p. 253, fig. 10.1.

13. For images of nomadic peoples wearing leather boots, see nos. 3, 5, 11. A small bronze ornament in the shape of a boot was recovered with other late-second-millennium B.C. northern artifacts from Liulin Xian in northern Shanxi Province. *Kaogu* 1981.3, plate 4.6. Excavated evidence for ornamented boots has been recovered from a non-Chinese burial near Shenyang in Liaoning Province and in Kazakhstan. *Kaogu xuebao* 1975.1, plate 2.2; Basilov 1989, p. 26.

14. Shaughnessy 1988, pp. 224–26, translates and discusses one of these inscriptions. The most important are also discussed by Yang Yezhang in *Wenbo* 1993.6, pp. 23, 27–28.

15. Jaroslav Průšek sees these early attacks as a primary instrument in the eastward migration of less-militant border settlements, displaced north and east in a rippling effect. Průšek 1966, especially pp. 35–46. However, evidence for the presence of non-Chinese tribes east of the Taihang Mountains during the late second millennium B.C. suggests that the region was, at least periodically, inhabited by foreigners well before the eighth century.

16. The most important sites are reported in *Kaogu xuebao* 1973.2, pp. 27–40; *Kaogu xuebao* 1975.1, pp. 117–40; also *Kaogu* 1981.4, pp. 304–8.

17. For example, see *Wenwu ziliao congkan* 9 (1985): 28, fig. 10.1.

18. For example, stone molds for casting a socketed ax and beaded ornaments have been recovered in the vicinity of Chifeng. *Kaogu* 1974.1, plates 11.6, 11.8; a stone mold for casting bronze daggers came from Shanwanzi in the Aohan Qi, both sites in southeast Inner Mongolia. *Beifang wenwu*, 1993.1, p. 20, figs. 3.4, 4. For discussions of earlier evidence for metalworking in the region, see Linduff 1994a; Linduff 1994b.

19. *Kaogu xuebao* 1980.2, p. 153, fig. 6.2; see, generally, pp. 139–62.

20. The length of this bone fragment (34 cm) and the paired holes visible along one edge suggest that it could be the remains of a scabbard ornament like no. 42.

21. *Kaogu xuebao* 1973.2, plates 5.1. 6.1–7, 7.4–7.

22. *Wenwu* 1989.2, pp. 54–56, plate 8.4–5, figs. 4, 5, 7, 8.17, 8.21, 8.24. Displaying a clan symbol on the chest rather than on the belt continued a local tradition that may be traced back to the late Neolithic Hongshan culture in southwestern Liaoning Province where jade plaques, often in the shape of animals, have been found at the chest of the buried. So 1993.

23. *Wenwu* 1987.5, p. 48, figs. 15.3, 15.5–8, 15.15.

24. *Wenwu* 1989.8, pp. 17–35; *Wenwu ziliao congkan* 7 (1983): 67–74. No detailed report has followed, and it is difficult to understand fully the relative chronology of the artifacts recovered based on the incomplete information presented in the published preliminary report.

25. See also examples in *Wenwu* 1989.8, plate 4.1–2, p. 31, fig. 24.1.

26. See *Wenwu* 1989.8, plate 4.3, pp. 23, 31, figs. 9, 24.4.

27. Průšek 1971, p. 143, and Průšek 1966 chose to identify these northerners in Hebei Province with the Shanrong (Mountain Rong), a tribe that attacked the northern Chinese state of Yan in 664 B.C. and subsequently settled in the mountainous areas north of Beijing. Chinese archaeologists have also tentatively associated the Shanrong with the burials in the Yanqing area, although this association is not universally accepted. *Wenwu* 1989.8, pp. 17–35.

28. Some of the Pingshan finds are published in *Kaoguxue jikan* 5 (1987): 157–93. A late development of this relationship is exemplified by the finds of the late-fourth-century tombs of the Zhongshan kings from Pingshan Xian. See So 1995, introduction, section 6.2.

29. See So 1995, introduction, section 4.2. Other examples of similar mixing of decorative vocabulary during the fifth century B.C. include a *hu* in the Shanghai Museum reportedly from northern Shanxi Province and a small *ding* from an early-fifth-century tomb outside Taiyuan, also in Shanxi Province. New York 1980, no. 69; *Wenwu* 1989.9, p. 67, figs. 9–10.

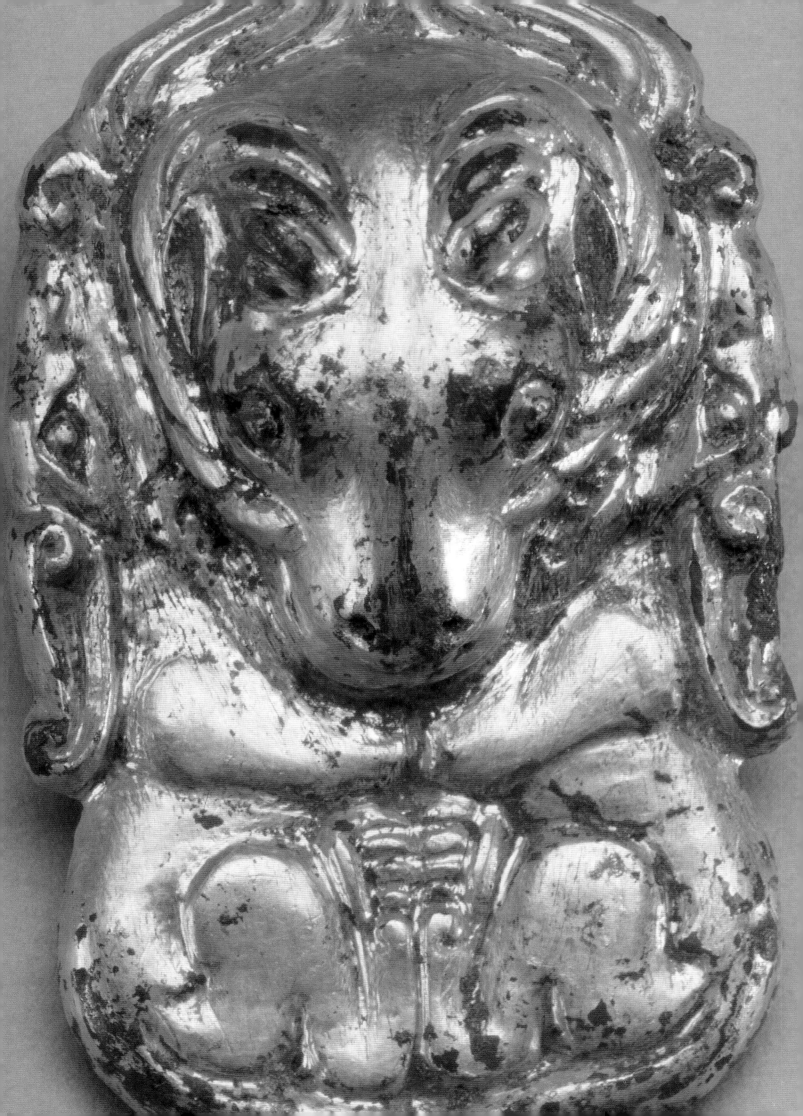

Luxury Exports from China to the North

SIXTH–FIRST CENTURY B.C.

BY THE MID-FIRST MILLENNIUM B.C., aggressive newcomers appeared along China's northern border. Changes in the character of the artifacts placed in their graves indicate that these groups had customs and beliefs different from those of their predecessors. References in ancient Chinese literature suggest that these tribes had originated farther west and slowly migrated eastward until some penetrated even beyond the Taihang Mountains.[1] In time, they became increasingly involved through trade, warfare, and marriage alliances with the Eastern Zhou states that had become regional powers in the north following the Zhou collapse in 770 B.C. The Eastern Zhou states eagerly supplied the new tribes with luxury goods. By the late fourth century B.C., some of the best belt and harness plaques found in frontier sites were made by Eastern Zhou artisans.

The Chinese also exported objects that were Chinese but useful to the northerners (see chap. 6), as evidenced in the belt hook found in a seventh–sixth-century B.C. grave in a tribal cemetery at Maoqinggou, Liangcheng Xian, Inner Mongolia.[2] Later, the Chinese began to add to the bronze vessels

they exported motifs that would appeal to northern taste (nos. 12, 21, 23, 24). As the following sections show, all sorts of exchange developed between the Chinese and their northern neighbors during this period. Perhaps the most surprising is the interactive nature of the exchange as well as the recent recognition that the Chinese actually supplied these neighbors, to a varying degree depending on the time and place, with many of their most valued metal items. This situation is paralleled in the West, where the Greeks also supplied their neighbors, the Scyths, with luxurious and precious personal markers. In addition, the appropriation of motifs, decor, and sometimes even metallurgical techniques by both Chinese and non-Zhou peoples on China's borders confirms adaptation to changing taste.

Like the Eastern Zhou states, the northern peoples also exhibited strong regional characteristics. Based on recent archaeological evidence, they can be divided economically and culturally into two main groups, one west and the other east of the Taihang Mountains. These two main groups can, in turn, be subdivided into smaller groups, each possessing its own artistic style, iconography, and particular metalworking techniques. Recent archaeology has shown that the tribes in each region

Detail from plate 11, see page 57

possessed distinctive artifacts and customs reflecting their individual characteristics and intertribal relationships. Their encounters with their Eastern Zhou neighbors varied according to proximity and varying degrees of compatibility.

West of the Taihang Mountains: Sixth–Mid-Fourth Century B.C.

The tribes west of the Taihang Mountains were primarily herders who practiced limited agriculture. They can be divided into the following cultural groups: one in Liangcheng and Horinger Xian in south-central Inner Mongolia; another in the Ordos region of western Inner Mongolia and northern Shaanxi Province; and a third in the grasslands of southern Ningxia Hui Autonomous Region and the Qingyang plateau of southeast Gansu Province.

A new range of artifacts and motifs not found in earlier burials has been excavated from graves belonging to the groups living west of the Taihang Mountains. These include finials (nos. 37, 38), animal-shaped belt plaques (plate 19; no. 89), frequent representations of animal combat (no. 52), coiled wolves (no. 47), and trefoil designs (no. 49). All these motifs and objects have been found at earlier sites in the Eurasian steppes.

These changes in the character of the artifacts coincide with two events that took place farther west in Central Asia and had a significant cultural impact on the art of the herding tribes on ancient China's northwestern borders during the Eastern Zhou period. Cyrus, the great Achaemenid Persian ruler, met his death in 530 B.C. while fighting the Massagetae, a horse-riding tribe that, according to Herodotus, was situated east of the Caspian Sea. Later, in 517 B.C., another Achaemenid ruler invaded parts of Central Asia. Both Achaemenid campaigns precipitated the displacement of certain tribal groups farther east across the Eurasian steppes, even to the northwest borders of China. These events help to explain the strong similarity in type and representation across such a long distance between the coiled wolf bridle

ornament from the Ningxia Hui Autonomous Region (no. 47) and the coiled wolf found at Simferopol in the Crimea (cat. fig. 47.1), the pronounced Siberian flavor of the animal combat scenes on nos. 30, 50, 52, and perhaps even the extraordinary Achaemenid-style goat-man on the zither tuning key (no. 71).

South-Central Inner Mongolia

Only a few Chinese exports, and no vessels or commissioned objects, have been found in south-central Inner Mongolia. Seventy-nine graves dated typologically from the seventh to third centuries B.C. have been excavated at Maoqinggou, Liangcheng Xian, near Huhehot. This massive inventory has provided valuable information about the distribution of artifacts within a representative group of graves.[3] The most prevalent artifacts are daggers (placed at the waist in male graves only), belt accessories such as Chinese belt hooks,[4] belt buckles, and belt ornaments and plaques decorated with a limited number of designs featuring conventionalized raptor-heads (no. 86; see also fig. 35) and standing carnivores (plate 19; no. 89).

The constant repetition of raptor and carnivore designs on numerous belt ornaments found both at Maoqinggou and in collections throughout the world suggests that they had some special heraldic significance related to clan and tribe recognition.[5] Some of the belt plaques are distinguished by shiny white surfaces achieved by dipping them in molten tin[6] (nos. 86, 90). Tinning enhanced the surface of an object and also inhibited corrosion, but it was seldom used to enrich bronze after the third century B.C. Before the development of mercury gilding, bronze belt plaques used by northern tribes living west of the Taihang Mountains were often tinned, but the practice is not known east of the mountains.

The designs on the belt ornaments derive from both Chinese and Siberian sources. The conventionalized bird and tiger S-shaped designs on ornaments from graves dated to the sixth–fifth century B.C. are, for example, very similar to those found on Chinese jades from the early Eastern Zhou site of

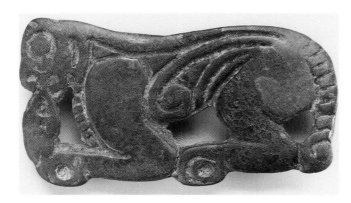

FIG. 19. Bronze ornament of a crouching feline savaging the head of a gazelle, Inner Mongolia Autonomous Region, 6th–5th century B.C. Length 6 cm. The Therese and Erwin Harris Collection

Shangcunling in Henan Province[7] (see no. 86). By contrast, the standing carnivores on plaques from the fifth century B.C. derive from images depicted on artifacts found in southern Siberia[8] (plate 19; no. 89; fig. 35b). Continued relations between China and the peoples of south-central Inner Mongolia are demonstrated by a number of Chinese seals and faience beads recovered from graves dating to the late Warring States and Han periods.

Other graves at Fanjiayaozi in Horinger Xian and Guoxianyaozi in Liangcheng Xian contained belt plaques depicting crude animal combat scenes in which a crouching feline is finishing off the remains of a small herbivore[9] (fig. 19). The animal combat motif was popular among many pastoral tribes throughout the Eurasian steppes. Its appearance on sixth–fifth century B.C. belt plaques in the northern zone coincides with its exotic intrusion into the bronze decor of northern Chinese vessels of the late Spring and Autumn period.[10]

Ordos Region

The burials associated with the tribes living farther west, in the Ordos Desert region of southwestern Inner Mongolia, have yielded grave goods quite different from those found at Maoqinggou. The major

sites are Taohongbala, Hangjin Qi,[11] and Yulongtai and Sujigou in Jungar Qi.[12] The most distinctive objects are finials (no. 37) and yoke ornaments (no. 32) for two-wheeled vehicles that may have played an important role in funerary rituals for the tribal elite as they did among the Scythian tribes in the West. Most vehicle ornaments portray local wild animals such as deer (no. 32) and gazelles (no. 37).

Belt accessories are not nearly as numerous as the chariot ornaments. Most are small plaques and simple buckles similar to minor examples at Maoqinggou. These similarities confirm contact with the tribes to the east at Maoqinggou, but there is little evidence for major cultural encounters with China. An exception is a Chinese *ge* (halberd) blade found at Gongsuhao in Hangjin Qi.[13]

Southern Ningxia Hui Autonomous Region and Southeastern Gansu Province

The third distinctive tribal area includes the grasslands of the southern Ningxia Hui Autonomous Region centered around Guyuan Xian and the Qingyang plateau of southeastern Gansu Province. Here excavated evidence is sufficient to suggest that the nearby Chinese state of Qin supplied local tribes with Chinese objects and custom-ordered ornaments, particularly belt plaques. The presence of numerous weapons, such as daggers, spear points, and axes indicates that these tribes were more aggressive than the tribes in the Ordos or Maoqinggou regions.

Chariot ornaments similar to those from the Ordos region abound at the tribal cemetery near Mazhuang, Yanglangxiang, Guyuan Xian, in Ningxia[14] and in burials on the Qingyang plateau.[15] Some appear to have been made locally; the construction of others, such as two yoke ornaments with sophisticated manufacture, points to Chinese workmanship (plate 3; no. 9). Several halberd blades excavated in the area have been identified as Qin products.[16] Other Chinese-made goods include belt hooks and superbly cast harness ornaments decorated with Qin patterns.[17] Chinese workmanship is also evident in the way that the bodies of five rams

on the tinned bronze harness jingle (no. 49) have been transformed into a decorative design.

The most distinctive artifacts from the Guyuan-Qingyang region are belt accessories: large plaques depicting animal combat motifs, small ornaments with stylized zoomorphic designs similar to those found at Maoqinggou and in the Ordos (no. 86), and buckles surmounted by animal figures (no. 87). Some of the large plaques appear to have been cast in mirror-image pairs that together constitute one complete buckle (nos. 50, 52). The wearer's left-hand plaque is pierced with a hole through which a cord is passed for fastening, while the matching right-hand plaque is not pierced. Mirror-image plaques were first developed among the tribes of southern Siberia and then became important items in the "status kits" of the tribes on China's north-western frontier.[18] This plaque buckling system was standard, and variations of its closure mechanism can be found in belt plaques manufactured for the northern zone during the first millennium B.C. (nos. 2, 6, 63, 64, 66).

Some harness ornaments and belt plaques may have been produced locally, but the surface decoration of a few clearly indicates that they were cast in the state of Qin (nos. 53, 54, 84). Their shapes and subject matter are based on northern concepts, but their decorative style is Qin. The birds with sweeping wings and returned heads on the fifth-century B.C. tinned belt ornament (no. 84) derive from earlier bird images found on Western Zhou vessels,[19] but the object type is northern. These Chinese artifacts made for northern consumption form a category of Sino-nomadic objects seldom recognized as such.[20]

Newcomers in the Far Northwest: Fourth–First Century B.C.

Dramatic changes took place in the far northwest in the second half of the fourth century B.C. with the arrival from points west of powerful, militant tribes practicing mounted warfare.[21] Their movement has been attributed to the displacement of tribes farther west, in Central Asia, by the Asian campaigns of Alexander the Great, who had penetrated as far as Bactria in present-day Afghanistan. Because these tribes had beliefs and livelihoods different from those of tribes they conquered and absorbed in China's northwestern frontiers, significant changes in the visual symbolism and the range of artifacts can be noted.

The emphasis on horseback riding among the new tribes appears to have prompted a shift from semisedentary pastoralism to full-scale transhumance. This seminomadic way of life involves highly structured seasonal migrations in the spring to designated areas with sufficient pasture and water for the summer, and returning home in late fall to market the animals and settle down for winter. It is not sur-

FIG. 20. Gold headdress, Nalin'gaotu, Shenmu Xian, Shaanxi Province, late 4th century B.C. Height 11.5 cm. After Bunker 1989, p. 54, fig. 3

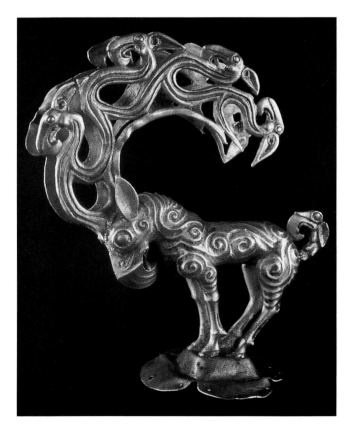

prising that Qin production of belt ornaments, plaques, daggers, and other objects for export increased significantly following the arrival of these militant herders in the Guyuan-Qingyang region. Tribes practicing transhumance have little time to make luxury goods and tend to acquire them from nearby settled peoples.[22] Many of the belt ornaments and plaques that have been discovered are clearly related to styles practiced at Qin metalworking centers in Shaanxi Province.[23] The discovery of large numbers of identical belt plaques indicates that these plaques were not only important but that they were cast in large numbers, conceivably following specific business agreements between the Chinese manufacturers and their seminomadic customers. This exchange was not just a matter of trading trinkets to the natives.

Detailed specifications concerning shape and design must have been provided so that Qin workshops could produce belt plaques that would meet with tribal approval. The zoomorphic symbols in the decoration were heraldic emblems that had special significance for those who wore them, so any old design would not suffice.

The immediate source for northern motifs and shapes is hard to determine, but locally carved bone artifacts with curvilinear patterns, such as those from a cemetery at Mazhuang, Yanglangxiang in Guyuan Xian, Ningxia Hui Autonomous Region,[24] compare well with those on the body of a wolf belt plaque (no. 50). The striated marks on the wolf-shaped bridle ornament (no. 47) also can be related to bone carving (see cat. fig. 56.1). The layered look on another belt plaque (no. 54) resembles appliqué work, suggesting that textiles as well as carved bone and wood served as models. Further comparisons between bone and metal artifacts are provided by a recumbent tinned bronze horse from northwest China (no. 57) that is surprisingly similar to a carved bone recumbent horse excavated in kurgan 2, Sagla-Bazha, in western Tuva, southern Siberia.[25]

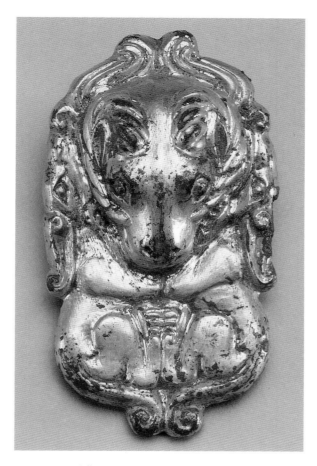

PLATE 11. Bridle ornament, no. 55

Intruders in Northwest China and the Ordos

In the late fourth century B.C. a new range of artifacts not found in earlier burials suddenly appeared in northwest China and southwest Inner Mongolia: flamboyant gold headdresses (fig. 20), silver animal chariot yoke ornaments,[26] riding bridle ornaments (plate 11; no. 55), numerous belt plaques, earrings, and necklaces, often of gold and silver. Many of these artifacts display metalworking techniques new to the area, such as repoussé work, granulation, strip-twisted wire, loop-in-loop chains, and cloisonné, which had been transmitted across the Eurasian steppes from metalworking centers farther west. The appearance of these techniques on China's northwest frontiers had a major impact on Chinese metallurgy.[27]

Some of the artifacts found in the Guyuan-Qingyang region are decorated with fantastic crea-

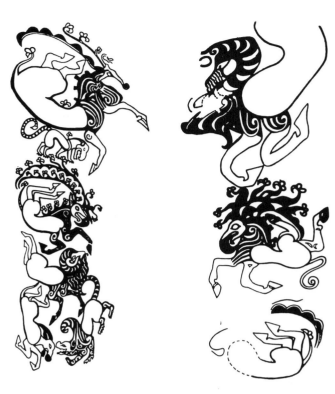

FIG. 21. *Above.* Drawings of zoomorphic symbols tattooed on body of man buried in kurgan 2 at Pazyryk, Altai Mountains, southern Siberia, 4th century B.C. After Bunker 1989, p. 53, fig. 2

FIG. 22. *Below.* Drawings of two boot soles: (a) hammered silver chisel-cut boot sole, Shihuigou, Ejin-Horo Qi, Inner Mongolia Autonomous Region, 3d century B.C.; (b) leather cutout boot sole from kurgan 2, Pazyryk, Altai Mountains, southern Siberia, 4th century B.C. Dimensions not specified. After Bunker 1992b, p. 106, fig. 15

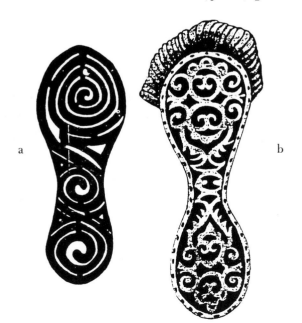

tures with raptor-head crests and tails (nos. 50, 51). These extraordinary creatures have traditionally been associated with pastoral tribes with an Indo-European–speaking ancestry, such as the Saka in Central Asia, the Scythians in southeastern Europe, and the Rouzhi/Yuezhi located farther west in Gansu Province.[28] The appearance of objects with raptor-head attributes in China's northwest frontiers coincided roughly with Alexander the Great's Asian campaigns and the adoption of mounted warfare by the state of Zhao from tribes referred to in ancient Chinese literature as Hu and Linhu. The names Hu and Linhu may refer to some Indo-European-speaking subtribe of the Rouzhi that moved into the Ordos region during the late fourth century B.C.[29] These fantastic creatures with raptor-head crests are startlingly similar to the mythological animals among the designs tattooed on the man from kurgan 2 in Pazyryk in the Altai Mountains in southern Siberia[30] (fig. 21). Another distinctive similarity is the practice of decorating the soles on the boots of the dead. At Pazyryk, the sole was adorned with a cutout leather appliqué, and at Shihuigou, Ejin-Horo Qi, in the Ordos, the sole was a cutout silver appliqué[31] (fig. 22). The practice was known in the Qin court, for a pair of jade soles has been recovered from the tomb of Duke Jing of Qin.[32] It may have been a steppe custom, because it occurs later among the Khitan tribes of the Liao dynasty.[33]

Unlike the previous period, during the late fourth and third centuries B.C. contact between China and the northern tribes in the Ordos was very close. Most of the cast items from Aluchaideng[34] and Xigoupan[35] in the Ordos were probably imports from China or cast by Chinese metalworkers in local employ. The presence of Chinese characters engraved on the backs of cast gold and silver artifacts to indicate the weight of the metal is indisputable evidence for Chinese manufacture of these luxury goods.[36] Many of these pieces must have been commissioned to meet the demands and cultural requirements of their pastoral owners.[37]

Understanding of trade in luxury goods is further illuminated by a cache of gold ornaments discovered

in tomb 30 at Xinzhuangtou, Yi Xian, Hebei Province, site of the southern capital of the Yan state during the late fourth and third centuries B.C. These ornaments, some inscribed with their weight, are adorned with distinctly northern subject matter and, on rare occasions, even include images of their intended owners (fig. 23). Two gold plaques (fig. 24) and several bronze belt plaques (plate 13; no. 56) are too similar to an example from Aluchaideng to be coincidental (fig. 25). The silver disk adorned with a coiled goat (plate 12; no. 58) also has a counterpart among the objects from Xinzhuangtou.[38] Many of these pieces display a woven textile pattern integral to the metal surface on the back, indicating that they were cast by a distinctive variation of the lost-wax process, known as lost-wax and lost-textile, used to make ornaments for the northern tribes[39] between the late fourth–third and the late first centuries B.C.

FIG. 23. Gold ornament from tomb 30 at Xinzhuang-tou, Yi Xian, Hebei Province, 3d century B.C. Height 5.1 cm

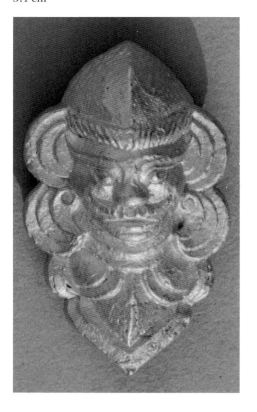

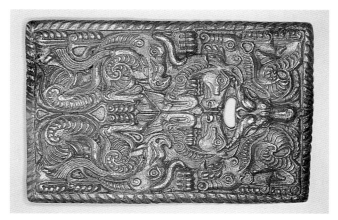

FIG. 24. Gold belt ornament, one of a pair, front and back views, from tomb 30, Xinzhuangtou, Yi Xian, Hebei Province, 3d century B.C. Length 11.6 cm

Developments in Casting Techniques

The earliest archaeological evidence for lost-wax casting in China was discovered at the sixth-century B.C. Chu state cemetery in Xiasi, Xichuan, in Henan Province.[40] Lost-wax casting was introduced into China ultimately from ancient West Asia, but exactly when and how is unclear. The possibility that the northern tribes played some part in its transmission is a tantalizing thought that demands further consideration. Technical advances often first appear in the manufacture of small objects such as personal ornaments and harness fittings.[41]

The direct lost-wax process was more practical than the section-mold process for casting ornaments

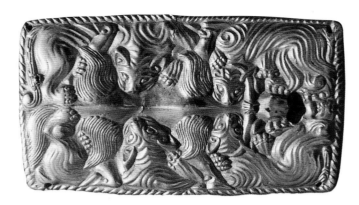

FIG. 25. Gold belt plaque,
one of a pair, Aluchaideng,
Hangjin Qi, Inner Mongolia
Autonomous Region, 3d
century B.C. Length 12.7 cm

with deeply undercut and openwork designs, which complicate the removal of mold sections from the model (see no. 7). The lost-wax process was also more economical than the section-mold process because the amount of metal used could be more easily controlled. The object to be cast is first modeled in wax and then surrounded with clay to form a mold. The clay-packed wax model is then burned out under high heat, hence the term "lost wax." Molten metal is poured into the mold, taking the place of the burned-out wax model. After cooling, the mold is broken open to reveal a metal copy of the original wax model.[42]

Many ornaments used by the northern tribes appear to have been cast by a variation of this process—the indirect lost-wax process (nos. 47–52, 54)—which made mass-production relatively easy. First a model of the plaque to be cast was made out of wood, stone, or clay (no. 62; cat. fig. 62.1). Then an open section "mother-mold" was formed by pressing the model into a piece of soft, damp clay. After the clay had dried, molten wax was poured into the open section mother-mold, then removed when it had hardened. The result was a wax plaque identical to the original clay model. The wax model was then packed in clay and baked at a high temperature. The investment usually retains air bubbles

that result in tiny, round, positive metal spheres on the back of plaques cast by this method (nos. 48, 49). The wax was burned out, leaving an empty mold into which molten metal was poured. When the metal had cooled, the mold was broken open to reveal a metal plaque that was identical to the original clay or wood model from which the mother-mold had been formed.

The great advantage of the indirect lost-wax casting method was that the original model was not destroyed (no. 62; cat. fig. 62.1). Instead, it could be used to make an indefinite number of wax models, allowing artisans to mass-produce the plaques. Sometimes the wax models were reinforced with a piece of coarse fabric, such as hemp. This cloth-supported wax model could then be made very thin, reducing the amount of metal needed as well as the weight of the final product. This process, known as lost-wax and lost-textile, is a distinctive variation of the indirect lost-wax process and was responsible for numerous belt ornaments (plate 13; nos. 56, 58–61, 63–66). Plaques cast by this technique can always be recognized by the appearance of a woven pattern on the backs of the plaques that reproduces

PLATE 12. Ornament, no. 58

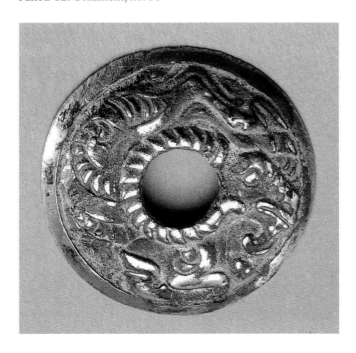

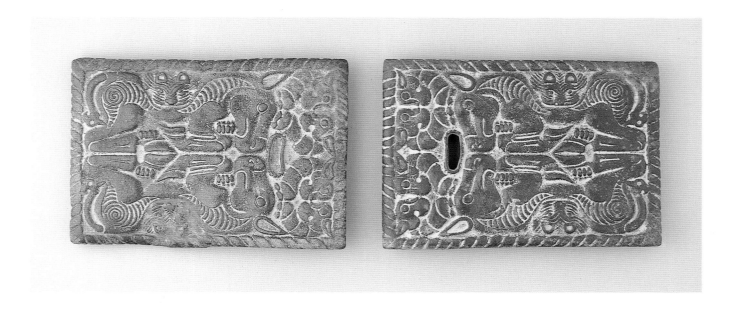

PLATE 13. Pair of belt
plaques, no. 56

the cloth backing used to support the wax model
from which the plaque was cast (see fig. 24; nos. 59,
64).

The lost-wax and lost-textile process appears to
have been used at several Chinese metalworking
centers from the late fourth–early third to the late
first century B.C.[43] Recent excavations at Xin-
zhuangtou revealed gold ornaments decorated with
northern motifs, of which several examples similar
in design to no. 56 (plate 13) were cast by the lost-
wax and lost-textile process (fig. 24). Xinzhuangtou
is near Yi Xian in Hebei Province, where the south-
ern capital of the state of Yan was located from the
late fourth century B.C. until 222 B.C., when it was
overrun by the Qin. Another pair of gold belt
plaques cast by lost-wax and lost-textile was excavat-
ed at Xigoupan, Jungar Qi, in the Ordos region.[44]
Besides the woven pattern on the reverse of each
plaque, one plaque is also engraved with Chinese
characters that give the weight and subject matter of
each plaque. The style of the characters suggests
that the Xigoupan plaques were made in the state of
Zhao expressly to be traded with the northern herd-
ing tribes, probably for horses.[45]

A reusable model must have been used to create a
mold in which multiple wax models could be made
to mass-produce these plaques. A Chinese artisan
would naturally turn to clay, which had been used in
bronze casting since the second millennium B.C.
The ceramic model of a camel plaque (no. 62) or the
model for a round camel ornament (cat. fig. 62.1)
would have been such models, used in the produc-
tion of plaques like no. 61 and other similar orna-
ments.[46] Locally made ornaments tended to be
made using traditional tribal methods, such as ham-
mering a thin sheet of metal over a model made from
a plentiful material such as bone or horn. A bone
model of a crouching feline and two very similar
gold, feline-shaped plaques that would have been
formed over something like it were recently exca-
vated in Pokrovka, Russia, in the southern Urals (fig.
26), a site dated to the sixth to fourth century B.C.[47]

The northern tribes must have acted as interme-
diaries between production centers in China and
far-off nomadic peoples buried at Pazyryk in the
Altai Mountains. A lively down-the-line trade from
China to Mongolia to Siberia was still in operation in
the nineteenth century according to the great
Russian explorer and scholar Wilhelm Radloff. This
type of long-distance trade would explain the spec-
tacular Chinese textiles in kurgan 5 at Pazyryk and
the presence of a Chinese bronze mirror like no. 68

in kurgan 6 at Pazyryk, made from a mold similar to no. 69, which could have come from Yan workshops in Xinzhuangtou, Yi Xian, Hebei Province.[48]

The Xiongnu and the First Steppe Empire
The Xiongnu appeared suddenly in the northwest in the third century B.C., and within decades of their arrival the cultural climate of the entire northern zone changed dramatically. The early history of the Xiongnu has not yet been determined,[49] but the recent theory by Sergei Minyaev suggesting a northeast origin is well worth further investigation.[50]

According to ancient Chinese literature, the Xiongnu were located in the Ordos region, at first associated with the Rouzhi confederacy, to which they owed nominal allegiance.[51] After several skirmishes with the Qin, who expelled them from the Ordos, the Xiongnu regrouped and returned after the Han had overthrown the Qin dynasty in 206 B.C. Shortly after the Han conquest, the Xiongnu leader Maodun assassinated his father and took over the leadership of the Xiongnu confederacy. He then proceeded to conquer all the northern tribes, including his earlier Rouzhi overlords, and to forge them into a vast steppe empire that stretched from Liaoning in the east to Xinjiang in the west and to Lake Baikal and the Yenisei valley in the north.

Chinese mass-production of belt plaques, ornaments, and silk for the Xiongnu elite accelerated significantly during the Han period, and the lives and economies of the two peoples became increasingly interlocked. The Xiongnu became so important that Sima Qian, the Herodotus of ancient China, devoted a whole chapter in the *Shiji* (Records of the Grand Historian of China) to them. "The animals they raised consist mainly of horses [no. 8], cattle, and sheep, but include such rare beasts as camels [no. 61]. They move about in search of water and pasture [no. 3]. In burials, the Xiongnu use accessories of gold, silver, clothing, and fur, but they do not construct grave mounds."[52] Sima Qian has, in fact, given an early description of transhumance.

Belt ornaments and plaques reflecting clan and rank continued to be important possessions among

FIG. 26. Objects from the Orenburg region of the southern Urals, 6th–4th century B.C.: (a) bone model from kurgan 2, burial 5, Pokrovka cemetery 1; (b) two hammered gold plaques from kurgan 2, burial 1, Pokrovka cemetery 2. Dimensions not specified

the Xiongnu, but the iconography changed.[53] Instead of animals with raptor-head attributes, real animals and human activities were emphasized (nos. 1, 2, 6, 8, 59, 61). The mythological animal most closely associated with the Xiongnu was a lupine-head, sinuous dragon that may have been an amalgamation of northern and Chinese motifs[54] (no. 80). The few plaques adorned with creatures with raptor-head attributes, such as nos. 63, 64, 66, 67, found in Xiongnu contexts, must have belonged to conquered Rouzhi men and women, because after the expulsion of the Rouzhi between 176 and 160 B.C., enthusiasm for these mythological creatures decreased dramatically. The images ultimately disappeared completely from the symbolic vocabularies of the area.[55]

Tinning appears to have been replaced by gold, silver, and gilded bronze, new ways to indicate status throughout the northern zone (nos. 59, 60, 61, 63–66). Whether all or only some of the plaques were Chinese-made is unclear, but certainly all the mercury gilded plaques were made by Chinese metalworkers because there is no evidence that the Xiongnu knew the mercury-amalgam gilding technique developed at Chinese workshops during the last centuries B.C.[56] By the late first century B.C., the Xiongnu had captive Chinese artisans in their employ at Noin Ula in northern Mongolia, but whether they were making tools, weapons, or luxury goods is not known.[57]

The Xiongnu continued to interact with the Chinese throughout the Han period. Goods passed back

and forth, and exchange was greater than ever. Early in the second century B.C., the Han emperors formulated the Heqin policy regulating exchange between the two powers on either side of the wall, and when enforcement of the policy was lax, the Xiongnu frequently raided. Several ornaments found in the tribal cemetery at Xichagou, Xifeng Xian, Liaoning Province, are Chinese objects that must have been either seized in raids or received as gifts.[58] Buried in the cemetery at Xichagou are both the Xiongnu and the Donghu whom they conquered.[59]

As the Xiongnu became more accustomed to Chinese luxury goods, the vitality of their visual imagery declined. Zhonghang Yue, their expatriate Chinese adviser, warned the Xiongnu of the dangers: "The strength of the Xiongnu lies in the very fact that their food and clothing are different from those of the Chinese, and they are not dependent on the Han for anything. Now the *Shanyü* has this fondness for Chinese things and is trying to change Xiongnu customs."[60] The Xiongnu leaders squabbled among themselves, and their power declined as the Chinese gained strength. Eventually, the Xiongnu were superseded by other tribes, such as the Xianbei, effectively terminating the first great nomadic empire in the north. The Xianbei would, in turn, be succeeded in later periods by other waves of non-Chinese peoples, such as the Khitans, Mongols, and Manchus.

East of the Taihang Mountains: Sixth–Third Century B.C.

East of the Taihang Mountains, land and climate supported a sedentary way of life, and some of the region was under Chinese control. The fertile soil in the Liao River valley promoted farming and non-transhumant animal husbandry. Forested regions rich in game made hunting and trapping the other main occupations of local tribes. Time-consuming tanning and the processing of fur and leather were possible in a more settled way of life. Archaeological evidence confirms that the northeastern tribes were primarily sedentary peoples who produced most of the goods they needed themselves, unlike the western pastoralists who relied heavily on Chinese products. Chinese objects found in the east were exotic prestige items that were symbols of power, not commissioned luxury items designed to appeal to northern taste.

Chinese Exports

There is no evidence that the Chinese produced commissioned artifacts for the northeastern tribes. Unlike the grave goods from areas in the west, burials in the northeast contain strictly orthodox Chinese objects with Chinese decor, such as ritual vessels, *ge* blades, small bells, and belt hooks, some of which represent very early types.[61] Some of the most important Chinese objects found at sites east of the Taihang are vessels (nos. 12, 21, 23). These Chinese vessels represent prestige items, valued as prized exotica, as demonstrated by the attention given to an unpublished *dou* from Jundushan, Yanqing Xian, outside Beijing, that was apparently crudely repaired to extend its life in antiquity.

Local Products and Iconography

Several features of the burials north of Beijing at Jundushan, Yanqing Xian, continued to demonstrate differences between the tribes living east and west of the Taihang Mountains at this time. East of the mountains a large number of daggers and knives have been found in the tombs (nos. 39, 40, 42). By contrast, burials west of the Taihang contained daggers but few knives (nos. 43–45). It must be remembered that the knife was not a weapon but a tool indispensable to a hunter or trapper who must skin and prepare fur and leather.

In one grave, the lower half of the body was literally covered with small metal animal-shaped ornaments that were probably attached to the belt or tunic (cat. fig. 83.1). Instead of the large heraldic animal-shaped belt plaques displayed at the waist by the western tribes, the bodies of the dead elite in the northeast were adorned with a single animal-shaped plaque worn high on the chest and masses of small

64

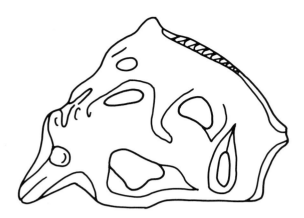

FIG. 27. Drawing of bronze
ornament depicting copulat-
ing boars, Tiejianggou,
Aohan Qi, Inner Mongolia
Autonomous Region,
6th–5th century B.C. Width
4.8 cm. After *Neimenggu
wenwu kaogu* 1992.1–2, p.
87, fig. 7.1

zoomorphic ornaments.[62] In burials at Huailai Xian
in northern Hebei Province, the dead were also
found with multiple animal-shaped ornaments that
must have been cast in large numbers, such as the set
of twenty stags[63] (no. 83). These multiple orna-
ments suggest that mass-production was already
practiced by the northeastern tribes, offering further
evidence for their sedentary existence.

Images of animal combat apparently had little sig-
nificance for the northeastern peoples compared to
their enormous popularity among western tribes. In
the west the image could have served as a power
emblem for herders who must protect their stock
against predators. The figure of a tiger with a tiny
hare in its paws excavated at Sanguandian, Lingyuan

Xian, Liaoning Province,[64] is hardly an impressive
power symbol; instead the motif of a leopard or tiger
with a hare may reflect a local hunting technique.
References abound in both art and literature to fal-
cons, dogs, tigers, and leopards used for hunting in
ancient times.[65] Certainly the carnivore depicted
standing on a cart on a second- to first-century B.C.
belt buckle must be tame (no. 2). By comparison to
the tribal groups west of the Taihang Mountains,
which used animals as symbols of power and author-
ity, there seems to have been more of a desire among
tribes east of the mountains to portray the natural
world in which animals play an integral role. What-
ever the explanation, animal combat was not an inte-
gral part of northeastern iconography until the
Xiongnu conquest in the late third century B.C. and
then only when the protagonists were mythological
beasts that can probably be associated with con-
quered subtribes in the Xiongnu confederacy (nos.
63, 67, 80). After the Xiongnu conquests in the east-
ern region, burials in Liaoning contained belt
plaques and buckles identical in type and design to
those found in the northwest (nos. 2, 63, 66, 67).

Some northeastern examples of animal combat
may have other interpretations. From the late second
millennium B.C. on, a few northern images showed a
frog under attack from two or more snakes. These
are not conventional animal combat scenes but
appear to have complex meanings that descend from

FIG. 28. Bronze awl, Inner
Mongolia Autonomous
Region, 6th–5th century B.C.
Length 20 cm. Museum of
Far Eastern Antiquities,
Stockholm, K.11004.25

FIG. 29. Drawing of bronze stag ornament, Jundushan, Yanqing Xian, Beijing, 6th–5th century B.C. Dimensions not specified

much earlier Bronze Age, northern traditions.[66] The image of a frog encircled by two snakes also occurs on plaques worn by women at the chest in burials dating to the sixth or fifth century B.C. in northern Hebei Province, suggesting that the motif may have fertility associations.[67]

Sex and fertility appear to have been of more interest to the tribes in the northeast than animal combat. The pommel of a dagger from Nanshan'-gen, Ningcheng Xian, southeast Inner Mongolia, is cast with nude male and female figures shown back to back dorsally placed across the handle.[68] Another popular fertility motif shows copulating animals: wild boars on a plaque discovered at Tiejianggou, Aohan Qi, southeast Inner Mongolia (fig. 27), or leopards and deer on plaques in many Western collections that are for reasons of delicacy seldom published.[69] The most splendid mating scene adorns a bronze awl in the Museum of Far Eastern Antiquities, Stockholm (fig. 28). A doe closely followed by four stags turns her head backwards to look at her potential mates. The intent is obvious, but the sensitivity with which the animals are portrayed is unequaled in the art of the northern tribes.

Hunting was a major activity among the tribes in the northeast (see figs. 16, 17), and the need for

visual fertility symbols to assure proliferation of game may explain the presence of these images. Such images were also of interest among hunting societies during the Paleolithic period.[70] By contrast, tribes herding domestic animals probably supervised animal reproduction as they do today, so disease, predators, and weather would have been the major concerns.[71] The psychology of the herder is different from that of a hunter, and this difference is reflected in the artistic motifs that gave visual form to the symbolic systems regulating their lives.

Contacts with Southern Siberia and Western Eurasia

Other distinctive zoomorphic motifs suggest some contact, as yet unexplained, with tribes inhabiting northeast Mongolia and southern Siberia that did not affect the tribes west of the Taihang Mountains. Long before the establishment of the more southerly Silk Route in the second century B.C., the northeastern tribes had indirect access to other Eurasian steppe tribes farther west by way of a complex ancient trading network—the Fur Route—that ran north via the Amur valley and then northwestward across Eurasia above the fiftieth parallel to the Caspian Sea and beyond to southeastern Europe, roughly the same route traveled by the Trans-Siberian railway today.[72]

Of particular importance is the coiled feline on the pommel of a dagger excavated from tomb 101 at Nanshan'gen, Ningcheng Xian, in Inner Mongolia.[73] The coiled carnivore, a major motif among the Eurasian steppe tribes, occurred earlier in southern Siberia than it did on China's northern frontier.[74]

Further evidence for long-distance foreign contact is provided by the close similarity between a harness jingle (no. 34) and a jingle discovered near the village of Korsukovo, Kachuga, in the Irkutsk region of southern Siberia,[75] found inside a bronze cauldron like the one from Jundushan, north of Beijing (cat. fig. 22.1). Even more clues for foreign contact are provided by the raptor-head tail on a recumbent stag plaque from Jundushan, north of

Beijing (fig. 29) and the animal-head tips on horns depicted on the *dou* (no. 12). The bird-head motifs marking the body of the carved bone animal may be an even earlier manifestation of this iconography (no. 29). Indo-European–speaking tribes who used this distinctive iconography inhabited Central Asia and the Minusinsk region of southern Siberia long before tribes associated with the same iconography appeared on China's northwestern frontiers in the fourth century B.C.[76]

Two other stylistic traits connect the art of the northeastern tribes with those from farther west: the portrayal of antlers by a series of tangent circles, and the folded leg pose (no. 83). Both artistic conventions occur throughout southern Siberia and Mongolia and among the early Scythians in the Black Sea region.[77]

—ECB

Notes

1. Chinese texts list many tribes, some of which have been identified archaeologically and some not. Precise correspondence between textual and archaeological data is very difficult. For more information, see Průšek 1966; Průšek 1971.

2. Thomas O. Höllman suggests a seventh-century date for tomb 58, where this belt hook was found. Höllmann and Kossack 1992, p. 29, plate 27. The grave chronology is based on typological studies of the grave goods.

3. See Tian and Guo 1986, pp. 227–315.

4. Ibid., pp. 269–70, plates 74–75.

5. Belt ornaments have been found in twenty-eight graves, only four of which have been identified as female. Twenty-one plaques are bird-shaped, seven are animal-shaped. For a detailed discussion on the distribution of artifacts, see Höllmann 1992; Höllmann and Kossack 1992.

6. Bunker 1990a. Han and Bunker 1993 indicate that mercury was not involved in the tinning, which could have been done locally.

7. Tian and Guo 1986, p. 117, fig. 82. Some of these designs are so stylized that their zoomorphic origins are difficult to reconstruct.

8. Rudenko 1970, pp. 268–69, fig. 136; Zavitukhina 1983, nos. 191–93.

9. See also *Wenwu* 1959.6, p. 79, fig. 3; *Kaogu xuebao* 1989.1, fig. 11.10, plate 16.4.

10. For an example, see New York 1980, pp. 267–68, no. 69.

11. *Kaogu xuebao* 1976.1, pp. 133–44, plates 1–4.

12. *Kaogu* 1977.2, pp. 111–14; *Wenwu* 1965.2, pp. 44–46.

13. Höllman and Kossack 1992, plate 14.4.

14. *Kaogu xuebao* 1993.1, p. 42, fig. 24.

15. *Kaogu* 1988.5, pp. 413–24.

16. *Kaogu* 1988.5, p. 416, fig. 7.1.

17. *Kaogu xuebao* 1993.1, p. 36, fig. 20.11, plate 3.3. From its appearance, this item has probably been tinned.

18. Rawson and Bunker 1990, p. 295.

19. Rawson 1990, nos. 53–54.

20. Bunker 1991b.

21. Bunker 1992b. Ancient Chinese texts recording events from the late fourth century B.C. refer to these tribes as Hu and Hume, names that specifically designate the new peoples on the northwest borders of China, replacing the older names of Rong and Di. See Průšek 1971, pp. 223–24.

22. For a list of imported manufactured objects and their provenance in the household of a contemporary steppe tribe, see Vainshtein 1980, p. 223.

23. Bunker 1991b.

24. *Kaogu xuebao* 1993.1, p. 45, figs. 26.2, 26.5, 26.6.

25. See London 1978, plate 101.

26. For example, see Osaka 1987, plate 11.

27. Bunker 1994b, pp. 44–47, for a detailed description of these techniques.

28. For Indo-European–speaking tribes using raptor-head attributes on objects, see Jacobson 1984; Bunker 1989; Bunker 1992b, pp. 100–106. The tribal name Rouzhi is used in Chinese archaeological literature today to refer to the Yuezhi, an alternative reading of this tribal name that resulted from confounding the contracted form of the 130th radical with the 74th radical. Bunker 1991b, n. 56.

29. It is clear that the names Linhu and Hu do not refer to the Xiongnu. See Průšek 1971, pp. 224–26; Bunker 1992b, pp. 111–12.

30. See also Jacobson 1984; Haskins 1988.

31. Bunker 1992b.

32. *China Pictorial,* 1987.5, p. 17.

33. *Neimenggu wenwu kaogu* 4 (1986): 78, fig. 2.5.

34. *Kaogu* 1980.4, pp. 333–38.

35. *Wenwu* 1980.7, pp. 1–10.

36. This evidence is extensively discussed in Bunker 1992b.

37. Li Xueqin 1985a, pp. 333–36.

38. Ibid., p. 334, fig. 15.

39. For other examples and discussions of this technique, see Bunker 1988b; Bunker 1992a; Bunker 1992b, fig. 20.

40. Li Xueqin 1991, pp. 1–22.

41. Hearn 1987, no. 67; Bagley 1987, p. 44; Smith 1970, p. 494.

42. See Bunker 1994b, pp. 41–42, for a discussion of lost-wax casting and its variations.

43. Bunker 1992b, pp. 106–9.

44. Bunker 1991b, fig. 19.

45. Li Xueqin 1985a, pp. 333–35.

46. See So 1995, introduction, sections 4.2, 4.3, for discussion of mass-production using clay molds and models in Chinese workshops.

47. Yablonsky 1994, figs. 37.16, 76.12–13.

48. Bunker 1991a. For an extensive discussion of the Pazyryk burials, see Rubinson 1990; special issue of *Source* 10, no. 4 (Summer 1991).

49. Haskins 1988, p. 1.

50. Minyaev 1992.

51. Průšek 1971, p. 14; Jettmar 1967, p. 143; Pulleyblank 1983, pp. 449–52.

52. Watson 1961, 2:155–92.

53. A summary of the primary themes and motifs from this period is provided by Rawson and Bunker 1990, pp. 301–4.

54. Ibid., pp. 302–3. The carpets decorated with mythological animals with raptor-head appendages found at Noin Ula are not Xiongnu but heirlooms from someplace else. For details, see Bunker 1992a, n. 69; Rawson and Bunker 1990, n. 99.

55. Bunker 1992b, p. 109.

56. Mercury gilding was inspired by Daoist alchemy and the search for immortality. See Bunker 1994b, pp. 47–48.

57. Vainshtein 1980, p. 199.

58. *Wenwu* 1960.8–9, p. 34, fig. 9, and a tiny unpublished gilded bronze crouching hare. Both items are either similar or identical to objects excavated at Mancheng, Hebei Province. See Beijing 1980b, p. 205, fig. 138.8, plate 131.

59. See Wu En 1990, pp. 409–34.

60. Zhonghang Yue, quoted in Barfield 1989, p. 52.

61. *Wenwu ziliao congkan* 7 (1983): 73, 70, figs. 16, 5.16–18.

62. *Wenwu* 1989.8, p. 23, fig. 9.

63. *Wenwu chunqiu* 1993.2, p. 31, fig. 9.4.

64. *Kaogu* 1985.2, p. 127, fig. 5.1–4.

65. See fig. 16; Andersson 1932, pp. 304–6; White 1939, pp. 48–50, plates 31, 83, 94.

66. For a discussion of this motif, see Bunker 1987.

67. Personal observation of an unpublished grave reconstructed at the provincial museum at Luanping Xian in northern Hebei Province. See also Gimbutas 1989, pp. 251–56, for a discussion of the connection between frogs and regeneration.

68. Tokyo 1983, no. 14.

69. Andersson 1932, pp. 287–88, plate 28; Rawson and Bunker 1990, p. 210.

70. For a similar Paleolithic scene, see Bahn and Vertut 1988, figs. 85, 86.

71. Only two examples of copulating animals have been reported on northwestern artifacts, both from the Ningxia Hui Autonomous Region. See *Kaogu xuebao* 1993.1, p. 32, fig. 8.11; *Kaogu xuebao* 1995.1, p. 94, fig. 15.2.

72. The existence of this route may explain the appearance at sites in northern Hebei and Liaoning Provinces of the distinctive funnel-shaped earrings. See Bunker 1993, pp. 30–31.

73. *Kaogu yu wenwu* 1984.4, fig. 3.

74. See the example found among the grave goods of a tribal chieftain at Arzhan. Griaznov 1984, plate 4. Coiled felines also occur on small plaques at Huailai Xian in northern Hebei Province. *Wenwu chunqiu* 1993.2, p. 19, figs. 10.8–9, 10.11.

75. *Sovetskaya Arkheologiya* 1991.2, p. 199, fig. 6.

76. Tchlenova 1963, table 1; Bunker 1989, p. 53.

77. Tchlenova 1963, table 1.1–5, table 2.

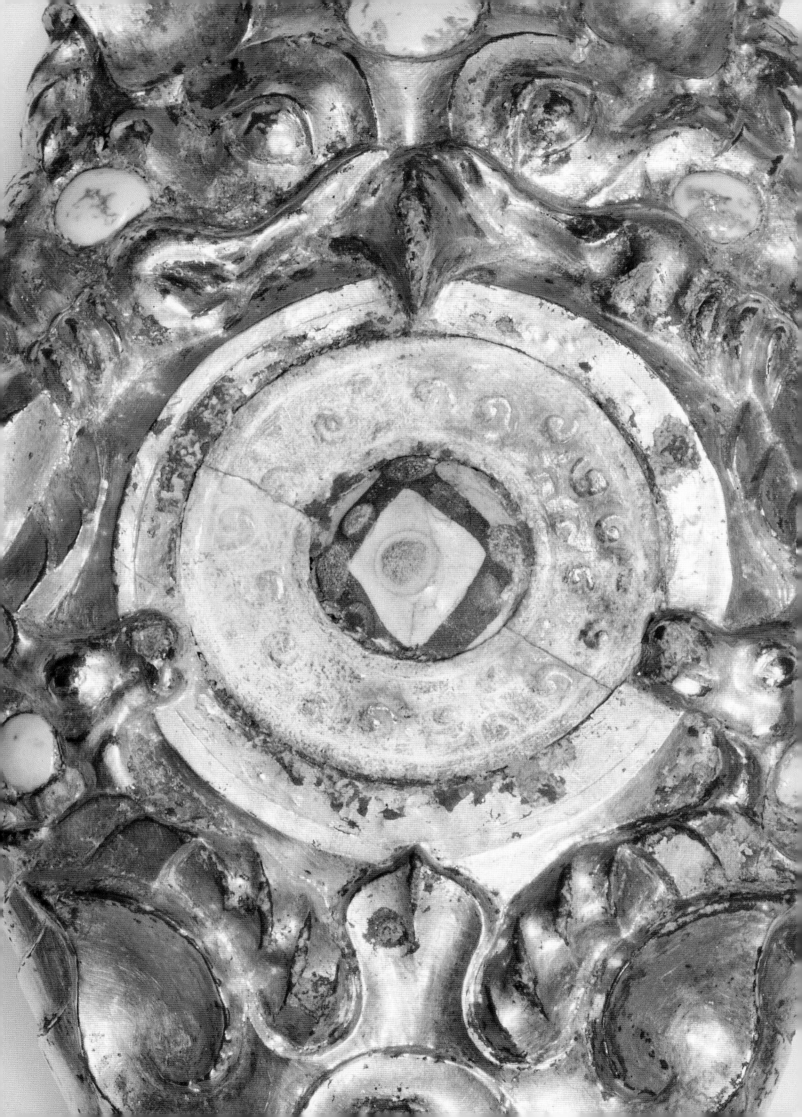

Chinese Luxury Goods Enhanced

FIFTH CENTURY B.C.–FIRST CENTURY A.D.

STRANGE IMAGES FOREIGN TO THE TRADI-
tional decoration of Chinese secular art
appeared repeatedly during the Warring States, Qin,
and Han periods (5th century B.C.–2d century A.D.).
Fittings for musical instruments (nos. 70–72), mir-
rors (no. 46), vessels (no. 73), belt and other orna-
mental accessories (nos. 75–80, 82), and horse gear
(no. 81) display exotic-looking images that reflect
cultural encounters about which little is yet under-
stood. A brief introduction to the many Chinese lux-
ury goods transformed by non-Chinese features
from the latter half of the first millennium B.C. will
demonstrate the artistic debt owed by the Chinese to
the tribes in the north and suggest how and why this
debt may have been incurred. The appearance of
foreign images must also reflect a less strict adher-
ence to tradition within China due to changes in the
ritual customs and the increased regionalism that
developed during the late Eastern Zhou period.[1]

Luxury Goods with Foreign Motifs: Fifth–Third Centuries B.C.

Some luxury goods decorated with non-Chinese
images made during the Warring States period have
an unsettling quality about them. The foreign motifs
are not integrated into the Chinese artistic vocabu-
lary but are startlingly alien, challenging the viewer
to conjure up what event could have made their
introduction into China possible. The most tantaliz-
ing example of this kind of exotica is the fantastic
recumbent goat-man who came straight out of
ancient Iranian mythology to surmount a tuning key
for a Chinese *qin* (zither) (plate 14; no. 71).

A silver belt ornament (fig. 30) recently discov-
ered in a fifth-century B.C. nomadic grave at Issyk
near Alma Ata in Kazakhstan provides a clue to the
route taken by the goat-man across the vast Eurasian
steppes. Four standing animals with bearded goat-
man heads similar to the head of the figure on the
tuning key are shown in profile. If an Achaemenid
goat-man image had been incorporated into the
artistic expression of pastoral tribes of Central Asia,
it could have reached China when these tribes were
pushed east by either the earlier Achaemenid cam-
paigns or Alexander's advance.

The zither tuning key is closely associated with
south China since the only surviving zithers have
come from south China burials along the Yangzi

Detail from plate 15, see page 71

70

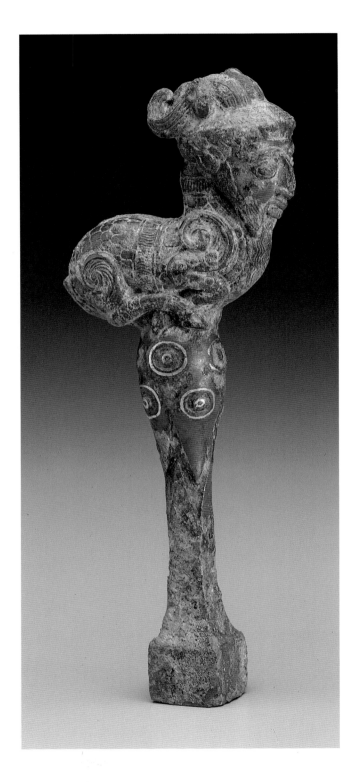

PLATE 14. Zither tuning key, no. 71

ridden there at that time.[3] Instead, camel riders in Chinese art are always foreigners who arrived with caravans from the West, where camels were more common (nos. 5, 61, 88). The Achaemenid goat-man on the zither tuning key may have been copied from a similar motif on a foreign object, perhaps in carved ivory or bone, brought east by migrating tribes or traveling merchants with their camel caravans. An increasing body of evidence suggests that serious trans-Asian trade existed long before the traditional establishment of the famous Silk Route by Han Wudi in the second century B.C., connecting the Han capital at Chang'an (present-day Xi'an) with the Mediterranean Sea.[4]

The exotic motif of a raptor with a bear cub in its talons, adorning another zither tuning key (no. 70), also derives from imagery found farther west. Although no early zither remains have been found in Chinese tombs other than those from south China associated with the state of Chu, this tuning key appears to relate stylistically to objects cast at the Jin state foundries in Houma, evidence that Houma may have been producing luxury items for an unusually wide market.[5]

Luxury Goods with Sinicized Foreign Motifs: Qin and Han Periods

The exotic motifs that adorn luxury goods during the Qin and Han periods are quite different from those found on earlier Warring States objects. The motifs have now become so completely Sinicized that their alien heritage is seldom apparent. After centuries of intercultural exchange, it is not surprising that the sacrosanct territory of Chinese bronze decor would be infiltrated by a horde of small creatures from beyond the Great Wall.

These creatures were not borrowed indiscriminately to decorate Chinese luxury items simply

basin (see entry no. 70). Evidence for encounters with trans-Asian trade is provided by a Chinese bronze lamp in the shape of a camel and rider found in a fourth-century Chu tomb at Wangshan, Jiangling Xian, Hubei Province.[2] Camels were not known before the fourth century B.C. in China and were not

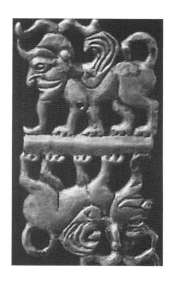

FIG. 30. Silver belt ornament from kurgan 3, Issyk cemetery II, Kazakhstan, 5th–4th century B.C. Dimensions not specified

PLATE 15. Belt hook, no. 75

head ornament (no. 36) and that on the silver cup (no. 73). The does' postures, upside down with their hindquarters twisted 180 degrees, reflect a popular northern method of representing savaged victims (no. 50).

On a gilded bronze plaque (plate 16; no. 82), a delightful creature with its hindquarters twisted 180 degrees looks as if it had stepped from the pages of

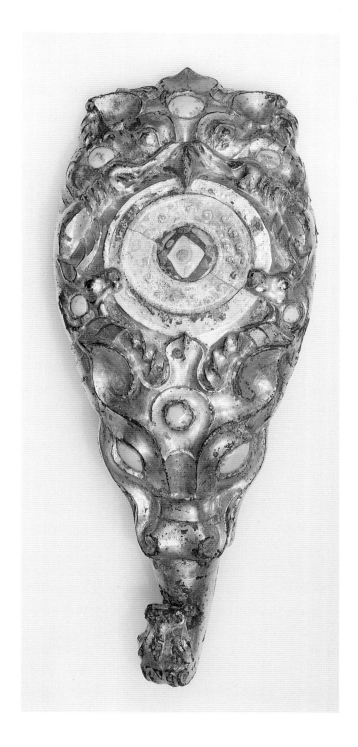

because they were novel. Instead, they fit into a kind of thinking called *xiangrui* (good omen) that figured prominently in the art and literature of the Han period. *Xiangrui* refers to auspicious zoomorphic phenomena that were considered good omens during the Western Han period because their appearance was thought to indicate the approval of Heaven.[6] A myriad of fantastic zoomorphs can be found in late Warring States texts, especially the *Shanhaijing* (Classic of Mountains and Seas). More of these zoomorphic *xiangrui* are mentioned in a second century B.C. *fu* (rhapsody) in which the author describes Han Wudi's magnificent Shanglin hunting park near present-day Xi'an.[7] Although the textual sources for *xiangrui* were Chinese, the zoomorphic images that describe them were frequently northern motifs with which artisans had become familiar through years of manufacturing belt ornaments for the northern tribes. They were, therefore, not part of the Chinese repertoire and could stand for something exotic and formerly unknown.

Northern motifs delight the eye in the sumptuous decor of a gilded bronze belt hook (plate 15; no. 75). The hook extends from a horned dragon-head that has lupine features: a bulging forehead, a curled-up snout, and pointy ears. A fierce-looking rapacious owl with ears holds the hindlegs of two tiny does in its claws on either side of the central jade inlay. The owl mask resembles the northern raptor-

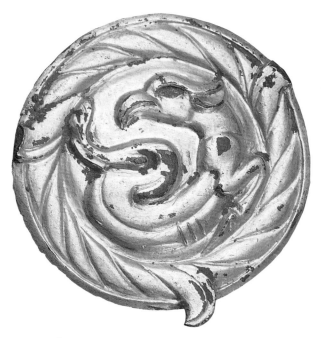

PLATE 16. Ornament, no. 82

the *Shanhaijing*. Its fantastic combination of animal forms is Chinese, but the way it has been represented, compared to a third-century B.C. gold roundel excavated from a tribal burial at Alagou in Xinjiang Uighur Autonomous Region, is unmistakenly steppe (fig. 31).

A long-eared raptor-head similar to the head of the creature that dominates the top of the belt hook (plate 15; no. 75) adds an exotic touch to a small silver cup (no. 73). Several similar cups with projecting raptor-heads are said to have come from Jincun, in the modern city of Luoyang, Henan Province, reportedly where tombs of the late Eastern Zhou kings were located.[8] The use of silver itself is somewhat unusual, and its adoption by Chinese workshops may also be due to foreign influence. Silver never attained the same popularity as gold in ancient China and may have been chosen here because of its malleability and shiny white color as the more valuable counterpart to tinned bronze.[9]

During the Western Han period, tiny metal creatures with their hindquarters twisted 180 degrees, such as the small gilt bronze gazelle with raptor-tipped horns and attachment prongs on the back

(plate 17; no. 78) were often attached to lacquered wood. The existence in many collections of plaques with similar prongs on the back (no. 77) suggest that they, too, once were attached to a larger object.

Birds and animals living in harmony with nature characterize a favorite *xiangrui* design typified by the fantastic craggy landscape teeming with animals represented on a second-century B.C. chariot ornament found in Ding Xian, Hebei Province.[10] Another landscape scene on a two-tone gilded belt plaque shows an array of wild beasts: camels, tigers, and wild boars carefully arranged in a rather tame mountainous setting (fig. 32). This setting may reflect the "correlative thinking" of early Han thought, which was frequently expressed in terms of animals and mountains, as in the following passage from the *Shiji* (Records of the Grand Historian of China): "As . . . wild beasts congregate in the most secluded mountains, so benevolence and righteousness attach themselves to a man of wealth."[11] The shape of the plaque, with its twisted rope border, is

FIG. 31. Hammered gold feline ornament, Alagou, Xinjiang Uighur Autonomous Region, 3d century B.C. Diameter 6 cm. After Yang Boda 1987, no. 14

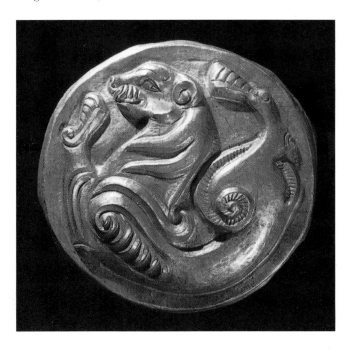

obviously northern, but the decoration, reflecting Western Han ideology, is strictly Chinese.

The Han dragon may also be a result of Sino-steppe encounters.[12] Typically it has a long sinuous body, prominent clawed feet, and a lupine head, similar to the dragon-head on the belt hook (plate 15; no. 75). This dragon appears in full bloom, shown under attack from two tigers, on belt plaques excavated at Ivolga near Lake Baikal from a burial associated with the Xiongnu, who dominated the eastern Eurasian steppes during the Western Han period.[13] The same dragon coiled around two tortoises also appears on a gilded bronze belt plaque of a type found in both Chinese and Xiongnu burials during the second century B.C. (no. 80). Here the attacking tigers of the Ivolga plaques have been replaced by two tortoises, thus changing the original animal combat motif to a scene with Chinese cosmological implications.

Even jade, the most sacred Chinese material, was not immune to northern decoration. The creature with a lupine-head that strides purposely through a swirl of landscape and cloud forms on a jade plaque (no. 79) descends from earlier northern wolf figures (no. 50). The striding creature with all four legs represented derives from the many images of carnivores that adorn belt plaques made by Chinese artisans for the northern tribes during the Warring States period (nos. 50–52, 89, 90). Nevertheless, the end result is a jade ornament that is totally Chinese in feeling. The convention of showing all four legs of an animal when it is depicted standing in profile was readily adopted by the Chinese and occurs on several typically Chinese artifacts (nos. 76, 77, 79).

The bear is another common steppe creature that crept into Chinese art (nos. 60, 64). It forms the loop on a Warring States mirror (no. 46). A squatting bear was compressed to fit into the circular top of a zither string anchor (no. 72). Squatting bears are ubiquitous during the Han period. Because of their association with strength and endurance, they are represented as feet on vessels, as small jade figures, and as decoration on small round plaques made for both Chinese and northern consumption.

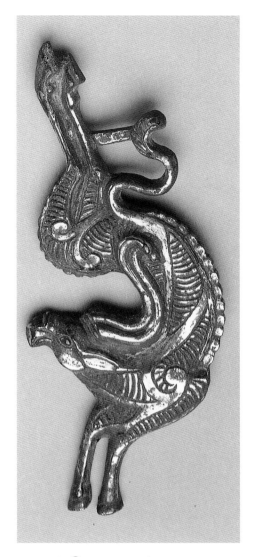

PLATE 17. Ornament, no. 78

New Metallurgical Techniques in Chinese Workshops

Chinese art was not only enriched visually through extended contact with the northern tribes; it also benefited technologically. Knowledge of several metalworking techniques can be shown to have been introduced into China through prolonged association with the northern tribes, who were themselves in contact with tribes farther west in Central and West Asia by long-distance down-the-line trade. Cloisonné, granulation, strip-twisted wire, and mechanically linked chains all originated outside of

FIG. 32. Two-tone gilded bronze belt plaque, 1st century B.C. Width 13.3 cm. Anonymous collection

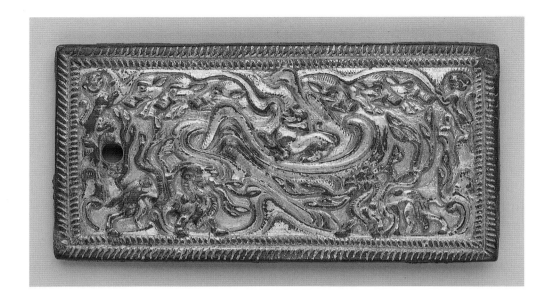

China and appeared for the first time on China's northern borders during the late Eastern Zhou period.[14]

Cloisonné was used for the colorful decoration of some Chinese belt hooks (no. 74). The cloisonné process produces a design made up of a network of cloisons, cells formed of thin strips of metal that are set on edge on a metal base and filled with enamel, glass, stone, or other materials. The technique originated in West Asia and was transmitted eastward. It also occurs on several gold ornaments found in tombs belonging to the herding tribes in the Ordos, such as the earrings found in a Xiongnu tomb at Xigoupan, Jungar Qi.[15] Each earring consists of a small gold plaque adorned with a stag represented by pieces of turquoise set in tiny cloisons, from which hangs a Chinese openwork jade plaque, mounted in gold, depicting a typical Han dragon amid cloud scrolls (fig. 33). The combination of local goldwork and Chinese jade is convincing evidence that northern and Chinese artisans were well aware of each other's products.

True granulation, which can be traced back to the third millennium B.C. in West Asia, occurs on the neckband of the bird that surmounts a gold crown[16] and on an earring[17] excavated at Aluchaideng, Hangjin Qi, in the Ordos, dating to the late fourth–third century B.C. Granulation is a technique in

which small gold spheres are attached singly or in a pattern to a gold background to give an object texture. By the Han period, the technique had been fully mastered by Chinese artisans.[18]

Ornaments made with strip-twisted wire were extremely popular among jewelers in Southwest Asia as early as the third millennium B.C. In ancient times wire was made by strip-twisting, that is, by twisting a thin sheet of hammered metal tighter and

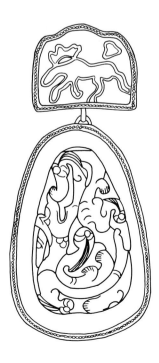

FIG. 33. Drawing of a gold and jade earring from tomb 4, Xigoupan, Jungar Qi, Inner Mongolia Autonomous Region, 2d–1st century B.C. Length 8 cm. After Tian and Guo 1986, p. 381, fig. 4.1

tighter. It can be recognized by spiral seam lines produced when the strips are twisted.

Loop-in-loop chains were constructed with previously prepared loops linked together in a very complex way.[19] These chains became very popular with Hellenistic artisans during the fourth–third century B.C. and can be found in nomadic graves throughout northern Eurasia. A pair of gold earrings with pendant loop-in-loop chains was recently discovered among artifacts associated with the ancient herding tribes in the vicinity of Guyuan in the Ningxia Hui Autonomous Region.[20] Similar earrings were discovered near the Chilik River in Kazakhstan.[21] Chains with a double loop-in-loop construction were also found at Alagou in the Xinjiang Uighur Autonomous Region[22] and at Aluchaideng, Hangjin Qi, in the Ordos area.[23] The locations of these sites indicate that tribes possessing such chains entered northwest China through the Gansu Corridor late in the fourth century B.C. and then progressed slowly north along the Yellow River until they reached the Ordos region, where they apparently stayed. Loop-in-loop chains were adopted by Chinese artisans, eventually replacing the labor-intensive mold-cast chains that had been characteristic of Chinese metalwork throughout the Eastern Zhou period (see nos. 21, 98, 102, 103).

Many Chinese luxury goods were truly enhanced, but only superficially changed, through contact with the northern tribes. Chinese art benefited greatly from an infusion of vigor from beyond the Great Wall, whereas Chinese manufacture of nomadic goods tended to weaken the northern designs. Exemplifying its celebrated ability to acquire, absorb, and assimilate, China selectively borrowed motifs and techniques from beyond its borders and made them its own.

—ECB

Notes

1. See So 1995, introduction, especially sections 6.1, 6.2.

2. Li Xueqin 1986, no. 137.

3. Schafer 1950.

4. Several tiny figures of West Asian lions, dating to the second millennium B.C., were found near Erlitou in Henan Province. *China Reconstructs* 1991.8, p. 36.

5. For further discussion of the market served by the Houma foundries, see So 1995, introduction, sections 4.2, 4.3, 5.1.

6. For a discussion of *xiangrui,* see Wu Hung 1984, pp. 39–46; Wu Hung 1986, pp. 270–73; Wu Hung 1989, pp. 76–85.

7. Sturman 1985, part 1, pp. 3–5.

8. See So 1995, introduction, section 6.1, for a discussion of these tombs.

9. Bunker 1994b.

10. See Wu Hung 1984, fig. 1. Northern sources for many of the figures in the Ding Xian landscape are also discussed in depth by Jacobson 1985.

11. The *Shiji* is quoted and explained in Sturman 1985, part 2, p. 67: "The correlation between beast and mountains points to the sharing of spiritual and physical qualities. . . . From this it should be clear that the beginnings of the description of landscape in China relied first upon a symbolic mode of representation. It was what the landscape was understood to be, a cultural perception, quite distinct from objective observation, that defined its representation in art."

12. Rudenko 1958.

13. *Sovetskaya Arkheologiya* 1971.1, p. 96, fig. 2.

14. For a more detailed discussion of these techniques and their origins, see Bunker 1993; Bunker 1994b, pp. 44–47.

15. *Neimenggu wenwu kaogu* 1981.1, p. 19, fig. 4.

16. Yang Boda 1987, plate 12.

17. Bunker 1993, fig. 23.7.

18. Shaanxi 1992, p. 21. See also Beijing 1993, nos. 113–14.

19. Bunker 1993, fig. 7; Bunker 1994b, pp. 46–47, fig. 9.

20. *Kaogu* 1990.5, plate 5.6.

21. Akishev 1978, plate 46.

22. Tokyo 1992, p. 116, no. 305.

23. *Kaogu* 1980.4, plate 12.

CHAPTER 6

Belt Ornaments and Fasteners

ETAL ORNAMENTS AND FASTENERS, affixed onto leather or cloth belts, form a large and varied group of objects used by the Chinese and the tribes in the north. To both these peoples, ornamented belts and belt fasteners were not just a practical article of clothing worn over a wrapped tunic or robe. Depending on ornamentation and materials—gold, silver, or gilded, tinned, and plain bronze—ornamented belts and fasteners indicated tribal affiliation, rank, or social status (see chap. 4). While northern belt ornaments and plaques are rich in religious and tribal symbolism, a Chinese belt hook often satisfied little more than the wearer's desire for ostentatious personal adornment.

Belt ornaments and fasteners are singled out for discussion here because, as a category, they occur in both Chinese and northern contexts and their predominance in the East coincides with the period of China's growing contact with the north throughout the first millennium B.C. As small, portable, and often necessary items for personal use and adornment, belt ornaments and fasteners are ideal clues for tracking the movement and interaction of peoples and ideas during this period. Recent archaeo-

logical discoveries of belt ornaments and fasteners from different periods and contexts and in various guises betray the trade and traffic of goods, the adoption of customs and ways of life, and the borrowing of artistic ideas and motifs between China and the north. The chronological and geographical distribution of different types of belts and belt-buckling devices, together with comparison of the ways belts were worn and ornamented, illuminates the cultural heritages of and the interactions among those who used them.

Ornamental belt fittings fall into at least four major categories, the first three closely associated with pastoral tribes. The first group comprises small belt ornaments, typically attached by loops on their backs in multiple numbers to decorate the leather or cloth front of the belt (nos. 84–86). The second includes small metal buckles or devices in other materials to secure the two ends of the belt. Buckles with outward pointing tongues—fixed or movable—constitute a large group of such fasteners (nos. 5, 87, 88, 98, 99). The third group consists of ornamental belt plaques, many worn in pairs. These are less numerous, but often animal-shaped, larger, and more impressive (nos. 1–3, 6, 8, 50–52, 56, 57, 59, 61, 63–67, 80, 89–91).

In the fourth group are a large number of belt hooks, distinguished from belt buckles and plaques by both shape and fastening mechanism (nos. 74–76, 92–97). A belt hook typically shows a button projecting from the underside of one end and an upward-facing hook at the opposite end. The button goes into an opening at one end of the belt, while the hook on the opposite end secures the other end of the belt. The majority of these are Chinese products and close contemporaries of the northern types.

A less common fifth group (nos. 98–103)—animal-shaped belt buckles or plaques equipped with buttons and hooks—is distinguished by its use with a linked chain. Finally, the S-shaped belt plaques (no. 104) represent a recently identified belt fastener that is not yet well understood. Each of these categories is discussed in greater detail below.

Belt Ornaments and Ornamented Belts: Early First Millennium B.C.

From their earliest appearance during the third millennium B.C. in the royal cemetery at Ur, ornamented belts were closely associated with weapons and military rituals.[1] When Assyrian and Persian kings of the late second and first millennia B.C. presented daggers and other ornaments for acts of valor, the belts to which they were attached probably accompanied them. In Viking legend, the belt of Thor, the Scandinavian god of thunder, was regarded as the source of his invincible power. Pastoral tribes of the ancient eastern steppes also presented belts as recognition of bravery, while the Mongols sealed military pacts by exchanging belts obtained from captured enemies.

Early ornamented belts from Ur were leather or fabric covered with a single, long metal sheet. Belts ornamented with a series of metal plaques instead of a single sheet of metal did not appear in the Caucasus until the beginning of the first millennium B.C.[2] The earliest excavated evidence for ornamented belts in the East seems to occur on China's northeastern frontier.[3] An eighth–seventh-century B.C. nomadic grave opened in Zhoujiadi, Aohan Qi,

in southeast Inner Mongolia, shows the deceased wearing two leather belts (fig. 34). Small roundels ornament the narrower leather belt, which was apparently fastened simply by inserting one end through a slit in the opposite end and then perhaps tucked in place. Large square plaques decorate the wider belt. For a fastener, this belt used a slender piece of dog bone shaped with a small hook at one end and a perforation on the other, functioning strikingly like the typical Chinese belt hook developed south of the Inner Mongolia border about a century or so later[4] (plate 18; nos. 92, 93). A leather sheath containing a bronze knife, awl, and bone needle hangs from the wider belt.

The custom of wearing two belts suggests they had different functions. The wider and more impressive belt, often carrying accessories, was, like the earliest ornamented belts in West Asia, probably a status symbol and worn over the outer jacket,

FIG. 34. Detail, showing two leather belts, with ornaments, *in situ* in tomb 45 at Zhoujiadi, Aohan Qi, Inner Mongolia Autonomous Region, 8th or 7th century B.C. After *Kaogu* 1984.5, plate 6

PLATE 18. Belt hook, no. 92

Aside from their importance as status symbols, belts carrying weapons, tools, and other paraphernalia denote a particular way of life for their wearers. The herding and hunting activities of the tribes along China's northern frontier dictated practical, nonconstricting clothing and portable tools and weapons: a short tunic tied at the waist by a belt from which tools, weapons, and accessories hung close at hand (see nos. 1–3, 5, 11; fig. 7).

In China's heartland, the earliest belt ornaments known, in distinctive Chinese style, came from burials dating no later than the early eighth century B.C. in southern Shanxi and western Henan Provinces. A gold as well as a bronze set were recovered from excavations of the cemetery of the Guo state at Sanmenxia, Shaan Xian, in western Henan Province, found in a loose horizontal arrangement around the waist.[8] Similar belt ornaments made of cheaper materials such as stone and shell were also recovered from the site.[9] More recently, a set of fifteen cast gold round, triangular, rectangular, and animal-head plaques was found in the grave of a duke of Jin in

while the narrower and less ornamented one presumably held up the trousers worn underneath the jacket. First-century A.D. Saka and Parthian rulers of Central Asia were still represented wearing several ornamented belts, with weapons and royal regalia suspended from one of them.[5]

Ornamented belts seem to appear somewhat later, but in larger numbers, on China's northwestern borders, in the seventh- and sixth-century graves in south-central and southwest Inner Mongolia. Nos. 84–86 represent just three styles from a wide range of shapes and sizes—S-shaped and scroll-shaped, squared, beaded, round, or animal-shaped.[6] Typically, some ten to twenty plaques ornament each belt, but at Maoqinggou, Liangcheng Xian, in south-central Inner Mongolia, as many as thirty-four were placed closely side-by-side on a leather or fabric belt (now disintegrated) worn by the deceased (fig. 35). The Maoqinggou belts also show the two commonest closing devices: a round buckle with a fixed tongue pointing out at one end and a perforated extension on the other (see fig. 35a), and paired animal-shaped plaques (fig. 35b). A bronze dagger hangs via a series of rings from the belt. Some ornamented belts at Maoqinggou apparently used no closing device; the ends of the belt overlapped or were tucked in place.[7]

FIG. 35. Belt plaques from Maoqinggou, Liangcheng Xian, Inner Mongolia: (a) drawing of tomb 60, showing belt ornaments and buckle *in situ*, 6th century B.C. After Rawson and Bunker 1990, fig. 1; (b) belt ornaments, plaque, and chain from tomb 5, 6th–5th century B.C. Plaque width 10.7 cm

a

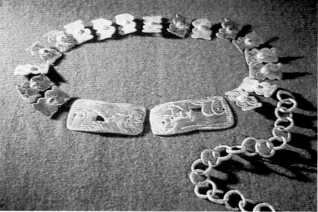
b

PLATE 19. Belt plaque, no. 89

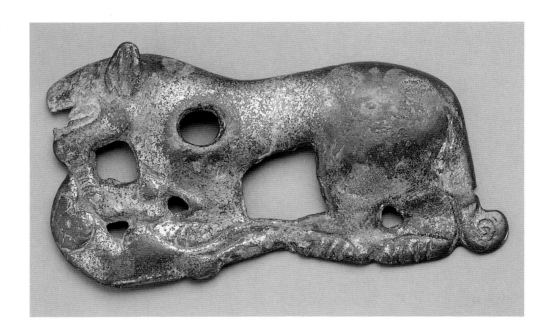

Qucun, Quwo Xian in southern Shanxi Province, adjacent to Henan.[10]

As the earliest-known examples of belt ornaments with Chinese decoration in Chinese territory, the Jin and Guo belt ornaments are unusual in Chinese contexts. Although belt ornaments seem to have appeared almost contemporaneously in the north, comparison with the Chinese examples shows that the northern ornaments occur more widely, over a longer period, and are clearly a common article in that context. The Chinese-style belt ornaments from the Jin and Guo burials were probably inspired by similar ones worn by northern immigrants, people with special skills brought in to serve the Guo and Jin courts (see fig. 7). Only from the Six Dynasties period on, when Central Asian tribes were constantly besieging and sometimes actually ruling parts of China, did leather belts ornamented with multiple plaques became widespread.[11]

Belt Buckles

Although the early tribes in south-central and south-eastern Inner Mongolia wore belts ornamented with multiple bronze plaques, they used different types of fasteners. In south-central Inner Mongolia, buckles with fixed outward pointing tongues were the common devices (see fig. 35a). They are virtually identical to buckles used in bridle fittings and may well have been adapted from them (nos. 5, 87, 88, 98, 99). As such, they are closely connected with the skill of harnessing horses for herding and perhaps hunting (see chap. 1; figs. 16, 17). In addition to metal belt buckles, certain inhabitants of southeast Inner Mongolia seem to have used slender hooked fasteners made of dog bone.[12] Belts were also sometimes simply tucked in place without the help of a fastener. The ornamented belts worn by individuals buried in the Guo cemetery also appear to use no fastener.

Ornamental Belt Plaques

Less common than the belt buckle is the ornamental belt plaque (nos. 1–3, 6, 8, 50–52, 56, 57, 59, 61, 63–67, 80, 89–91). Like the belt ornaments and buckles, these plaques are signature items of a northerner's gear. Prestigious counterparts to the modest buckle, ornamental belt plaques are worn singly or in pairs, one at each end of the belt. They are large and conspicuous, often taking the shapes of real or fantastic animals savaging smaller crea-

tures. Small loops on the back allow these plaques to be sewn onto one or both ends of the belt. Some, like the pair excavated from tomb 5 at Maoqinggou, Liangcheng Xian, southwest Inner Mongolia, do not have attachment loops and were probably attached through the perforations on the plaque[13] (fig. 35b). These Maoqinggou plaques also have no projecting tongue for closure. Most animal-shaped plaques, however, have either an outward-pointing fixed tongue or an opening in the matching plaque so that they can be tied together (plate 19; no. 89).

The large, ornamental belt plaques, however, have meaning far beyond their basic functions. If the ornamented belt signified bravery and martial prowess, then the large ornamental belt plaque would be the crowning symbol of its wearer's rank. Archaeological evidence indicates that only select individuals were allowed to possess them.[14] The subject matter of the animal-shaped plaques is also imbued with tribal, mythological, and even magical symbolism.[15] Changes in iconography can signify differences in clan, rank, and beliefs; they can also be an index of political or migrational activity (see chap. 4). When the realistically rendered tigers and wolves of the earlier plaques (plate 19; nos. 50–52, 89) gave way to fantastic creatures with bird-head antlers toward the end of the fourth century B.C. (nos. 56, 64, 66, 67, 90, 91), the Rouzhi had arrived at China's border, a tribe of mixed Indo-European heritage forced east by the campaigns of Alexander the Great. The motif of no. 54—a carnivore devouring a tangled mesh of serpents—and its ornamental style with curls and commas against a pebbled ground on the wolf's body, illustrate commercial and artistic traffic. As a belt plaque displaying the theme of animals in combat, it is a northerner's article. Its animal and decorative vocabulary, however, carries a distinct Chinese accent. It forms part of a large number of Chinese-made exports, products of cultural intermingling between China and the northern tribes.

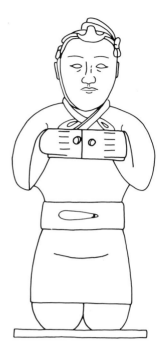

FIG. 36. Drawing of bronze kneeling figural lamp from Sanmenxia, Shaan Xian, Henan Province, 4th century B.C. Height 48.9 cm. After *Wenwu* 1976.3, p. 54, fig. 4

Belt Hooks

Unlike the previous groups of belt ornaments and fasteners, the belt hook occurs primarily in Chinese contexts. Belt hooks are most commonly club-shaped with a button on the underside of one end and a small upturned hook at the other (plates 15, 18; nos. 74–76, 92–97). The button and hook are the only constants in the design; the body can vary in size and shape, ranging from shield-shaped to rectangular to countless irregular sculptural forms.[16] Most belt hooks are bronze, but they were also made in gold, silver, iron, jade, or bone. Chinese bronze sculptures from the fourth century B.C. provide a clear picture of the way these belt hooks were worn: around the waist to secure a belt over an ankle-length wrapped robe in front[17] (fig. 36). Some hooks were apparently used to secure different parts of the garment or weapons and other accessories to the belt[18] (plate 20; nos. 96, 97).

In most cases, a single belt hook would suffice; occasionally, two or more hooks were worn, perhaps to prevent a wider belt from rolling.[19] The second, smaller projection on the underside near the neck of the hook on no. 92 (plate 18) might have been used to tie and align several hooks when they are worn together. A few rare examples of exceptional size

would be unwieldy to wear.[20] Such belt hooks were probably presented in recognition of outstanding achievements, thereby acquiring a ceremonial significance like that of the northern belts and belt plaques.

The earliest examples of the belt hook in its typical form are datable around the sixth century B.C.[21] These are often small, usually plain or decorated with simple geometric patterns, and the button is placed near the end of the buckle opposite the hook[22] (plate 18; no. 92). Their modest appearance indicates a mundane function. By the late sixth and early fifth centuries B.C., belt hooks became larger and more elaborately decorated, with multiple inlays of gold, silver, turquoise, or malachite (nos. 74, 93). They were also made of gold or jade.[23] Their materials and elaborate decoration demonstrate that belt hooks had become luxury items rather than simply functional articles.

The early appearance of belt hooks in Chinese territory in a wide array of sizes, shapes, and materials, closely contemporary with non-Chinese belt buckles and plaques, demands a reassessment of ideas about their origins. Ancient Chinese texts recount the introduction of the belt hook from the north by the Zhao ruler in 307 B.C., together with nomadic dress and the skill of mounted warfare.[24] This textual argument has been effectively contradicted by excavations of belt hooks from sixth-century sites, in particular the recovery of innumerable clay casting molds for belt hooks from a sixth–fifth century foundry site in the town of Houma, southern Shanxi Province.[25] Attempts to connect the belt hook with Central Asian tribes by recognizing Indo-European or Hunnic words behind the ancient Chinese terms for the belt hook have also been recently reviewed, with similar resulting skepticism.[26]

The introduction of the belt hook from foreign sources was also argued on stylistic grounds. A small number of Scythian belt hooks were once cited as foreign prototypes for the Chinese ones.[27] However, a fundamental difference in the orientation of the hook on the Chinese and Scythian types

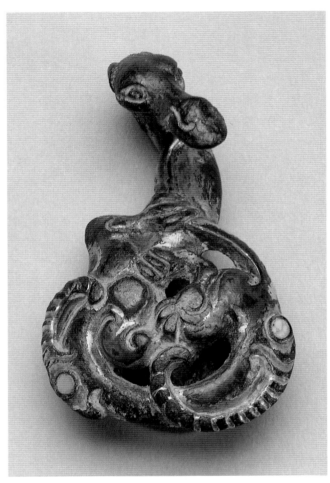

PLATE 20. Belt or accessory hook, no. 97

denies any direct relationship between the two: the hooks on Scythian examples always turn under onto the same side as the button. The rarity of the Scythian examples compared with the vast numbers and variety of the Chinese examples also speaks against a West Asian origin. Apparently it was not until the first centuries A.D. that the Scythian belt hooks appeared in China, as evidenced by an example recovered from an Eastern Han context in Sui Xian, Hubei Province.[28]

Another group of seventh- or sixth-century animal-shaped belt hooks may, on first encounter, seem to be possible northern ancestors to the Chinese belt hook[29] (nos. 94–96). Careful study of these tiger- and other animal-shaped belt hooks suggests, however, that the extended hook was never conceived as

an integral part of the design, like the earliest Chinese belt hooks, but rather was added as an afterthought to an animal-shaped ornament. In multianimal belt hooks like no. 100, a hook was simply added to a typically northern design, commonly found on buckles with fixed tongues (nos. 98, 99). The animal-shaped belt hooks from northern and Scythian contexts are therefore likely to be adaptations of a Chinese article.

Excavations of burials from the northern zone, in Inner Mongolia, and Central Asia further support the independent Chinese origin of the belt hook.[30] The Saka noble buried in the fourth-century B.C. grave at Issyk, near Alma Ata in southeast Kazakhstan, wore a belt adorned with gold animal-shaped ornaments and plaques but no belt hook.[31] Northeast of Kazakhstan, in the Altai Mountains of southern Siberia near Pazyryk, rich nomadic barrows dating from the late fourth century B.C. yielded remains of leather belts with ornamental silver plaques and buckles, again with no belt hooks.[32]

Closer to China, the tribes that lived along the southern border of modern Inner Mongolia did not appear to favor belt hooks. Non-Chinese tombs excavated at Maoqinggou, Liangcheng Xian, in south-central Inner Mongolia, have yielded the richest assortment of decorated belts and belt fasteners in recent years.[33] Fifty-seven of the seventy-nine burials, most of them male, contained remains of leather belts and metal belt fittings. Of these, only fifteen graves contained belt hooks.[34] The remaining

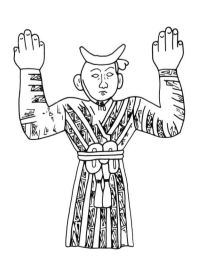

FIG. 37. Drawing of figure on clay mold from Houma, Shanxi Province, 6th–5th century B.C. Height 9.8 cm. After Hayashi 1985, p. 89, fig. 3

graves contained belt buckles or animal-shaped belt plaques.[35] The burials with belt hooks were also oriented differently, suggesting that their occupants, practicing different burial customs, came from different cultural backgrounds.[36] The accumulated evidence thus suggests that the belt hook was perhaps as foreign to the tribes in the Eurasian steppes as their belt buckles and animal-shaped plaques were to the Chinese.

The Chinese may have developed the shape of the belt hook on their own; however, they could have borrowed the *idea* of fastening a belt with some kind of device from the northern tribes.[37] Although sculptures from fifth and fourth centuries B.C. in China show figures wearing belts closed by belt hooks (see fig. 36), most others wear belts that are simply tied and knotted without any fastening device (no. 11). Clay molds for casting bronze figures recovered from the late-sixth- to early-fifth-century bronze foundry site at Houma, Shanxi Province, show figures wearing wrapped robes elaborately knotted at the waist (fig. 37). The painted bronze figures supporting the bell rack from the late-fifth-century tomb of the Marquis Yi of Zeng in Leigudun, Sui Xian, Hubei Province, also wear belts secured without any device.[38] While it was probably considered fashionable or prestigious, during the last centuries B.C. in China, to wear a belt fastened with a belt hook, clearly not everyone was allowed to wear belt hooks or able to afford this novel luxury.

Precisely where, when, and how this transfer of idea took place remains to be determined. Recent excavations suggest, however, that western China may be a useful starting point. Sixth- and fifth-century Qin tombs opened near Fengxiang Xian in Shaanxi Province, site of the ancient Qin capital Yong from 677 to 424 B.C., yielded the greatest variety of belt hooks, including both the common belt hook in bronze and small gold hooks with a hooked end but a projection encased in a hollow cavity on the underside.[39] Qin tombs were also the only known context for the unusual tinned bronze S-shaped belt plaques in the Walters Art Gallery and

Calon da Collection (no. 104), whose unusual manufacturing and decorative techniques suggest that they were perhaps brought into Qin territory by immigrants from farther north and west.

Finally, it was also in Qin context that the earliest known hooked device was found. Sets of bells discovered in a pit at Taigongmiao near Baoji Xian, Shaanxi Province, were found with hangers in the shape of a ring with an animal-head hook.[40] The Taigongmiao bells can be dated by inscription to the early seventh century B.C.[41] Whether these seventh-century bell hooks have any direct relation with the later ones worn with a belt is still unclear. Noteworthy, however, are the facts that the bell hooks accompanied Qin bells and some of the earliest and the greatest variety of belt hooks were found in Qin contexts. The extended co-existence of Chinese and non-Chinese tribes in northwest China since the late second millennium B.C. would have provided ample opportunity for contact and transfer of ideas and customs, and the belt fastener—small, portable, and practical—would be a prime candidate for transmission and transformation.[42] The thriving trade between Qin and its northwestern neighbors during the fifth and fourth centuries B.C. further corroborates this relationship (see chap. 4).

Other Sundry Types

In addition to the four major categories discussed above, two other types of belt fasteners should be mentioned. The first is a hybrid creation in which animal-shaped plaques secured with a Chinese-style hook are attached to linked chains hanging at right angles to the belt (nos. 101–3). Animal-shaped plaques originated in the north, but their actual shapes—demure animals adorned with cowrie-shell collars, elegantly curled haunches, and granulated ears—are distinctly Chinese, their decorative vocabulary duplicated by finds in China's heartland.[43] Similar linked chains hang from loops at the base of northern plaques (nos. 98, 99) and may have served much the same functions as the linked bronze rings

worn with the ornamented belts recovered at Maoqinggou[44] (see fig. 35). Precisely how the linked chains were worn in relation to the belt remains unclear, since all extant chains are incomplete and the archaeological circumstances surrounding the only excavated chain and hook remains unpublished (see entry no. 102). Perhaps these linked chains were used to carry weapons and personal regalia.

The last aberrant type is represented by two belt plaques in no. 104. Their function as belt fasteners is demonstrated by their location on the deceased, but, to date, they remain very restricted in provenance, shape, and decorative technique. That they are found in modest, almost poor, attendant burials indicates that their wearers were ordinary or subservient members of the society. As a type, they also seem to be rather short-lived, occurring mainly in fifth- and early-fourth-century Qin burials, and they cannot therefore be taken as ancestors to the Chinese belt hook.[45] Until more is known about these plaques, they are perhaps appropriately regarded as belt fasteners worn by a small group of immigrants from the northwest living in Qin territory who might have played a role in the introduction or transmission of artistic ideas and techniques between the Chinese and nomadic spheres.

—JFS

Notes

1. For a detailed discussion of the significance of the ornamented belt in ancient West Asia, see Moorey 1967, especially pp. 83–85, 98.

2. Ibid., p. 85.

3. An early Western Zhou tomb opened in Weiyingzi, Chaoyang Xian, Liaoning Province, contained some fifty bronze plaques, each three by four centimeters, which conceivably could have been belt ornaments. *Kaogu* 1977.5, p. 307, figs. 3.1, 3.2. These would provide the northeastern predecessors for the belt ornaments from Zhoujiadi, in neighboring southeast Inner Mongolia. The connection between the early appearance of belt ornaments in the northeast and the slightly later ones in China's heartland—southern Shanxi and western Henan Provinces—remains obscure.

4. *Kaogu* 1984.5, p. 423, fig. 12.3. The belts are described and discussed on pp. 424–25.

5. Brentjes 1989, pp. 41–44.

6. For some of these other shapes, see Tian and Guo 1986, pp. 112–27, figs. 77, 78, 81, 84, 86, 89–91.

7. Ibid., p. 243, fig. 13.

8. Beijing 1959, p. 23, fig. 16. The gold set includes seven round, three animal-head, one triangular, and one rectangular plaque. Beijing 1992b, no. 123. From a contemporary burial at Xincun, Xun Xian, also in Henan Province, another triangular bronze belt ornament was recovered. Guo Baojun 1964, plate 47.2. For discussion of the date of the Guo burials, see So 1995, appendix 1, 2.B.

9. Beijing 1959, plates 52.1, 52.4, 57.2–3.

10. *Wenwu* 1994.1, colorplate, p. 17, fig. 20.

11. Sun Ji 1987.

12. *Kaogu* 1984.5, p. 423, fig. 12.3.

13. Tian and Guo 1986, p. 281, fig. 45.1.

14. Of the seventy-nine graves opened at Maoqinggou in south-central Inner Mongolia, only seven contained animal-shaped belt plaques. Ibid., pp. 265–68.

15. Jacobson 1984; Bunker 1992b.

16. Nagahiro 1943; Wang Renxiang 1985.

17. Other examples are collected in Hayashi 1985, figs. 8, 10, 18, 43. For detailed discussion of the various possible ways the belt hook was worn, see Wang Renxiang 1982.

18. For a detailed discussion of these other functions of the hooks, see Lawton 1982, p. 91; Wang Renxiang 1982, pp. 78–90; Wang Renxiang 1985, pp. 298–300.

19. A bronze figure in the Worcester Art Museum is shown wearing two belt hooks in parallel formation over the width of the belt. Hayashi 1985, fig. 18. See also a double belt hook excavated from Luoyang, Henan Province. So 1995, introduction, fig. 100, also published in *Kaogu* 1991.6, plate 7.7.

20. For example, see New York 1980, no. 76.

21. Chapter 4 suggests an even earlier date for the appearance of belt hooks in China. A detailed discussion and listing of belt hooks from recent excavations is available in Wang Renxiang 1985.

22. See also Lawton 1982, nos. 42, 43, 46, 61–67.

23. Four small, undecorated gold belt hooks were found with two inlaid and two plain bronze belt hooks in the late-sixth or early-fifth-century tomb of a Jin noble near Taiyuan, the capital of Shanxi Province. *Wenwu* 1989.9, p. 61. A small jade belt hook was recovered from an early-fifth-century burial at Gushi Xian, Henan Province. *Wenwu* 1981.1, p. 7.

24. The key passages recounting this event in the *Shiji* and *Zhanguoce,* both compiled during the late first millennium B.C., are quoted in Nagahiro 1943, pp. 134–35.

25. The site is discussed in So 1995, introduction, section 4.2. A few molds are illustrated in *Kaogu* 1959.5, plate 4; *Kaogu* 1962.2, plate 2.5. See also Loehr 1965a, pp. 776–77; Lawton 1982, p. 89; Wang Renxiang 1982, pp. 75–77; Wang Renxiang 1985, pp. 289–90.

26. Mäenchen-Helfen 1944; Wang Renxiang 1985, pp. 294–98; Zhang Boquan 1989.

27. Rostovtzeff 1929, plate 12.1–2, p. 42; Nagahiro 1943, p. 7; Karlgren 1966.

28. *Wenwu* 1993.7, p. 64, fig. 39.4–5.

29. Discussed in Loehr 1965a, p. 777; other examples are in Bunker et al. 1970, no. 83; Nagahiro 1943, plates 41–42.

30. See Palmgren 1948, p. 31, for an early statement of this idea.

31. For a reconstruction of this Golden Man's costume, see Basilov 1989, p. 26; examples of the gold belt ornaments are illustrated on pp. 32–33.

32. Rudenko 1970, plates 67, 94.F, 96.G, 140.B, 140.E. For more recent finds in the Altai, see Polosmak 1991, especially p. 8, fig. 10.

33. Tian and Guo 1986, pp. 227–341, especially pp. 265–83.

34. Ibid., pp. 269–70, figs. 37, 38, plates 74, 75.

35. Ibid., pp. 236, 243–44, figs. 7, 13, 14, plates 56–58, 79, 80.

36. Ibid., pp. 302–5.

37. Sirén 1929, p. 62, writes, in regard to the Chinese belt hook, that "the influence of the Nomadic neighbors of the Chinese may well have had something to do with this new form of personal ornament."

38. Hayashi 1985, pp. 92–93, figs. 7, 8; other examples are illustrated on pp. 88, 98, 116, figs. 2, 9, 17.

39. *Kaogu yu wenwu* 1981.1, p. 30, figs. 19.2, 19.10, 19.15, 19.16, 19.20; *Wenbo* 1986.3, p. 20, figs. 23.1, 23.3.

40. *Wenwu* 1978.11, plates 1–2. A later example is in the Freer Gallery of Art (Lawton 1982, no. 56), where it was incorrectly interpreted as military trappings for a soldier or chariot.

41. The bells belonged to Duke Wu of Qin, who ruled from 697 to 676 B.C. *Wenwu* 1978.11, pp. 1–5.

42. Both Max Loehr and Edward L. Shaughnessy saw a similar role for western China in their discussion of Ordos and Chinese art. Loehr 1965a, pp. 780–81; Shaughnessy 1989, pp. 6–8.

43. See discussion of Jin bronzes from southern Shanxi Province in So 1995, introduction, section 4.2.

44. It should be noted here that the chain is made differently: the Maoqinggou chains are essentially a series of interlocking rings, but the others use hourglass-shaped connectors between two rings.

45. This interpretation was suggested in Wang Renxiang 1985, pp. 291–92.

Conclusion

*T*HE ANCIENT CHINESE CONSIDERED THEIR country a benevolent, cultured center surrounded by an uncultured barbarian world that was to be either civilized or dismissed. One of Confucius' greatest disciples, Mencius (372–289 B.C.), put it this way: "I have heard of men using doctrines of our great land to change barbarians, but I have never heard of any being changed by barbarians."[1] This traditional, Sinocentric perspective so dominated the historical accounts since antiquity that the role of the northern tribes in the development of Chinese history has been often misrepresented or overlooked.

In reality, the northern tribes had much to offer.[2] Surviving artifacts and evidence recovered from recent archaeological discoveries in north China reveal that ancient China's relations with these tribes were more pragmatic and complex than commonly acknowledged. The military alliances, intermarriages, and trade and tribute agreements referred to in ancient texts suggest that the early Chinese often treated the northern tribes as equal partners in trade and politics.[3]

The northern tribes encompassed varied groups of herders, hunters, trappers, fishermen, and farmers, depending on their natural environments. They were not one large howling horde of greedy, needy nomads bent on harassing the Chinese. They had lived along the fringes of China's northern lands since antiquity and were often important business associates of northern Chinese states. The herding tribes of the northwest supplied the early Chinese with horses, jade, and sometimes even additional soldiers for their interstate battles. The hunting tribes of the northeast provided leopard, tiger, and other animal skins.[4] In return, the Chinese furnished necessities and luxuries such as grain, silks, lacquerware, and tribal and status insignia of superior workmanship and materials. Just as the Greeks in the West made luxury goods for their Scythian neighbors, certain Chinese centers produced luxury items for specific northern tribes.

Not only did the ancient northern tribes trade with—and occasionally raid—the Chinese,[5] they were also economically linked to tribes in Inner Asia. Thus they played an important role in the development of trans-Asian trade and the transmission of technologies and artistic and cultural traits from diverse and distant traditions. Such a confluence of cultural traditions provided opportunities for cross-fertilization and selection. Wheeled transport and chariotry, cavalry, royal hunting rituals,

mirrors, ornamental belt fittings, plaques, and buckles, metalworking techniques for granulation, twisted wire, mechanically linked chains, and lost-wax casting were all introduced into ancient China through contact with the northern tribes.

The symbiotic relationship between the ancient Chinese and the northern tribes infused unexpected vigor into their artistic traditions, resulting in an astounding array of artifacts that reflected complex, sometimes hybrid, cultural heritages. These artifacts became the physical embodiments of the ever-changing relationship between the ancient inhabitants of north China, the only unbiased testament to a long-term association that either went unrecorded or was misrepresented in history.

The relations between the Chinese and the northern tribes—the "significant others" beyond the Great Wall—have been a recurrent theme throughout East Asian history.[6] Their interactions have run the gamut from strong diplomatic ties to fierce warfare and even conquest.[7] This book has dealt with the early stages of this relationship, during the Bronze Age. Subsequently, a steady succession of non-Chinese tribes occupied the northern zone beyond the Great Wall in an ongoing Sino-steppe drama that was to continue in varying intensity until the Manchu conquest of China in the seventeenth century A.D. The Great Wall itself, created at the end of the third century B.C. by connecting earlier, isolated sections, stands at once as the ethnic, economic, social, and cultural divide between the Chinese and the northern tribes, and as the meeting ground where the two mingled to create the richly multifaceted and multicultural heritage of modern China.[8]

—JFS and ECB

Notes

1. Quoted in Tao 1988, p. 2.

2. A history of the cultural development of the northern tribes will be the subject of a forthcoming monograph, *Symbols for Survival: Bronzes of the East Asian Grasslands in the Arthur M. Sackler Collections* (1996).

3. Creel 1970, pp. 194–241.

4. Leopard and tiger skins are specifically listed as "treasures of the northeast" in the *Huainanzi,* a Daoist anthology compiled in south China in the first century B.C. See Major 1993, p. 164.

5. Di Cosmo 1994.

6. Barfield 1989; Yü Ying-shih 1990.

7. For a good picture of later northern tribal groups and their relationships with China, see Rossabi 1983; Tao 1988.

8. For the complex history of the Great Wall, see Waldron 1990.

Catalogue

*T*HE ARTIFACTS IN THE CATALOGUE REPRESENT the material culture of the Chinese and the northern tribes. They must speak for themselves since no written records remain that describe in any detail the intricate and often devious dealings between these two culturally diverse groups that created them. The artifacts fall into several categories: definitely Chinese; definitely not Chinese; and hybrid objects that exhibit characteristics of both cultures. The hybrid objects, in turn, can be divided into three distinct groups: those that were made by the northern tribes for themselves; those that were made by the Chinese specifically for non-Chinese consumption; and those that were made by the Chinese for themselves but that incorporated certain artistic styles and motifs derived from a northern heritage. Although these artifacts are unprovenanced, their cultural contexts are suggested by comparison to scientifically excavated examples.

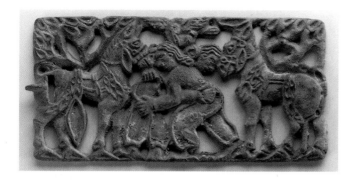

1 *Belt plaque*

Cast bronze
Width 14.4 cm, height 7.1 cm
Northwest China or south-central Inner Mongolia
2d century B.C.
Reproduced in color: plate 1, p. 22
Published: Rawson and Bunker 1990, no. 221
Xiwenguo Zhai Collection

This belt plaque depicts two bare-chested men, wearing long, loose trousers drawn in at the ankles, locked in a wrestling match while their horses stand in attendance in a wooded setting. Its subject matter, realistic description, and suggestion of space reflect West Asian origins and influence.[1]

Significantly, both wrestlers have shoulder-length wavy hair and other pronounced features indicating that they are not Chinese (see also no. 2). Their faces resemble the faces on no. 41, a scabbard ornament made some eight hundred years earlier, suggesting that peoples of similar ethnic—probably West Asian—origins may have arrived at China's northwestern borders as early as the beginning of the first millennium B.C.

An identical plaque is in the Victoria and Albert Museum.[2] Two matching plaques depicting the same scene, excavated from a Western Han burial at Kexingzhuang near Xi'an, Shaanxi Province, provide an archaeological context.[3]

—JFS

1. The plaque's stylistic connections with other narrative plaques and nomadic pictorial textiles are discussed in entry no. 2; Rawson and Bunker 1990, no. 221.

2. Another plaque (not openworked and of dubious authenticity) is in the Sackler Collections, New York. See Salmony 1933, plates 21.1–2.

3. Beijing 1962, plate 103.5, p. 139, figs. 92–93.

2 *Pair of belt plaques*

Cast bronze
Width 10.25 cm, height 6.5 cm (each)
North China
2d–1st century B.C.
Published: Rawson and Bunker 1990, no. 228
Xiwenguo Zhai Collection

These two mirror-image plaques together form one belt buckle once belonging to the Xiongnu tribes that dominated the eastern Eurasian grasslands during the last three centuries of the first millennium B.C. Each plaque portrays a narrative scene in which a mounted warrior grabs the hair of a pot-bellied demon wrestling with a dog. The warrior's other hand brandishes a dagger, a familiar gesture found also on the famous Hosakawa mirror said to come from Jincun, Luoyang, Henan Province.[1]

The mounted warrior on these plaques is Europoid, shown with long hair and facial features like those of the wrestlers on no. 1. A second dog pointing at a bird hidden in the foliage stands on the roof of a waiting cart. The landscape setting is indicated by leafy branches. The cart is pulled by two reindeer, common draft animals in the Lake Baikal region where the Xiongnu had their summer campgrounds. This kind of cart was used to transport belongings and the elderly when tribes moved about following their herds. Buckles consisting of two plaques that each represent this scene have been recovered from burials at both Xichagou in northeast Liaoning Province[2] and at Daodunzi, Tongxin Xian, Ningxia Hui Autonomous Region,[3] sites that can be dated numismatically to the second or first century B.C.

Narrative scenes such as this and the wrestling match in no. 1 illustrate episodes from the oral epic traditions of seminomadic pastoral peoples throughout the Eurasian steppes. They are translations into metal of scenes originally represented in textiles, a far more perishable medium. Tribes practicing transhumance did not have grandiose buildings with walls on which to paint. Instead, their heroic tales adorned textiles, such as the famous felt hanging from Pazyryk.[4] Even the stepped triangular borders that mark the rims of these plaques reflect the appliquéd felt seen on Pazyryk textiles.[5] Evidence for the importance of textiles in Xiongnu society is provided by their abundance among the grave goods at Noin Ula in northern Mongolia, some Central Asian and others Chinese.[6]

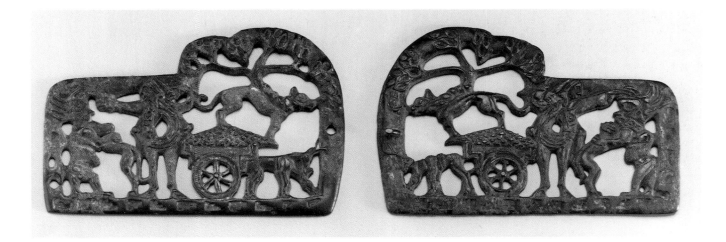

The pictorial scenes on these plaques owe little to Chinese traditions. The attempt to integrate the figures into a landscape setting and the foreshortened view of the horse and rider derive from Hellenistic traditions prevalent at oasis centers in Central Asia following the intrusive adventures of Alexander the Great. Similar foreshortened views of horses abound in Greek vase painting.[7]

Narrative scenes on belt plaques belonging to the northern pastoral tribes did not inspire major new directions in mainstream Chinese pictorial representation, although a few minor zoomorphic motifs did creep into Chinese art as *xiangrui* elements (good omens). Instead, the later developments of the narrative traditions that inspired the Xiongnu scenes must be sought in the painted murals of Central Asia found at Sogdian sites along the Silk Route.[8]

—ECB

1. Umehara 1937, frontispiece.

2. *Wenwu* 1960.8–9, p. 30.

3. *Kaogu xuebao* 1988.3, p. 345, fig. 10.6.

4. Rudenko 1970, no. 147.

5. Ibid., plate 160.

6. Umehara 1960, plates 1–2.

7. Bunker 1978.

8. Azarpay 1981.

3 Belt plaque

Cast bronze
Width 11 cm, height 5.8 cm
North China and Inner Mongolia Autonomous Region
2d–1st century B.C.
Published: Bunker 1978, plate 5b; Bunker 1981, no. 887
Los Angeles County Museum of Art, Gift of the Ahmanson
 Foundation, M.76.97.582, formerly Heeramaneck Collection

This rectangular openwork plaque depicts a northern tribal group on the move. A man wearing typical northern dress—a belted jacket over loose trousers and leather boots—precedes a horse-drawn covered cart through a wooded area indicated by a leafy tree. The driver is shown leaning out of the cart as he grasps the horse's reins. Although similar in appearance to the cart represented in no. 2, the wheel on the present plaque has eleven spokes instead of the six shown there. The outdoor setting for the present scene is established by the stylized tree branches that act as stage props.

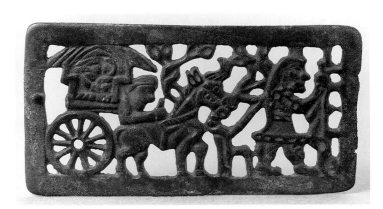

A mirror-image version of this plaque was recently collected in the vicinity of Wengniuter Qi, Chifeng Xian, southeast Inner Mongolia. This find confirms that these plaques were worn as mirror-image pairs and together constituted one belt buckle. These plaques are crudely cast, suggesting that they were manufactured locally.
—ECB

4 Ritual food container (ding)

Cast bronze
Height 23.2 cm, width 18.2 cm
North-central China
12th–11th century B.C.
Published: Bagley 1987, no. 86 (and references therein);
 Lawton et al. 1987, no. 118
Arthur M. Sackler Gallery, Smithsonian Institution,
 Gift of Dr. Arthur M. Sackler, s1987.48

From its sturdy, well-proportioned shape to its elaborate surface pattern and accomplished craftsmanship, this tripod container embodies the ancient Chinese preoccupation with ritual and ceremony. Compared with the typical nomadic vessel (no. 10), its size, weight, careful

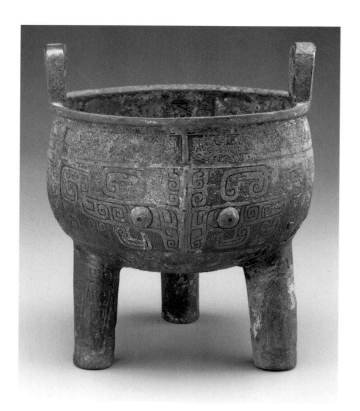

workmanship, and elaborate decoration betray its function in a formal ritual setting rather than the north's less formal, constantly changing venues. Its sophistication further denotes an organized society in which the ruling elite could mobilize large numbers of skilled workers to produce a rich array of ritual paraphernalia. Finally, its fantastic—not realistic—imagery reflects an agrarian society protected from the rigors of the wild, which can only be imagined, not experienced[1] (see also no. 12).
—JFS

1. For a detailed discussion of this vessel as a classic Chinese type, see Bagley 1987, entry no. 86.

5 Buckle

Tinned cast bronze
Width 5.6 cm, height 5 cm
Northwest China
4th century B.C.
The Therese and Erwin Harris Collection

This small, tinned bronze buckle is cast in the shape of a camel shown with a rider sitting between its two humps. The rider, portrayed from the back, is dressed in a long, belted jacket and trousers. He leans slightly forward and urges the camel onward with a stick held in his right hand, which he applies to its rump. His left hand, shown close to the head, presumably holds the rein, which would be attached to a plug in the camel's nose (rather than to a bit, used only for horses). The designer of this plaque obviously knew all about camels, as the features are anatomically correct.

The ground line extends up to the camel's muzzle and carries the fixed hook of the buckle, while the back of the plaque has a vertical attachment loop behind the camel's rump. The surface of the buckle has been deliberately tinned to achieve a shiny whiteness. Similar plaques showing kneeling camels have been found in southern Ningxia Hui Autonomous Region along the famous Silk Route[1] (see no. 88). The camel made trans-Asian travel possible. With its big padded feet that could walk on sand and ability to store water in its humps, the camel could cross deserts. The particular camel known to the Chinese was the Bactrian camel, recognizable by its two

1. Japan 1992, no. 64.

2. For camels in China, see Schafer 1950.

3. Li Xueqin 1986, no. 137.

4. Schafer 1950, p. 174.

5. Ibid., p. 176.

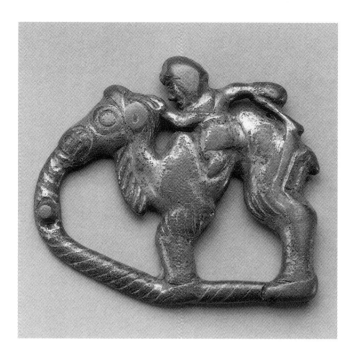

6 *Pair of belt plaques*

Gilded cast bronze
Width 5.5 cm, height 4 cm (each)
Northwest China
3d–2d century B.C.
Leon Levy and Shelby White Collection

prominent humps.[2] The earliest evidence for the camel in Chinese art appears to be a bronze lamp in the shape of a standing camel and rider, excavated from Chu tomb 2 at Wangshan, Jiangling Xian, Hubei Province.[3] According to the *Zhanguoce* (Annals of the Warring States), domestic camels were already in service at the courts of Zhao, Dai, and Yan before the end of the Warring States period.[4] During the Han dynasty, large herds of camels were raised in Gansu Province for travelers on the Silk Route.[5] The camel drivers and riders were all foreigners, however, just like the rider on this plaque.

—ECB

These mirror-image plaques depict a lively scene in which a man is attempting to catch and subdue an ox. The ox is shown in a three-quarter view with his head down as he plunges forward, and his would-be captor behind him struggles to get a rope on him. The ox's furry coat is indicated by short, indented lines. The scene on each plaque is enclosed within a rope frame described by a herringbone pattern. Each plaque displays two rounded vertical loops on the back for attachment purposes. The wearer's left-hand plaque also has a loop that projects to the side, through which a strap was passed to fasten the buckle.

Many plaques associated with the northern tribes during the late third through the first century B.C. carry this type of frame. The animation of this action-packed scene is more typical of Chinese art of the Western Han period

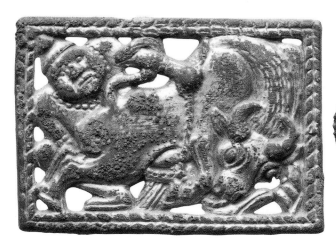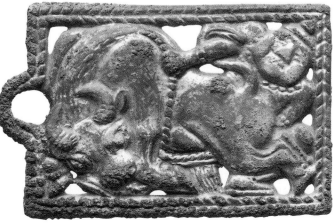

than the art of the Xiongnu, which tends to represent scenes that are more symbolic and static. Gilding is a further indication of Chinese workmanship, as there is no evidence that the Xiongnu practiced mercury amalgam gilding, a complex process.

The scene itself is rather curious. The man attempting to conquer the ox is obviously not Chinese, nor is he a Xiongnu. His coiled hair (or headdress) is most unusual and must reflect the fashion of some herding tribes with whom the Chinese interacted. A similar hairstyle or headdress occurs on a much earlier jade figure excavated from a late Western Zhou period site at Baicaopo, Lingtai Xian, Gansu Province.[1]

—ECB

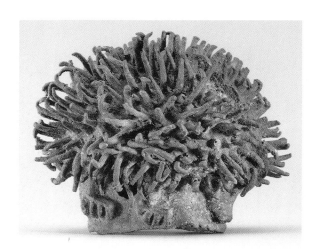

1. *Kaogu xuebao* 1977.2, p. 120, fig. 19.1.

7 Finial

Cast bronze
Height 6.35 cm
Northwest China
4th century B.C.
Reproduced in color: plate 2, p. 24
Buffalo Museum of Science, Br164, formerly Chauncey J.
 Hamlin Collection

This small hedgehog originally surmounted a finial, the rectangular shaft of which is now broken off. The artist has managed to capture the prickly quality of this nocturnal animal with great sensitivity. Hedgehogs are known to live in northern Shaanxi Province on the fringe of the Ordos Desert.[1] Spines cover their bodies, and, when frightened, they roll up into a prickly ball for safety. Otherwise hedgehogs tend to be friendly creatures, and, in Europe, they figure prominently in folk tales. According to Alfred Salmony, hedgehogs were among the sacred animals of Siberian shamanism.[2]

Two finials, each surmounted by a similar crouching hedgehog, were discovered at Nalin'gaotu, Shenmu Xian, in northern Shaanxi Province,[3] and ten small, hollow repoussé gold hedgehogs were discovered at Aluchaideng, Hangjin Qi, in the Ordos region of western Inner Mongolia Autonomous Region.[4] With a few exceptions, hedgehogs are rare in the art of the northern zone. A few plaques show tiny profile hedgehogs combined with

felines and wild boars,[5] and an unusual gold belt buckle depicting two hedgehogs being bitten by snakes was formerly in a private collection in Hong Kong.[6] A small bronze buckle in the shape of a hedgehog attacking a snake was recently found in Yulin Fu, Shaanxi Province.[7] None of the other hedgehog figures express the essential qualities of the animal as well as the figure here.

A close examination of the present piece suggests that it was cast by the direct lost-wax process. A wax model of the small, rounded body was formed over a core by two pieces of wax that met at the center of the back, where an uneven seam mark running from head to tail remains on the finished bronze. The spines were subsequently formed by sticking tiny wax pieces into holes poked in the wax body. The final wax casting model was then cast by the usual lost-wax technique, and a bronze hedgehog complete with prickly spines resulted. A square attachment hole occurs on one side of the socket. The interior has small metal spheres reflecting air bubbles in the casting investment.

—ECB

1. Tate 1947.
2. Salmony 1933, p. 33.
3. *Wenwu* 1983.12, plate 4.2.
4. *Kaogu* 1980.4, plate 11.5.
5. Salmony 1933, plate 16.12.
6. Chen Rentao 1952, p. 93, fig. 10.7. The gold buckle is now in a collection in Japan. See Osaka 1991, no. 183.
7. *Wenbo* 1988.6, inside back cover, no. 4.

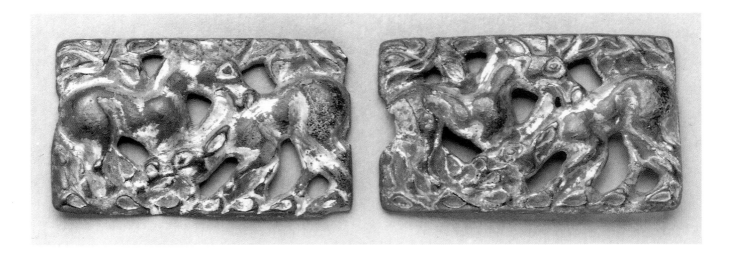

8 *Pair of belt plaques*

Gilded bronze
Width 5.3 cm, height 3.3 cm (each)
Eastern Eurasian steppes
2d–1st century B.C.
The Therese and Erwin Harris Collection

Each of these gilded bronze plaques portrays two fighting stallions. The horses are represented in typical northern fashion, with all four legs shown. One horse bites the other on the back, while the other horse bites his opponent in the leg. Leafy foliage in the background indicates an outdoor setting. Each plaque carries two tiny horizontal loops on the back at either end at the center of the edge. These plaques are not symmetrical mirror-images. Instead, they appear to be identical and may have been cast from the same model by the indirect lost-wax process.

Larger versions of these plaques that form buckles have been found at sites associated with the Xiongnu all over the eastern Eurasian steppes: in southern Siberia[1] and in northwest China at Daodunzi, Tongxin Xian, Ningxia Hui Autonomous Region, where they have been found with *wuzhu* coins, a Han dynasty coin not minted before 118 B.C.[2] One example was discovered near Dongsheng in the Mulei Kazakh Autonomous District in eastern Xinjiang Uighur Autonomous Region, but it was misidentified as a combat between a boar and a horse.[3] The vast range of the find spots of these plaques reflects the expansion of the Xiongnu empire.

In nature, stallions fight fiercely for possession of the available mares. Such combat is, therefore, a natural motif for ancient peoples involved in stockbreeding and livestock trading.

—ECB

1. Devlet 1980, plates 8–10.
2. *Kaogu xuebao* 1988.3, p. 344, fig. 9.6, plate 17.3.
3. *Kaogu* 1986.10, p. 888.

9 *Two chariot yoke ornaments*

Cast bronze
Width 11.4 cm, height 7.5 cm (each)
Northwest China
5th–4th century B.C.
Reproduced in color: plate 3, p. 25
Leon Levy and Shelby White Collection

These two rams are shown with their legs folded in such a way that the back legs overlap the front legs, the front hooves facing upward and the hind hooves facing downward. Both rams are hollow, so that their bodies can fit over the rounded yoke of a two-wheeled vehicle that may have played an important role in funeral ceremonies. Originally, these rams must have belonged to a larger set of four or more identical figures that would have been placed on the yoke on either side of the draft pole. Unfortunately, the function of such hollow animal figures was not recognized until recently; consequently many sets of yoke ornaments were split up by dealers and collectors[1] (see no. 32).

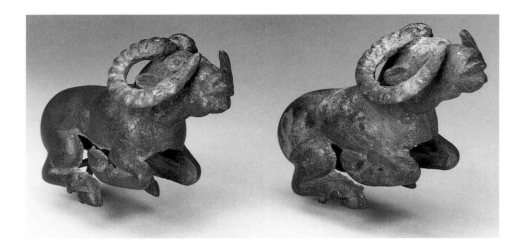

A predynastic Qin tomb dating to the late Spring and Autumn period at Bianjiazhuang, Long Xian, Shaanxi Province, contained a chariot with a yoke adorned with four rabbits whose scooped out bodies are similar to those of the rams shown here.[2] This discovery suggests that the custom of placing animal figures on a vehicle's yoke was also practiced in the state of Qin. Such chariot yoke ornaments were peculiar to burials belonging to the herding tribes of the northwest and, to date, have not been found in burials east of the Taihang Mountains, where different burial rituals must have prevailed. Yoke ornaments ultimately went out of fashion with the appearance in the northwest frontier regions of mounted warfare, which placed a greater emphasis on the horse than on a vehicle drawn by horses. By the end of the third century B.C., neither vehicles nor yoke ornaments were included among the grave offerings.

Similar ram yoke ornaments have been excavated from burials near Mazhuang, Yanglangxiang, Guyuan Xian, of southern Ningxia Hui Autonomous Region.[3] The examples from Ningxia were rather crudely cast in two-piece molds. By contrast, the present rams show mold joint seams that indicate a very complex piece-mold system, suggesting that these two figures were cast by the Chinese for northern consumption.
—ECB

1. For a full set of six recumbent does, see Rawson and Bunker 1990, no. 205.

2. *Wenwu* 1988.11, pp. 16, 17, figs. 3.39–42, 4.7.

3. *Kaogu xuebao* 1993.1, p. 42, fig. 24.9.

10 *Cauldron (fu)*

Cast bronze
Height 17.8 cm, diameter 11.4 cm
North China
3d–2d century B.C.
Published: Érdy 1995, p. 92, table 6.3, no. 3
Dr. and Mrs. George Fan

This bronze cauldron is typical of the vessels used by the herding tribes that lived beyond the northern frontiers during the first millennium B.C. Such vessels were primarily utilitarian, with a cone-shaped base that was pierced in three places to allow heat to escape. The prominent mold joint marks that bisect the vessel vertically indicate that the vessel and handles were cast integrally in a two-piece mold. The rough casting here suggests that this cauldron was made locally. A similar example with rectangular handles from Gansu Province is described as having the same pendant casting sprue on the bottom as the present *fu*, and evidence of smoke on its body.[1]

The prototype for this type of vessel (see no. 22) is obviously Chinese, and it also retains the remains of a similar casting sprue on the base. Unlike ornate Chinese ritual vessels, cauldrons have had little serious attention until recently. They occur during the early first millennium B.C. among the northern tribes, as evidenced by their appearance at Jundushan, Yanqing Xian, north of Beijing (see cat. fig. 22.1). They were later adopted by the Xiongnu, who ultimately carried them west and into Europe.[2]

Cauldrons with rounded handles are earlier than those with rectangular handles like the example here.[3] A

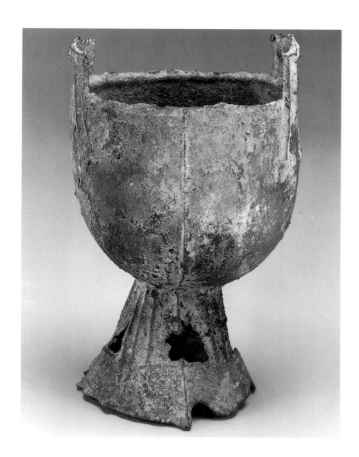

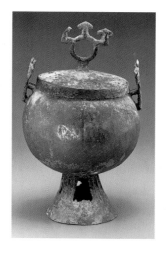

CAT. FIG. 10.1. Bronze cauldron with lid, 2d–4th century A.D. Height 37.5 cm, diameter 22.3 cm. Dr. and Mrs. George Fan

1. *Wenwu* 1986.2, p. 42, fig. 3.

2. For the most up-to-date research on cauldrons, see Érdy 1995.

3. Ibid., p. 38.

4. Egami and Mizuno 1935, p. 180, fig. 106.2.

5. Tokyo 1983, no. 53.

6. Érdy 1995.

very similar but smaller cauldron with rectangular handles was found in the Qingyang region of southeastern Gansu Province,[4] suggesting that the present cauldron may come from the same general vicinity. Miklos Érdy dates both the present cauldron and the Qingyang example to the late first millennium B.C.

Later cauldrons associated with the Xiongnu had handles surmounted by mushroom-shaped projections (cat. fig. 10.1). This was the type of cauldron carried into eastern Europe between the mid-second and fourth centuries A.D. Its transport suggests that cauldrons ultimately developed into ritual vessels, acquiring decorations that are little understood today but must have been meaningful to those who owned them years ago. The example in cat. fig. 10.1 is similar but far more complete than the cauldron excavated from a tomb at Lingpi village, Horinger Xian, south-central Inner Mongolia.[5] This type of cauldron with mushroom-shaped projections has been traditionally associated with the Xianbei, but, as Érdy points out, the Xianbei must have borrowed the form from their northern predecessors, the Xiongnu, who designed it first.[6]

—ECB

11 *Young entertainer*

Cast bronze
Height 10.2 cm
North China, Shanxi or Hebei Province
5th century B.C.
Published: Hearn 1987, no. 49 (and references therein)
Metropolitan Museum of Art, Gift of Ernest Erickson
Foundation, Inc., 85.214.48

This small sculpture depicts a young man caught as if in midaction, his face turned expectantly toward an unknown audience. He wears a short tunic tied at the waist with a sash, which runs through a scabbard slide securing a short sword at his back. Thick incrustation obscures any evidence for long trousers under the tunic, but lines marking his shoes are clearly indicated on both feet.

This figure has a virtually identical counterpart in the Freer Gallery of Art.[1] The Freer figure is misrepresented through the clever addition, presumably in the early decades of this century, of a zither tuning key (compare nos. 70, 71) to suggest that the youth was performing tricks with his trained animal. To make this balancing act possible, the raised hand supporting the tuning key has been reshaped into a rectangular stump. A similar attempt was also made to "enhance" the present figure.[2]

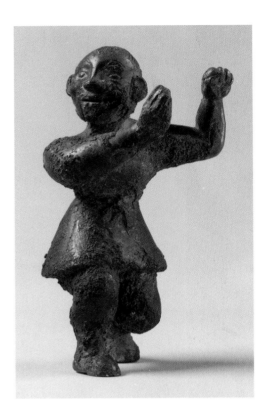

12 *Food container (dou)*

Cast bronze inlaid with pigmented paste
Height 19.7 cm
North China, Shanxi or Hebei Province
Late 6th or early 5th century B.C.
Published: Weber 1968, figs. 52, 66.a–h
Walters Art Gallery, Baltimore, 54.2182

A pictorial design, accented with a pastelike, reddish brown substance, densely covers the surfaces of this covered, round food container on a flared stem *(dou)* that is one of a pair.[1] The shape is Chinese,[2] but the use of contrasting inlay and the pictorial motifs are inspired by contacts with the north. The vignettes of hunters among deer, boars, rhinoceroses, and other fantastic beasts (see details) present a quaintly picturesque version of a harsh reality that its Chinese designer may not have ever experienced. The scenes of music-making and wine-

These figures, with others in the Museum of Fine Arts, Boston,[3] and the Metropolitan Museum of Art, New York,[4] form a vivid group representing the active engagement of non-Chinese peoples in Chinese courts. Their portrayal seems to reflect the Chinese perception of their particular talents—as entertainers, tumblers, or acrobats valued for their exoticism and physical agility, or as grooms and drivers prized for their skills and experience with horses. Excavations at a large sixth- to fifth-century bronze foundry site at the town of Houma, in southern Shanxi Province, yielded clay molds and models of similarly clad figures (see fig. 37), indicating that such sculptures were likely made in Chinese rather than northern workshops.[5]

—JFS

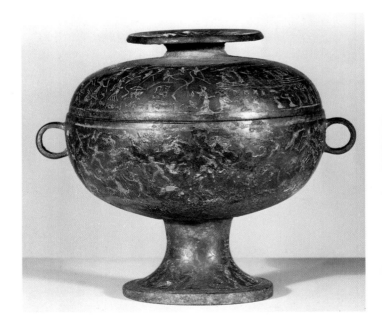

1. Lawton 1982, no. 37.
2. See Hearn 1987, p. 50.
3. Mizuno 1959, plate 156.
4. Lally 1990, no. 3.
5. *Wenwu* 1960.8–9, p. 7, figs. 1–2; Shanxi 1980, nos. 87–89.

Details, no. 12, schematic drawings showing designs on food container

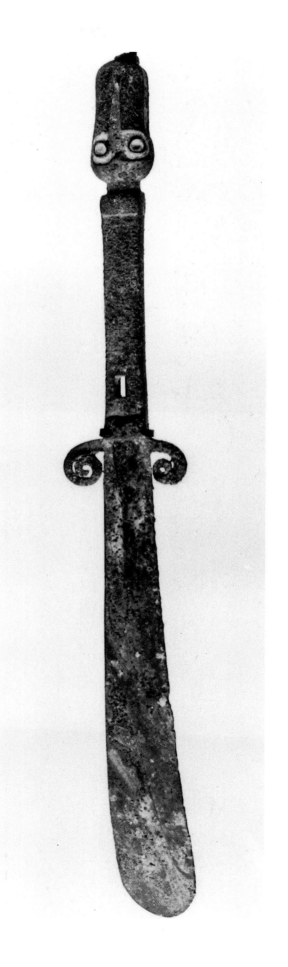

drinking festivities under two-storied structures, and bird hunting and harvesting by figures wearing long robes, are, however, typically Chinese in both content and setting. The *dou*'s decoration presents at once a vivid picture of the structured, formal, and ritualistic lives of the Chinese, and their idealized impression of the unfettered and exciting lives of their northern pastoral neighbors.

Clay casting molds for similar pictorial scenes have been recovered from the late-sixth- to fifth-century B.C. bronze foundry site at the town of Houma, southern Shanxi Province, supporting the likely Chinese manufacture of such vessels.[3] However, finished products with these designs have been found mostly at northern sites along the Great Wall stretching from Shanxi to Hebei Provinces.[4] Recent excavations in Pingshan Xian, south of Beijing, in Hebei Province, yielded a *dou* virtually identical to the present example in shape, size, design, and decor technique.[5]
—JFS

1. For detailed descriptions and discussions of this *dou* and other related vessels, see Weber 1968, pp. 169–237; Barnard 1988.

2. The type's development within the Chinese tradition is discussed in So 1995, entry no. 24.

3. See ibid., introduction, section 4.2.

4. See New York 1980, no. 70, pp. 258–62; also So 1995, introduction, section 4.2.

5. *Kaoguxue jikan* 5 (1987): 177–78, figs. 27.7, 29. The significance of the Pingshan excavations is discussed in chapter 3.

13 *Ritual implement*

Cast bronze inlaid with turquoise
Length 30.5 cm
Northwest China
13th–11th century B.C.
Metropolitan Museum of Art, Fletcher Fund, 23.226.6

This ritual implement has a handle that terminates in a head with protruding, goggly eyes and a tongue that moves from side to side. Behind the guard on one side is a long, raised triangular shape that represents the tail.

Although the creature that decorates this implement

100

has been traditionally described as a snake, there is nothing snakelike about it.[1] It exhibits all the essential features of an alligator: a broad blunt head with a bony ridge that runs from the eyes to the snout; closely set eyes on the upper part of the head; a tongue that is not forked; and a broad tapering tail. Similar implements with alligator characteristics have been excavated at several sites in Shanxi Province.[2] An alligator identification is reinforced by a favorable comparison between this animal and the alligator depicted on the side of a bronze vessel excavated at Taohuacun, Shilou Xian, Shanxi Province.[3] Alligators were apparently found in northern Shanxi, an area within the great bend of the Yellow River. The frequent reference to these creatures as crocodiles is zoologically inaccurate.[4] The remains of a drum made of alligator skin recently excavated from a Neolithic site at Taosi, Linfen Xian, in northern Shanxi Province, confirms the existence of alligators there in antiquity.[5]

A similar ritual implement terminating in a wild goat-head was discovered east of the Taihang Mountains in northern Hebei Province at Taixicun, Gaocheng Xian.[6] The choice of a wild goat to enhance an implement for tribes living in the mountainous regions of northern Hebei is understandable, since this region would have been inhospitable for alligators but was presumably teeming with wild goats the tribes hunted.

—ECB

1. Lin Yün 1986, p. 249, fig. 50.1.

2. *Wenwu* 1962.4–5, pp. 33–34; *Kaogu* 1972.4, p. 30, fig. 6; *Wenwu* 1981.8, pp. 50–51, figs. 4, 14.

3. Beijing 1990, no. 43.

4. Bunker 1979.

5. *Kaogu* 1983.1, plate 6.5.

6. Lin Yün 1986, p. 249, fig. 50.6.

14 *Dagger*

Cast bronze
Length 26.6 cm
Northwest China
12th–11th century B.C.
The Therese and Erwin Harris Collection

The flattened ovoid hilt and blade of this dagger were cast in one piece. The solid grip curves near the top and terminates in a slit pommel with a low domed cap, inside of which is a small metal pellet that rattles when the dagger is wielded. A small loop spans the slit pommel and the top of the grip. A pronounced midrib runs the length of the blade, continuing past the notched guard that projects as straight, blunt wings. A single row of triangular motifs runs down the middle of the hilt, its top and bottom bounded by parallel horizontal lines. The surface has been polished to a smooth dark gray-black.

Weapons, tools, and ornamental paraphernalia decorated with jingles or rattles are characteristic of northern artifacts. Their prevalence in the north has been recognized as a sign of their invention in that area. Their particular shapes may represent the vestiges of a more primitive smithied metalworking tradition, which created the earliest jingles by slashing the top of a hollow, tubular hilt, bending the slashed ends, inserting the pellet, then soldering a metal sheet over the top.[1]

Excavations in northern Shanxi and Shaanxi Provinces have yielded jingle-pommeled daggers and knives to confirm their essentially northern and northwestern provenance.[2] In what may be taken to be a typical non-Chinese grave opened in Ji Xian, northern Shanxi Province, a virtually identical jingle-pommeled dagger was placed near the left shoulder of the deceased, while a bronze socketed ax was found near the right shoulder and a spoon with dangles was found at the waist.[3]

Daggers with curved hilts, like the present example, are closely related to knives with stylistically similar curved handles found in comparable northern contexts (nos. 15, 16). They were later replaced by daggers with straight hilts, which became the standard form made and used by northern tribes well into the first millennium B.C. (nos. 43–45).

—JFS

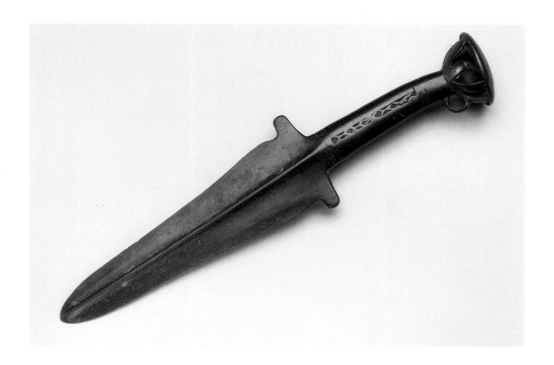

1. Loehr 1949, pp. 29–34.

2. See *Wenwu* 1972.4, plate 6.5; *Wenwu* 1981.8, p. 51, fig. 13; *Kaogu* 1981.3, plate 5.1. These and other examples are listed in Wu En 1985, pp. 136–37.

3. *Kaogu* 1985.9, pp. 848–49, figs. 2, 3.1–3.

15 *Knife*

Cast bronze inlaid with turquoise
Length 24.1 cm
Northwest China
12th–11th century B.C.
Reproduced in color: plate 4, p. 34
Published: Bunker et al. 1970, no. 54
Anonymous loan

The integrally cast handle and blade of this knife forms a gentle curve. A goat's head tops the handle, the circular sockets of its eyes and nostrils accented with turquoise. An extension issuing from under its nostril meets the handle in a bird-head, whose eye sockets are also inlaid with turquoise. As on no. 16, a series of raised parallel lines mark the handle just below the goat's head. A saw-tooth pattern runs down the middle of both sides of the flat handle, ending at the projecting ridge at the junction of the handle and blade. The tip of the blade was damaged and repaired.

Knives with curved, integrally cast handles and blades are the most common artifacts found in non-Chinese contexts in Inner Mongolia and neighboring northern Shaanxi, Shanxi, and Hebei Provinces.[1] Virtually identical goat-head knives have been recovered at Suide Xian in Shaanxi Province,[2] Qinglong Xian in Hebei Province,[3] and even in the Shang capital at Anyang in Henan Province.[4] Goat- and other animal-heads also decorate the pommels of daggers from northern sites.[5] Although knives with similar animal-head handles are characteristic of southern Siberia as well, they cannot match the northern examples in variety and workmanship, thus leading scholars to suggest a possible northern rather than Siberian origin for the type.[6]

The ubiquitous presence of such knives in the north reflects the importance of hunting in the region. Although most of these knives are utilitarian articles for daily use, those with more elaborate handles, like this and no. 16, may signify rank or tribal affiliations and were prized possessions of special individuals in each tribe.

Together with the animal pommels, geometric design and turquoise inlay are the typical decoration on these knives. The use of colored stone inlay is a northern ornamental device that was revived during the sixth century B.C. (nos. 43, 44), sparking an outburst of color in the decoration of northern and Chinese artifacts alike (nos. 12, 97, 103).

—JFS

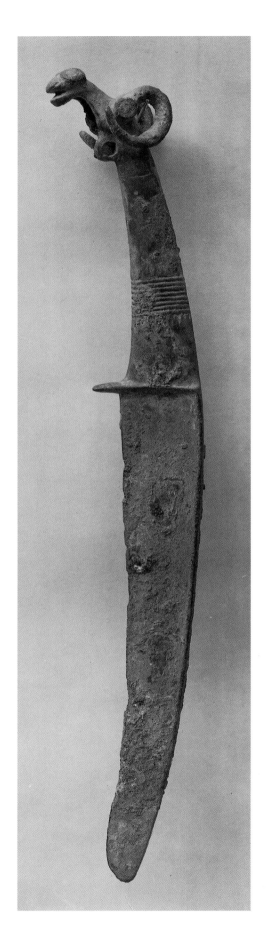

1. See examples listed in Wu En 1985, pp. 138–39; also Tian and Guo 1986, pp. 15–32. They are studied in detail in Loehr 1951.

2. *Wenwu* 1975.2, p. 83, fig. 3.

3. Beijing 1980a, no. 83, where it is found together with a dagger topped by a ram's head (no. 84).

4. Beijing 1980c, plate 66.1; other examples from Anyang cited in Wu En 1985, pp. 147–48.

5. Beijing 1980a, no. 87.

6. See Loehr 1956, pp. 101–5; Loehr 1965a; Wu En 1985, pp. 147–48.

16 *Knife*

Cast bronze inlaid with turquoise
Length 27.0 cm
Northwest China
12th–11th century B.C.
Published: New York 1970, no. 20
Metropolitan Museum of Art, Gift of Mrs. John Marriott, Mrs. John Barry Ryan, Gilbert W. Kahn, and Roger Wolfe Kahn (children of Addie W. [Mrs. Otto] Kahn), 49.136.9

Slightly longer than no. 15, this knife shows a handle terminating in a ram's head with its signature curled horns. Like no. 15, turquoise inlays accent the circular sockets on the ram's head. However, only a dense series of parallel lines decorate the hilt. The extension that connects the animal's muzzle with the hilt is damaged, and much of the original crusty patina has been preserved.

—JFS

17 *Ax blade*

Cast bronze
Width 11.1 cm, height 18.4 cm
Northwest China
12th–11th century B.C.
Reproduced in color: plate 5, p. 35
Published: (in rubbing only) Yu Xingwu 1941, fig. 1; (in rub-
bing only) Hayashi 1972, p. 155, fig. 221
Freer Gallery of Art, Smithsonian Institution, Study Collection,
FSC-B-500

This handsome ax blade is distinguished by shapely
volutelike tips and a perforation near the center of the
blade. For strength and sharpness, the blade tapers in
thickness from the butt to a finely honed edge. The thick-
ened area is expressed as a design that follows the curled
tips, extending in a point toward the center of the edge. A
low ridge marks the center of the point, interrupted by
the perforation, but continues to end abruptly at the
junction of the blade with its now-missing hafting device.
A raised collar encircles the perforation, which is flanked
by a pair of intaglio T-shaped motifs. A second pair of
intaglio L-shapes flanks the ridge near the end.

From its first publication (as a rubbing only) in
Beijing in 1941 to its appearance in London in 1984,[1]
the blade was without any hafting device. When it reap-
peared in New York in 1992,[2] it had acquired a butt and
tang (see detail) clearly modeled after a virtually identical
tanged blade in the collection of the Royal Ontario
Museum, Toronto.[3]

Recent finds of similarly shapely ax blades, most of
them from northwestern sites, question the validity of the
tanged butt. Examples recovered suggest that such blades
were most likely equipped with tubular shafts (a typical
northern feature) rather than tangs (used commonly on
Chinese weapons). A particularly pertinent example is an
ax reportedly recovered from Yulin Fu in northern
Shaanxi Province (cat. fig. 17.1), in which the long tubu-
lar shaft is ornamented by typically northern motifs: geo-
metric patterns, three-dimensional animals, and a jingle.
Other similarly shafted blades, both excavated and in
museum collections, attest to the likelihood that such
blades originally had tubular shafts rather than flat tangs.[4]

It is clear from ax blades datable stylistically to the
early Western Zhou period that these curvilinear shafted
non-Chinese blades did spawn tanged Chinese types
flamboyantly decorated with dragons, felines, and other
Chinese motifs.[5] The restoration on the present blade
reveals a misguided dependence on unreliable, unprove-
nanced evidence and ignorance of its non-Chinese origin.

Finally, two further features should be noted in regard
to this blade. The first is its unusual shape, which may
have been a deliberate exploitation, for visual effect, of a
technical feature resulting from hammering (thereby thin-
ning and spreading) the blade's edge in early smithied
versions.[6] The second feature is the perforation, which
has no apparent function here but is clearly a vestige of the
holes on more ancient stone blades that enabled lashings
to pass through and secure the blade to its wooden shaft.
These two features are survivals of more ancient manufac-
turing techniques and prototypes and telling clues to the
historical development of these blades.
—JFS

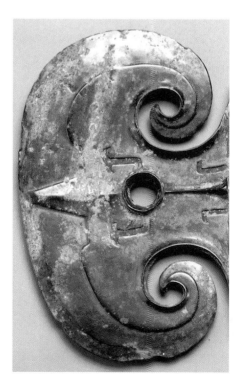

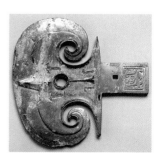

Detail, no. 17, showing ax
with restored tang

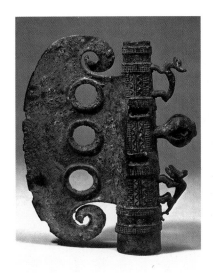

CAT. FIG. 17.1 Bronze socketed ax, reportedly from Yulin Fu, Shaanxi Province, late 2d millennium B.C. Length 18 cm. After Li Xueqin 1985b, no. 91

example excavated from Luoyang, Henan Province, see Cheng Dong and Zhong Shaoyi 1990, fig. 3.34.

6. This process was suggested by Cyril Smith when he studied a similarly splayed edge of a Thai bronze blade. Smith 1973, pp. 27–28.

18 *Ornament with human heads*

Cast bronze
Width 15.5 cm
North China
Late 2d or early 1st millennium B.C.
Anonymous loan

1. Sotheby's (London), June 19, 1984, lot 47.

2. Christie's (New York), December 3, 1992, lot 198.

3. The Toronto blade has been widely known and published by Umehara since 1933. See Umehara 1933, part 3, vol. 2, plate 96. However, recent technical examination of the Toronto blade suggests that the blade and tang may have been a dealer's fabrication dating from the early decades of this century.

4. For excavated examples, see ax from the Qinghai Province in Cheng Dong and Zhong Shaoyi 1990, fig. 2.116; from Chunhua Xian, Shaanxi Province, in *Kaogu yu wenwu* 1986.5, p. 13, fig. 9. Unprovenanced examples are in the Palace Museum in Taipei and the Shanghai Museum. Chen Fangmei 1991, figs. 30–31, 34–36, 38–41; Ma Chengyuan 1986, p. 76, plate 13b. See also Rawson and Bunker 1990, no. 57, entry no. 14, n. 3.

5. Examples of these unmistakably Chinese blades are illustrated in Umehara 1931, plate 6; see also the example formerly in the Stoclet Collection in Visser 1948, p. 155, plate 37. For an

In front of the pointed tips of a recumbent C-shaped tubular arc of bronze are two round buttonlike projections. Each is shaped like a human face framed by a flat border. The face shows rounded depressions for eyes, a low-molded nose, and a broadly grinning mouth with neatly lined teeth at top and bottom. Behind each face-like button, projecting sideways into the inner arc of the C-shape, are three short prongs; the top prong is broken and missing on one, and the bottom is broken and missing on the other.

The human face is a rare ornamental motif in Bronze Age China, but similar faces used as ornaments are known among late-second-millennium B.C. finds associated with China's frontier tribes. A group of five face-shaped ornaments was recovered from the fourteenth- to thirteenth-century B.C. tomb at Liujiahe, Pinggu

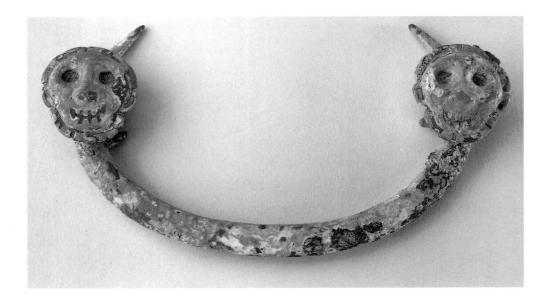

Xian, near Beijing.[1] The Liujiahe faces do not have a flat border, like the present example, but holes suggest that they may have been sewn on as garment ornaments. Many similar face-shaped ornaments have been recovered in a single cache in Chenggu Xian, southwestern Shaanxi Province,[2] while round ornaments with a face surrounded by a flat border have been recovered from Hejiacun near Qishan Xian, along the Wei River valley in western Shaanxi Province.[3] It is striking that while these rather stylized face motifs tend to cluster in the northwest during the late second millennium B.C., a more realistic version seems to predominate, during the first millennium B.C., in northeastern sites (see no. 39).

The function of this unusual object is unclear, but it was obviously a part of the ornamental paraphernalia of the northern tribes.[4] Judging from surviving face-shaped ornaments from western China, it is possible that the present example was also used as an ornamental accessory.

—JFS

1. *Wenwu* 1977.11, p. 6, fig. 15; see discussion of this find in chap. 2.

2. Beijing 1979, no. 116. Supposedly dozens of these face-shaped ornaments have been found. Similar facelike ornaments were also recovered from Laoniucun, outside Xi'an. *Wenwu* 1988.6, pp. 13–14, figs. 21.1, 22.

3. Beijing 1979, no. 40.

4. Remains of a fitting with similar three-pronged extensions issuing sideways have been recovered from tomb 101 at Nanshan'gen, Ningcheng Xian, Liaoning Province. *Kaogu xuebao* 1973.2, plate 11.14. The site dates from the eighth–seventh century B.C.

19 *Wine container (hu)*

Cast bronze
Height 41.1 cm
North and northwest China
Late 11th–early 10th century B.C.
Reproduced in color: plate 6, p. 42
Dr. and Mrs. George Fan

A flowing slender silhouette and a smooth, undecorated surface distinguish this wine container. The fitted lid, when inverted, is a goblet on a low flared stem (see detail). When the two holes on the stem of the lid are aligned with the holes on the undecorated tubular han-

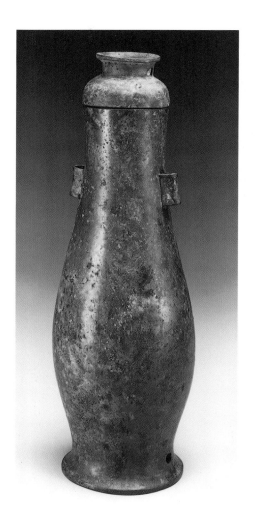

dles at the base of the neck and the two holes on the flared foot ring, rope or leather strapping can pass through them and secure the container for travel.

Similarly shaped containers have been recovered from early first millennium B.C. tombs in north and northwestern China from non-Chinese and culturally mixed contexts.[1] Those dating from the late eleventh and early tenth century B.C. tend to be plain, perhaps reflecting the non-Chinese patrons' pragmatic attitude toward vessels. The same shape elaborately decorated with traditional Western Zhou patterns, some of which even carried routine dedicatory inscriptions, would likely be made for Chinese consumption.[2]

Undecorated, portable containers like the present example are forerunners of the variety of later vessels encased in imitation rope cages (see nos. 20, 21). They reflect China's increased traffic with non-Chinese patrons and its fascination with the exotic foreign ways of life of the northern tribes.

—JFS

106

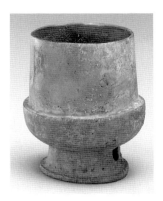

Detail, no. 19, showing inverted lid serving as drinking goblet

1. For example, at Baifu, Changping Xian, outside Beijing, and from the Yu family cemetery at Rujiazhuang, Baoji Xian, in southern Shaanxi Province. *Kaogu* 1976.4, plate 2.4; Beijing 1988, plate 160.2.

2. See Rawson 1990, figs. 15.4, 95, pp. 74–75. Rawson also recognizes the shape as a "new type" that appeared during the early tenth century B.C.

20 *Asymmetrical wine container (hu)*

Cast bronze, spurious single-character inscription
Height 25.4 cm
North-central China
8th century B.C.
Published: Ackerman 1945, plate 46; Karlgren 1948, plate
 26.1; Lippe 1950, p. 106; Chen Mengjia 1977, no. 759; So
 1995, fig. 39.1
Metropolitan Museum of Art, Bequest of Addie W. Kahn,
 49.135.9ab

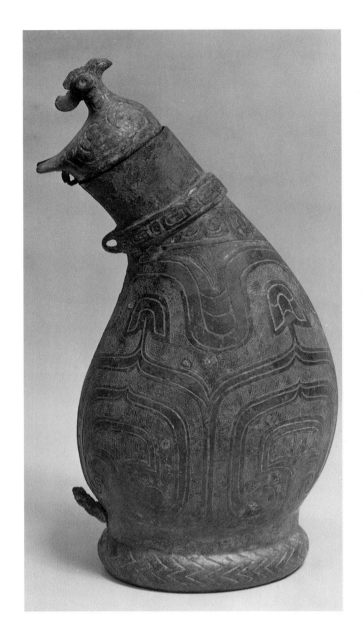

The neck of this elliptical container is bent backward. Its curved silhouette and soft, pouchlike shape are not matched by known bronze or ceramic prototypes but suggests containers made of skin. This association is supported by the bulging silhouette of the ring foot and its zigzag, rushlike pattern, suggesting the rope or fabric ring often needed for skin flasks to stand.[1] Actual fragments of woven mat with a zigzag pattern adhere to one side of the ring foot. The stump of a handle, issuing from above the ring foot and presumably once connected to the loop projecting from the collar around the neck, imitates twisted rope.

Although the vessel shape is unconventional, its surface decoration is unmistakably Chinese: large petal-shaped motifs in smooth bronze against a background of angular spirals executed in thin, raised lines.[2] Misalign-

ments in the surface decoration on the body indicate that the vessel was cast using a two-piece mold.

The bird-shaped lid sits a trifle too loosely inside the mouth and may have come from a different vessel, used here to replace a now-lost lid. A virtually identical vessel with a similar bird-shaped lid in the Museum of Far Eastern Antiquities, Stockholm, may have inspired this replacement.[3]

An undecorated container of this shape, its imitation twisted rope handle intact, found in Xingtang Xian, at the foot of the Taihang Mountains in northern Hebei Province, probably belonged to a member of a northern tribe.[4] The present vessel, however, in its blatant melding of the shape and decoration of two cultures, expresses

the Chinese people's growing curiosity about the exotic "other" that prompted their artisans to borrow and reinterpret a non-Chinese article in a typically Chinese idiom.

—JFS

1. See the wooden container with a felt ring recovered from a nomadic grave in Pazyryk, south Russia. Rudenko 1970, no. 54.B.

2. The development and stylistic peculiarities of this vessel type in the context of first millennium B.C. China are discussed in So 1995, entry no. 39.

3. Karlgren 1948, plate 26.1.

4. Beijing 1980a, no. 159.

21 *Wine container (hu)*

Cast bronze
Height 31.6 cm
North China
6th–5th century B.C.
Published: Erdberg 1978, no. 55
The Art Museum, Princeton University, Gift of Mr. and Mrs.
 Chester Dale Carter, 66.197

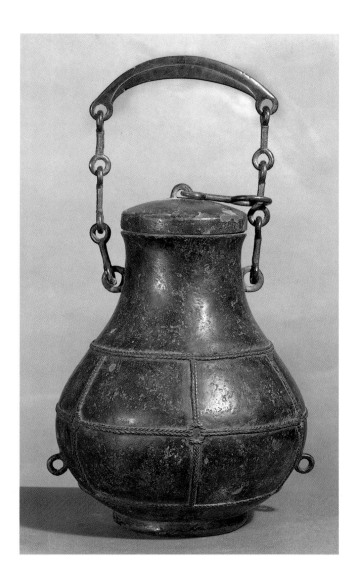

This pear-shaped wine container on a low ring foot is plain except for cast decoration imitating a rope cage on its body. A long, linked chain handle attaches to two ring handles projecting from the neck and is itself attached to the lid. Like the chains on the belt hooks (nos. 98, 102, 103), the rings are connected with a decorated 8-shaped element. The rings on this *hu,* however, differ in that each unit—consisting of ring-bar-ring (the second ring placed at right angles to the first)—is conceived and cast integrally as one. The original surface of the vessel is much obscured by a thick dark brownish red layer resembling lacquer.

 Containers with imitation rope cages are typically associated with frontier sites in northern Shanxi and Hebei Provinces.[1] They are clearly inspired by portable beverage containers, often made of other materials, used by northern tribes on the move. Many such vessels appear to have been made in Chinese workshops, however, since fragments of clay molds showing similar rope designs have been recovered from the foundry site at Houma, in southern Shanxi Province.[2] Containers like

this one therefore represent, on one hand, Eastern Zhou China's debt to the northerners for vessel design and, on the other, an active exploitation of its industrial skills to meet their needs.

—JFS

1. See So 1995, entry no. 41, for a detailed discussion of the type and comparable excavated examples.

2. See So 1995, introduction, sections 4.2, 4.3, for a discussion of Houma, and fig. 41.6 for an example of such a mold.

22 *Stemmed food container (fu)*

Cast bronze
Height 21.8 cm, width 18.8 cm
Northwest China
8th century B.C.
Dr. and Mrs. George Fan

A deep U-shaped bowl sits on a low trumpet-shaped stem. Two inverted U-shaped handles, made to resemble twisted rope, stand upright from the rim of the bowl. A molded twisted rope band divides the decoration on the bowl into two sections: a narrower section at the top filled with repeated large, hooked S-shaped motifs, and a wider section below filled with two rows of large, U-shaped, scalelike motifs. A sooty black substance fills the narrow grooves and shallow ground between the decor motifs. Prominent mold marks indicate that the bowl and hollow stem were cast integrally in a two-piece mold.

This vessel ranks among the earliest examples of its kind recovered in western China. A smaller vessel with virtually identical shape and handles but only a single register of S-shaped design was recovered from a northern suburb of Xi'an.[1] Another small container, also with twisted rope handles but undecorated, came from one of the non-Chinese burials at Jundushan, Yanqing Xian, north of Beijing (cat. fig. 22.1).

As one of the earliest examples of its kind, this vessel represents the likely prototype for the only vessel identified with tribes in north and northwest China—the cauldron (see no. 10). Its unmistakably Chinese decoration places it in the transitional period between Western and Eastern Zhou (eighth century B.C.) and suggests that the Chinese might have been among the first peoples to make this shape, which then traveled far into western Eurasia, becoming the signature article of the peoples in the Black Sea region.[2] The example from Jundushan (cat. fig. 22.1), from a hundred years or so later, already displays the characteristic bulbous silhouette, unusually small stem, and undecorated surfaces typical of the later nomadic cauldrons.

—JFS

1. *Kaogu yu wenwu* 1991.4, p. 7, fig. 1.13. Four other, plainer versions were found in the same vicinity. Ibid., figs. 1.2–3, 1.6–7.

2. The types and development of Chinese and Western cauldrons are studied in Érdy 1995.

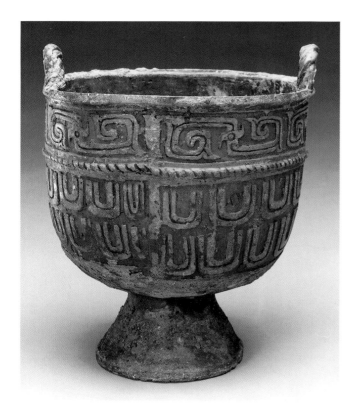

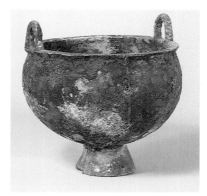

CAT. FIG. 22.1. Bronze *fu*, Jundushan, Yanqing Xian, Beijing, 7th or 6th century B.C. Height not specified. Cultural Relics Research Bureau, Beijing

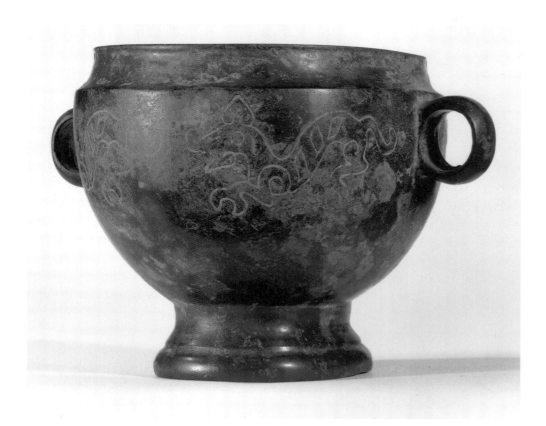

23 *Stemmed food container*

Cast bronze inlaid with copper
Height 11.5 cm, width 16 x 12 cm
North or northeast China
6th century B.C.
Published: Erdberg 1978, no. 84
The Art Museum, Princeton University, Museum Purchase
 from the C. D. Carter Collection, by subscription, 65.79

Unlike the previous vessel, the bowl of this food container is elliptical. The low-stemmed foot is molded and better shaped, and the concave rim suggests that it once had a lid, now missing. Two ring handles issuing from below the rim replace the upright handles on no. 22. Four felines seen in profile rendered in sunken lines and accented by a reddish inlay suggesting copper decorate the otherwise plain vessel exterior just under the rim. Lines on their bodies suggest that they are tigers. Each animal has a rolled muzzle, an inverted heart-shaped ear, spiral haunches, and wrench-shaped claws.

Although copper-inlaid felines decorate a large group of bronze vessels dating from the sixth and fifth centuries B.C.,[1] the felines on this vessel—with their heart-shaped ears, striped bodies, and realistic running poses—are matched by those on only a small handful of vessels with a northeastern provenance.[2] The close similarities between these felines and the tiger ornament (no. 26) further suggest that the motif had predecessors among ornaments from China's western frontiers.

The elliptical shape of the bowl is ultimately related to leather shapes, copied and developed by Chinese bronze masters during the seventh and sixth centuries B.C.[3] Setting the bowl on a low flared stem links it to the *fu* in no. 22. The copper red inlay represents contemporaneous sixth-century trends in bronze decoration. The shape and decoration of this vessel constitute a thorough blending of Chinese and non-Chinese features, refined by Chinese workmanship to satisfy the northerners' yearning for the sophisticated products of their agrarian neighbors.
—JFS

1. See Weber 1968, figs. 36–39, discussed on pp. 99–112.

2. See So 1995, entry no. 29; also Weber 1968, fig. 70.a–f, for examples of related motifs.

3. The prototypes and development of the shape are discussed in So 1995, entry nos. 53, 57.

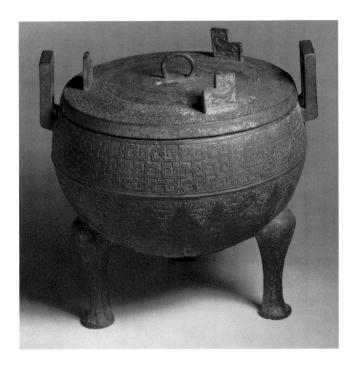

24 Food container (ding)

Cast bronze
North-central China
7th or 6th century B.C.
Height to top of handles 26.7 cm, width at handles 25.9 cm
Published: Erdberg 1978, no. 34; So 1995, no. 8
The Art Museum, Princeton University, Museum Purchase
from the C. D. Carter Collection, by subscription, 65.72

This vessel is part of the long tradition of ritual tripods
made since the Shang period (see no. 4). The angular
interlocking dragon designs are, however, Eastern Zhou
developments, commonly found on vessels associated
with Chinese burials in the Shanxi-Henan regions.[1]

Particularly noteworthy are the felines filling the flat
faces of the L-shaped lugs on the lid. Closely linked with
those inlaid in copper on the stemmed food container
(no. 23) and the tigers forming belt hooks (nos. 94, 95),
they signal an infiltration of non-Chinese motifs into
bronze workshops in China's heartland. The addition of
a popular foreign motif on an otherwise Chinese shape
with conventional Chinese decoration indicates that its
intended owner favored northern novelties.
—JFS

1. For a detailed discussion of the stylistic characteristic and
provenance of this vessel, see So 1995, entry no. 8.

25 Two deer-shaped pendants

Jade (nephrite)
Height x width: (a) 4 x 8.5 cm, (b) 5.4 x 2.6 cm
North-central China
10th century B.C.
Published: (b) Rawson 1987, fig. 23; Francfort et al. 1990,
fig. 10
Arthur M. Sackler Gallery, Gift of Arthur M. Sackler: (a)
s1987.872, (b) s1987.873

Two jade ornamental pendants are shaped in the form of
deer with head regardant, one recumbent and the other
standing. Both display multibranched antlers and
smoothly polished surfaces. On the recumbent deer,
made from a pale green jade, a drilled hole for its eye also
serves for suspension. The standing deer, made of an
olive brown jade, has almond-shaped eyes executed as
thin incised lines, with an additional small hole at the
base of the antlers for suspension. Both depict the animal
simply and realistically, without the elaborate surface
decoration usually applied to jade ornaments.

Many deer-shaped jade pendants, both standing and
recumbent, have been recovered in a large tenth-century
tomb at Rujiazhuang, Baoji Xian, in Shaanxi Province,
providing a secure temporal and archaeological context
for these examples.[1] The recumbent deer sits with both
legs forward, unlike the typical northern pose in which
the front legs are folded back (compare fig. 29; nos. 9,
35, 83). This pose relates the pendant to other early por-
trayals of animals, such as the bronze felines (nos. 26, 31)
and carved bone ornaments (no. 29). It is this pose that
was adopted by the northerners who made the later
feline ornaments of nos. 26, 28, and 34.

The image of a deer with fancy antlers is closely asso-
ciated with the peoples of the Eurasian steppes, where
some of the most outstanding examples have occurred.[2]

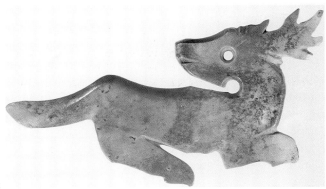

a

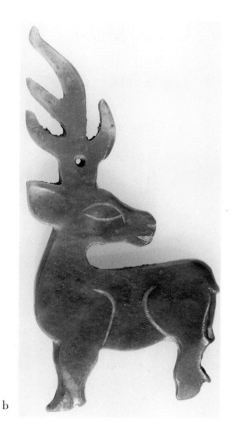

b

Among China's frontier finds, an ornamental jade head of a deer was recovered with late-second-millennium B.C. artifacts at Jieqi, Lingshi Xian, in northern Shanxi Province.[3] This jade deer-head ornament is worked in the round, its head showing almond-shaped eyes and upright antlers similar to those on the present standing deer.

The deer's early appearance in China's northwestern borders is an additional indication of these tribes' early infiltration into northwestern China and their influence on China's ruling house, the Zhou, who originally lived among them in that region. Their subsequent popularity among China's northern tribes is evidenced by stag ornaments such as no. 83 and figure 29.
—JFS

1. Beijing 1988, pp. 342–43, figs. 236–37, plates 183–84. A bronze standing deer was also recovered with a cache from Baoji Xian, Shaanxi Province. *Kaogu yu wenwu* 1990.4, inside front cover, no. 4.

2. See Loehr 1955 for a detailed study of the image throughout Eurasia.

3. *Wenwu* 1986.11, p. 16, figs. 40.1, 41.1. The finds at Jieqi, Lingshi Xian, are also discussed in chapter 2.

26 *Tiger ornament*

Cast bronze
Width 6 cm, height 2.7 cm
Northwest China
9th or 8th century B.C.
The Therese and Erwin Harris Collection

A small crouching tiger with a long drooping tail forms this ornament. Two large spirals mark its fore and hind haunches, vertical rows of scallops suggest its striped pelt, and comma-shapes indicate its claws. Its ear is an inverted heart-shape. A straight bar on its slightly concave underside acts as an attachment loop. Fabric impressions remain on the thick surface incrustation near the tiger's front and back haunches.

Three tiger-shaped ornaments, two of which are virtually identical to the present example, were recovered with late Western Zhou bronzes from a burial in Yucun, Ning Xian, Gansu Province[1] (cat. fig. 26.1). The remains of fabric impressions on this example suggest that such ornaments might have been sewn on articles of clothing. They are closely related to similar ornamental plaques in jade excavated from Western Zhou tombs in the same region (see fig. 12).

The crouching feline continues to appear in later Chinese bronzes,[2] and it was particularly popular among the northern tribes (see nos. 23, 27, 28, 31, 34; fig. 18). In West Asia, the crouching feline is represented on seventh- and sixth-century B.C. Scythian ornaments such as a gold plaque from Kelermes or gold ornaments from Ziwiye.[3] The similarities between the Harris and Gansu felines and the Scythian ones are striking: the pose, the drooping tail, and, above all, the inverted heart-shaped

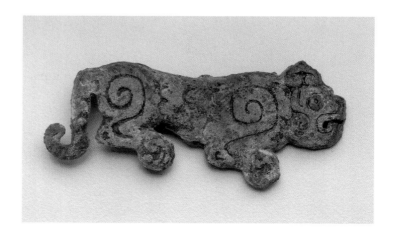

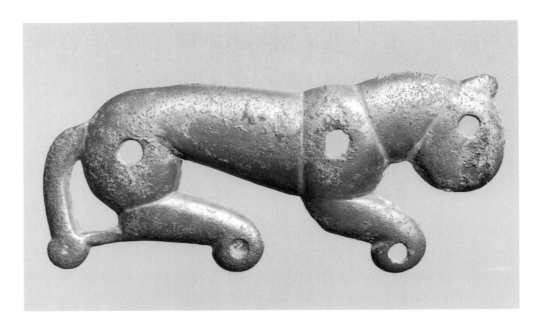

ear. Distinctly different, however, is the position of the head—the Chinese felines (nos. 23, 26, 31) look straight ahead, while the Scythian and northern felines look down (nos. 27, 28, 34). The excavation of Chinese ornaments like the present example from a ninth- to eighth-century context raises intriguing questions on the movement and traffic of artistic motifs between the eastern and western edges of the Eurasian steppes.
—JFS

1. The find is reported in *Kaogu* 1985.4, pp. 349–52, plate 5.1. A larger tiger-shaped ornament was also recovered from the same tomb (plate 5.3). The bronze dagger from this tomb is discussed in entry no. 43.

2. For a good example, see felines on the foot of bronze *hu* from Xinzheng Xian, Henan Province. So 1995, introduction, fig. 19.

3. Bunker et al. 1970, p. 27, fig. 7, nos. 16–17.

CAT. FIG. 26.1. Rubbings of tiger ornaments from Yucun, Ning Xian, Gansu Province, 9th–8th century B.C. Length x height: (a) 6.2 x 2.5, front view, (b) back view, (c) 6.7 x 2.6 cm. After *Kaogu* 1985.4, p. 350, fig. 3.4–6

27 *Pectoral*

Cast bronze
Width 9.4 cm
Northeast China, northern Hebei Province
6th–5th century B.C.
Leon Levy and Shelby White Collection

This crouching leopard plaque originally indicated the clan and rank of the northeastern chieftain who wore it high on his chest. An identical example was recently excavated at Luanping Xian, and a similar example without the pierced circles was excavated at Longhua Xian in northern Hebei Province; both remain unpublished. Officials at the regional museum in Luanping informed me that both pieces were found on the chest just under the chin of a dead male.

Status in the local tribal groups was indicated by the choice of metal. A superior chief was provided with gold leopard-shaped plaques (fig. 18), several of which have been discovered also in northern Hebei Province,[1] while minor chiefs were apparently distinguished only by bronze examples. This pectoral is typical of status symbols belonging to the northeastern tribes.

The back of this plaque has two attachment bars that extend from the top rim to the bottom: one behind the leopard's neck and another just in front of the haunches. Mold marks around the edge suggest that the wax casting model was formed in a two-piece mold.

Pierced circles that mark the eye, shoulder, and

...

...

haunch of the leopard reflect the use of inlay on plaques cast in gold. Similar gold plaques in the shape of leopards display turquoise inlays in such circular pierced cells,[2] but, to date, no bronze examples have been found with turquoise inlays.

—ECB

1. Beijing 1980b, no. 170.
2. Ibid.

28 *Ornamental plaque*

Tinned cast bronze
Width 7 cm, height 3.5 cm
Northwest China
5th century B.C.
The Calon da Collection

This tinned bronze plaque is cast in the shape of a standing leopard whose pelt is indicated by striated circles described in sunken line relief. The leopard is portrayed in profile, with only two legs shown. The pendant tail is marked by indented diagonal lines, and the ear is described by a spiral that begins at the inside. The leopard's fierceness is convincingly expressed by open jaws revealing pointed teeth and fangs, and two paws each display four prominent claws. The front of the plaque has a silvery-looking surface achieved by a deliberate wiping with molten tin, which has worn off in places. The plaque has a smooth concave back with a small vertical attachment loop in the middle. It may have been cast by lost wax.

Similar indented striated circles mark the pelts of two crouching leopards represented on a fitting of a type that has been found in Xietuncun, Ansai Xian, in northern Shaanxi Province.[1] These fittings can be associated stylistically with bronzes cast at Houma in southern Shanxi, where the Jin state foundry was located during the late Spring and Autumn period.[2] The association with Houma is further confirmed by the presence of similar striated circles on a typical Jin state animal-shaped vessel.[3] Similar circles also occur on the body of the leopard that surmounts a zither tuning key in the Freer Gallery of Art,[4] further evidence for either the existence of zithers in the state of Jin or that Jin was manufacturing objects for markets as far away as Chu, where zithers were common (see entry no. 70).

This leopard is a combination of northern and Chinese characteristics. In some ways, it is similar to two tiger plaques excavated from a late Western Zhou burial at Yucun, Ning Xian, Gansu Province, and a near identical tiger ornament[5] (no. 26). They share the same kind of single vertical loop in the middle of the back. On the other hand, the emphasis on sharp fangs and claws on the present plaque is a northern characteristic that derives ultimately from the wood-carving traditions of southern Siberia, exemplified by the tigers carved on the side of the sixth-century B.C. wooden coffin from Bashadar in the Altai Mountains.[6] The spiral that describes the present leopard's ear runs in the same direction as the spiral indicating the Bashadar tiger's ear, while the ear of the very similar tiger (no. 26) is heart-shaped.

—ECB

1. *Wenbo* 1989.4, plate 4.1; Beijing 1992, no. 112.
2. For a discussion of these fittings, see Rawson and Bunker 1990, no. 229.
3. *Orientations,* November 1994, p. 11; see also *Wenwu* 1995.2, p. 46, fig. 16.
4. Lawton 1982, no. 13.
5. *Kaogu* 1985.4, p. 350, fig. 3.4–6, plate 5.1.
6. Jettmar 1967, p. 116, fig. 98.

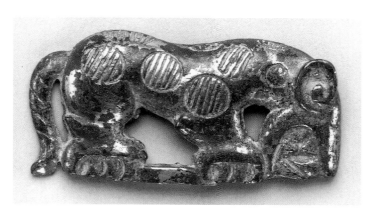

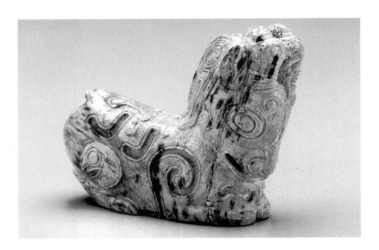

29 *Recumbent animal ornament*

Carved bone
Width 6.2 cm, height 4.8 cm
North China
8th century B.C.
The Therese and Erwin Harris Collection

The pose of this recumbent animal, cleverly shaped to reflect, perhaps, the natural branching at the base of an antler, is strikingly reminiscent of the bull that adorns the columns at the Persian ruins in Persepolis. However, the present animal sits with both legs pointing forward, a pose that is more typical of Chinese recumbent animals from the early centuries of the first millennium B.C. (see nos. 25, 26, 31). The limbs appear to be clawed, not hoofed. Its large head shows inward-spiraling ears (compare nos. 28, 30), large oval eyes raised in low relief and bordered by fine raised lines culminating as two large addorsed bird-heads above the muzzle, and upright horns that also end in bird-heads. Bird-heads also decorate the spiral-accented hind haunch as well as the mane-like cascade behind the head.

Spirals and other geometric motifs decorate the rest of the body, bordered by thin raised lines and filled with fine meander patterns. The flat underside, with two small depressions, is stained by cuprite and malachite incrustations, probably from contact with a bronze hairpin or similar ornament that it once surmounted.

Fragile material such as bone seldom survives intact. Only fragments remain of carved bone ornaments, closely similar in style and execution to the present animal, from a tomb of a noblewoman of the Wei state, excavated in the early 1930s in Xincun, Xun Xian, northeast Henan Province[1] (cat. fig. 29.1). This tomb contained other bone ornaments, including a curved ornament decorated by a parade of animals in the round[2] (cat. fig. 29.2), reminiscent of the bronze awl in Stockholm (fig. 28). Animals in queue occur mainly on northern artifacts,[3] suggesting that the buried woman was either of northern origin or had northern tastes.

In the context of the Xincun finds, the present animal ornament becomes particularly meaningful. Motifs terminating in bird-heads, as they appear abundantly on the present animal, are typical of northern artifacts dating from the later first millennium B.C. (see nos. 50, 56, 60, 63; figs. 20, 21, 29). If bird-head terminations are closely identified with the Rouzhi (see chap. 4), the motif's appearance on this eighth-century B.C. bone ornament suggests that tribes ethnically or culturally related to the Rouzhi were at China's northwestern borders much earlier than most evidence suggests. Furthermore, the unmistakable Chinese workmanship on this carving (closely comparable to decorated jades from the period) and the legs-forward pose imply that Chinese artisans were already manufacturing luxury objects for non-Chinese consumption well before large-scale enterprises developed during the late first millennium B.C.
—JFS

1. The severely looted tombs at this site are published in Guo Baojun 1964; tomb 5, where the bone fragments were found, is discussed on p. 18.

2. For other examples, see ibid., plates 54.2, 54.6.

3. For a late second millennium B.C. example, see the bronze ladle from Qingjian Xian in northern Shaanxi Province. Beijing 1979, no. 78.

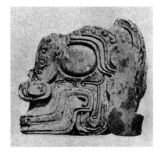

CAT. FIG. 29.1. Fragment of bone ornament from tomb 5 at Xincun, Xun Xian, Henan Province, 9th–8th century B.C. Width 5.7 cm, height 7.3 cm. After Guo Baojun 1964, plate 54.5

CAT. FIG. 29.2. Bone ornament from tomb 5 at Xincun, Xun Xian, Henan Province, 9th–8th century B.C. Length not specified. After Guo Baojun 1964, plate 54.1

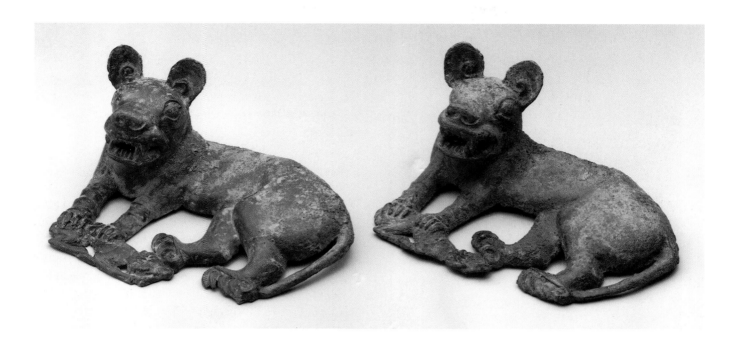

30 *Two harness ornaments*

Cast bronze
Height 13.8 cm (each)
Northwest China
5th–4th century B.C.
Leon Levy and Shelby White Collection

These two harness ornaments are each cast in the shape of a carnivore clutching a fallen ram in its paws. Each exhibits an odd combination of feline and canine features, making a specific identification difficult. Each displays all four legs, with five prominent claws on each paw: four semicircular front claws and one semicircular dewclaw curved in the opposite direction. The jaws are open wide, revealing fangs and teeth represented by half-circles. A spiral that describes each rounded ear runs from the inside base to the ear's outside base.

The ornament backs are concave, and the heads are hollow. Two vertical attachment loops are provided for each ornament: one behind the haunches and the other close to the edge of the ornament behind the head. The position of the loops and the orientation of the animals suggest that these objects may have originally been breast-strap ornaments for a horse's harness.

These powerful carnivore figures derive from earlier southern Siberian artistic traditions, exemplified by the fifth-century B.C. carved wooden tigers on harness ornaments from Tuekta in the Altai Mountains of southern

Siberia.[1] Breast-strap ornaments from later southern Siberian sites, such as Pazyryk, have similar shapes.[2]

Two tiger-shaped gold ornaments that may have been harness decorations were found in a disturbed grave at Nalin'gaotu, Shenmu Xian, in northern Shaanxi Province (cat. fig. 30.1). Comparison with the gold examples leaves no doubt that these ornaments, are to be worn vertically and not horizontally. Two more ornaments in the Nelson-Atkins Gallery in Kansas City, which must also be harness ornaments, are quite similar in shape to the present ornaments.[3]

However, the way in which the present animals are portrayed, with the body in profile and the head in the round with a full-face view, occurs on a small plaque excavated from a Western Zhou tomb at Huangdui, Fufeng Xian, Shaanxi Province,[4] suggesting that these ornaments can also be associated with the herding tribes that inhabited the frontier areas of northwest China.

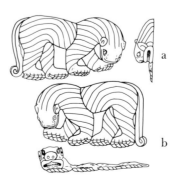

CAT. FIG. 30.1. Drawings of tiger-shaped gold ornaments from Nalin'gaotu, Shenmu Xian, Shaanxi Province, late 4th century B.C. Height x width: (a) 12 x 5.6 cm, (b) 12.2 x 5.7 cm. After *Wenwu* 1983.12, p. 24, fig. 2.4–5

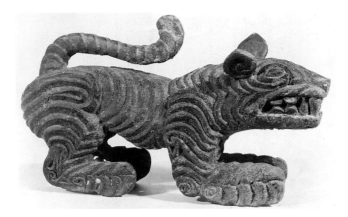

CAT. FIG. 30.2. Bronze tiger yoke ornament, 5th century B.C. Height 14 cm, length 22.8 cm. Grenville L. Winthrop Bequest, Sackler Museum, Harvard University Art Museums, 1943.52.98

Furthermore, the tiny ram victims resemble closely the recumbent rams on the rim of the gold crown found at Aluchaideng in the Ordos Desert.[5] The rams' forelegs are shown pointing forward rather than folded under the body on both the present plaques and on the Aluchaideng crown.

A striking similarity also appears between the present ornaments and a standing tiger yoke ornament from the Winthrop Bequest in the Sackler Museum, Harvard University Art Museums (cat. fig. 30.2). The direction of the ear spiral, the rounded teeth, and the multiclawed paws are the same on all three animals. Moreover, representing the claws as a pattern in which the front claws curve one way and the dewclaw curves the opposite way is a Chinese convention.[6]
—ECB

1. Piotrovskij 1987, nos. 121–22.

2. Rudenko 1970, plate 89.

3. Bunker et al. 1970, no. 84.

4. *Wenwu* 1986.8, p. 63, fig. 30.

5. Tian and Guo 1986, colorplate 1.

6. Beijing 1992a, p. 145.

31 *Two feline yoke ornaments*

Tinned cast bronze
Length x width x height: (a) 8.5 x 3.3 x 4.5 cm, (b) 8.4 x 3.5 x 4.4 cm
Northwest China or southwest Inner Mongolia
6th or 5th century B.C.
Reproduced in color: plate 7, p. 44
(a) The Therese and Erwin Harris Collection, (b) The Calon da Collection

These two matching crouching felines may have once belonged to a larger set of four or more chariot ornaments (see entry nos. 9 and 32). They have hollow U-shaped cross-sections so that they can be fitted easily over the wooden draft pole of the yoke or comparable part of a wheeled vehicle.

In many ways, these two felines closely resemble the leopard on the ornamental plaque (no. 28). Physically, the animals express a similar brutish quality with their large heads and incised, almond-shaped eyes, bared rows of sharp teeth, inward-spiraling ears, oversized paws and claws, and a thick, diagonally scored tail. Like no. 29, these felines are also seen with their front and hind legs pointing forward. The spirals on the two felines' bodies indicate that tigers (like no. 26, with striped pelts) are not intended; instead they suggest the spots of a leopard (no. 28). Technically, they are enhanced in the same way—by tinning. A noteworthy difference, however, is the orientation of the head: these two felines look forward (see no. 26), unlike the leopard (no. 28), which looks down.

The non-Chinese origin of such yoke ornaments, their relatively early appearance in western China (see entry no. 9), and the felines' resemblance to woodcarvings from sixth-century B.C. nomadic burials at

a b

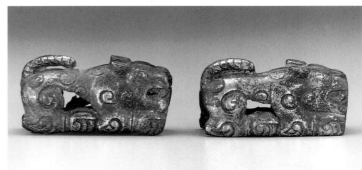

Bashadar in the Altai Mountains of south Russia (see entry no. 28) affirm the important role of western and northwest China in long-range and long-term exchange in custom, art, and technology between China and non-Chinese tribes. Predynastic Qin's special role in this exchange is illustrated by the recovery of a set of four hare-shaped yoke ornaments from a seventh-century B.C. Qin tomb in Long Xian, Shaanxi Province, among the earliest set of its kind found in a Chinese context.[1]
—JFS

1. *Wenwu* 1988.11, plate 3.5.

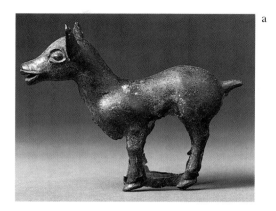

a

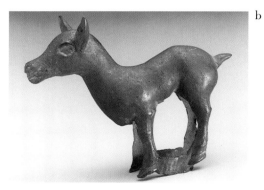

b

32 *Set of four chariot yoke ornaments*

Cast bronze
Width x height: (a) 11.3 x 9.5 cm, (b) 11.6 x 9.6 cm, (c, d) 11.4 x 9.6 cm (each)
Northwest China and Western Inner Mongolia
5th–4th century B.C.
Published: (a) Bunker 1981, no. 778, (c, d) Hearn 1987, nos. 81–82
(a) Los Angeles County Museum of Art, Gift of the Ahmanson Foundation, M.76.97.662, formerly Heeramaneck Collection, (b) The Calon da Collection, formerly Plummer Collection, (c, d) Metropolitan Museum of Art, Gift of Ernest Erickson Foundation, Inc., 85.214.88–89

These four standing does originally belonged to the same set of chariot yoke decorations and have been reunited here after years apart. They all once belonged to the noted dealer, Nasli Heeramaneck, who sold two to Ernest Erickson, one to James Marshall Plummer, and retained the fourth for himself. They were bought together but sold separately because their function as a set was not recognized years ago. Two more standing does once in the Von der Heydt Collection may also have been part of the original set.[1] Possessing only one of a set of ornaments is like reading only one verse of a poem: the original impact of many deer is lost.

Like the ram yoke ornaments (no. 9), the deer ornaments were hollow cast so they could fit over a wooden

c, d

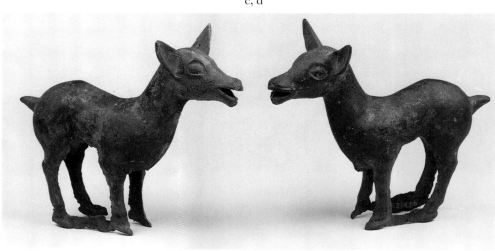

yoke. These four does were cast in simple two-piece molds that must not have fit together snugly, because the mold joint marks are too prominent. Several of these standing doe figures still retain the clay casting core along with remnants of some unidentified red substance around the face.

Similar standing animals once adorning the yokes of chariots used in funeral rituals were excavated at Sujigou, Jungar Qi, western Inner Mongolia.[2] Several similar ornaments were also found in conjunction with the remains of a wheeled vehicle at the site of Yulongtai, Jungar Qi, in western Inner Mongolia.[3]

—ECB

1. Griessmaier 1936, no. 109, whereabouts unknown.

2. *Wenwu* 1965.2, pp. 44–46, plate 6.

3. *Kaogu* 1977.2, pp. 111–14.

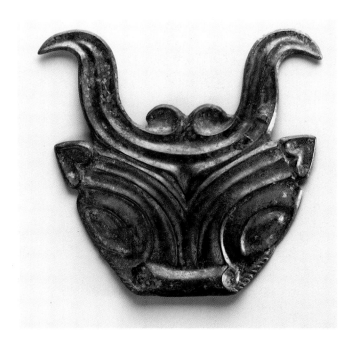

33 *Harness ornament*

Cast bronze
Width 21.2 cm, height 20.3 cm
Northwest China
6th century B.C.
Reproduced in color: plate 8, p. 45
The Therese and Erwin Harris Collection

This spectacular harness ornament once adorned the forehead of a horse. It has been cast in the shape of a bovine mask with large almond-shaped eyes, tiny heart-shaped ears, and a broad nose with nostrils indicated by spirals. The surface is distinguished by deeply grooved curved bands that follow the contours of the face and horns. Two heavy horizontal loops are placed side-by-side in the middle of the reverse for attachment purposes. The harness ornament is made of a high-lead bronze and was cast in a mold made from a wood or clay model. Close examination has revealed the presence of horsehair pseudomorphs on the reverse.

No similar ornaments have been excavated, but several artifacts found at sites belonging to herding tribes in the Ordos Desert region during the late fourth century B.C. are stylistically related. One silver tiger ornament from Nalin'gaotu, Shenmu Xian, Shaanxi Province,[1] and two gold belt plaques from Aluchaideng, Hangjin Qi, western Inner Mongolia,[2] display the same distinctive grooved bands. The same grooved bands also mark the pelt of the tiger in cat. fig. 30.2. By contrast, the tiny heart-shaped ears are typically Chinese and occur on many Western and Eastern Zhou artifacts, such as the bronze tiger (no. 26) and a jade tiger from Baoji Xian in Shaanxi Province (fig. 12), but the tiny ear on a Liyu-style bird-shaped vessel *(zun)* in the Freer Gallery of Art[3] and the ear on a small bovine-head from Fenshuiling, Changzhi Xian, Shanxi Province,[4] are the closest match to the present ornament's ear. An even more tantalizing comparison is provided by the similar grooved fluting on a *hu* related stylistically to vessels cast at Houma in southern Shanxi Province.[5] These strong similarities to styles found in the northwest suggest that the present ornament was made at some northwestern Chinese metalworking center during the first half of the Eastern Zhou period.

—ECB

1. *Wenwu* 1984.12, plate 5.5.

2. Tian and Guo 1986, colorplate 5.

3. Lawton 1982, no. 3.

4. *Kaogu xuebao* 1974.2, plate 5.3.

5. *Oriental Art* 38, no. 4 (Winter 1992–93): 227, fig. 7.

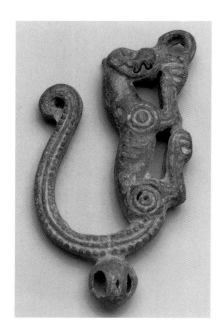

34 Harness fitting

Cast bronze
Height 9.5 cm, width 6 cm
Northeast China
6th–5th century B.C.
Published: Cheng Tê-K'un 1963, plate 37a
The Calon da Collection, formerly Lord Cunliffe Collection

This harness ornament is cast in the shape of a crouching tiger with bared, jagged teeth and a long, gracefully curved tail from which a bell projects. Indented concentric circles mark the shoulder and haunches, and two rows of pseudobeading mark the tail longitudinally.

A similar, but slightly earlier harness jingle was recovered from an Upper Xiajiadian burial at Xiaoheishigou in Ningcheng Xian, southeast Inner Mongolia Autonomous Region, with other horse and chariot fittings.[1] The open jaws and jagged teeth seen on the present tiger occur also on Upper Xiajiadian objects, such as the tigers that form the handle of a dagger found at Nanshan'gen, Ningcheng Xian.[2]

A harness jingle of this type was also discovered in a bronze cauldron in the Irkutsk region of southern Siberia,[3] evidence for long-distance contact between the non-Chinese tribes in the northeast and tribes living to the north in southern Siberia. Further evidence for contact between these two areas is provided by another jingle found with scrap metal by workers in a Beijing factory.[4] This jingle is tantalizingly close in shape and style to the Irkutsk example. Another jingle, once in the David-Weill Collection, is stylistically related to the present jingle but shows a similar carnivore attacking a small animal that may be a rabbit.[5]
—ECB

1. *Wenwu ziliao congkan,* no. 9 (1985): 56, fig. 59.
2. Tokyo 1983, no. 16.
3. *Sovetskaya Arkheologiya* 1991.2, p. 199, fig. 6.
4. *Wenwu* 1982.9, p. 31, fig. 25.
5. Janse 1935, plate 9.35.

35 Two harness ornaments

Cast bronze
Width 6.4 cm, height 5.5 cm (each)
Northeast China
5th–4th century B.C.
The Calon da Collection

These two mirror-image plaques are each cast in the shape of a sensitively portrayed gazelle. Each gazelle is shown in profile in such a way that the back legs overlap the forelegs. The hooves point forward and backwards, rather than up and down, with their soles parallel to a hypothetical ground line, as ungulates are depicted on ornaments cast in northwest China (compare no. 9). The almond-shaped eyes are indicated by intaglio lines. Four attachment loops, vertical ones at both top and bottom and horizontal ones on either end (see detail), suggest that they are harness ornaments.

A garment hook excavated at Wudaohezi, Lingyuan Xian, Liaoning Province,[1] and a plaque from Jilin Province[2] are each in the shape of a gazelle with S-

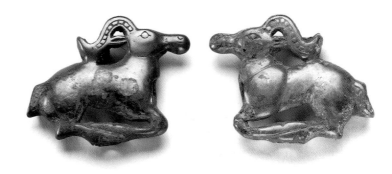

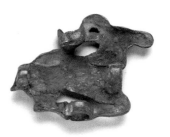

Detail, no. 35, showing back of one ornament with positions of loops

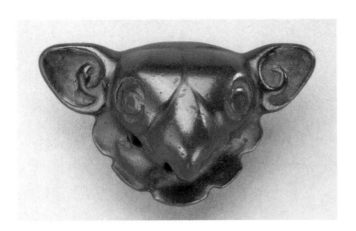

shaped curved horns and folded legs very similar to the present animals. This pose is characteristic of ungulate images on artifacts belonging to the hunting tribes of northeast China and is distantly related to early ungulate images found in southern Siberia and western Eurasia,[3] but not to those found in northwest China.

—ECB

1. *Wenwu* 1989.2, p. 56, fig. 8.12.
2. Nelson 1995, p. 210, fig. 7.2.
3. Tchlenova 1963, pp. 66–67, tables 1–2.

36 *Ornament*

Cast bronze
Width 4.5 cm, height 2.8 cm
Northwest China
4th–3d century B.C.
Published: Salmony 1933, plate 11.22
The Therese and Erwin Harris Collection, formerly
 C. T. Loo Collection

A raptor-head shown frontally forms this small bronze ornament. The raptor has large ears, each indicated by an elongated spiral that begins at the lower inside of the ear, similar in shape to the raptor ears on a small silver cup (no. 73). The bird's beak is short and hooked. The broadness of the bird's head and the scalloped ruff suggest it is an owl; some owls have feathery tufts that could be misconstrued as ears. The soft appearance of the interior of the hollow back of the ornament suggests it was cast by the lost-wax process. A vertical loop in the center of the back provides a means of attachment.

Although the presence of ears relates the raptor image here to that of the mythological griffin, the eyes are round bird's eyes and not the almond-shaped animal eyes usually associated with a griffin-head. The use of the term "griffin" in connection with the art of the northern zone is somewhat questionable. The griffin—a mythological

creature with a bird's beak, long ears, and animal-shaped eyes—belongs to the fantastic fauna represented in ancient West Asian and Greek art.[1] Griffins may have been introduced into Scythian art in the northwest when the Greeks began to produce luxury goods for Scythian tribes, but, by the time these images appeared at the eastern end of the Eurasian steppes, they were no longer related to Greek images and should not be called griffins lest the very use of the term be taken to imply Greek influence where it does not exist.

Several similar raptor-head plaques are found among the small bronzes associated with the northern zone in many collections,[2] but, to date, none have been found in an archaeological context.

—ECB

1. Mayor 1994, pp. 52–58.
2. Salmony 1933, plate 11.22.

37 *Chariot finial*

Cast bronze
Height 6.6 cm, width 5.4 cm
Northwest China or Inner Mongolia
5th–4th century B.C.
Published: Bunker 1981, no. 775
Los Angeles County Museum of Art, Gift of the Ahmanson
 Foundation, M.76.97.572, formerly Heeramaneck Collection

A very animated gazelle with its feet gathered together surmounts the top of a finial with pendant attachment tangs. The gazelle is hollow cast in a two-piece mold, as indicated by a mold joint mark that bisects the body.

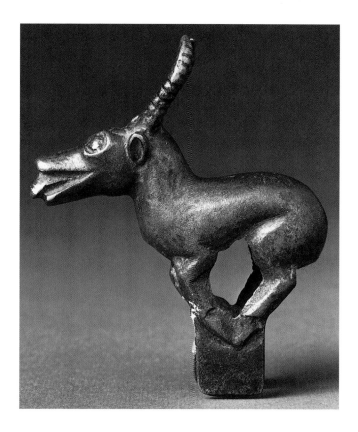

Gazelles abound in the grasslands of northwest China according to the records of numerous explorers. This animal was identified by Alfred Salmony as a Saiga antelope,[1] but the characteristic Saiga swollen muzzle is lacking, suggesting that it is a gazelle instead.

Similar finials, traditionally referred to as poletops, occur at numerous sites belonging to the herding tribes on China's northwestern frontiers[2] and were originally cast in sets of four or more. Such finials surmounted by ungulates adorned wheeled vehicles that were used in funeral processions to transport the body to the grave, a practice also known in the West among the Scythian tribes[3] and at Arzhan in Tuva, southern Siberia,[4] to decorate a funerary canopy.
—ECB

1. Salmony 1933, plate 7.4, p. 34.

2. For excavated examples, see *Kaogu* 1977.2, plates 2–3; *Kaogu yu wenwu* 1981.4, plate 5.

3. *Sovetskaya Arkheologiya* 1988.2, p. 163, fig. 8.

4. Griaznov 1984, plate 25.

38 *Finial*

Cast bronze
Height 7.5 cm, width 5.2 cm
Northwest China
5th–4th century B.C.
The Therese and Erwin Harris Collection

This small finial is cast in the shape of a raptor-head with a round neck that turns into a circular socket. The piece is hollow cast with a hole in the side of the finial by which it is secured to a piece of wood. The bird has a round eye, indicated by indented lines, and a small, hooked beak.

Similar finials occur at several sites in far northwest China, such as Guyuan Xian[1] and at Langwozikeng, Zhongwei, both in the Ningxia Hui Autonomous Region,[2] and Yushugou, Yongdeng Xian, in Gansu Province.[3] Finials with rapacious bird-heads have not been found in the Ordos Desert or east of the Taihang Mountains. The raptor image was popular among the herding tribes of the Eurasian steppes throughout the first millennium B.C., particularly among the Scythians.[4]
—ECB

1. *Zhongguo kaogu xuehui disici nianhui lunwenji* (1983), pp. 203–13, fig. 3.5–7.

2. *Kaogu* 1989.11, p. 976, fig. 6.4.

3. *Kaogu yu wenwu* 1981.4, plate 5.4.

4. Watson 1971, p. 112.

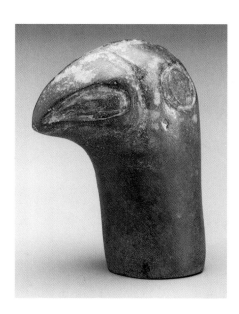

39 Knife

Cast bronze
Length 21.6 cm
Northeast Hebei–Liaoning–southeast Inner Mongolia
8th century B.C.
Published: Takács 1929, plate 2.1; Andersson 1933, plates 1, 3;
 Salmony 1933, plate 16
Metropolitan Museum of Art, Rogers Fund, 24.216.1

This knife differs from late-second-millennium B.C. examples (see nos. 15, 16) in the less-pronounced heel where blade meets handle and in the button-shaped projection at the end of the handle. A realistically rendered human face decorates the top of the projection. A procession of four horned animals executed in thin, raised lines

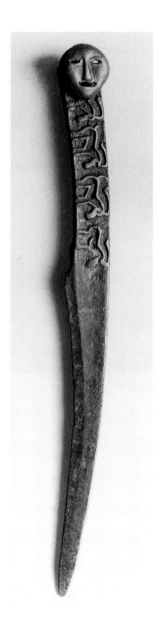

decorates the handle on the side of the face, while a zigzag pattern fills the other side of the handle.

Recent excavations of non-Chinese burials in the hilly terrain of northeast Hebei and Liaoning Provinces, extending into neighboring southeast Inner Mongolia Autonomous Region, have yielded numerous bronze knives, weapons, and tools to support a similar cultural and chronological context for the present knife. Listed below are a few of the more telling excavated examples[1] for comparison:

1. a bronze dagger with hilt rendered as standing human figures, from Nanshan'gen, Ningcheng Xian, southeast Inner Mongolia[2]
2. bronze fittings ornamented with a human face, from Chaoyang Xian, Liaoning Province[3]
3. a bronze awl with a buttonlike top, also rendered as a face, from Xuanhua Xian, Hebei Province[4]
4. a bronze knife showing a similar button-shaped top, also from Nanshan'gen, Ningcheng Xian[5]
5. a bronze dagger decorated with a similar procession of animals (horses?) in thin raised lines, also from Nanshan'gen, Ningcheng Xian.[6]

—JFS

1. Similar unprovenanced knives are illustrated in Loehr 1951, nos. 33–38.
2. Inner Mongolia 1987, no. 14.
3. *Kaogu xuebao* 1960.1, p. 67, fig. 4.2.
4. *Wenwu* 1987.5, p. 48, fig. 15.1.
5. *Kaogu xuebao* 1973.2, plate 9.7.
6. *Kaogu xuebao* 1973.2, p. 33, fig. 5.5.

40 Knife

Cast bronze
Length 25 cm
Northeast China–southeast Inner Mongolia
8th or 7th century B.C.
Published: Miami 1978, no. 29
The Therese and Erwin Harris Collection

Sturdier than the previous example (no. 39), this knife has a more elaborate handle decorated with regularly intertwining serpentine bodies executed in openwork. In spite of the more complex decoration, both handle and blade appear to be cast integrally, like all other northern

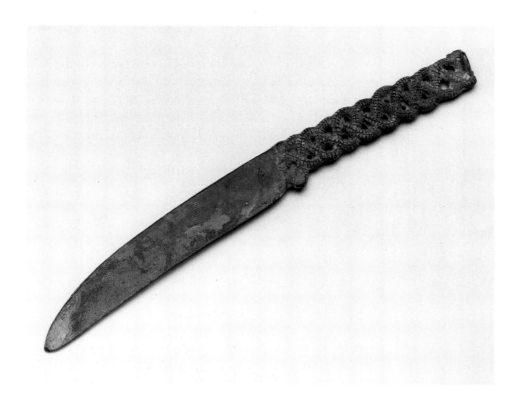

knives (see nos. 15, 16, 39), using a two-piece mold divided along the edge of the knife. A thin, raised line marks the median of the serpentine bodies, with short, straight scoring running at right angles to it. The serpents' heads are only cursorily described. A small loop, perhaps for suspension, is located at the top.

A knife with similar intertwined openwork design was recovered from one of the large tombs at Nanshan'gen, Ningcheng Xian, southeast Inner Mongolia.[1] The Nanshan'gen knife is topped by a mushroom cap (typically found on early-first-millennium B.C. knives and daggers) and shows the slim silhouette of the previous knife (no. 39). Symmetrically interwoven openwork designs also form hilts for several daggers (to date unpublished) recovered from non-Chinese graves at Jundushan, Yanqing Xian, north of Beijing. Simpler serpentine configurations occur on bronze fittings recovered from the Ningcheng area.[2] It is likely that the present knife originates from a similar cultural and chronological context.

—JFS

1. *Kaogu xuebao* 1973.2, plate 9.5.

2. For example, see *Wenwu ziliao congkan* 9 (1985): 31, fig. 14.8.

41 *Scabbard ornament*

Cast bronze
Length 19.3 cm, maximum width 10.2 cm
Northwest China
10th century B.C.
Reproduced in color: plate 9, p. 48
Published: New York 1970, no. 31
The Therese and Erwin Harris Collection, formerly John D. Rockefeller 3d Collection

A slender, tapering U-shape forms the underlying frame of this scabbard ornament. Over the frame lies an elegant openwork system of interlacing tendril-like ribbons that spill over the edge of the frame on the upper half, terminating in budlike, floral formations. A human figure seen sideways kneels at each of the top corners, hand resting on the knees (see detail). Their oversized heads rise above the top edge of the ornament, clearly isolated from the flowing interlacery below. Each head is sculpturally modeled with pronounced features—almond-shaped eyes bordered by raised lines, broad nose, thick lips, unusually large ear—and wavy, shoulder-length hair gathered as if in a bun behind their backs (compare no. 1). Pairs of small holes near the top and at the bottom are used for attachment to a leather or wooden sheath. A

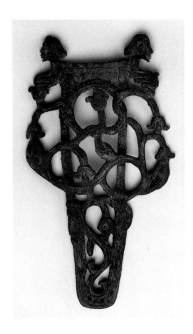

idiom (interlacing tendrils) to adapt it for an essentially Chinese weapon (tanged sword). The Europoid faces of the two figures atop the present ornament are the only other clues to its non-Chinese origins. It is therefore almost inevitable that such scabbard ornaments should appear in far western and northern contexts, where cultural exchange was easiest and most active.

—JFS

1. *Kaogu xuebao* 1977.2, plate 14.3–4, p. 115, fig. 13.1. The scabbards are about 18 centimeters long.

2. Li Xueqin 1985b, no. 169. The second, more severely damaged example is illustrated in *Kaogu* 1974.5, plate 10.3c. These measure 22.8 centimeters long.

3. Beijing 1988, plates 14.1, 119.4.

4. Loehr 1949, pp. 54–55.

5. The independent development of the tanged short sword in China is discussed in Loehr 1948; Loehr 1956, chap. 5.

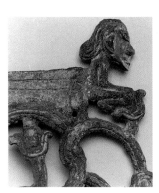

Detail, no. 41, showing kneeling figure at top of ornament

CAT. FIG. 41.1 Bronze scabbard ornament, 10th century B.C. Length 21.3 cm. Freer Gallery of Art, Smithsonian Institution, 16.393

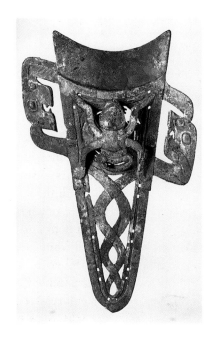

thick, crusty green patina covers much of the surface, including the extensive repairs around the frame.

Recent excavations of early Western Zhou tombs have yielded scabbard ornaments with closely similar designs. Four with nearly identical interlacing tendrils—but topped by buffaloes instead of figures—were excavated with accompanying tanged daggers from two separate tombs in Baicaopo, Lingtai Xian, Gansu Province.[1] Remains of lacquered wood on the backs of the Baicaopo ornaments suggest that the sheath was made of lacquered wood. At least two more virtually identical scabbard ornaments were recovered from contemporaneous burials in the east, at Liulihe, Fangshan Xian, just south of Beijing. One of these shows seated figures at the top corners, but their hair appears closely cropped.[2] Less ornate scabbard ornaments were also recovered from the later Western Zhou burials in Baoji Xian, Shaanxi Province.[3] The Harris, Baicaopo, and Fangshan scabbard ornaments are the few examples known from the early tenth century B.C.

As a type, the decorated sheath appears to have originated in the north.[4] The primary decor motif on a bronze scabbard ornament in the Freer Gallery of Art—a deadly spider hovering over its web (cat. fig. 41.1)—links the type directly to its northern home. It is interesting, therefore, to see such scabbard ornaments used on the sheath for a tanged sword, the early Chinese counterpart of the hilted daggers of the northern zone[5] (see no. 14).

A complex mixing of cultural and artistic traits is embodied in these scabbard ornaments: a non-Chinese article (the ornamented sheath) is decorated in a Chinese

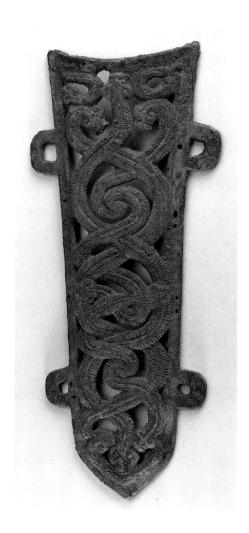

42 *Scabbard ornament*

Cast bronze
Length 23.5 cm, maximum width 9.8 cm
Northeast China or southeast Inner Mongolia
6th–5th century B.C.
Published: La Plante 1958, no. 158; Bunker 1962, no. 10
Anonymous loan

Entwined serpentine motifs executed in openwork fill the space within the tapering trapezoidal outline of this scabbard ornament. Pairs of small holes along the edge serve to attach it to a cloth back, as suggested by the remains of fabric found on the back. Two pairs of U-shaped loops, projecting from the long edges, are decorative features derived from functional elements in the design of its southern Siberian prototypes.[1]

While the medially accented and finely scored bodies of the serpentine creatures are linked to those on the openwork knife (no. 40), their heads show the scrolled

muzzles usually given to Chinese dragons. The workmanship and casting of the present scabbard are also significantly more refined, further suggesting Chinese manufacture.

Most unusual is the irregular and unpredictable way the bodies intertwine, in contrast to the symmetrical interlacery of traditional Chinese designs.[2] A total of nine heads can be counted, but only eight bodies, as the longest, which runs down the center from top to tip, has a head at each end. Each serpentine creature differs from the others in length, and, except for the two shortest ones at the top corners, no two entwine or relate to another in the same way. Workmanship and casting are precise and crisp.

This striking feature of the scabbard's design links it with the scabbard and a matching dagger formerly in the Frederick M. Mayer Collection, New York (cat. fig. 42.1). Although the Mayer scabbard shows dragon-head

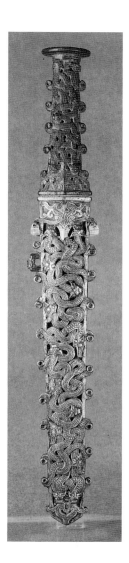

CAT. FIG. 42.1. Bronze dagger and scabbard, 5th century B.C. Total length 33 cm. Formerly Frederick M. Mayer Collection, New York. After Christie's (London) sale catalogue, June 24, 1974, lot 211

creatures seen in profile with bodies distinguished by three different patterns—scaled, scored, and granulated—they also entwine and interweave irregularly and asymmetrically. The serpentine creatures on the hilt of the Mayer dagger intertwine in a similarly unpredictable manner.

The design on the hilt of the Mayer dagger is closely matched by that on daggers[3] recovered in graves together with late-sixth- and early-fifth-century bronzes like nos. 12 and 21 in Pingshan Xian, Hebei Province, where the ancient capital of the Zhongshan state, founded by eastward migrating non-Chinese tribes, was located.[4] These daggers should therefore also date from the early fifth century B.C. at the latest. However, no scabbard ornaments have been reported to have accompanied these daggers.[5]

The Pingshan examples suggest that this scabbard and the Mayer dagger and matching scabbard are likely to have come from similar cultural and chronological contexts. They are outstanding examples of non-Chinese articles with essentially non-Chinese designs manufactured under close supervision of Chinese artisans to the exacting standards of the best Chinese products for demanding non-Chinese patrons.
—JFS

1. See Rubinson 1992. A similarly shaped scabbard but with a different design was reportedly found in Jehol, formerly part of Manchuria. Bunker 1962, p. 15. For a magnificent gold-encrusted example from Bactria, see Sarianidi 1985, no. 4.8, figs. 157–61.

2. Exemplified by products of the sixth- to fifth-century foundries at Houma, Shanxi Province, these are discussed in So 1995, introduction, section 4.2.

3. See *Kaoguxue jikan* 5 (1987): plates 19.7, 22.2, also pp. 177–81, figs. 27.9, 33.2–3.

4. For a discussion of the history and cultural traits of the Zhongshan state, see So 1995, introduction, section 6.2.

5. From an adjoining habitation site came a harness fitting decorated with similar irregularly intertwining serpent-dragons. Ibid., plate 20.4, p. 165, fig. 8.7.

43 *Dagger*

Cast bronze, originally inlaid
Length 27.5 cm
Northwest China
7th or 6th century B.C.
Reproduced in color: plate 10, p. 49
The Therese and Erwin Harris Collection

This short sword with a hollow hilt was cast in one piece using a two-part mold. A pronounced shoulder, accented by a masklike guard with spirals at the sides, separates the ornate hilt from the double-edged blade that is strengthened by a raised midrib. The hilt is composed of a stacked column of dragonlike heads, seen in profile. Each head has a deep round socket for an eye (probably once accented with turquoise or other semiprecious stones), a rolled muzzle, and sometimes a spiral crest. The spirals of the muzzles and crests line the edges of the hilt, punctuating its straight profile with a regular series of spiraling outcroppings. A narrow twisted band marks the largest head at the hilt's top. Similar daggers are in the Baron von der Heydt Collection in Vienna and in the Rietberg Museum, Zurich.[1]

Recent excavations of similar artifacts from western China provide a likely provenance for the present dagger. A dagger with a more irregular version of the hilt design was among the bronzes recovered from the ninth- or eighth-century B.C. burial at Yucun, Ning Xian, Gansu Province (also discussed in entry no. 26). This dagger was apparently buried wrapped in hemp or some similarly coarse fabric.[2] Another, whose hilt closely duplicates the present dagger, came from a seventh-century burial at Baqitun, Fengxiang Xian, in Shaanxi Province, heart of predynastic Qin territory.[3]

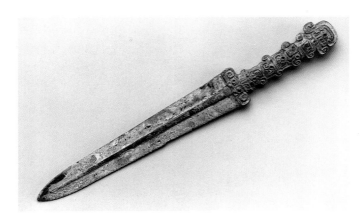

Daggers with rhombic blades, raised midribs, and integrally cast hilts and blades originated among northern tribes.[4] However, daggers with ornate hilts like the present example are probably Chinese products, as the densely packed dragon-heads closely duplicate bronze and jade designs of the same period.[5] These Chinese-made daggers from the seventh century were probably early luxury exports of Qin or neighboring workshops.

Continued trade in ornate daggers, clearly status symbols to their owners, is supported by the excavation of daggers with cast-iron blades and cast-gold hilts, lavishly inlaid with turquoise, from sixth-century Qin tombs in Yimencun, Baoji Xian, Shaanxi Province.[6] These daggers (see also nos. 44, 45) and other bronze artifacts (nos. 22, 24, 31, 50–54, 104) supply ample evidence that predynastic Qin territory was an active trading center serving the Chinese and tribes to the west throughout the first millennium B.C.

—JFS

1. Griessmaier 1936, no. 138; Brinker 1975, no. 75.

2. *Kaogu* 1985.4, plate 5.2, p. 350, fig. 3.1. The dagger is 23.1 centimeters long.

3. *Wenwu ziliao congkan* 3 (1980): 84, fig. 23.2.

4. Loehr 1949, p. 38.

5. For a bronze example, see no. 24; So 1995, introduction, fig. 29; for jade examples, see Loehr 1975, no. 372.

6. Beijing 1993, no. 99. Cruder bronze versions, but still inlaid with turquoise, have also been recovered from other western and northern sites. *Kaogu yu wenwu* 1991.2, p. 9, fig. 5; *Kaogu yu wenwu* 1991.4, p. 7, fig. 10; Beijing 1980a, no. 96. An even later gold dagger hilt is in the collection of the British Museum. So 1995, introduction, fig. 63.

44 *Dagger*

Cast bronze inlaid with turquoise
Length 25.9 cm
Northwest China or southwest Inner Mongolia
7th or 6th century B.C.
The Therese and Erwin Harris Collection

Unlike the previous example (no. 43), the rhombic blade of this dagger is not strengthened by a raised midrib. Its hilt is also less ornate (hence, more practical), as the solid grip is plain and only the openwork pommel and guard are decorated with dragon-heads similar to those on no. 43. Turquoise remains in the circlets that mark the dragon's eyes on the guard. The entire dagger is, however, still cast integrally in a two-piece mold, with mold join seams running down the edges.

A bronze dagger with a similarly designed hilt is in the collection of the Inner Mongolia Museum.[1] A more luxurious version of the hilt design, cast in gold, lavishly inlaid with turquoise, and attached to a cast-iron blade, has been recovered from a sixth-century Qin tomb in Yimencun, Baoji Xian, Shaanxi Province.[2]

—JFS

1. Tian and Guo 1986, plate 31.3, p. 10, fig. 3. The authors note, however, that the dagger was not scientifically excavated.

2. Beijing 1993, no. 99. A second gold-hilt iron dagger from the same tomb is discussed in entry no. 43.

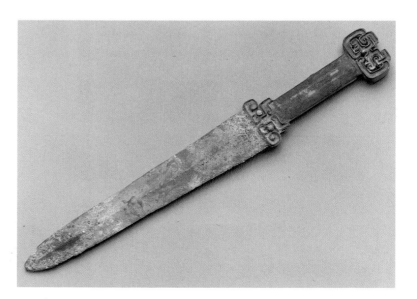

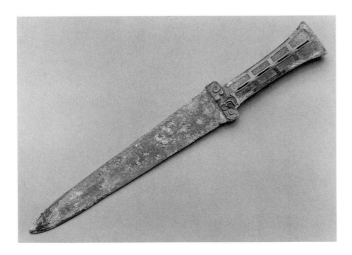

45 *Dagger*

Cast bronze
Length 27.3 cm
Northwest China
7th or 6th century B.C.
The Therese and Erwin Harris Collection

The blade and dragon-head guard on this dagger dupli-
cates that on the previous example (no. 44). Its hilt, how-
ever, is quite different. The grip, a hollow six-sided
prism, flares toward a trumpet-shaped flat top. Eight rec-
tangular panels filled with minute but crudely executed
angular meanders occupy its entire length. Four vertical
slits run down the center and along each edge. Two dag-
gers in the Sawyer Collection duplicate the dragon-head
guards, pommels, and the slit grip on the two daggers
discussed here[1] (nos. 44, 45), reaffirming the stylistic
and temporal relationships among them.

Slit hilts probably served a practical purpose, allowing
silk or fabric to be wrapped through and around them for
improved grip. Evidence for this practice dates back to
the second millennium B.C. (see fig. 11a). The hilt of a
dagger with a cast-iron blade (now largely disintegrated),
excavated from a seventh–sixth-century B.C. tomb in
Jingjiazhuang, Lingtai Xian, Gansu Province, is identical
to the present example.[2] It was apparently also wrapped
in silk.
—JFS

1. Loehr 1949, nos. 29–30.
2. *Kaogu* 1981.4, plate 5.10, p. 299, fig. 2.7. The height of the
hilt and guard alone measures 12.5 centimeters, closely match-
ing the height of the hilt and guard on the present dagger.

46 *Mirror*

Cast bronze
Diameter 10.0 cm
North or northeast China
5th century B.C.
Xiwenguo Zhai Collection

A refined pattern of interlacing dragon bands decorate
the back of this small, thinly cast mirror. The outermost
circumferences are encircled by a band of twisted-rope
pattern followed by a band of cowrie pattern. These pat-
terns appear widely on fifth-century Chinese bronzes
and are especially closely associated with the Jin work-
shops in Houma, Shanxi Province.[1] The most striking
feature, however, is the central loop, here shaped as a
small crouching bear (see detail). Rough green incrusta-
tions cover most of the mirror's surfaces.

The present mirror belongs to a rare and select group
of late-first-millennium B.C. mirrors with animal-shaped
loops. A virtually identical mirror, slightly smaller than
the present example, was recovered from a culturally
mixed site in Pingshan Xian, Hebei Province.[2] Another
nearly identical example, also showing a bear-shaped
loop, is in the collection of the Museum of Far Eastern
Antiquities, Stockholm.[3] A third example, with a hare-
shaped loop and dragons resembling those on the buckle
(no. 53) is in the Mengdiexuan Collection.[4]

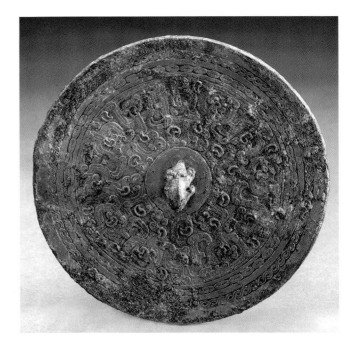

As an object, the bronze mirror appears to have originated with the northern tribes.[5] By the late first millennium B.C., however, it was manufactured in large numbers in Chinese workshops using Chinese methods of production and decoration (see nos. 68, 69). The present mirror is an outstanding example of a creative combination of Chinese and non-Chinese artistic traditions. Typically Chinese decorative patterns are placed on an article of northern origin, while the bear-shaped loop acts as a subtle concession to its intended owner from the north. The Hebei provenance of the excavated counterpart cited above situates these mirrors with bear-shaped loops well within Zhongshan territory, the small state established by nomadic tribes that came to be profoundly Sinicized as subjects of Chinese rule surrounded by an essentially Chinese population.[6]
—JFS

1. For a detailed discussion of the Houma workshop and related bronzes, see So 1995, introduction, sections 4.2, 4.3.

2. *Kaoguxue jikan* 5 (1987): 190, fig. 39.4. This mirror is 8.3 centimeters in diameter.

3. Karlgren 1968, plate 1.A2.

4. White and Bunker 1994, no. 9.

5. See O'Donoghue 1990.

6. For discussion of the Zhongshan state and its bronzes, see So 1995, introduction, section 6.2.

Detail, no. 46, showing bear-shaped loop

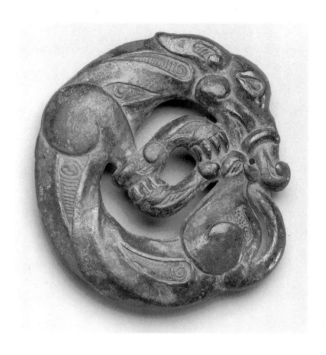

47 *Bridle ornament*

Cast bronze
Height 7.4 cm, width 6.7 cm
Northwest China
5th century B.C.
The Calon da Collection

This bridle ornament is cast in the shape of a wolf shown in profile and turned into a circle. The hind legs and forelegs form a smaller circle within the perimeter of the body. Each paw has only four claws. The ear is described by an elongated spiral that begins at the inner edge. The wolf's body has been slightly fluted and marked with very finely patterned striated enclosures. A large volute marks the shoulder and haunch. The reverse shows three squared attachment loops. The way in which the loops are formed confirms that the ornament was cast by the lost-wax process. Each loop was made by placing a thin, unevenly shaped strip of wax on two projecting round wax posts.

This circular carnivore is not stylistically related to the tiny coiled felines found at earlier sites east of the Taihang Mountains in northern Hebei Province. Instead it derives from coiled wolf images found farther west dating to the fifth century B.C. A bridle ornament in the shape of a coiled wolf (cat. fig. 47.1) discovered in a barrow near Simferopol in the Crimea is startlingly close in concept to the present wolf.

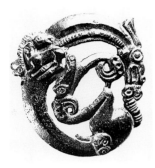

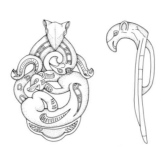

CAT. FIG. 47.1. Bronze bridle ornament, Simferopol, Crimea, late 6th century B.C. Width 10.5 cm. After Artamonov 1969, plate 78

CAT. FIG. 47.2. Drawings of bronze fitting, front and side views, Guyuan Xian, Ningxia Hui Autonomous Region, 5th century B.C. Height 7.1 cm. After *Kaogu* 1992.6, p. 574, fig. 1.11

The present wolf is very similar to the small coiled wolf portrayed on a fitting recently found at Xinyingxiang, in Guyuan Xian of southern Ningxia Hui Autonomous Region[1] (cat. fig. 47.2). The design and concept are steppe and were introduced into the Ningxia grasslands by herding tribes arriving from farther west during the late sixth–fifth century B.C. A smaller and less-sophisticated rendition of this motif was found on a small plaque in the Qin'an region of Gansu Province.[2] In all these examples, the artist has caught the essential lupine characteristics, including the soft paws and slightly swollen forehead.

—ECB

1. *Kaogu* 1992.6, p. 574, fig. 1.11.
2. *Wenwu* 1986.2, p. 41, fig. 2.1.

48 *Bridle ornament*

Tinned cast bronze
Height 6.5 cm, width 6.1 cm
Northwest China, Shaanxi Province
5th century B.C.
The Therese and Erwin Harris Collection, formerly Paul Pelliot Collection

This tinned bronze fitting is enhanced by four crested animal-heads with round eyes, elliptical-shaped ears, and long, hooked beaks. Their necks are marked with a series of tiny striated enclosures. The front surface has been given a shiny surface by a deliberate wiping with molten tin. The back is flat and has no loops.

This piece is stylistically related to the previous ornament (no. 47) and exhibits the same high-quality casting. It, too, displays evidence of lost-wax casting: positive bronze spheres on the back like those on no. 47. The fantastic appearance of the animal-heads relates them to the new iconography brought into the grasslands of southern Ningxia Hui Autonomous Region by herding tribes from farther west in the late sixth–fifth century B.C. The tiny ears depicted by raised ovals around a striated interior are identical to the raptors' ears on an excavated piece from Ningxia (see cat. fig. 47.2).

—ECB

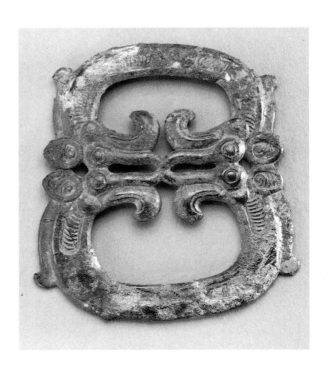

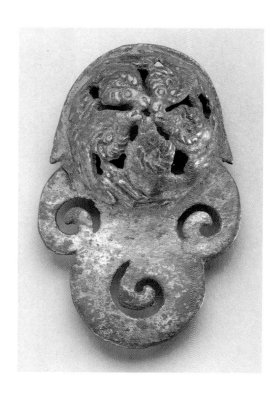

Detail, no. 49, schematic drawing showing design on dome of jingle

the owner of a plain bronze jingle. Since this ornament was to be used on a horse that would become sweaty, tinning would have the additional advantage of inhibiting corrosion.

Bronze and wood harness ornaments with very similar spiral-shaped apertures occur earlier at Tuekta, barrow I, a late-sixth-century B.C. site in the Altai Mountains of southern Siberia.[1] This similarity further confirms the arrival of tribes from farther west on China's frontier during the late sixth–fifth century B.C.
—ECB

1. London 1978, no. 79.

49 *Harness jingle*

Tinned cast bronze
Height 8.2 cm, width 5.4 cm
Northwest China
5th–4th century B.C.
The Therese and Erwin Harris Collection

This ingeniously designed harness ornament consists of a round jingle with a pendant trefoil flange that is pierced with three spiral-shaped apertures. The jingle appears to have a ball inside for sound. The reverse has four squared loops for securing crossed straps on a bridle.

The jingle is decorated with a very sophisticated openwork design of five rams joined at the muzzle. Each ram is depicted in profile with only two legs showing and its hindquarters inverted (see detail). The position of these rams resembles that of a tiny victim on animal combat plaques (see no. 50).

The sophisticated quality of the workmanship and the decorative complexity of the design suggest that this ornament was made by Chinese artisans for herding peoples. The presence of positive bronze spheres on the reverse confirms that the jingle was cast by the lost-wax process, like nos. 47 and 48. The bronze surface has been deliberately tinned to achieve a shiny appearance and to indicate that the owner was of a higher status than

50 *Belt plaque*

Cast bronze
Width 10.2 cm, height 6.1 cm
Northwest China
4th century B.C.
Published: Rawson and Bunker 1990, no. 207; Bunker 1992b, fig. 5a
The Calon da Collection

On this bronze belt plaque, a standing wolf is about to annihilate a doe clutched between its muzzle and raised right forepaw. The doe's head appears under the wolf's open jaws, which reveal four rounded teeth and two fangs about to sink into the succulent flesh of the doe's chest. The doe's hindquarters, underneath the wolf's right forepaw, are twisted 180 degrees. A tiny wolf pup appears on the ground line between the wolf's front and back legs. The wolf's ear is a distinctive comma shape, and its pelt is marked by a variety of linear patterns such as braided bands, scrolls, dots, and scales. The crest and tail each terminate in an eared raptor-head. The reverse

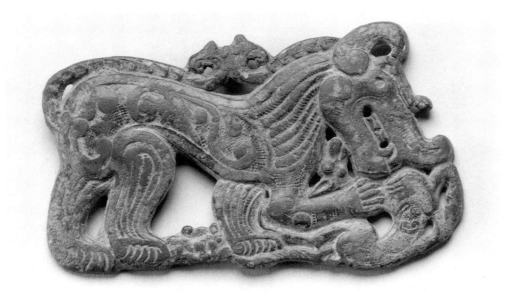

has a button behind the wolf's haunches and a vertical loop behind the head (see detail). The plaque has thick, turned-over edges on the reverse, as does the tiger plaque (no. 52), indicating that they were probably cast by the indirect lost-wax process. In some areas, the joints between pieces of wax are still visible on the back.

Originally this plaque had a matching mirror-image plate carrying the buckle hook on the front of a loop that was tangent to the wolf's head, similar to the loop on the wolf and ram plaque (no. 90). A very similar plaque in mirror-image was discovered around 1990 in the Qingyang area but remains unpublished.[1] The surface texturing on the present wolf's pelt relates to both spiral carved designs found on bone carving in the Guyuan Xian of Ningxia Hui Autonomous Region[2] (see cat. fig. 56.1) and to appliqué work found in fourth-century B.C. tombs at Pazyryk in southern Siberia. The convention of inverting the victim's hindquarters was also used in nomadic art in southern Siberia, both at Bashadar and at Pazyryk.[3] The rounded, curved forms that indicate teeth derive from a wood-carving tradition also found at Bashadar and in the art of Pazyryk,[4] suggesting some distant connection between Qingyang and the Altai already proposed by John Haskins.[5] The teeth of the two carnivores (no. 30) are also represented this way.

The raptor-head appendages associate this fantastic wolf with the mythological animals tattooed on the man from kurgan 2 at Pazyryk (fig. 21). This symbolic system appears on artifacts belonging to the pastoral tribes inhabiting northwest China in southern Ningxia and

Qingyang during the second half of the fourth century B.C., and then occurs about the late fourth–third century in the Ordos region.[6]
—ECB

1. A plaque with an almost identical composition was recently discovered in the vicinity of Guyuan Xian, southern Ningxia Autonomous Region. *Kaogu* 1992.6, p. 574, fig. 1.10, plate 8.4.

2. *Kaogu xuebao* 1993.1, p. 7, fig. 5.7–10.

3. Rudenko 1970, plate 139L, pp. 268–69, fig. 136.

4. Rudenko 1970, plate 138b.

5. Haskins 1988; Rudenko 1970, pp. 268–69, fig. 136.

6. Bunker 1992b.

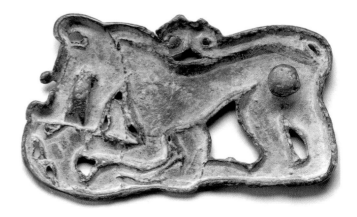

Detail, no. 50, showing back of plaque

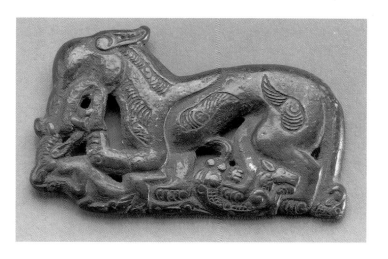

marks where the wax was worked by fingers, indicating indirect lost-wax casting. The reverse displays two vertical loops, one behind the head and the other behind the haunch.

There is a stylistic similarity between the way the victim under the hind feet is represented here and the tiny animals with inverted hindquarters at one end of no. 53. Both plaques were probably cast in neighboring Qin territory as a commissioned order. Wolves did not play an important role in Chinese iconography but would have been very important to a herding society, where they were major predators. Tinning appears to have been a status indicator before the development of mercury gilding.
—ECB

51 *Belt plaque*

Cast bronze, with traces of tinning
Width 7.9 cm, height 4.8 cm
Northwest China
4th century B.C.
The Therese and Erwin Harris Collection

On this belt plaque, a standing wolf menaces a fallen gazelle whose body lies beneath the wolf's raised left front paw. Another intended victim with tiny three-clawed paws is at risk in being trampled under the wolf's left hind leg. The hindquarters of both victims are twisted 180 degrees. The wolf's elongated ear is described by a raised outline that begins with a spiral at the outside edge. Each of the wolf's four paws is distinguished by four claws and a dewclaw. The slightly open jaws reveal two sharp fangs, and the pendant tail terminates in an eared raptor-head. The wolf's fur is given texture by indented striated enclosures, while the body of the second victim is accented by pebbling and spirals marking the haunch and shoulder areas. The front surface of the plaque is somewhat worn, but traces of the original tinning still remain. The back surface reveals

52 *Belt plaque*

Tinned cast bronze
Width 8.25 cm, height 3.5 cm
Northwest China
4th century B.C.
Published: Rawson and Bunker 1990, no. 206; Bunker 1991b, fig. 3
The Therese and Erwin Harris Collection

This bronze belt plaque is cast in the shape of a standing tiger attacking a fallen ram. The tiger is represented in profile with all four legs shown and four large claws on each paw. The ram has its muzzle between the tiger's open jaws and its body beneath the tiger's right forepaw. The tiger's ear is described by a raised spiral that begins at the outside base, and the eye is indicated by an intaglio line. The pelts of both animals are marked by striated comma shapes that accent the contours of their bodies. In addition, the tiger's neck is marked longitudinally by alternating plain and striated bands. The back of the plaque has a round button that projects from the surface

CAT. FIG. 52.1. Drawing of one of a pair of bronze plaques, Guyuan Xian, Ningxia Hui Autonomous Region, 4th century B.C. Width 10.6 cm, height 5 cm. After *Kaogu* 1990.5, p. 413, fig. 12.3

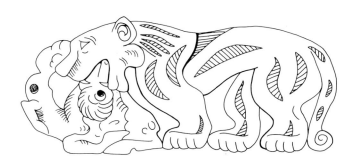

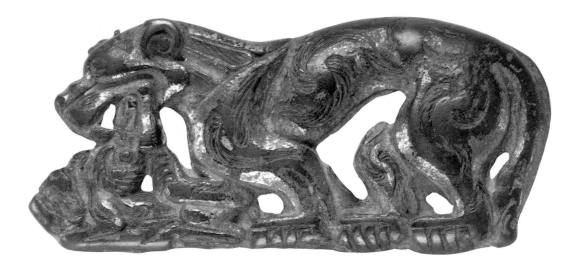

behind the tiger's haunch. The front surface of the plaque has been enhanced by a wiping with molten tin to produce a shiny silvery surface, now partially rubbed off by the wear and tear of time. The presence of metal flashes around the openings in the design and mold join marks on the edges indicate that the piece was cast from a wax model formed in a two-piece mother-mold.

This plaque was originally one of a mirror-image pair that together constituted one complete belt buckle. A complete set was recently discovered in Guyuan Xian, southern Ningxia Hui Autonomous Region (cat. fig. 52.1). An example almost identical to the present plaque was also recovered from a grave on the Qingyang plateau of southeastern Gansu Province.[1] The Qingyang example has a hook projecting from a loop tangent to the tiger's head. This feature, an essential part of the fasten-

ing system, is broken off on the present plaque. A close look at the wearer's left-hand plaque from Ningxia indicates that a small dog shown upside down once decorated the loop now missing on this plaque.

This plaque is a perfect blend of Chinese and steppe traditions.[2] The shape and design are based on images found in the art of the eastern Eurasian steppes. The striding carnivore attacking a doomed herbivore is a well-known steppe power theme that first originated in the art of southwest Asia and was later transmitted eastward by the Eurasian pastoral tribes. Similar tigers are carved on the side of the famous wooden coffin from Bashadar in the Altai Mountains of southern Siberia[3] and shown on a silver plaque excavated at Shihuigou, Ejin-Horo Qi, in western Inner Mongolia Autonomous Region.[4] The placement of the ram's muzzle within the tiger's jaws is a typical motif found also at Pazyryk on a wood carving from barrow 4 (cat. fig. 52.2). By contrast, the surface decoration on the animals pelts and the tinning technique can be easily related to metalwork produced in the state of Qin during the Eastern Zhou period.[5]

—ECB

CAT. FIG. 52.2. Drawing of wood-carving, Pazyryk, 4th century B.C. Dimensions not specified. After Rudenko 1970, plate 110

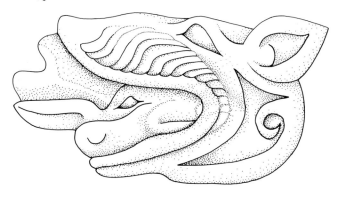

1. *Kaogu* 1988.5, p. 419, fig. 14, plate 4.2.

2. Bunker 1991b.

3. Jettmar 1967, fig. 98.

4. *Neimenggu wenwu kaogu* 1992.6–7, p. 92, figs. 1–5.

5. Compare the striated commas with those on a Qin belt ornament excavated at Xicun, Gengxiang Xian, Shaanxi Province. *Kaogu yu wenwu* 1981.1, p. 30, fig. 29.2, no. 104.

53 *Belt buckle*

Tinned cast bronze
Width 7.4 cm, height 3.9 cm
Northwest China
4th century B.C.
The Calon da Collection

A rectangular-shaped buckle is slightly wider at the pointed end than at the opposite blunt end, where the sides curve in to meet it. A squarish opening near the pointed end is preceded by a fixed projection for fastening. On the underside near the blunt end, in line with the opening, issues a stemmed stud, also part of the fastening device.

A dense mass of squirming serpentine bodies enclosed within a narrow border of scalelike motifs decorates the top of the buckle. A large dragonlike head with a typical Chinese rolled muzzle and heart-shaped ears fills the blunt end. Behind it, the body splits into two, each part bordered by two pebbled strips, with one fore and one hind leg issuing from spiral haunches. Sandwiched between the rumps and facing the opening is a second, smaller bovine-head. Two small animals, almost identical to the tiny victim on the plaque (no. 51), also rendered with pebbled bodies, fill the space on either side of the opening and the pointed tip of the buckle. Fine crosshatching highlights the larger animals' heads. The silvery sheen on both top and bottom is a result of tinning.

This buckle and the following plaque (no. 54) embody Chinese and northern worlds in form and decoration. The buckle with a tongue is a northern fastening device; the serpentine dragons prevail on Chinese ritual bronzes of the fifth century B.C.[1] A virtually identical buckle is in the collection of the Metropolitan Museum of Art, New York.[2]

A significant discovery is a closely comparable buckle recovered from a tomb in Yuanjiacun, Ning Xian, in the Qingyang region of southeastern Gansu Province.[3] This buckle was recovered from a cemetery where tinned bronze belt plaques closely resembling nos. 50–52 and 54 and belt ornaments like nos. 84–86 have also been found.[4] The amount of horse and harness equipment as well as the abundance of belt ornaments and plaques recovered at the site indicate that this was a burial ground for non-Chinese peoples. The presence of this Chinese buckle in an otherwise clearly non-Chinese context further supports the argument that many types of belt paraphernalia—in both Chinese and northern styles—were made primarily for export to nomadic patrons.

—JFS

1. See So 1995, introduction, sections 4.2, 4.3, figs. 48, 63, 64.

2. The Metropolitan buckle (24.64.1) has a loop instead of a stud on the underside and a V-shaped slit near the loop.

3. *Kaogu* 1988.5, pp. 414–15, figs. 2.11, 4.2. Like the Metropolitan buckle cited in n. 2, the Yuanjiacun buckle uses a loop instead of stud for attachment.

4. Ibid., pp. 414–15, 418–21, figs. 2.12, 4.1, 10.4, 11.2, 12.3, 12.7, 14, 17.3, 17.4, 18.5, 18.10.

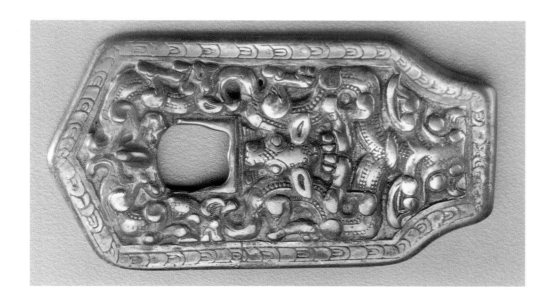

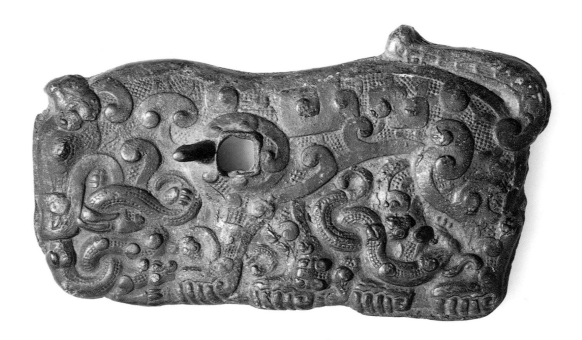

54 *Belt plaque*

Cast bronze
Width 12.4 cm, height 7.2 cm
Northwest China
Warring States period, 4th century B.C.
Arthur M. Sackler Gallery, Smithsonian Institution,
 Gift of Arthur M. Sackler, s87.0448

This bronze plaque depicts a standing carnivore whose tail sweeps upward along its back haunches. The long muzzle and pointed ear suggest a wolf. The curved, heart-shaped ear is like the comma-shaped lupine ears portrayed on other plaques (no. 50). The wolf in this example is represented in profile with all four legs shown. Each paw displays four prominent claws and a curved dewclaw behind. Sinuous zoomorphs with serpentine bodies and feline heads are tangled around the wolf's legs. One zoomorph is held firmly in the wolf's slightly open jaws, which reveal two rows of teeth. The body of the wolf is marked by curved bands in low relief against a pebbled ground, while the zoomorphs' bodies are given texture by two longitudinal rows of pseudo-granulation. A hook projects from the front of the plaque in front of a squared hole. On the reverse, behind the haunch, is a vertical loop. The surface is covered with a blackish patina. The bronze was rather crudely cast in a two-piece mold that left join marks at the plaque edges.

The animal combat motif has been totally Sinicized here and subordinated to the overall design scheme in comparison with several slightly earlier plaques (nos. 50–52). This plaque was originally one of a mirror-image pair that together formed one belt buckle, such as the plaque recently discovered on the Qingyang plateau in southeastern Gansu Province.[1] The wolf on the Qingyang plaque has similar animal forms, distinctly Chinese in accent, superimposed on its body (see no. 53).
—ECB

1. *Kaogu* 1988.5, p. 420, fig. 17, plate 4.3.

55 *Bridle ornament*

Gilded cast bronze
Height 5.6 cm, width 3.3 cm
North China
3d century B.C.
Reproduced in color: plate 11, p. 57
Published: Rawson and Bunker 1990, no. 214
The Therese and Erwin Harris Collection

A frontal ram-head flanked by two crouching wolves shown vertically in profile distinguish this bridle pendant. Each wolf has a turned-up snout, a long, attenuated comma-shaped ear, and four front claws and a dewclaw on the hind paw. A vertical loop for attachment is placed behind the hollow ram-head. This

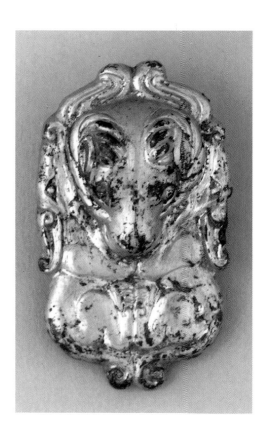

tomb 30 at Xinzhuangtou[3] (fig. 23). This type of bridle ornament appears to have fallen into disfavor after the Xiongnu conquest in the late third century B.C. and does not appear in Xiongnu burials.
—ECB

1. Rudenko 1970, plate 112G.
2. Bunker 1992b, p. 105, fig. 11.
3. Ibid., p. 108, fig. 20.

56 *Pair of belt plaques*

Cast bronze with traces of silver foil
Length x height: (a) 10.6 x 7.5 cm, (b) 10.6 x 7.4 cm
North China
3d century B.C.
Reproduced in color: plate 13, p. 61
The Therese and Erwin Harris Collection

ornament appears to have been cast by the lost-wax process and then heavily gilded on the front.

The basic shape of this bridle ornament derives from southern Siberian types seen at Pazyryk in the Altai Mountains.[1] Such bridle ornaments became popular among the herding tribes in the northwest after the introduction of mounted warfare in the fourth century B.C. Silver examples with Chinese characters inscribed on them were found at Xigoupan, Jungar Qi, in western Inner Mongolia.[2] A gold example with Chinese characters engraved on the reverse side was excavated from

A conventionalized animal combat scene within a simple rope border distinguishes the two mirror-image plaques that constitute this belt buckle. The victims in this symbolic combat scene are two recumbent mythological beaked ungulates with eared raptor-head appendages shown opposite each other longitudinally. The attackers are tigers, represented by masks that each bite the ungulates in the back and four-clawed paws grasping the ungulates' legs. The bodies of the two ungulates are marked with fluid striated enclosures that accentuate their contours. The backs reveal the lost-wax and lost-textile woven pattern. One plaque has two vertical attachment loops on the back at one end and a horizontal

a b

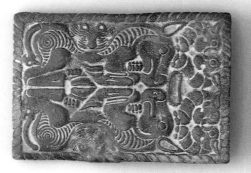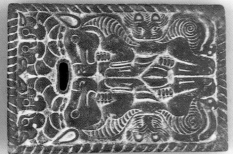

CAT. FIG. 56.1. Motif on bone cylinder, northwest China, 4th–3d century B.C. The Calon da Collection

one at the other; the matching plaque has two vertical loops at one end and a pierced oval opening at the other.

Under a microscope, traces of silver foil can be detected in channels along the edges on the backs of the plaques together with bits of lead used to secure the foil. Apparently, these plaques were once wrapped in silver foil to present the illusion that they were made of silver. Compared to gold, in ancient China silver was scarce and did not become an important metal in ancient China until the Han period; even then, its white color may have been of greater importance than its monetary value.[1] By contrast, silver ornaments were highly regarded among the northern herding tribes (see no. 58). Excavations at Shihuigou, Ejin-Horo Qi, in western Inner Mongolia, have yielded numerous cast silver ornaments that can be dated to the late fourth or third century B.C.[2]

This pair of plaques is so similar in design concept and casting technology to the gold belt plaques excavated from tomb 30 at Xinzhuangtou near Yi Xian, northern Hebei Province, that it can be assumed that it, too, was cast at Xiadu by Yan artisans for northern consumption (fig. 24). The surface of a very similar bronze plaque in the Mengdiexuan Collection has been tinned

rather than wrapped in silver, suggesting experimentation in the means for achieving a shiny white surface.[3]

The striated patterns on the animals' bodies derive from wood-carving traditions found earlier in southern Siberia that were carried into China during the Warring States period. A carved bone cylinder said to come from Ningxia Hui Autonomous Region shows a beaked ungulate with surface texturing similar to that on these two plaques (cat. fig. 56.1).

—ECB

1. Bunker 1994a.

2. *Neimenggu wenwu kaogu* 1992.6–7, pp. 91–96; Beijing 1993, nos. 104–7.

3. White and Bunker 1994, no. 21.

57 Belt plaque

Tinned bronze
Width 11.1 cm
Northwest China
4th century B.C.
The Therese and Erwin Harris Collection, formerly
 Dr. Fritz W. Bilfinger Collection

This tinned bronze belt plaque is cast in the shape of a recumbent horse with its legs folded underneath its body. The soles of the front hooves face upward, and the soles of the back hooves face downward. The body of the horse is decorated with indented lines that reflect pat-

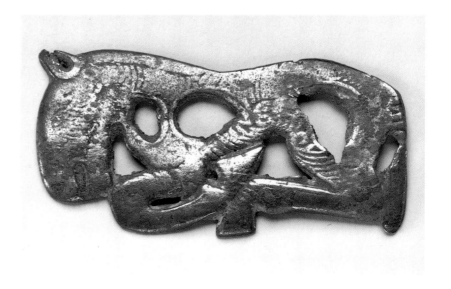

terns on stamped leather and carved wood and bone artifacts found in southern Siberia. The surface of the plaque has been deliberately tinned to give it a shiny, silvery appearance. The round hole in the horse's shoulder suggests that it was originally the left-hand plaque of a belt buckle formed by two mirror-image plaques. The other two tear-shaped openings are unexplained, unless the plaque was designed to have some colored fabric, such as felt, behind it.

The present plaque is startlingly similar to a carved bone plaque excavated from a nomadic tomb at Sagla-Bazha, kurgan 2, in western Tuva, southern Siberia.[1] Even the surface decoration of curvilinear lines and striations is basically the same, but more elaborate on the Sagla-Bazha example.

The particular horse that is represented by both the present tinned bronze plaque and the Sagla-Bazha bone plaque is a Przewalski's horse, the wild Asian horse that inhabited the Eurasian steppes until the early twentieth century and parts of Europe in Paleolithic times. Przewalski's horse is sandy beige in color and has a short black mane that sticks straight up. It is about the size of a pony and adapts well to the rigors of the steppes. The species is formally known as *Equus przewalskii,* after Col. Nikolai Przewalski, a Russian explorer of Polish descent who first identified it in the Gobi Desert in 1879.

By 1970 Przewalski's horse was almost extinct, but two years ago the Foundation for the Preservation and Protection of the Przewalski Horse in the Netherlands reintroduced domestically raised Przewalski's horses into Mongolia, where they appear to be thriving.
—ECB

1. London 1978, pp. 77–78, plate 101.

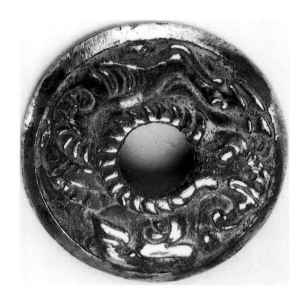

58 *Ornament*

Cast silver
Diameter 3.7 cm
North China
3d century B.C.
Reproduced in color: plate 12, p. 60
The Therese and Erwin Harris Collection

A goat with its inverted hindquarters slung over its head decorates this small silver ornament. Striated enclosures mark the goat's body, which has been ingeniously manipulated to surround the central opening described by the curve of the goat's horn. The reverse clearly shows a raised woven pattern, indicating that the plaque was cast by the lost-wax and lost-textile process. Analysis by x-ray fluorescence spectrometry shows that the metal is a high copper-silver alloy.

Several objects of this shape cast in gold were excavated from tomb 30 at Xinzhuangtou near Yi Xian in northern Hebei Province.[1] The Xinzhuangtou examples all have their weight inscribed on them in the Yan weight system, providing further evidence for Chinese manufacture of luxury goods for the northern tribes. To date, there is no agreement as to how these small circular fittings were used.
—ECB

1. Shi Yongshi 1980, pp. 172–75; Li Xueqin 1985a, p. 335, fig. 150.

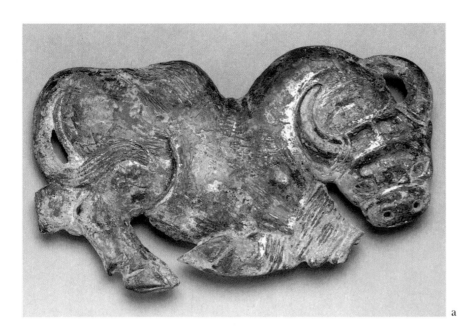

a

59 Two belt plaques

Gilded cast bronze
Width x height: (a) 12.3 x 7.1 cm, (b) 9.4 x 5.5 cm
North China
3d–2d century B.C.
The Therese and Erwin Harris Collection, (b) formerly
 Norbert Schimmel Collection

These two bovine-shaped plaques originally had matching mirror-image mates, now missing. A woven pattern on the back of each plaque indicates that they were cast by the lost-wax and lost-textile process.

A bovine-shaped plaque discovered near Shijiazhuang in southern Hebei Province is an almost identical mirror-image of the earlier version of these two plaques

b

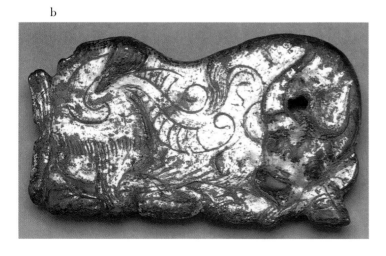

(a) and could conceivably be the missing mate.[1] Personal observation during a visit to Professor Zheng Shaozong confirms that the Shijiazhuang plaque was also cast by the lost-wax and lost-textile process. The present plaque and the Shijiazhuang plaque each have three attachment loops on the back: two horizontal ones behind the rump and one vertical one behind the head.

A plaque in Stockholm reported to have been found at Shouzhou in Anhui Province consists of two mirror-image plaques very similar to the later of these two plaques (b).[2] This later plaque has two vertical loops on the reverse side—one behind the head and the other behind the rump, the same as its counterpart in Stockholm.

Shouzhou was the capital of the state of Chu from 241 until 223 B.C., when it was conquered by Qin. Apparently, it was a city of some sophistication. Its significant bronze foundries were presumably in operation before the Chu took over and probably continued after the Qin conquest into the early second century B.C.

Another bovine-shaped plaque similar to but later than the Shouzhou pair was excavated from a Western Han period tomb at Suide Xian in northern Shaanxi Province.[3] This belt plaque may well have been made in workshops at the Han capital in Chang'an (present-day Xi'an) by foundry workers from other parts of the empire who were familiar with the lost-wax and lost-textile process.

The differences among these three plaques separated in time by perhaps only a few decades suggests that they

may have been products of different workshops: one at Xiadu, the capital of Yan; one at Shouzhou, the capital of Chu; and another at Chang'an, the capital of the Han dynasty. If these plaques were commissioned by the northern herding tribes, the designs would remain constant but the minor technical details might vary.
—ECB

1. Beijing 1980a, no. 285.

2. Karlbeck 1955, plate 32.1–2.

3. Fu Tianqiu 1985, plate 139.

60 *Bridle ornament*

Gilded cast bronze
Height 11.5 cm, width 7.6 cm
North China
3d–2d century B.C.
The Therese and Erwin Harris Collection

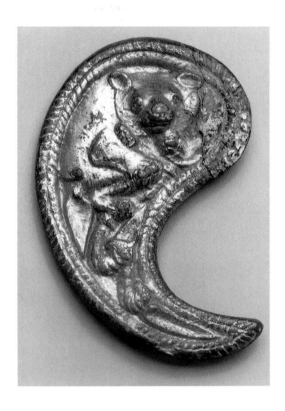

This crescent-shaped ornament carries an animal combat scene in which a bear is devouring a mythological ungulate; only two raptor-head antler tines remain. A double-rope-pattern frame surrounds the plaque, which is cast in an inverted comma shape. The front of the plaque has been mercury gilded, and the back displays a woven pattern integral to the metal surface. Two squared attachment loops also occur on the back: a vertical one behind the bear's head and a horizontal one behind the victim's antler tines.

A similar undecorated crescent-shaped ornament was found with horse and vehicle equipment in an Upper Xiajiadian burial at Tianjuquan in the western portion of Ningcheng Xian, southeastern Inner Mongolia Autonomous Region.[1] This discovery confirms its function as horse equipment but does not explain its decoration, which has no known excavated counterpart. The shape of the fitting is northeastern, the iconography is nomadic, but the presence of mercury gilding indicates that it was cast either in some Western Han workshop or by Han artisans in Xiongnu employ.

The bear was a favorite motif on small circular Xiongnu plaques[2] and Han fittings (see no. 72), and the ungulate with raptor-head antler tines was a symbol associated culturally with the Rouzhi confederacy that had once been overlords of the Xiongnu. That the iconography of this ornament is intended to celebrate the Xiongnu conquest of the Rouzhi is a tempting speculation.
—ECB

1. *Wenwu ziliao congkan* 9 (1988): 30, fig. 13.3.

2. *Sovetskaya Arkheologiya* 1971.1, p. 105, fig. 9.

61 *Belt plaque*

Gilded cast bronze
Width 8.7 cm, height 5.1 cm
China
3d–2d century B.C.
Published: Bunker 1981, no. 837
Los Angeles County Museum of Art, Gift of the Ahmanson Foundation, M.76.97.616, formerly Heeramaneck Collection

A Bactrian camel with a man standing on the far side and peering between the two humps decorates this belt plaque. The camel is represented in a rather awkward, semikneeling position as the man grips the two humps with his hands and prepares to mount. Because of their

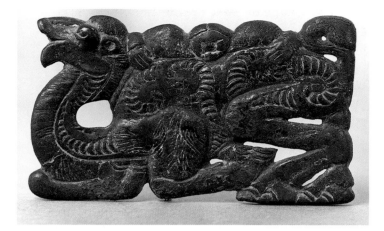

The back of each plaque carries a woven pattern that indicates both were cast by the lost-wax and lost-textile method, a variation of the indirect lost-wax technique. The plaque is mercury amalgam gilded, suggesting that it was made either by Chinese artisans to northern requirements or by Chinese artisans in the employ of the northern tribes, in this instance the Xiongnu.

—ECB

62 *Model*

Clay
Width 10.16 cm, height 7.62 cm
North China
3d–2d century B.C.
Metropolitan Museum of Art, Rogers Fund, 18.43.2

height, camels were always made to kneel for the rider to mount them. The man has Mongoloid features and may represent a Xiongnu, who were known to specialize in breeding and trading camels to the Chinese.

The contours of the camel are marked by striated enclosures that derive from the wood- and bone-carving traditions of southern Siberia (see cat. fig. 56.1). These patterns were extremely popular on animal bodies decorating plaques cast during the Han period for the northern herding tribes.

This plaque is the wearer's left-hand plaque of a mirror-image pair of plaques that formed one complete belt buckle. The back displays two vertical squared attachment loops. The mirror-image mate to this plaque is now in a private collection. Both were originally owned by Nasli Heeramaneck, who kept one and sold the other to Ernest Erickson, whose estate was subsequently sold through Sotheby's.

A camel in high relief within a herringbone-pattern frame is depicted on this clay model. Such models were used by artisans during the last three centuries B.C. in making metal plaques for the northern herding tribes. The scene on this clay model is typical of numerous bronze and gilded bronze plaques made during the late third through the first centuries B.C.

This model for a nomadic belt plaque was used to produce a mother-mold in which wax models of the plaque to be cast were formed. These models were used to mass-produce bronze plaques cast by the indirect lost-wax process. It is most unusual that such a clay model

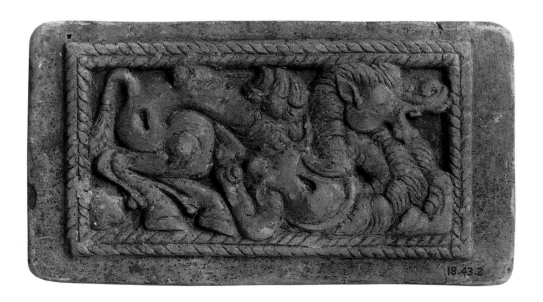

CAT. FIG. 62.1. Clay model of a camel ornament, 3d–2d century B.C. Diameter 3.9 cm. Freer Gallery of Art, Smithsonian Institution, 16.8

has survived, and its existence greatly illuminates our understanding of one of China's ancient casting processes. Several clay models exist in Western museum collections (cat. fig. 62.1), but, to date, no similar models have been published in Chinese excavation reports. Some examples must exist in China, but their function may not be understood.
—ECB

63 *Two belt plaques*

Gilded cast bronze
Width x height: (a) 9.4 x 4.5 cm, (b) 8.9 x 4.2 cm
North China
3d–2d century B.C.
The Therese and Erwin Harris Collection

A complex design of zoomorphic forms covers the surface of these bronze belt plaques decorated by two nearly identical designs. The main animal is a recumbent wolf shown in profile, with a pointed ear, almond-shaped eye, turned-up snout, open jaws revealing fangs and teeth, and two paws with five claws each. Two coiled argali rams with their hindquarters slung over their heads are

superimposed on the wolf's body. Above the wolf is a row of horned gazelle-heads, and above the gazelles is a row of eared raptor-heads. The front of each plaque has been mercury gilded. The back of each plaque displays two vertical attachment loops and a woven pattern indicating that it was cast by the lost-wax and lost-textile process.

An almost identical plaque was found among the grave goods from Xichagou, Xifeng Xian, in northeast Liaoning Province, but remains unpublished. The animal combat scene, so dramatically portrayed on earlier plaques such as no. 50, has been reduced to a pleasing design that is almost impossible to decipher at first glance. The eared raptor-heads refer to the antlers with raptor-head tines found on earlier plaques, but only someone initiated into this iconography would recognize it. The symbolic content has been overwhelmed by a stylized design of curves and countercurves. The presence of mercury gilding and the emphasis on pattern are typical of Han workmanship and confirm Chinese manufacture. Two ornaments found at Xichagou were definitely produced at the workshops in Hebei Province, where the luxury goods found in the Western Han tombs at Mancheng were cast. Artisans from Yi Xian may have fled to Mancheng after the capital fell to Qin in 222 B.C.
—ECB

a b

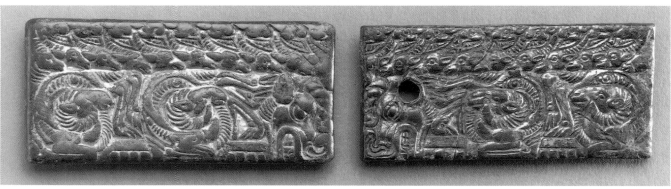

a

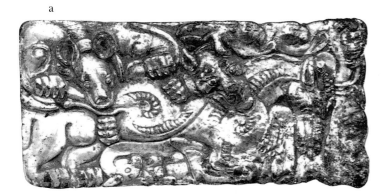

b

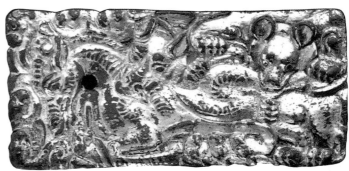

64 *Two belt plaques*

Gilded cast bronze
Width x height: (a) 12.1 x 6.1 cm, (b) 11.9 x 5.7 cm
North China
3d–2d century B.C.
The Therese and Erwin Harris Collection

These two mirror-image plaques form one complete belt buckle, but the discrepancies in size suggest that they were not originally a pair. Each plaque shows a fallen mythical ungulate with raptor-head appendages being attacked by a bear and a wolf. The back of each plaque has two vertical attachment loops and the woven pattern indicating it was made by the lost-wax and lost-textile process. A close look at the pierced hole in the wearer's left-hand plaque shows that it was punched through the wax model and the cloth backing from the front.

An identical pair of plaques was excavated from a Han antiquarian's tomb near Sandiancun in the eastern suburbs of Xi'an, Shaanxi Province, where the capital was located during the Western Han period.[1] An identical single right-hand plaque was recently excavated from a Hun burial in cemetery 2, kurgan 17, at Pokrovka in Kazakhstan in the southern Urals.[2] Such a discovery so far from where it originated suggests that the plaque must have been a treasured heirloom acquired by trade or warfare and demonstrates how small objects traveling great distances can aid in the transmission of styles.

This animal combat scene belongs to the symbolic system introduced into the frontiers of northwest China during the late fourth century B.C. and then represented on belt plaques through the early part of the Han period until the Indo-European–speaking Rouzhi tribal confederacy was driven far west by the Xiongnu in the second century B.C.[3] The vigor of the attack scene has been Sinicized and almost lost in the manipulation of shapes

into pleasing patterns, just like the scene on the previous plaque (no. 63). Where these plaques were actually made is hard to determine, since workers from all over north China may have congregated at the capital after the Han defeat of the Qin.
—ECB

1. *Kaogu yu wenwu* 1983.2, p. 24, fig. 1.1, plate 7.2; Bunker 1987, p. 52, fig. 1.

2. Yablonsky 1994, fig. 81.13. This publication erroneously identifies this as cemetery 1 instead of cemetery 2. I am most grateful to Jeannine Davis-Kimball for bringing this reference to my attention.

3. Bunker 1989, pp. 52–55, plates 1–5.

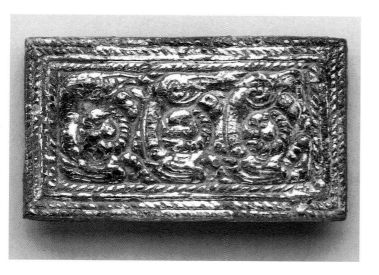

Small ornaments decorated with rams in the same pose have been found at several fourth–third century B.C. sites in the Ordos Desert[2] and also on certain Qin harness fittings. The three rams have been turned into three spirals with zoomorphic features. There are literally dozens of plaques with this symbolic design in collections around the world.[3]

—ECB

1. *Kaogu xuebao* 1988.3, p. 344, fig. 9.1 (upside down), plate 17.1.
2. *Kaogu* 1980.4, p. 335, fig. 3.8.
3. Karlbeck 1955, plate 32.3.

65 *Belt plaque*

Gilded cast bronze
Width 6 cm, height 3.6 cm
North China
2d–1st century B.C.
The Therese and Erwin Harris Collection

Three rams with their front legs folded beneath their bodies and their hindquarters slung over their heads are represented within a double-rope-pattern frame on this small plaque. This plaque is the wearer's right-hand plaque of a belt buckle consisting of two mirror-image plaques, one of which is now missing. The back of the plaque has two vertical attachment loops and a woven pattern indicating the lost-wax and lost-textile casting process.

This plaque was produced by Chinese artisans expressly for a northern commission. An identical plaque was excavated from a Xiongnu cemetery at Daodunzi, Tongxin Xian, Ningxia Hui Autonomous Region, dated by coins to the second–first century B.C.[1]

66 *Pair of belt plaques*

Gilded cast bronze
Width x height: (a) 10.9 x 5.5 cm, (b) 11 x 5.5 cm
North China
3d–2d century B.C.
The Therese and Erwin Harris Collection

This gilded bronze belt buckle is a classic example of an ornament made by Chinese artisans for northern consumption. Each plaque depicts two addorsed beaked ungulates whose hindquarters have been rotated 180 degrees and whose tails terminate in eared raptor-heads. These mythological creatures descend from the glorious creature that surmounts the Nalin'gaotu headdress (fig. 20), but their earlier exuberance has been sacrificed to the demands of a design that deliberately orchestrates curves and striated markings. Plaques with this motif are common and must have been mass-produced to supply hundreds of northern herdsmen who were entitled to wear

a b

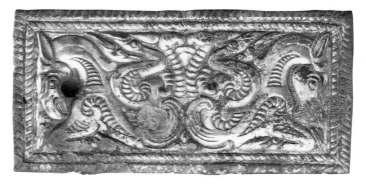

146

this symbol.[1] The backs each show two vertical loops and a finely woven pattern, indicating that the plaques were cast by the lost-wax and lost-textile process.

Plaques with this design have been excavated at two sites associated with the Xiongnu confederacy: Xichagou, Xifeng Xian, in Liaoning Province (example unpublished), and Daodunzi, Tongxin Xian, Ningxia Hui Autonomous Region.[2] They relate to symbols traditionally worn by tribes with an Indo-European heritage and slowly became scarce after the Xiongnu drove off the Rouzhi around 160 B.C.

—ECB

1. See Rawson and Bunker 1990, no. 225, for an identical pair.
2. *Kaogu xuebao* 1988.3, p. 344, fig. 9.13, plates 15.5, 20.12.

67 *Pair of belt plaques*

Cast bronze
Width 12.5 cm, height 7.8 cm
North China
3d–2d century B.C.
Published: Bunker 1990b, no. 48
Leon Levy and Shelby White Collection

A mythological scene of animal combat is represented on this pair of bronze mirror-image belt plaques. On each plaque, a small carnivore bites the chest of a fantastic ungulate. Each ungulate has a rapacious beak and raptor-head antler tines and tail tip. The wearer's left-hand plaque has a small hook that protrudes from the front, alongside a vertical slit near the ungulate's head.

An almost identical single plaque was recovered from the disturbed cemetery at Xichagou, Xifeng Xian, in northern Liaoning Province.[1] This cemetery can be dated numismatically to the second century B.C. The Xiongnu may be buried in some graves; others appear to belong to the local Donghu, whom the Xiongnu conquered early in the second century B.C.

The ungulate with raptor-head appendages belongs to the same symbolic system that governed the tattoos found on the Mongoloid man buried in kurgan 2 at Pazyryk in the Altai Mountains of southern Siberia dated to the fourth century B.C.[2] (fig. 21). The same type of fantastic creature adorns the remains of a headdress found at Nalin'gaotu in Shenmu Xian in northern Shaanxi Province[3] (fig. 20). This iconography has been associated with the tribes that appeared on China's northwestern frontiers in the fourth century B.C. and introduced mounted warfare.

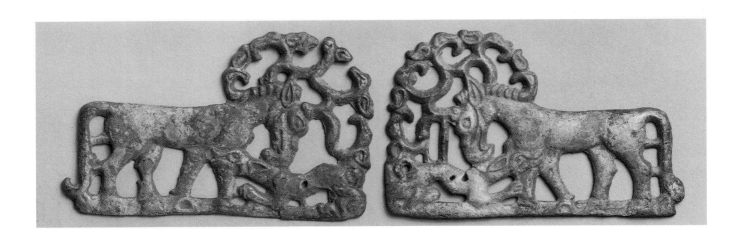

The horizontal B-shape and the animal combat scene on these plaques are almost identical to a gold plaque discovered near Verkhne-Udinsk, present-day Ulan Ude, near Lake Baikal in southern Siberia, with one exception.[4] This example has several animal figures superimposed on its body that do not appear on any of the bronze examples, but a gold tiger plaque excavated at Nianfangqu, Dongsheng Xian, in western Inner Mongolia, has animal figures superimposed all over its body.[5] These similarities suggest a strong connection between the Lake Baikal gold plaque and the similar bronze examples associated with the tribes occupying China's northern zone during the last four centuries of the first millennium B.C.

—ECB

1. *Wenwu* 1960.8–9, p. 33.6.

2. Rudenko 1970, figs. 130–31.

3. *Wenwu* 1983.12, plate 4.1.

4. Rudenko 1962, plate 4.2.

5. *Kaogu* 1991.5, p. 406, figs. 2–4.

68 *Mirror*

Cast bronze
Diameter 16 cm
North-central China
4th or 3d century B.C.
Arthur M. Sackler Gallery, Smithsonian Institution, Purchase,
 Friends of Asian Arts, s1993.5, formerly Henri Hoppenot
 Collection, Paris

Four large T-shapes, placed aslant over a background pattern of scrolls in low relief, decorate the back of this mirror. A square field frames the small fluted loop in the center. From the corners of the square issue petal-shaped elements on long stems that crisscross underneath the T-shapes, while one branch ends in a long flail-like shape between two Ts. The polished reflecting surface is plain.

Mirrors such as this one were produced in large numbers in Chinese workshops during the fourth and third centuries B.C. and traded far and wide throughout China. A fragment of a mirror virtually identical to this example recovered from a nomadic tomb in Pazyryk, in the Altai Mountains of southern Siberia, indicates the extent of trade during the late first millennium B.C.[1] Since bronze mirrors seem to have special religious or shamanistic

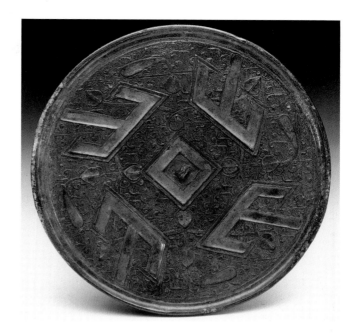

meaning among the northern tribes,[2] possessing such an exotic, Chinese-made example would add to the owner's prestige or even the object's potency. Continued trade of Chinese luxury articles far into Central Asia is demonstrated by the discovery of two second-century mirrors in noble burials of ancient Bactria dating from the first century B.C.[3]

—JFS

1. Rudenko 1970, p. 115, fig. 55. This mirror fragment is also discussed in Bunker 1991a, which suggests a possible third-century B.C. date for such mirrors.

2. O'Donoghue 1990.

3. Sarianidi 1985, nos. 2.34, 6.31, plate 145.

69 *Fragment of a mirror mold*

Clay
Maximum dimensions 7.0 x 8.5 cm
North China
Late 4th or 3d century B.C.
Freer Gallery of Art, Smithsonian Institution, Study Collection,
 FSC-P-200

This clay fragment, with an impressed design closely resembling that on the previous mirror (no. 68) and virtually identical to the fragmentary mirror from Pazyryk,[1]

was likely used to cast bronze mirrors like it. Clay mirror molds have been recovered from the sixth- to fifth-century Chinese bronze foundry site at Houma in southern Shanxi Province,[2] and fragments of mirror molds, with designs virtually identical to this fragment and the previous mirror, have been recovered from Yi Xian, Hebei Province.[3] Yi Xian is the site of Xiadu, the ancient capital of Yan, where other Chinese luxury exports to the north have been recovered from recent excavations (see nos. 56, 58, 59, 62). It appears that such mirrors were made in north Chinese workshops partly to supply nomadic demands.[4]

—JFS

1. Rudenko 1970, p. 115, fig. 55.

2. *Kaogu* 1962.2, plate 4.9.

3. *Kaogu* 1962.1, p. 18, fig. 10. The Yi Xian fragment appears to be stone rather than clay.

4. See Bunker 1991a, pp. 20–21, for a discussion of mirror production at the Yi Xian workshops.

70 *Zither tuning key (qin zhen yao)*

Cast bronze
Height 7.7 cm
North-central China
4th century B.C.
The Therese and Erwin Harris Collection

A raptor flying with a bear cub in its talons surmounts the top of a rectangular shaft ending in a square socket. The bird has a rapacious beak, wrench-shaped claws, scaled neck and body, and feathered wings and tail. The surface has been cleaned and polished to a smooth, dark gray.

The function of this enigmatic object was often misunderstood until the excavation of similar pieces together with a set of tuning pegs for a Chinese *qin*—a plucked string, zitherlike musical instrument, smaller than the *se*—from the second-century B.C. tomb of the king of Nanyue in Guangzhou, capital of Guangdong Province.[1] Unlike the larger *se* zither, which is tuned by raising each string from the surface of the sound box with a wooden bridge, the *qin* is tuned by tightening each string wound around or tied to a tuning peg. If the placement of the pegs makes it awkward to turn them by hand, a tuning key helps facilitate the task.

Although the *qin* figures in the poems dating from the early centuries of the first millennium B.C. collected in the *Shijing* (Book of Odes), the earliest surviving *qin*-like string instrument in China that uses tuning pegs comes from the late fifth-century B.C. tomb of the Marquis Yi of Zeng in Sui Xian, northern Hubei Province.[2] The pegs on the Sui Xian *qin* are semicircular in section, unlike the squared ones with which the present key would have been used. The squared tuning pegs recovered from Guangzhou suggest that this type was in use by the second century B.C.

In the history of plucked string instruments from the ancient world, the Chinese *qin* was the earliest known to use the tuning peg and key for tuning.[3] Most West Asian string instruments use a movable collar.[4] When tuning pegs appeared on Western instruments in Anatolia around the third or second century B.C., they were placed laterally as on a modern violin, in contrast to tuning pegs on a typical Chinese *qin*, which are placed axially. It would appear that the tuning key was created to meet special needs in the design of an ancient instrument in China.

However, the ornamental motifs on surviving tuning keys persistently relate them to northern traditions (see

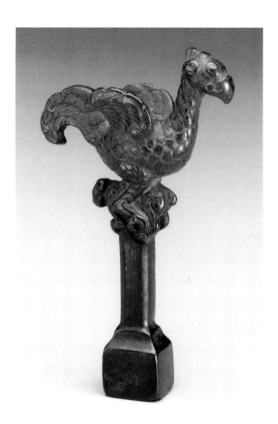

1. Beijing 1991b, plate 47.1, p. 93, fig. 62.1.

2. Beijing 1989, plate 48, p. 167, fig. 78. Only four tuning pegs have been found in the compartment on the bottom of this ten-stringed instrument.

3. Dr. Bo Lawergren, personal communication, 1994.

4. For studies on ancient musical instruments and their various tuning systems, see Lawergren 1980; Lawergren 1984; Lawergren 1990; Lawergren 1993.

5. See the bird-shaped finial with small caprid in its claws in Bunker 1981, no. 780 (detail not noted in description,) and the eagle with cervid on stamped leather fragment from kurgan 2 at Pazyryk in Rudenko 1970, plate 139.1.

6. Loehr 1965b, no. 112.

7. Lawton 1982, no. 13.

8. DeWoskin 1982, pp. 58–59.

9. It must be noted, however, that although Han texts mention only the nomad flute or pipes, the remains of a harplike instrument recovered from a fourth-century B.C. nomadic grave in Pazyryk in south Russia suggest that some form of plucked string instrument was played in nomadic circles. Fryer 1975, p. 66; Lawergren 1990.

also no. 71). The bird with a small animal in its claws, a variation of the animal combat theme, occurs frequently on northern and Central Asian artifacts.[5] A tuning key in the Singer Collection is adorned with a bear on top of a bird;[6] one in the Freer Gallery of Art shows a leopard, bird, and snake locked in combat.[7]

Distinctly northern ornaments for *qin* accessories and the *qin*'s portability logically suggest that the instrument originated among the northern peoples with their mobile way of life. Yet to date, *qin* and *qin*-like instruments have been recovered only in central and south Chinese sites. As the origins of the *qin* are far from understood,[8] and the scarce surviving evidence may be the result of archaeological accident rather than historical reality, the possibility that this classic Chinese instrument—the *qin*—or its unusual tuning system might have been inspired by lost nomadic prototypes warrants serious investigation.[9]
—ECB and JFS

71 *Zither tuning key (qin zhen yao)*

Cast bronze inlaid with gold
Height 10.9 cm
North China
3d century B.C.
Reproduced in color: plate 14, p. 70
The Therese and Erwin Harris Collection

A recumbent, human-head goat figure surmounts this zither tuning key. The human face sprouts pointed goat's ears. The goat's body has legs that end in cloven hooves. The face is realistically rendered with almond-shaped eyes, thick brows, full lips, and a long wavy beard. A horned cap tops its head. Two rows of concentric circles accented with gold inlay, resembling glass eye-beads, decorate the shaft.

The goat-man image dates back to the late fourth millennium B.C. in ancient West Asia. The image apparently survived into the Achaemenid period, when it may have had apotropaic qualities.[1] Images wearing horned caps abound in ancient Mesopotamian art,[2] and a human-head winged ibex decorating a bronze goblet reportedly from Luristan may be ancestral to later images.[3]

A more immediate link between the goat-man on the present tuning key is provided by the recumbent human-

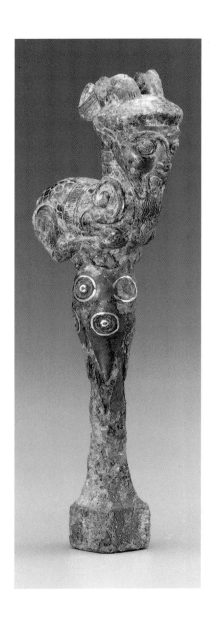

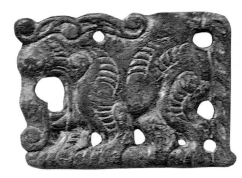

CAT. FIG. 71.1. Gilded bronze plaque, 3d–2d century B.C. The Calon da Collection

represented in the same way (cat. fig. 71.1). The similarities between the Issyk and north Chinese plaques further support a West Asian origin of the image on the present tuning key and suggest the route over which the motif might have traveled.

—ECB and JFS

1. Correspondence between Dr. Edith Porada and Erwin Harris, 1991.

2. *Biblical Archaeology Review* 11, no. 2 (March/April 1985): 38.

3. Schmidt et al. 1989, vol. 2, plate 264a.

4. Porada 1965, p. 146, fig. 79.

5. Davis-Kimball 1991, p. 20.

head bulls with horned headdresses surmounting columns at Persepolis.[4] These monumental architectural figures not only share the man-beast character of the much smaller figure on the present tuning key but also wear the distinctive horned headdress. They also show a similar long wavy beard and overlapping scalelike patterns on the body.

The recent discovery of two fifth- to fourth-century B.C. silver plaques, each showing a winged goat-man, in kurgan 3 at the Issyk cemetery in Kazakhstan, may represent the missing link in the transmission of this motif from ancient West Asia to China[5] (fig. 30). These goat-men are shown in profile with one horn pointing forward and one backward. A pair of gilded bronze plaques similar to Chinese-made plaques of the third and second centuries B.C. depicts a fantastic wolf whose horns are

72 *Zither string anchor (se rui)*

Gilded cast bronze
Height 5 cm, dimensions of top 4.3 x 4.2 cm
North China
2d–1st century B.C.
The Therese and Erwin Harris Collection, formerly Carnegie Museum, Jay C. Leff Collection

A crouching bear with rounded ears, long muzzle, and all four paws shown surrounding its body serves as the domed round cap for a square socket. The bear's ruff continues as outward spirals at both ends to form the ears, a stylistic peculiarity of bear representations during the Western Han period. A set of four such fittings excavated from an early Western Han context outside Xi'an in Shaanxi Province uses the same bear as primary motif.[1] The motif appears frequently on other circular fittings of the period.[2]

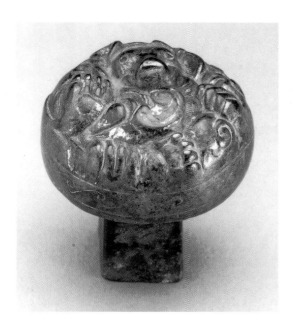

art of the north. The coiled, crouching bear on the present example—an animal more likely found in the forests of the north—is among the most popular, while a mountainous landscape inhabited by animals (fig. 32) is another. These motifs provide another reason for investigating the possible northern origin of or influence on the development of early plucked string instruments in China.
—ECB and JFS

1. Xi'an 1993, no. 20.

2. See also Beijing 1980b, p. 205, fig. 138.16.

3. See Beijing 1986, plates 86–87; Beijing 1989, plate 45; Beijing 1991a, plate 36.1–2.

4. *Bulletin of the Museum of Far Eastern Antiquities* 27 (1955): 105–6, plates 41.1–6.

5. See, for example, set of four anchors from the late-second-century B.C. tomb of the king of Nanyue in Guangzhou, capital of Guangdong Province, in Beijing 1991b, plate 48.1.

6. See nn. 1, 2, 4, 5 above.

Wooden versions of the same objects recovered intact in sets of four at one end of large *se* zithers indicate that they are anchors for the strings, which were gathered into bundles and wound around them[3] (cat. fig. 72.1). Several anchors like the present one in the Museum of Far Eastern Antiquities in Stockholm still retain traces of these strings.[4] Examples like the present string anchor should therefore also come in matching sets of four. The early anchors were often carved from wood; by the second century B.C., they were often cast in bronze.[5]

Although few *se* zithers have survived from the late first millennium B.C., their popularity is evidenced by the large numbers of similar bronze string anchors found in tombs and Western collections.[6] Like the *qin* tuning keys (nos. 70, 71), the most common motifs decorating these *se* string anchors tend to have strong connections with the

73 *Wine cup*

Gilded cast silver
Height 4.1 cm, width at rim 10.7 x 10.5 cm
North-central China
4th or 3d century B.C.
Published: Bunker 1962, no. 69; Bunker et al. 1970, no. 75
Metropolitan Museum of Art, Purchase, Arthur M. Sackler Gift, 74.268.16, formerly Frederick M. Mayer Collection

A shallow oval, flat-bottomed bowl with a heart-shaped rim is adorned with a realistic raptor-head. The exterior rim and the raptor-head are accented with gilding. A number of similar cups are in Western collections, many reportedly from the looted royal Zhou burials in Luoyang, Henan Province.[1] The choice of silver for this group of vessels reflects influence from non-Chinese circles (see entry nos. 56, 58), as does the striking addition of the purely ornamental raptor-head motif borrowed directly from such northern artifacts as nos. 36, 60, 66, 67.[2]

Given the present vessel's northern traits, it would not be surprising to find prototypes of these silver vessels from sixth- to fourth-century contexts in the north.[3] The early versions are supported on three legs; the bird-head actually functions as an ornate spout, and an additional bird on the opposite end serves as the handle.

CAT. FIG. 72.1. Drawing of *se* showing position of string anchors. After Beijing 1986, p. 92, fig. 61

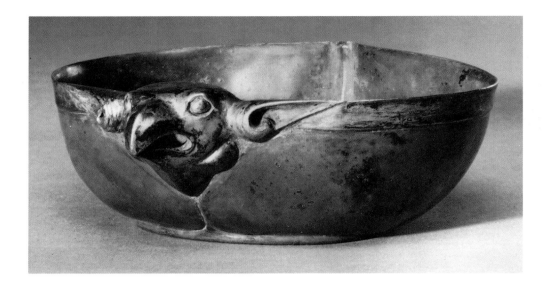

By the late fourth-century B.C., the type had apparently gained popularity in south-central China, evidenced by three similar bird-head vessels recovered from the large tomb at Baoshan, Jingmen Xian, in northern Hubei Province.[4] The vessels are set on flared stems rather than legs and made in gilded bronze and colorfully painted lacquered wood. The bird-heads have lost their functions as spouts, however, serving more as handles. They have also been totally Sinicized, transformed into Chinese phoenixes each with a precious "jewel" in its beak.

Unlike the Baoshan examples, the bird-head ornaments on the present group of silver cups have retained their northern raptorlike character. Their shape, however, reflects an intrusion from south China, where bronze or lacquered wood containers—with flat bottoms and pouring channels—appear frequently in fourth- and third-century B.C. burials of Chu nobles, the "southern barbarians" of the Zhou realm.[5]

Under these circumstances, the alleged Luoyang and royal Zhou provenance of these silver vessels should perhaps be taken seriously. The eclectic combination of northern materials and motifs with a southern shape seems to suggest that this group of raptor-head silver cups should best be regarded as luxury products of Chinese workshops, made as "barbarian exotica" for the tradition-bound Chinese ruling elite in the region of the Zhou capital.

—JFS

1. Examples are in the Seattle Art Museum, Freer Gallery of Art, the Grenville L. Winthrop Bequest to the Fogg Art Museum, Harvard University, and the Carl Kempe Collection in Stockholm. Umehara 1937, plate 44. The Jincun tombs are discussed in detail in So 1995, introduction, section 6.1.

2. See Jacobson 1984 for origin of eared raptor images.

3. For example, see bronze vessels recovered from Jiagezhuang, Tangshan Xian, Beichengzi, Tang Xian, and a pottery version from Yan Xiadu, Yi Xian, all in Hebei Province. *Kaogu xuebao* 1953.6, plate 15; Beijing 1980a, nos. 126, 164.

4. Beijing 1991a, colorplates 6.4, 6.5, 11.3.

5. For bronze examples, see Beijing 1981, plates 26.3–4, 27.1; Beijing 1986, plate 41.3; Beijing 1991a, plates 34.1, 225.3.

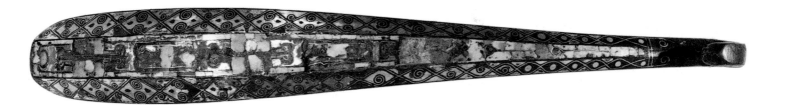

74 *Belt hook*

Bronze inlaid with gold, silver, malachite, and turquoise
Width 17.8 cm, height 2.3 cm
North-central China
Late 4th or early 3d century B.C.
Published: Lawton et al. 1987, no. 158
Arthur M. Sackler Gallery, Smithsonian Institution,
 Gift of Dr. Arthur M. Sackler, s1987.413

The slender club shape, small animal-head hook at one end, and button on the underside near the opposite end are classic features of the Chinese belt hook. The top is divided into three facets. In the center, an irregular pattern of cloisons created by thin strips of gold soldered on edge to the bronze surface is inlaid with turquoise and malachite chips, some missing. Crisscrossing spirals in gold form a lozenge pattern on the flanking facets, contrasted by triangular areas of silver inlay. Even the side edges and the flat top of the button on the underside are inlaid with gold and silver spiral designs. The hook has been restored. The silver has tarnished, but the gold and semiprecious stone inlays have retained much of their original color.

Belt hooks in this shape and decorated with inlaid geometric patterns were manufactured in large numbers in Chinese workshops from the late sixth century B.C.[1] However, inlaid examples using cloisons, a technique that originated in West Asia and was brought to China by nomadic tribes in the north, are rare and did not appear until the third century B.C. Belt hooks decorated with turquoise-inlaid gold cloisons are associated with the third-century B.C. royal Zhou burials at Jincun in Luoyang, Henan Province, and with the late-second-century B.C. tomb of the king of Nanyue in Guangzhou, capital of Guangdong Province.[2] The irregularly shaped cloisons and turquoise chips on the present belt hook

suggest a stage in the Chinese adaptation of this technique earlier than the refined, imbricated patterns of the third- and second-century examples.
—JFS

1. See So 1995, introduction, section 4.2.

2. See Lawton 1982, no. 49; So 1995, introduction, section 6.1, fig. 102; Beijing 1991b, plate 96.3.

75 *Belt hook*

Gilded cast bronze, inlaid with turquoise, jade, and glass
Width 14.2 cm, height 5.8 cm
North-central China
Late 4th or early 3d century B.C.
Reproduced in color: plate 15, p. 71
Published: Lawton et al. 1987, no. 162
Arthur M. Sackler Gallery, Smithsonian Institution,
 Gift of Dr. Arthur M. Sackler, s1987.436

The gilded and sharply convoluted surface of this lute-shaped belt hook portrays a dragon with a large lupine-head and spiral horns facing the dragon-head hook. Turquoise accents its eyes and forehead. A smaller raptorlike head, its sharp beak as if gripping the gilded frame for the pale, yellowish white jade ring in the center, occupies the opposite end. Turquoise cabochons are inlaid into its forehead and cheeks. In its claws are the twisted hindquarters of two does, whose heads appear on opposite sides of the jade ring (see detail). Turquoise also accents each doe's head. A rusty brown, blue, and white glass bead fills the perforated center of the jade. The thick gold cover wraps around the edge of the belt hook on to the underside. The button is missing.

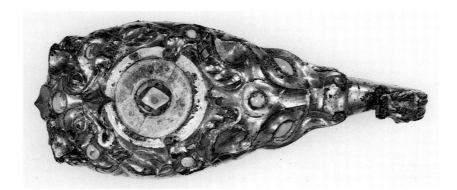

The luxurious effect of the gold, fluted surface and multicolored inlays dominate the animal motifs of the design. Even the drama of the doe in the clutch of the raptor's claws is overshadowed by the glamor of the object. The design of this belt hook can therefore be seen as a civilized and Sinicized version of more brutal nomadic portrayals (compare nos. 50–52, 67, 89–91).

A large, gold-covered silver belt hook, closely resembling the present example in design, motifs, and inlays, was recovered from the fourth-century tomb of a Wei noble at Guweicun in Hui Xian, Henan Province.[1] Similarly extravagant belt hooks, some in solid cast gold, reportedly formed part of the cache from the royal Zhou burials at Jincun in the city of Luoyang, also in Henan

Province.[2] The connection with powerful ruling houses of late Eastern Zhou further indicates that belt hooks such as these were made as extravagant personal ornaments for prestigious members of Chinese society.
—JFS

1. See Lawton 1982, p. 123. The date of the Guweicun tomb is discussed in So 1995, appendix 1, section 6.C.

2. See Lawton 1982, no. 72; also Loehr 1975, no. 476.

Detail, no. 75, showing entangled doe on side of belt hook

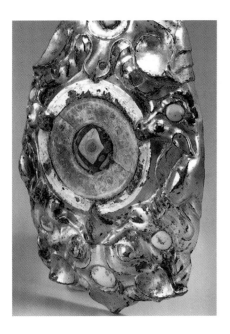

76 *Belt hook*

Cast bronze
Width 9.8 cm, height 4.4 cm
South-central China
1st or 2d century A.D.
Arthur M. Sackler Gallery, Smithsonian Institution,
 Gift of Dr. Arthur M. Sackler, s1987.427

This belt hook takes the form of a large prowling feline with hind legs extended and one front paw raised. Its dotted pelt suggests a leopard. The clump between its mouth and raised paw is perhaps the remains of its prey. The large and rather shapeless hook appears to be a replacement.

The sculptural form, animated pose, and subject matter link this feline with animal-shaped hooks of obvious northern inspiration (see nos. 94–96). The addition of striated wings and hooked crests on its head, neck, and tail, however, mark this feline as a fanciful Chinese creation (compare no. 79), although it has not been completely transformed into the elegant catlike creature of

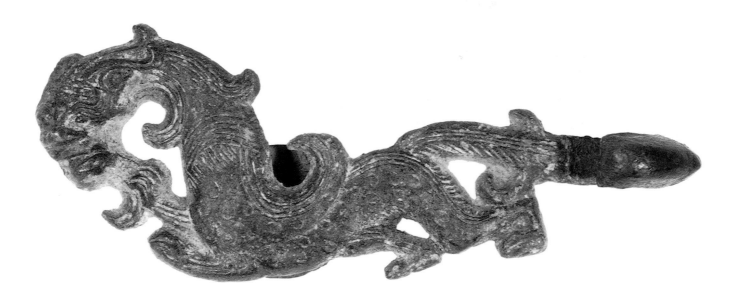

no. 77 or the imaginary hybrid of no. 79. It is therefore not surprising to find similarly Sinicized feline belt hooks in south and southwestern China, where northern and Chinese influences arrived late, at the very end of the first millennium B.C.[1]

—JFS

1. Two almost identical feline-shaped belt hooks were recovered from Eastern Han tombs in Changde Xian, Hunan Province. *Kaoguxue jikan* 1 (1981): plate 25.1–2. A third, unprovenanced example is in Nagahiro 1943, plate 43.119a.

77 *Ornament*

Gilded cast bronze
Width 10.5 cm, height 4.2 cm
North China
1st or 2d century A.D.
The Therese and Erwin Harris Collection, formerly Paul Pelliot
 Collection

A prowling feline in a pose similar to the previous example (no. 76) forms this ornament. Its head, however, turns back against its body and is seen *en face*. The body is undecorated except for large spirals at the haunches and the end of the tail and the patchy remains of gilding.

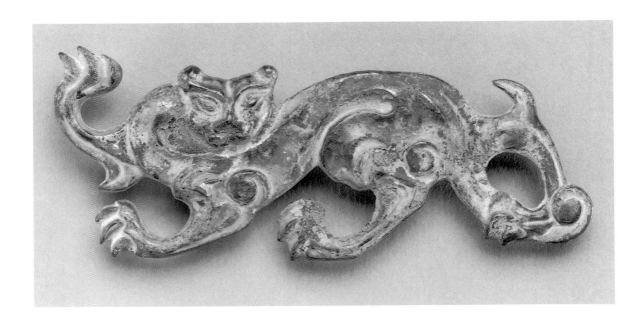

On the back are stumps of two pins like those on the leaping gazelle (no. 78).

Felines with similarly shaped heads seen flatly *en face* often decorate jade pendants and fittings recovered from Western and Eastern Han contexts.[1] One of the jade insets for a pair of earrings recovered from a second-century B.C. Xiongnu grave at Xigoupan, Jungar Qi, southwest Inner Mongolia, shows a similar feline contorted to fit the pear-shaped gold frame.[2] With its northern origin,[3] this Sinicized feline may have been as equally welcome in the north as it was in Chinese circles.

—JFS

1. Yang Boda 1986, nos. 148–52, 162, 172, 176, 190–91.

2. Tian and Guo 1986, p. 381, fig. 4.1 left.

3. The northern origins of this motif are discussed in chapter 5 and entry no. 79.

78 *Ornament*

Gilded cast bronze
Height 7.9 cm, width 3.2 cm
North China
2d century B.C.
Reproduced in color: plate 17, p. 73
The Therese and Erwin Harris Collection

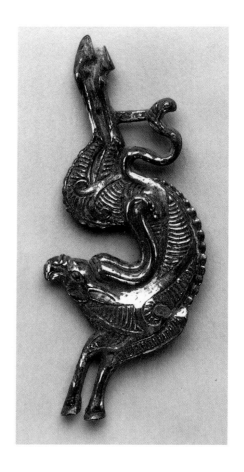

This playful gazelle kicking up its hooves may have originally been an inlay in a larger lacquer object. Its hindquarters are rotated 180 degrees, and its horns together terminate in a raptor-head. Two projecting pins on the flat back are provided for attachment purposes.

The fanciful gazelle exemplifies the best of Han workmanship, while the subject matter and pose of the animal reflect traditions more frequently associated with the northern herding tribes.[1] This delightful ornament exemplifies the exotica that were introduced into Chinese art as *xiangrui* (good omens) during the Western Han period. Similar creatures animate the Chinese decor on the famous painted lacquer Mawangdui coffin.[2]

The startling similarity between this gazelle and the beaked ungulate carved on a small cylindrical bone bead (cat. fig. 56.1), especially the striated enclosures, demonstrates the earlier carving traditions that lay behind this design and much of the art of the herding tribes.

—ECB

1. Rawson and Bunker 1990, no. 234.

2. Bunker 1991b, pp. 580–81, figs. 13, 14.

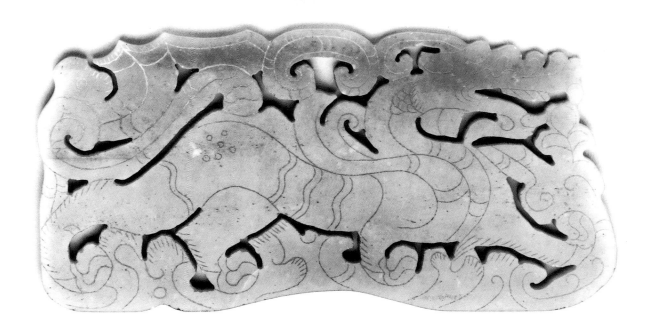

79 *Ornamental plaque*

Translucent pale gray-white jade (nephrite)
Width 18.7 cm, height 9.4 cm
North China
2d or 3d century A.D.
Published: Lawton et al. 1987, no. 67
Arthur M. Sackler Gallery, Smithsonian Institution,
 Gift of Dr. Arthur M. Sackler, S1987.683

The striding animal represented in this openwork jade plaque, with its lupine (or dragonlike) head and winged feline body and limbs, exemplifies the *bixie*—the fabulous Chinese creature often equated with the Western chimera. Here the *bixie* is seen striding defiantly forward, its four paws walking on scalloped scrolls. A long tail sweeps from its rump, where additional flourishes are added to ensure that there is no unnecessary waste to the essentially rectangular shape of the jade slab. Fine wavy lines as well as circlets mark the creature's body, so that its exact identity (tiger or leopard) is ambiguous. The plaque is decorated in the same way on both sides.

Large jade plaques such as this one were probably used to compose small decorative screens[1] or as ornamental insets in larger furnishings found in tombs of Chinese nobility from the Western and Eastern Han periods.[2] The subject matter, however, derives from the north. A similar jade plaque in the Musée Guimet of Paris, showing a tiger on scalloped scrolls, echoes northern bronze belt plaques with the same motif[3] (compare nos. 50–52, 89, 90). A pair of smaller openwork jade belt plaques features a recumbent camel—another favorite steppe theme (compare no. 61)—also embellished by typically Chinese scalloped scrolls.[4] Chinese jade plaques with similar dragon designs, inset into gold earrings, were also favored by Xiongnu nobility[5] (fig. 33). By the end of the first millennium B.C., northern influence had infiltrated the art of jade working—the most ancient of Chinese traditions—and left its stamp on jade decoration of the Western and Eastern Han periods.
—JFS

1. See Yang Boda 1986, no. 192.

2. Four such plaques, each measuring about 14.5 x 6.5 centimeters, were inset into the sides of a gilt bronze pillow from the tomb of the Western Han prince Liu Sheng in Mancheng Xian, Hebei Province. Beijing 1980b, colorplate 11, p. 80, fig. 53.

3. See Bunker et al. 1970, no. 78.

4. Yang Boda 1986, no. 180. These were recovered from a first-century B.C. tomb in the city of Changsha in Hunan Province.

5. Ibid., no. 183.

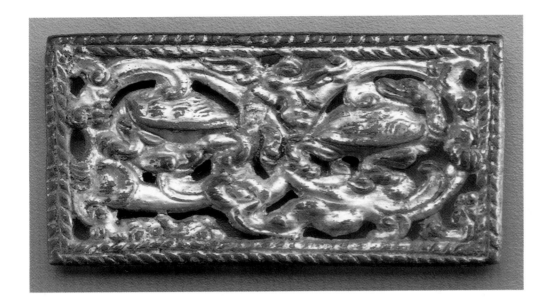

80 *Belt plaque*

Gilded cast bronze
Width 8.8 cm, height 4.6 cm
North China
2d century B.C.
The Calon da Collection

A twisted rope border serves as a rectangular frame for an openwork design showing a large dragon with its 8-shaped body wrapped around two tortoises. The dragon has a lupine head seen in profile, just like the head of the animal on the jade plaque (no. 79). Two angular loops on the back are for attachment. A pair of belt plaques with identical designs, also executed in openwork, was recovered from the late-second-century B.C. tomb of the king of Nanyue in Guangzhou, Guangdong Province.[1]

As a type, matched pairs of rectangular belt plaques are clearly northern (see nos. 61, 63–66), but the form of the dragon is Chinese (see entry no. 79). It is striking that the combination of dragon and tortoise has been found on a bronze basin made for the late-fourth-century B.C. king of Zhongshan,[2] rulers of non-Chinese origins who had settled near Pingshan Xian, northern Hebei Province, and that the same motif should, two centuries later, become an established cardinal symbol for north in Han mythology.[3]

—JFS

1. Beijing 1991b, colorplate 19.1 right; plate 96.1, drawing on p. 166, fig. 104.1.

2. The motif decorates the interior of a bronze basin from the tomb. See So 1995, fig. 66.2.

3. See Cohn 1940–41 for a discussion of the Han symbols for the four cardinal points.

81 *Horse bit*

Height of each cheekpiece 13.2 cm, width of bit 10.6 cm
North China
1st–2d century A.D.
Published: Rawson and Bunker 1990, no. 233
The Therese and Erwin Harris Collection

This horse bit for a riding bridle consists of two S-shaped cheekpieces executed in scalloped openwork linked by a mouthpiece constructed from three ring-and-bar sections. The delicate design and unusually small size suggest that this gear was suited more for ceremonial (or burial) than for daily use. A set of four identical bits was recovered from a second-century A.D. tomb in Huayin Xian, Shaanxi Province.[1]

The flat, S-shaped cheekpiece originated outside of China.[2] The first of these to appear in Chinese territory during the late third century B.C. are simple S-shapes.[3] By the late second century B.C., scalloped fringes adorned the broad ends.[4] Openwork scalloped fringes began to appear on cheekpieces from late-first-century

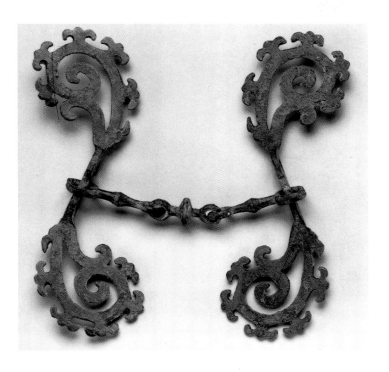

82 Ornament

Gilded cast bronze
Dimensions 5.4 x 5.0 cm
North China
2d century B.C.
Reproduced in color: plate 16, p. 72
The Calon da Collection

This thickly gilded round ornament is decorated by a fantastic creature with a bird-head, cloven front hoof, hindquarters twisted 180 degrees, all coiled to fit into a thick, twisted, ropelike frame. Only one of three hooked excrescences remain to project from the edge of the roundel; the other two have broken off. A small loop is located in the center on the underside.

Fantastic, composite creatures with twisted hindquarters originated in nomadic contexts during the last centuries B.C. (see figs. 21, 31; also nos. 50, 66, 78). The elegance of the present roundel, however, signals a Sinicization of this northern motif often associated with princely tastes of the Western Han period.[1] In design, it is linked directly with other popular fittings of the period that are decorated with animals wrapped around themselves to fit the circular format (see no. 72).
—JFS

B.C. graves.[5] The elegantly formed S-shaped cheekpieces in this example represent a direct development from these earlier types, using ornamental vocabulary shared by other luxury fittings of the time (compare no. 79).
—JFS

1. *Kaogu yu wenwu* 1986.5, p. 50, fig. 5.11. The tomb is identified with a Han noble who died during the second quarter of the second century A.D. Ibid., p. 56.

2. Rawson and Bunker 1990, entry no. 233.

3. For example, see bits that have survived on the terracotta horses from the tomb of the Qin Shihuangdi. New York 1980, no. 102.

4. See examples from Liu Sheng's tomb at Mancheng Xian, Hebei Province. Beijing 1980b, plates 141.1, 142.3.

5. *Wenwu* 1990.1, p. 11, fig. 20.6.

1. Compare, for example, the coiled animal on a set of four gilt bronze roundels from the early-second-century B.C. tomb of a Han prince near Zibo City in Shandong Province. *Kaogu xuebao* 1985.2, p. 249, fig. 23.14.

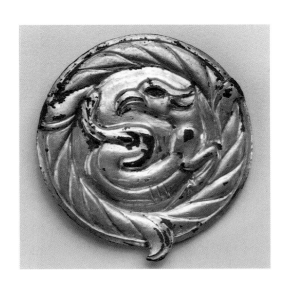

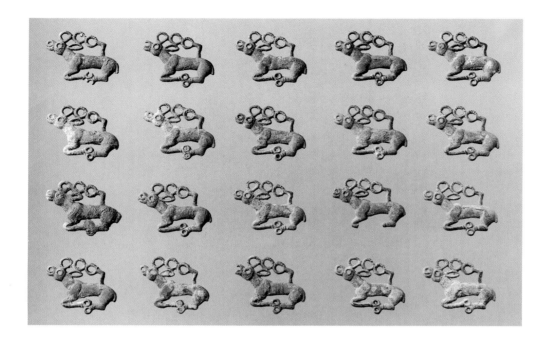

83 Set of twenty garment ornaments

Cast bronze
Average width 4.3 cm, height 3.1 cm
Northeast China
6th century B.C.
Leon Levy and Shelby White Collection

These twenty stags once served as personal ornaments for a member of a non-Chinese tribe living in the frontier region of northeast China. Each stag is depicted in profile with its legs folded in such a way that the back legs overlap the forelegs and its antlers turned into a series of tangent circles. This characteristic pose for representing stags had developed throughout the Eurasian steppes by the early first millennium B.C. It can be seen on numerous stag stones found throughout southern Siberia and Mongolia.[1] Each stag plaque has a long horizontal loop on the back extending from the rump to the chest for attachment purposes (see detail).

Similar stag images have been collected from various northern frontier regions east of the Taihang Mountains, but seldom under scientific circumstances. The recent publication of excavations undertaken in northern Hebei Province have now provided a cultural context for such images. Burials dating about the sixth century B.C. at Ganzibao, Huailai Xian, in northern Hebei Province, have revealed graves in which the dead were literally covered with animal-shaped ornaments, just as they are at

related sites in Jundushan, Yanqing Xian, north of Beijing (cat. fig. 83.1). Deer with folded legs and their antlers transformed into a series of circles occur in tomb 3.[2]

The present set of stag plaques demonstrates the importance of keeping duplicates together. A tiny, lone stag could never equal the impact achieved by twenty. Five very similar gold stags from the Carl Kempe Collection in Stockholm[3] reinforce the observation that status was partially expressed by the metal from which personal heraldic ornaments were cast.

Detail, no. 83, showing back of one ornament

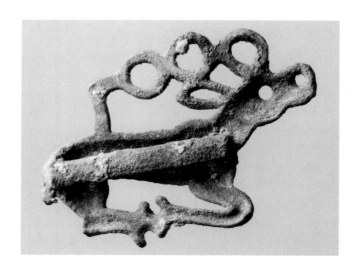

These stag images are not related to stag images found in burials in the Ordos area and northwest China west of the Taihang Mountains. Instead, their style relates more to stag images found in southern Siberia and Mongolia and provides further evidence for some contact, as yet unexplained, between China and northeastern tribes via the Amur valley.

—ECB

1. Tchlenova 1963, pp. 66–67, tables 1–2.
2. *Wenwu chunqiu* 1993.2, p. 31, fig. 9.4.
3. Gyllensvärd 1953, pp. 82–83, figs. 25–26.

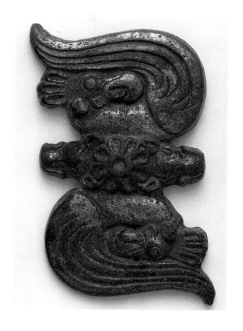

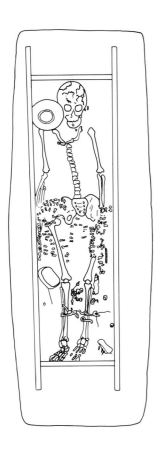

CAT. FIG. 83.1. Drawing of tomb 156, Jundushan, Yanqing Xian, Beijing, 6th–5th century B.C. After *Wenwu* 1989.8, p. 23, fig. 9

84 *Belt ornament*

Tinned cast bronze
Height 4.5 cm, width 3.7 cm
Northwest China
5th–4th century B.C.
Published: Bunker 1981, no. 900
Los Angeles County Museum of Art, Gift of the Ahmanson
 Foundation, M.76.97.641, formerly Heeramaneck Collection

This belt ornament depicts two winged birds above and below a central rosette that is flanked by two boars' heads seen from above. Each bird-head has a small ear and a prominent crest. The birds are shown in profile with sweeping curvilinear wings and their heads rotated 180 degrees. The back has a vertical loop placed behind the concave rosette. The front surface has been deliberately tinned to give it a shiny white appearance and to indicate that its wearer had a status higher than one who wore plain bronze belt ornaments.

The birds have been reduced to conventional designs that can ultimately be traced back to Western Zhou bird images found on vessels.[1] Even the birds with ears can be found on Western Zhou vessels.[2] These birds have been inaccurately described as griffins and the surface as silvered.[3] The birds have round eyes, while the mythical griffin has almond-shaped animal eyes.

The shape and zoomorphic theme of the ornament are northern, but the execution and decorative style are Chinese. Similar ornaments with almost identical deco-

ration have been recovered from the Qingyang region of southeastern Gansu Province, where they were worn as belt ornaments by the herding tribes during the fifth century B.C.[4] The Qingyang ornaments were probably made by Qin artisans during the late fifth to fourth century B.C. to appeal to northern taste, as were this ornament and no. 54.

—ECB

1. Rawson 1990, nos. 53–54.

2. Rawson 1990, no. 91.

3. Bunker 1981, no. 900. The mistakes were changes in the wording by the editor, not the curator.

4. *Kaogu* 1988.5, p. 420, fig. 17.4.

85 *Belt ornament*

Tinned cast bronze
Height 4.8 cm, width 2.5 cm
Northwest China
5th–4th century B.C.
The Therese and Erwin Harris Collection

This belt ornament is adorned with two stylized carnivore-heads in profile, joined by a central boss and attached to serpentine bodies marked longitudinally with two rows of raised spheres that suggest granulation. The

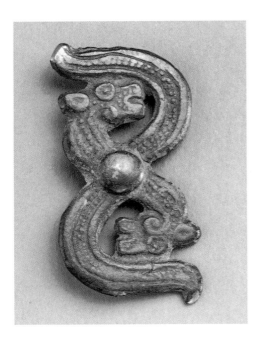

front surface has been tinned, and the back shows a vertical loop behind the boss.

This type of belt ornament was worn in multiples (fig. 35) and was decorated with either a bird-head or a carnivore-head. Twelve similar belt ornaments with bird-heads were found near Qingyang in southeastern Gansu Province with a buckle similar to no. 53.[1] The surface decoration and the pseudogranulation relate to Qin workmanship of the late fifth century B.C.

—ECB

1. *Kaogu* 1988.5, p. 414, fig. 2.11–12.

86 *Four belt ornaments*

Tinned cast bronze
Height x width: (a) 5.6 x 3.0 cm, 5.3 x 2.9 cm, (b) 4.4 x 2.8 cm, 4.1 x 2.8 cm
North China
6th–4th century B.C.
(a) The Calon da Collection, (b) Walters Art Gallery, Baltimore, 54.1902–1903

Belt ornaments similar to these have been found in most of the burials belonging to herding tribes throughout the northern zone west of the Taihang Mountains. Like these four examples, the majority are tinned by being dipped in or wiped with molten tin without the benefit of mercury.[1] Each ornament has a vertical loop behind the central boss.

a

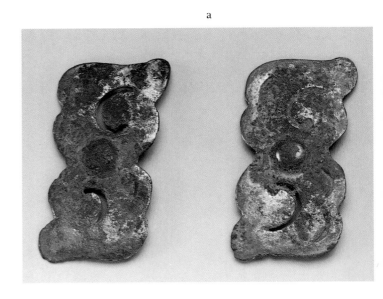

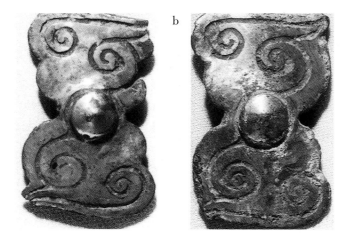

The scrolled design derives from earlier belt ornaments in the form of raptors or carnivores with serpentine bodies similar to nos. 84 and 85. These designs derive ultimately from zoomorphic patterns found on early Eastern Zhou Chinese jades.[2] Whether these ornaments were all made at one Chinese metalworking center or several, or possibly by itinerant Chinese artisans, is unclear.

—ECB

1. Han and Bunker 1993.

2. For an investigation of the ancestry of these scrolled belt ornaments, see Tian and Guo 1986, pp. 115, 117, 165, 272–73, figs. 40–41, 81, 82, 113.

87 *Buckle*

Tinned cast bronze
Height 6.2 cm, width 4.5 cm
Northwest China
5th–4th century B.C.
Published: Bunker et al. 1970, no. 91
Metropolitan Museum of Art, Rogers Fund, 24.180.4

This small buckle is decorated with a recumbent hoofed animal surmounting an undulating double-headed snake marked by a pseudogranulation pattern. The surface of the buckle has been deliberately tinned to give it a shiny appearance, typical of many belt ornaments found in the northwest. A small hook, now much worn, is placed on the front in the middle of the snake, and a small horizontal loop occurs on the back behind the animal.

An almost identical buckle was recently found near the hip of the deceased in a burial at a cemetery near Mazhuang, Yanglangxiang, belonging to the herding tribes that inhabited southern Ningxia Hui Autonomous Region during the fifth or fourth century B.C.[1] The positioning of the hooves in this folded-leg pose is quite different from that seen on the twenty stags from the

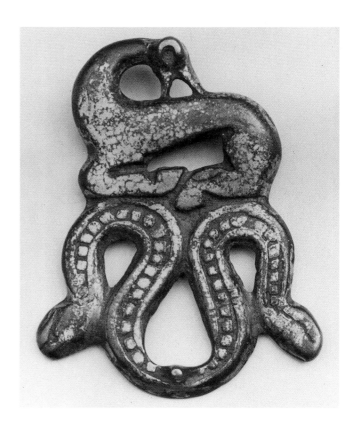

northeast (no. 83). Here the hooves on the forelegs face up and the hooves on the back legs face down, so that the bottoms of all the hooves are parallel to a hypothetical ground line. This conventionalized positioning of the hooves occurs earlier in Qin art than in the art of the herding tribes.[2]

Recent research has demonstrated that artifacts belonging to the herding tribes in the Qingyang region that are decorated with snakes and pebbled textures were probably made in Qin workshops in Shaanxi Province.[3]
—ECB

1. *Kaogu xuebao* 1993.1, p. 32, fig. 18.12.

2. Tchlenova 1963, p. 167, table 2; *China Pictorial* 1987.5, p. 15.

3. So and Strahan 1995.

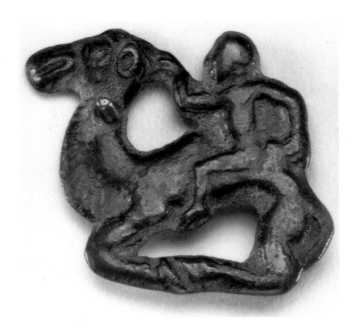

88 *Buckle*

Cast bronze
Length 4.8 cm, width 4.2 cm
Northwest China
4th century B.C.
Published: Salmony 1933, plate 29.3; Janse 1935, plate 9.36
The Therese and Erwin Harris Collection, formerly David-
 Weill and C. T. Loo Collections

This small belt plaque is cast in the shape of a kneeling, two-humped Bactrian camel and rider. Camels are so tall that they must be trained to kneel so the rider can mount. The camel is shown in profile, and the rider is shown with his back turned to the viewer. He holds the camel rein in the left hand while urging the camel to get up and get going by hitting the rump with a stick held in his right hand. His face is shown in profile with a very prominent nose, identifying him as a foreigner who has arrived in northwest China via the trans-Asian Silk Route. A hook projects from the camel's neck on the front of the plaque, and a vertical loop is placed on the back behind the camel's rump.

A very similar but more elaborate plaque was discovered in the Ningxia Hui Autonomous Region.[1] The Ningxia example is a mirror-image plaque and has no hook, suggesting that the present plaque may once have had a matching plaque to complete the buckle. The popularity of belt ornaments depicting camels (see nos. 5,

61, 62, 97) reflects the local preference for these "ships of the desert," without which the great trans-Asian trade of the Han through Tang periods would not have been possible. Camels were extremely important for the Han, who developed a whole hierarchy of camel specialists to tame and handle them.[2] As late as the twentieth century, herds of wild camels still roamed Ningxia in the vicinity of Etsingol.[3]
—ECB

1. Japan 1992, no. 64.

2. Schafer 1950, pp. 176–77.

3. Ibid.

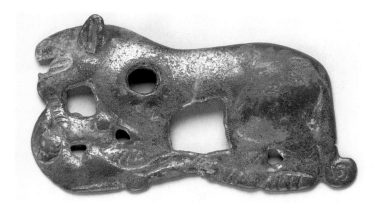

A similar standing carnivore image without a victim was excavated from tomb 55 at Maoqinggou, Liangcheng Xian, south-central Inner Mongolia.[1] The Maoqinggou example also possesses an ear that projects out from the head in the same way the ear projects out in three-dimensional form on the present plaque, suggesting that it may have come from the Liangcheng region. Another tinned bronze carnivore plaque collected in the same general area has the same raised front paw and projecting ear as the present plaque and is also about to dispatch a ram.[2]
—ECB

1. Tian and Guo 1986, colorplate 9.3.
2. Ibid., plate 70.2.

89 *Belt plaque*

Tinned cast bronze
Width 12.4 cm, height 6.8 cm
South-central Inner Mongolia Autonomous Region
5th century B.C.
Reproduced in color, plate 19, p. 80
The Therese and Erwin Harris Collection

A standing carnivore with its front paws holding down a ram lying on its back forms this belt plaque, which was originally one of a mirror-image pair. The carnivore is shown in profile with all four legs represented and prominent clawed paws. A circular hole that was part of the buckling system pierces the carnivore's shoulder. The front surface of the plaque has been intentionally tinned. The back is slightly concave and displays the remains of two small vertical attachment loops.

90 *Belt plaque*

Tinned cast bronze
Width 9.3 cm, height 4.3 cm
Northwest China
4th century B.C.
Published: Rawson and Bunker 1990, no. 208
The Therese and Erwin Harris Collection

A standing wolf menacing a recumbent ram under its jaws and one forepaw decorates a belt buckle that originally consisted of two plaques with mirror-image designs. Although very similar to no. 50, this plaque is

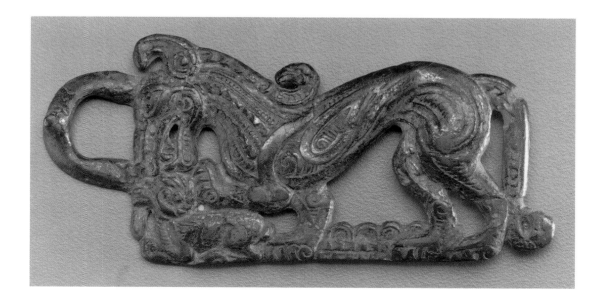

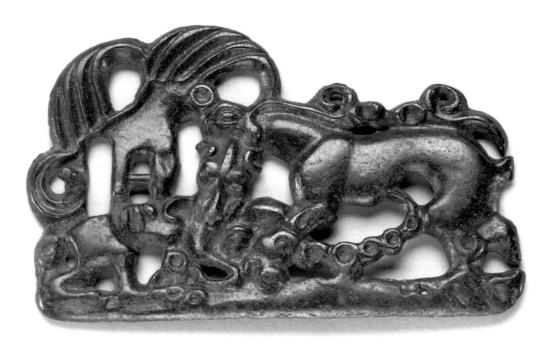

slightly later in date. The wolf image is the same, but the ram is now shown in a stereotyped pose that lacks the drama expressed by the contorted body of the victim in the earlier animal attack scene. The pup that crouches between the wolf's legs on the earlier plaque has been reduced to a series of scalloped forms, suggesting that the artist did not understand the original composition.

This plaque displays a tangent loop and hook that belong to the fastening system. The back of the plaque has a vertical loop behind the haunch. A matching plaque in the Asian Art Museum of San Francisco has attachment loops on the back but no tangent loop or hooks.[1] A careful examination of the surface of this plaque reveals that it was tinned, although much of this surface enrichment has now worn off.

The presence of a raptor-head at the end of the wolf's manelike crest and the possibility that the worn tip of the tail is also a raptor-head relates this belt ornament to the iconography introduced during the late fourth century B.C. from farther west by pastoral tribes set in motion by Alexander's Central Asian campaigns. The essentials of the wolf have been realistically represented, but the patterns on the pelt derive from carved wood or bone, stamped leather, appliqué, and textile patterns that were part of the herding tribes' artistic traditions. Belt ornaments such as this one have been collected from disturbed burials throughout southern Ningxia Hui Autonomous Region but remain unpublished. They were probably commissioned from Qin workshops that

must have used objects made of carved wood or appliquéd fabrics and felts as models for their finished products.

—ECB

1. Bunker 1988a, pp. 58–59.

91 *Belt plaque*

Cast bronze
Width 10.7 cm, height 6.6 cm
North China
3d century B.C.
The Therese and Erwin Harris Collection

A three-way animal combat scene enhances the front of this belt plaque. A fantastic raptor stands on the body of a fallen wild goat that is being attacked by an equally fantastic carnivore. The goat has collapsed and is shown in profile, with its long, ridged horns extending under the carnivore's belly. With its front paws, the carnivore clutches the goat and bites it in the neck, as the raptor bites the carnivore's neck.

The raptor's almond-shaped animal eye and the carnivore's raptor-head tail and crest tips connect these two predators to the mythological system that appeared sud-

denly during the fourth century B.C. on China's north-western frontiers. In spite of the fantastic nature of this scene, the combat is probably based on actual observation of real life. Descriptions of wolves and eagles contesting their prey abound in travel literature concerning Central Asia.[1]

This plaque was originally one of a mirror-image pair that together formed one belt buckle, as indicated by the discovery of a complete buckle in grave 7 at Derestui near Lake Baikal.[2] A secure third-century B.C. date for the present plaque is provided by a plaque excavated from a Qin period tomb at Zaomiao in the city of Tongchuan Xian, Shaanxi Province.[3]

An earlier version of this combat scene appears on a gold sheet ornament worked in repoussé that was excavated at Xigoupan in Jungar Qi, western Inner Mongolia,[4] indicating that this mythological combat was first portrayed by the herding tribes locally in repoussé, a goldsmith's art, before it was cast in bronze. Whether such bronze plaques were cast locally or made to order at nearby Chinese centers has not yet been determined. An examination of the piece suggests that it was cast by the indirect lost-wax process. A gilded example of this same composition is in the Mengdiexuan Collection.[5]

—ECB

1. Andersson 1932, plate 33.2.

2. Minns 1942, plate 18.

3. *Kaogu yu wenwu* 1986.2, p. 10, fig. 4.17.

4. *Wenwu* 1980.7, p. 2, fig. 3.2.

5. Rawson and Bunker 1990, no. 217; White and Bunker 1994, no. 28.

92 *Belt hook*

Tinned cast bronze
Width 9.4 cm
West-central China
5th century B.C.
Reproduced in color: plate 18, p. 79
The Calon da Collection

This small belt hook is undecorated except for a crisply shaped bird-head hook. Its striking features, however, are the identical bird-head located on the underside in place of the usual round button and a second smaller

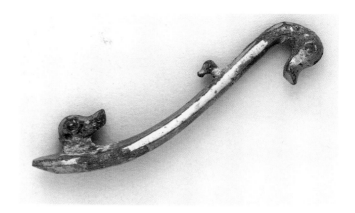

bird-head, also on the underside facing the opposite direction, about halfway between the two larger ones. The smooth surfaces have been deliberately tinned to a shiny, silvery color.

A virtually identical belt hook, but without the second bird-head hook on the underside, was recovered from a fifth-century grave in predynastic Qin territory in Zaomiao in Tongchuan Xian, Shaanxi Province.[1] For reasons as yet unknown, bird-head belt and garment hooks seem particularly common among grave goods in predynastic Qin territory,[2] as is the practice of tinning (see nos. 53, 54, 104). However, examples with three bird-heads, such as the present belt hook, are still rare. The extra small hook on the underside may have served to align more than one belt hook worn on a wider belt.

—JFS

1. *Kaogu yu wenwu* 1986.2, p. 11, fig. 5.8. The report indicates that it was "silvered" (p. 8); more likely it was also tinned like the present belt hook.

2. See representative examples from Gaozhuang, Fengxiang Xian, Shaanxi Province, in *Kaogu yu wenwu* 1981.1, p. 30, fig. 19.

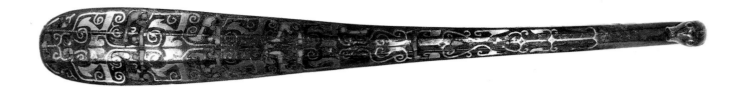

93 *Belt hook*

Cast bronze inlaid with gold and turquoise
Width 20.6 cm
North-central China
5th or 4th century B.C.
Arthur M. Sackler Gallery, Smithsonian Institution,
 Gift of Dr. Arthur M. Sackler, s1987.414

The slender club shape, three-faceted top, and geometric patterns accented with gold and turquoise inlays are typical features of Chinese belt hooks made in the fifth century B.C. (compare no. 74). The small hook is shaped like an animal-head, and a button is located toward the broad end. Belt hooks with similar shapes and symmetrical scroll patterns inlaid with gold or turquoise bits are known from wide-ranging locations in north-central China, indicating that they were particularly popular among the Chinese population at the time.[1] Innumerable clay casting molds for belt hooks in this shape with similar designs recovered from the sixth- to fifth-century B.C. foundry site in the town of Houma, Shanxi Province, demonstrate that most were made in Chinese workshops.[2]
—JFS

1. An almost identical belt hook was recovered from Xingtai Xian, Hebei Province. Beijing 1980a, plate 110 top. Similar belt hooks, some inlaid in gold only, have also been recovered from Fenshuiling, Changzhi Xian, Shanxi Province. *Kaogu* 1964.3, plate 5.20, p. 133, fig. 24.1.

2. The Houma foundry is discussed in So 1995, introduction, sections 4.2, 4.3.

94 *Belt hook*

Cast bronze
Width 10.5, height 4.7 cm
North or northeast China
7th or 6th century B.C.
The Therese and Erwin Harris Collection

A tiger with head regardant forms the main body of this belt hook. The undecorated hook extends toward the wearer's left from the animal's chest, and an oversize button is located under its frontquarter. Rounded parallel ridges, reminiscent of those on the harness ornament (no. 33), cover its entire body to suggest a striped pelt. Its exaggerated paws echo those on the felines of nos. 28, 31,

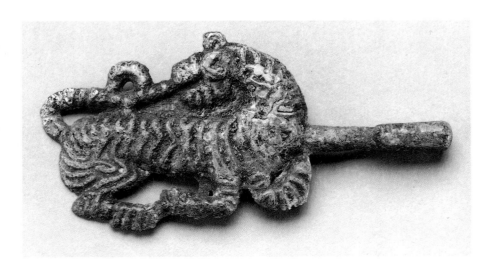

and 89. One hind leg and paw seem to be missing. The long tail turns back to rest in a loop on the tiger's rump. Bits of coarse fabric adhere to the surface of the belt hook.

This belt hook belongs to a small group of tiger-shaped hooks known since the early 1940s but not duplicated in excavated contexts[1] (see also no. 95). The closest parallels are the small animal-shaped hooks recovered from sixth-century northern graves at Jundushan, Yanqing Xian, in northern Hebei Province[2] (see no. 96; cat. fig. 95.1). Tigers with bodies grooved to suggest striped pelts also decorate the hilt of a dagger from an earlier site in southeast Inner Mongolia.[3] The subject matter, representational style, rugged workmanship, and arbitrary addition of the hooked extension, as well as related archaeological evidence, tend to link belt hooks like the present one with tribes on China's northeastern borders.
—JFS

1. Most of these are published in Nagahiro 1943, plates 41–42.
2. The site is discussed in chapter 3. Most of the Jundushan hooks display other real or fantastic animals rather than tigers.
3. *Kaogu xuebao* 1980.2, p. 153, fig. 6.2.

95 *Belt hook*

Cast bronze
Width 10.4 cm, height 6.0 cm
North or northeast China
6th century B.C.
Published: Bunker et al. 1970, no. 83.
Anonymous loan

Another tiger, head regardant, forms the main motif of this belt hook. Only one front and one hind leg are depicted, both ending in three-clawed paws. Intaglio stripes mark its body from neck to tail. A plain bar extends from the back of the tiger's neck to form the hook, which is now broken. A small button issues from the underside.

The fluid lines of this tiger's body and pose resemble the animal decorating the lid of the *ding* (no. 24). Its stripes, however, appear to be flatter and schematized versions of those on the previous tiger belt hook (no. 94). Similar intaglio stripes decorate the body of an animal-shaped hook from non-Chinese graves at Jundushan, Yanqing Xian, in northern Hebei Province[1] (cat. fig. 95.1).
—JFS

1. A virtually identical hook was recovered from another site in northern Hebei Province. *Wenwu chunqiu* 1993.2, p. 33, fig. 13.7.

CAT. FIG. 95.1 Bronze hook from Jundushan, Yanqing Xian, Beijing, 6th century B.C. Width ca. 5.1 cm

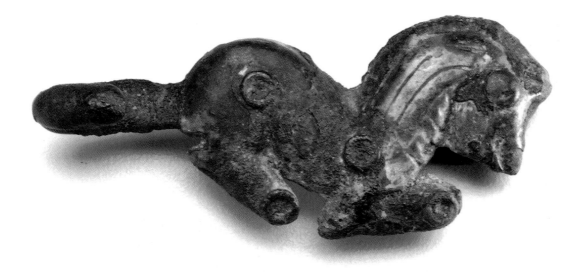

96 *Belt or accessory hook*

Cast bronze
Width 5.8 cm, height 3.0 cm
Northeast China
6th century B.C.
The Therese and Erwin Harris Collection

This small hook is in the shape of a horse with front and back legs bent forward. Unlike the preceding tiger-shaped belt hooks (nos. 94, 95), the plain hook extends from the horse's rump toward the wearer's right. Furthermore, two (not one) buttons issue from the underside (see detail). Circlets accent the horse's eye, haunch, and hoofs, while a few intaglio lines with curled ends decorate its body.

A variety of small animal-shaped hooks, also equipped with two buttons on the back and hooks that extend to the wearer's right, have been recovered from nomadic graves in Jundushan, Yanqing Xian, north of

Beijing[1] (see cat. fig. 95.1). Among them is a horse-shaped hook virtually identical to the present example[2] (cat. fig. 96.1). The only two-buttoned hook published by Toshio Nagahiro also shows the hook extending in the same direction.[3]

Their locations inside the graves indicate that such hooks were worn around the waist,[4] but the reasons for two buttons on a hook of such small size and the different orientation of the hook are perplexing. It is possible that these small, two-buttoned, animal-shaped hooks were not used to fasten the ends of a belt, but rather for the attachment on the belt of personal accessories, such as daggers, knives, or small tools.[5] The hook and buttons would therefore be oriented vertically, and the two buttons, inserted through vertically aligned slits in the belt,

CAT. FIG. 96.1 *Below left.* Bronze horse-shaped hook, Jundushan, Yanqing Xian, Hebei Province, 6th century B.C. Width ca. 5 cm.

Detail, no. 96, showing back of hook with two buttons

would ensure that the horse plaque remained flat even under the weight of its burden. Since daggers, knives, and tools also formed a large part of the grave furnishings at Jundushan (see chap. 3), it would be reasonable to assume that some kind of device for carrying them on the belt would be necessary.

—JFS

1. Preliminary reports have appeared in *Wenwu* 1989.8, pp. 17–35. See also chap. 3.

2. The Yanqing example was found hooked on to a ring.

3. Nagahiro 1943, drawings plate 10.71.

4. See, for example, the location of a gazelle-shaped hook from another nomadic grave in Liaoning Province. *Wenwu* 1989.2, p. 54, fig. 5. Note that its hook also extends to the wearer's right, like the present example.

5. See Lawton 1982, pp. 90–91, for excavated evidence of accessory hooks.

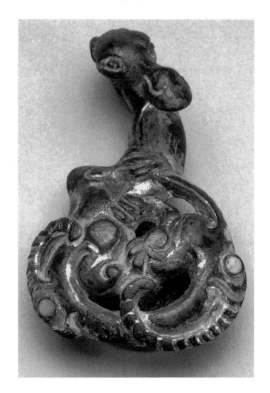

97 *Belt or accessory hook*

Gilded cast bronze inlaid with turquoise
Width 4.5 cm, height 3 cm
North China
3d or 2d century B.C.
Reproduced in color: plate 20, p. 82
The Therese and Erwin Harris Collection

Unlike the previous animal-shaped hooks (nos. 94–96), the camel that forms this hook is wrapped around itself, with its neck and head issuing as the hook. This ingenious design is made even more striking by the twist of the camel's neck and the placement of the camel's head aslant, both features unduplicated in known examples of the type. The modeling and casting are crisp and bold, and the camel's head is particularly expressive of the animal's character. Much of the gilding has worn off, although turquoise remains in the circular sockets. The silver-colored button on the underside is almost the size of the camel's body.

The circular design of this camel hook is reminiscent of similar designs featuring gilded bears and other creatures (see nos. 72, 82). It is, however, an inspired variation on a popular theme, a creation of Chinese artisans who used clay models like the one in the Freer Gallery of Art (see cat. fig. 62.1) and made other luxury fittings with similar designs (nos. 58, 72, 82). Its circular format makes it difficult to determine precisely how the hook should be worn—horizontally like a belt fastener (compare nos. 94, 95) or vertically as an accessory hook suspended from the belt (compare no. 96).

—JFS

98 *Belt buckle with chain*

Cast bronze
Width 6.8 cm, height (without chain) 5.4 cm
North or northeast China or Inner Mongolia
6th or 5th century B.C.
The Therese and Erwin Harris Collection

An openwork pattern of irregularly intertwined serpents constitutes the squarish end from which a rounded loop with a fixed outward-projecting tongue extends. Oblique striations decorate the buckle and the serpentine bodies. Two loops hold the remains of linked chains below, constructed of rings linked by 8-shaped connectors that are also decorated with a diagonal pattern. A button issues from the underside.

The buckle with fixed tongue is a belt and harness fas-

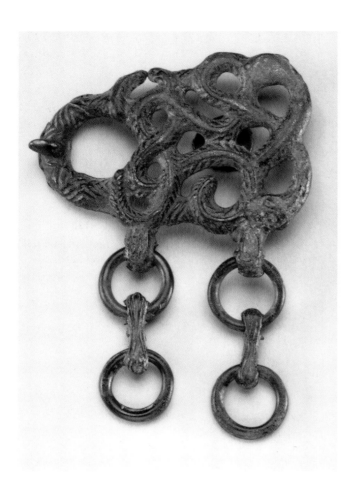

tice of wearing two belts, but exactly how the chains were worn and what purpose they served remain unclear (see entry no. 102).

—JFS

1. Bunker 1993; Bunker 1994b, pp. 40–41, 47.

99 *Belt buckle*

Tinned cast bronze
Width 4.8 cm, height 5.2 cm
North China
5th century B.C.
The Therese and Erwin Harris Collection, formerly von Bissing
 Collection

A medley of three animals, one large and two small, embellishes this buckle. Each is distinguished by round or crescent-shaped openings on the shoulder and haunch. A fixed tongue projects from the neck of the largest animal, and a circular button issues from the back at the opposite end. The remains of two loops at the bottom once held linked chains like those on nos. 98 and

tening device of northern origin. Chinese influence is clearly evidenced, however, by the button, a feature not usually associated with the buckle but rather borrowed directly from the Chinese belt hook. Furthermore, the difference between the construction of this chain (see also nos. 102, 103) and the construction of nomadic chains (see fig. 35b) suggests different places of manufacture. Nomadic chains are formed by mechanically linking cast or hammered rings together; chains like the present example consist of 8-shaped connectors that were cast onto the rings to form a long chain. Linked chains cast in multiple steps are typically used on bronze vessels of Chinese manufacture during the Eastern Zhou period (see no. 21). This complicated method of making chains was eventually replaced by loop-in-loop chains formed by hammering, not casting.[1]

The serpents' striated bodies, their irregular interlace, the complex chains, and the crisp workmanship link this buckle with the openwork scabbard ornament (no. 42), suggesting that it, too, was probably made in Chinese workshops for northern consumption. Such belt buckles with linked chains may be related to the northern prac-

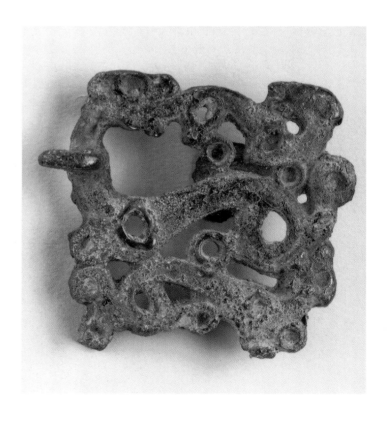

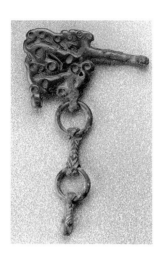

CAT. FIG. 99.1. Bronze belt hook, 5th century B.C. Width 7.2 cm. The Therese and Erwin Harris Collection

possibility that buckles like this one were manufactured in Chinese workshops and exported to northern markets is supported by the discovery of similar buckles with linked chains in northern Shaanxi Province (see entry nos. 100–102). A further technical detail that points to likely Chinese workmanship is the manufacturing technique of the linked chains (see entry no. 98).

—ECB and JFS

1. Andersson 1932, plates 13–14.

2. See, for example, Bunker et al. 1970, nos. 40, 118.

3. *Wenwu* 1987.6, pp. 76, 78, figs. 13, 19, also reproduced and discussed in So 1995, introduction, section 4.3, fig. 62.

102. This buckle entered the Harris Collection together with a belt hook of similar, but not identical, design (cat. fig. 99.1), a random marriage of two functionally incompatible articles since the fixed tongue and hooked extension are mutually exclusive components in a belt fastener.

This buckle belongs to a large group of belt fasteners with multianimal designs accented by geometric perforations that are found in collections throughout the world[1] (see also no. 100). The geometric perforations may be related to inlaid cloisons on more luxurious versions of the design.[2] Although this buckle's iconography and type both point to the north, it should be noted that a fragment of a clay model showing a large boar and a baby boar, also accented with geometric perforations, was recovered among the foundry debris at Houma in southern Shanxi Province, in the heart of Jin territory.[3] The

100 *Belt hook*

Tinned cast bronze
Width 10 cm, height 5.4 cm
North China
5th century B.C.
Published: Bunker 1981, no. 914
Los Angeles County Museum of Art, Gift of the Ahmanson Foundation, M.76.97.560, formerly Heeramaneck Collection

Another medley of animals—one feline and five cervids—forms this openwork belt fastener. A long hook extends tangentially to the wearer's left from the neck of the largest cervid, and a button projects from under its hindquarters. As in the previous buckle (no. 99),

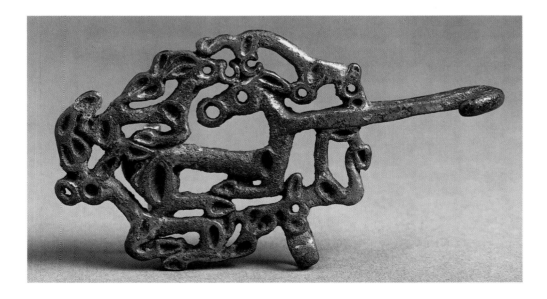

174

geometic openings mark the animals' shoulders and haunches. A single pendant loop at the bottom once held a chain, now missing. The surface has been deliberately tinned to give it a silvery sheen.

A belt buckle featuring a doe similar to the large cervid on the present example was collected from Yanchuan, in the Yan'an area of Ansai Xian in northern Shaanxi Province.[1] The similarities between the cervid on the present belt hook and the Yanchuan example suggest that this multianimal version could also have come from non-Chinese contexts in northern Shaanxi. The use of an extended hook instead of the fixed point in the previous example (no. 99), however, reveals even stronger Chinese influence in its design.

An isolated example, showing a design of one large and one small animal but also equipped with an extended hook and double chains below, has been recovered from a seventh-century B.C. grave in the coastal site of Penglai Xian in Shandong Province.[2] The eastern coastal location of the site poses interesting questions about movement and trade between the peoples commonly associated with China's northern frontiers who wore such multianimal chain-linked belts and the inhabitants of China's eastern coast.
—ECB and JFS

1. *Wenbo* 1989.4, plate 5.1.
2. *Wenwu ziliao congkan* 3 (1980): 53, fig. 5. Tomb 6, where this belt hook was found, also contained daggers, chariot fittings, horse bits, and only a few vessels—typical tomb furnishings for a nomadic burial.

101 *Belt hook and matching plaque*

Cast bronze
Width x height: (a) plaque with hook 10 x 4.4 cm, (b) plaque without hook 7 x 4.2 cm
North or northwest China
5th century B.C.
Published (b) Brinker 1975, no. 117; London 1989, no. 19 (and references therein)
The Therese and Erwin Harris Collection, (b) formerly C. T. Loo and Franco Vannotti Collections

A crouching feline forms the main motif of this belt hook and matching plaque. Each stands on a baseline composed of two serpents with pebbled bodies, the tail of the longer one ending in the animal's mouth while the shorter serpent bites the animal's drooping tail. The felines are identically decorated with cowrie-shell collars and waistbands and large spirals on the haunches outlined by a pebbled frame. The collars suggest that the felines were trained hunting animals.[1] Pebbling also accents the heart-shaped ears and mouth. The tails are striated.

The left-facing feline plaque has an additional hooked extension in the shape of a fantastic creature whose claws and jaws also grip the tail of the serpent just below the feline's mouth. The extension hooks onto the tail of the serpent on the right-facing plaque, so that the two animals confront one another when the plaques are worn together. Two loops issuing from the serpents' bodies were probably meant to hold linked chains like those on nos. 98–100, 102–3. A button issues from the back of each animal.

a b

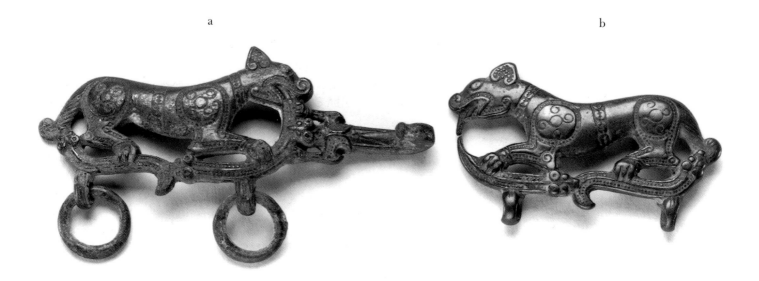

A feline belt hook with chain, virtually identical in all details to the present one, was found in an unspecified context in Xietuncun, Ansai Xian, northern Shaanxi Province.[2] The Xietuncun example appears to be incomplete, consisting of only one feline plaque and a single long chain. The second loop and chain appear to have broken off, and the matching plaque is missing. If complete, it would be a close match for this ensemble and the one that follows (no. 102).

A regardant feline belt hook was recovered from an early-fifth-century B.C. tomb in Fenshuiling, Changzhi Xian, southern Shanxi Province.[3] It has similarly decorated haunches against a plain body marked by a single character for "king." Cowrie collars and pebbled textures also decorate bronze animals and vessels associated with the sixth- and fifth-century B.C. bronze foundry at Houma, where the present plaques might have been made.[4]

—JFS

1. See White and Bunker 1994, entry no. 7, where the animals are described as "caninelike carnivores." Their uncertain identities stem largely from the ambiguity in their physical features.

2. First published in *Wenbo* 1989.4, plate 4.4, with chain on p. 72, fig. 1, again in a configuration of dubious validity in Beijing 1992b, no. 112. A fitting with two felines decorated in a similar manner was also collected from the area. *Wenbo* 1989.4, plate 4.1. See also Rawson and Bunker 1990, no. 229.

3. *Kaogu* 1964.3, plate 5.11.

4. For examples, see Lawton 1982, nos. 35–36. The Houma foundry is discussed in detail in So 1995, introduction, section 4.2.

b

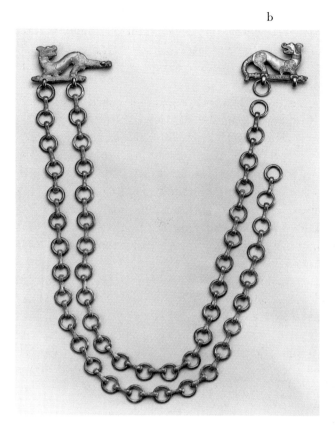

102 *Belt hook and matching plaque with chains*

Cast bronze
Width x height: (a) plaque with hook 8.3 x 4.5 cm, (b) plaque without hook 6.8 x 4.6 cm; length of chain 68.1 cm
North or northwest China
5th century B.C.
Published: Brinker 1975, no. 118; London 1989, no. 20 (and references therein)
The Therese and Erwin Harris Collection, formerly C. T. Loo and Franco Vannotti Collections

Like no. 101, this ensemble uses matching animal-shaped hook and plaque to form a complete belt fastener. Unlike no. 101, the creatures are rendered with heads regardant, asymmetrical heart-shaped ears, wrench-shaped (not three-clawed) paws, pebbled (not cowrie-filled) collars, and volute-filled haunches (see detail). The serpent forming the baseline is straight rather than curved, and a head is found at each end of the pebbled body. The tail of one animal extends straight to the wearer's left to end in a bird-head hook that latches onto the tail of the other in the opposing plaque. A button projects from under each animal's chest.

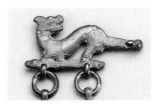
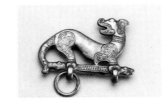

Detail, no. 102, showing belt hook and matching plaque at top of chain

Similar paired animals and double chains are found in Western collections.[1] The only provenanced example of this type of hook and chain was unfortunately only collected, not excavated, in 1983 from Xietuncun in Ansai Xian, northern Shaanxi Province.[2] The chain on the Xietuncun example measures 66 centimeters long, comparable to those on the present ensemble. The lack of dependable archaeological information surrounding these belt hooks and chains has made understanding of their function difficult.
—JFS

1. Andersson 1933, plates 13–14; Osaka 1991, nos. 180–82; White and Bunker 1994, no. 7.

2. First published in *Wenbo* 1989.4, plate 4.4, with chain on p. 72, fig. 1, again in a configuration of dubious validity in Beijing 1992b, no. 112. A fitting with two felines decorated in a similar manner was also collected from the area. *Wenbo* 1989.4, plate 4.1. See also Rawson and Bunker 1990, no. 229.

103 *Belt hook with chain*

Cast bronze inlaid with turquoise
Width 14.8 cm, height (without chain) 8.7 cm
North or northeast China
5th century B.C.
The Therese and Erwin Harris Collection

In type, this belt fastener belongs with the previous group (nos. 100–102): a hooked plaque with a linked chains hanging at right angles to it. Notable is the fact that only one chain hangs from the openwork plaque, and not the usual two (compare nos. 98–102). As in the examples discussed previously, the construction of the chain using 8-shaped connectors suggests Chinese workmanship. A button projects from the underside.

The near-round plaque that forms the main body of the belt hook is composed of an animal with large head seen flat, from above. The long neck of the hook issues from its mouth. Its body is seen in profile as it makes a sharp curve to form half the plaque, with a fore and a hind limb turned toward the center. Circular and pear-shaped depressions at the animal's haunches, claws, nostrils, eyes, and tail are inlaid with turquoise. The other half of the plaque is composed of an animal with a similar body but a smaller head, also seen flat, from above, biting on the curved neck of the other animal. Turquoise also accents geometric depressions on its body. Oblique striations resembling those on the buckle (no. 98) decorate the neck of the animal with the larger head.

The stiff postures of the animals in this unusual design resemble circular ornaments showing a single coiled animal, also with head seen from above and parts of its body accented by geometric shapes, associated with sites in

northeast China.[1] The abstract surface pattern created by the inlaid geometric cavities also echoes those on multianimal belt buckles and plaques (see nos. 99, 100). In the absence of an archaeologically excavated counterpart, stylistically and typologically comparable examples suggest a possible northeastern provenance for this belt hook and chain.

—JFS

1. See Rawson and Bunker 1990, nos. 192–93.

104 *Two belt plaques*

Tinned cast and hammered bronze
Width x height: (a) 9.7 x 4.7 cm, (b) 12.8 x 6.5 cm
Western China
5th century B.C.
Published: (b) So and Strahan 1993, fig. 1
(a) The Calon da Collection, (b) Walters Art Gallery, Baltimore, 54.1793

These two belt plaques are identical in shape and manufacture. Each was made from a rectangular sheet of cast bronze that has been bent in opposite directions at the ends to form an S-shaped profile. The visible top surface is then decorated with engraved geometric designs and tinned.

The first plaque (a) shows a central band of large lozenge pattern flanked by two parallel bands of smaller lozenges and a narrow, diagonally scored band near the edge. These are separated by narrow grooved bands. The entire plaque was then dipped in molten tin to give the bronze a silvery sheen.

The second plaque (b) shows a different design composed of two wide bands separated by a narrow one down the center. Volutes and spirals in contrasting smooth and "furred" textures fill the wide bands. Running volutes also accented with "furred" marks decorate the central band. Diagonally scored and plain bands, like those on plaque (a), embellish the edges. Only the top of the plaque was wiped with molten tin; the underside, not protected by tinning, is heavily corroded. A break across the middle has been repaired, but a piece is missing from the bent section on top.

To date, similar plaques have only been recovered from attendant burials in the Qin capital of Fengxiang in Shaanxi Province.[1] Their unusual shape, geometric ornaments, and decorative and maufacturing technique are all new to Chinese contexts. The discovery of fragments of similarly decorated tinned bronze armlets or

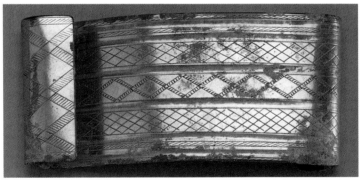

a

b

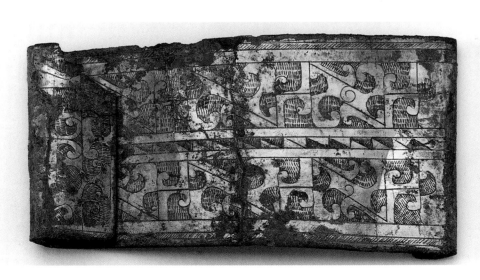

bracelets from pastoral territory in the Ningxia Hui Autonomous Region is the only available clue to the origin of this intriguing group of belt plaques[2] (cat. fig. 104.1). The belt plaques buried in Qin territory were probably brought there by members of northwestern tribes who came to serve predynastic Qin nobles in their capital. The limited distribution of these belt plaques and their association with subservient members of the community both support this possibility.

—JFS

1. These plaques and the related excavated examples are studied in detail in So and Strahan 1995.

2. See *Kaogu xuebao* 1995.1, p. 97, fig. 17.7.

CAT. FIG. 104.1. Fragments of tinned bronze armlets or bracelets, Ningxia Hui Autonomous Region, 5th century B.C.

Glossary of Chinese Characters

Ansai Xian	安塞縣	Ding Xian	定縣
Anyang	安陽	Dongsheng	東勝
Aohan Qi	敖漢旗	*dou*	豆
Baode Xian	保德縣	Dulan Xian	都蘭縣
Baoji Xian	寶雞縣	Ejin-Horo Qi	伊金霍洛旗
bixie	辟邪	*fang*	方
Changde Xian	常德縣	Fangshan Xian	房山縣
Changping Xian	昌平縣	Fen River	汾河
Changsha	長沙	Fengxiang Xian	鳳翔縣
Changzhi Xian	長治縣	*fu*	鍑
Chaoyang Xian	朝陽縣	*fu*	賦
che	車	Fufeng Xian	扶風縣
Chenggu Xian	城固縣	Gaocheng Xian	藁城縣
Chifeng Xian	赤峰縣	*ge*	戈
Chunhua Xian	淳化縣	Guangzhou	廣州
Dai	代	*gui*	簋
Di	狄	Gushi Xian	固始縣
ding	鼎	Guyuan	固原

Han Shu	漢書	Mancheng Xian	滿城縣
Han Wudi	漢武帝	Mawangdui	馬王堆
Hangjin Qi	杭錦旗	Ning Xian	寧縣
Heqin	和親	Ningcheng Xian	寧城縣
Hongshan	紅山	Penglai Xian	蓬萊縣
Horinger Xian	和林格爾縣	Pinggu Xian	平谷縣
hu	壺	Pingshan Xian	平山縣
Hu	胡	Qi	旗
Hume	胡貊	*qin*	琴
Huailai Xian	懷來縣	Qin	秦
Huayin Xian	華陰縣	*qin zhen yao*	琴軫鑰
Hui Xian	輝縣	Qin'an	秦安
Ji Xian	吉縣	Qingjian Xian	清澗縣
Jiangling Xian	江陵縣	Qinglong Xian	青龍縣
Jingmen Xian	荊門縣	Qingyang	慶陽
Jungar Qi	准格爾旗	Qishan Xian	岐山縣
Liangcheng Xian	涼城縣	Quanrong	犬戎
Liao River	遼河	Quwo Xian	曲沃縣
Linfen Xian	臨汾縣	Rong	戎
Lingshi Xian	靈石縣	*se*	瑟
Lingtai Xian	靈台縣	*se rui*	瑟枘
Lingyuan Xian	凌源縣	Shaan Xian	陝縣
Linhu	林胡	Shangcunling	上村嶺
Liulin Xian	柳林縣	*Shanhaijing*	山海經
Long Xian	隴縣	*shanyü*	單于
Longhua Xian	隆化縣	Shenmu Xian	神木縣
Luanping Xian	灤平縣	Shenyang	沈陽
Lulong Xian	廬龍縣	Shihuangdi (Qin)	始皇帝（秦）
Luo River	洛河	*Shiji*	史記
Luoyang	洛陽	Shijiazhuang	石家莊
ma	馬	*Shijing*	詩經

Shilou Xian	石樓縣	Xuzhou	徐州
Shouzhou	壽州	Yan'an Xian	延安縣
Sima Qian	司馬遷	Yangzi River	揚子江
Sui Xian	隨縣	Yanqing Xian	延慶縣
Sui Zhou	隨州	Yanshi Xian	偃師縣
Suide Xian	綏德縣	*Yantielun*	鹽鐵論
Sunzi	孫子	*yi*	邑
Sunzi Bingfa	孫子兵法	Yi Xian	易縣
Taihang Mountains	太行山	Yinshan	陰山
Taiyuan	太原	Yongdeng	永登
Tang Xian	唐縣	Yulin Fu	榆林府
Tangshan Xian	唐山	Yumen	玉門
Tongchuan Xian	銅川縣	*Zhanguoce*	戰國策
Tongxin Xian	同心縣	Zhukaigou	朱開溝
Wei River	渭河	Zibo	淄博
Wen Ji	文姬	*zun*	尊
Wengniuter Qi	翁牛特旗		
wuzhu	五銖		
Xian	縣		
Xi'an	西安		
Xianbei	鮮卑		
xiangrui	祥瑞		
Xichuan	淅川		
Xifeng Xian	西豐縣		
Xiji Xian	西吉縣		
Xingtai Xian	邢台縣		
Xingtang Xian	行唐縣		
Xinzheng Xian	新鄭縣		
Xiongnu	匈奴		
Xuanhua Xian	宣化縣		
Xun Xian	濬縣		

References

ACKERMAN 1945
Ackerman, Phyllis. *Ritual Bronzes of Ancient China.*
New York: Dryden Press, 1945.

AKISHEV 1978
Akishev, K. A. *Issyk Mound: The Art of Saka in
Kazakhstan.* Moscow: Iskusstvo Publishers, 1978.

ANDERSSON 1932
Andersson, J. G. "Hunting Magic in the Animal Style."
Bulletin of the Museum of Far Eastern Antiquities 4
(1932): 221–321.

ANDERSSON 1933
Andersson, J. G. "Selected Ordos Bronzes." *Bulletin of
the Museum of Far Eastern Antiquities* 5 (1933):
155–75.

ARTAMONOV 1969
Artamonov, M. I. *The Splendor of Scythian Art.* New
York and Washington, D.C.: Frederick A. Praeger,
1969.

AZARPAY 1981
Azarpay, Guity. *Sogdian Painting.* Berkeley, Los
Angeles, and London: University of California Press,
1981.

BAGLEY 1987
Bagley, Robert. *Shang Ritual Bronzes in the Arthur M.
Sackler Collections.* Washington, D.C., and Cambridge,
Mass.: Arthur M. Sackler Foundation and Harvard
University Press, 1987.

BAHN AND VERTUT 1988
Bahn, Paul G., and Jean Vertut. *Images of the Ice Age.*
New York and Oxford: Facts on File, 1988.

BARFIELD 1989
Barfield, Thomas J. *The Perilous Frontier: Nomadic
Empires and China.* Cambridge, Mass.: Basil Blackwell,
1989.

BARNARD 1988
Barnard, Noel. "Bronze Vessels with Copper Inlaid
Decor and Pseudo-Copper Inlay of Ch'un-ch'iu and
Chan-kuo Times." Paper presented at the Kiola
Conference, New South Wales, Australia, February
8–12, 1988.

BASILOV 1989
Basilov, Vladimir N., ed. *Nomads of Eurasia.* Seattle:
University of Washington Press, 1989.

BEIJING 1959
Shangcunling Guo guo mudi. Beijing: Kexue Press, 1959.

BEIJING 1962
Fengxi fajue baogao. Beijing: Wenwu Press, 1962.

BEIJING 1979
Shaanxi chutu Shang Zhou qingtongqi. Vol. 1. Beijing: Wenwu Press, 1979.

BEIJING 1980a
Hebei Sheng chutu wenwu xuanji. Beijing: Wenwu Press, 1980.

BEIJING 1980b
Mancheng Han mu fajue baogao. Beijing: Wenwu Press, 1980.

BEIJING 1980c
Yinxu Fu Hao mu. Beijing: Wenwu Press, 1980.

BEIJING 1981
Yunmeng Shuihudi Qin mu. Beijing: Wenwu Press, 1981.

BEIJING 1986
Xinyang Chu mu. Beijing: Wenwu Press, 1986.

BEIJING 1988
Baoji Yu Guo mudi. 2 vols. Beijing: Wenwu Press, 1988.

BEIJING 1989
Zeng Hou Yi mu. 2 vols. Beijing: Wenwu Press, 1989.

BEIJING 1990
Zhongguo wenwu jinghua. Beijing: Wenwu Press, 1990.

BEIJING 1991a
Baoshan Chu mu. 2 vols. Beijing: Wenwu Press, 1991.

BEIJING 1991b
Xi Han Nanyue Wang mu. 2 vols. Beijing: Wenwu Press, 1991.

BEIJING 1991c
Xichuan Xiasi Chunqiu Chu mu. Beijing: Wenwu Press, 1991.

BEIJING 1992a
Treasures: 300 Best Excavated Antiques from China. Beijing: China Cultural Relics Promotion Center, New World Press, 1992.

BEIJING 1992b
Zhongguo wenwu jinghua. Beijing: Wenwu Press, 1992.

BEIJING 1993
Zhongguo wenwu jinghua. Beijing: Wenwu Press, 1993.

BRENTJES 1989
Brentjes, Burchard. "Incised Bones and a Ceremonial Belt: Finds from Kurgan-Tepe and Tillia-Tepe." *Bulletin of the Asia Institute,* n.s., 3 (1989): 39–44.

BRINKER 1975
Brinker, Helmut. *Bronzen aus dem alten China.* Zürich: Museum Rietberg, 1975.

BUNKER 1962
Bunker, Emma C. *The Art of Eastern Chou.* New York: Chinese Art Society of America, 1962.

BUNKER 1978
Bunker, Emma C. "The Anecdotal Plaques of the Eastern Steppe Region." In *Arts of the Eurasian Steppelands,* edited by Philip Denwood, pp. 121–42. London: University of London, Percival David Foundation of Chinese Art, 1978.

BUNKER 1979
Bunker, Emma C. "Alligators or Crocodiles in Ancient China." *Oriental Art,* n.s., 25, no. 3 (1979): 340–41.

BUNKER 1981
Bunker, Emma C. "The Ancient Art of Central Asia, Mongolia, and Siberia." In *Ancient Bronzes, Ceramics and Seals,* edited by Glenn Markoe, pp. 139–85. Los Angeles: Los Angeles County Museum of Art, 1981.

BUNKER 1983
Bunker, Emma C. "Sources of Foreign Elements in the Culture of Eastern Zhou." In *The Great Bronze Age of China: A Symposium,* edited by George Kuwayama, pp. 84–93. Los Angeles: Los Angeles County Museum of Art, 1983.

184

BUNKER 1987
Bunker, Emma C. "Two Snakes and a Frog."
Orientations, January 1987, pp. 42–45.

BUNKER 1988a
Bunker, Emma C. "Diverse Cultural Encounters in the
Art of the Steppes." In *Lotus Leaves: A Selection of
Essays from Past Issues of the Society of Asian Art
Newsletter,* edited by Marlo Implay et al., pp. 58–59.
San Francisco: Society of Asian Art, 1988.

BUNKER 1988b
Bunker, Emma C. "Lost Wax and Lost Textile." In *The
Beginning of the Use of Metals and Alloys,* edited by
Robert Maddin, pp. 222–27. Cambridge, Mass.:
Massachusetts Institute of Technology Press, 1988.

BUNKER 1989
Bunker, Emma C. "Dangerous Scholarship: On Citing
Unexcavated Artefacts from Inner Mongolia and North
China." *Orientations,* June 1989, pp. 52–59.

BUNKER 1990a
Bunker, Emma C. "Ancient Ordos Bronzes with
Tin-Enriched Surfaces." *Orientations,* January 1990,
pp. 78–80.

BUNKER 1990b
Bunker, Emma C. "Bronze Belt Ornaments from North
China and Inner Mongolia." In *Glories of the Past:
Ancient Art from the Shelby White and Leon Levy
Collection,* edited by Dietrich von Bothmer, pp. 65–72.
New York: Metropolitan Museum of Art and Harry N.
Abrams, 1990.

BUNKER 1991a
Bunker, Emma C. "The Chinese Artifacts Among the
Pazyryk Finds." *Source: Notes in the History of Art* 10,
no. 4 (Summer 1991): 20–24.

BUNKER 1991b
Bunker, Emma C. "Sino-Nomadic Art: Eastern Zhou,
Qin and Han Artifacts Made for Nomadic Taste." In
International Colloquium on Chinese Art History.
Proceedings, part 2, pp. 569–90. Taipei: National
Palace Museum, 1991.

BUNKER 1992a
Bunker, Emma C. "Gold Belt Plaques in the Siberian
Treasure of Peter the Great: Dates, Origins and
Iconography." In *The Nomad Trilogy 3, Foundations of
Empire: Archaeology and Art of the Eurasian Steppes,*
edited by Gary Seaman, pp. 201–22. Los Angeles:
Ethnographics Press, University of Southern California,
1992.

BUNKER 1992b
Bunker, Emma C. "Significant Changes in Iconography
and Technology Among Ancient China's Northwestern
Pastoral Neighbors from the Fourth to First Century
B.C." *Bulletin of the Asia Institute,* n.s., 6 (1992):
99–115.

BUNKER 1993
Bunker, Emma C. "Gold in the Ancient Chinese World:
A Cultural Puzzle." *Artibus Asiae* 53, nos. 1/2 (1993):
27–50.

BUNKER 1994a
Bunker, Emma C. "The Enigmatic Role of Silver in
China." *Orientations,* November 1994, pp. 73–78.

BUNKER 1994b
Bunker, Emma C. "The Metallurgy of Personal
Ornament." In Julia M. White and Emma C. Bunker,
*Adornment for Eternity: Status and Rank in Chinese
Ornament,* pp. 31–54. Denver and Hong Kong: Denver
Art Museum and Woods Publishing Company, 1994.

BUNKER et al. 1970
Bunker, Emma C., Bruce Chatwin, and Ann Farkas.
Animal Style Art from East to West. New York: Asia
Society, 1971.

CAO DINGYUN 1989
Cao Dingyun. "'Fu Hao' nai 'Zi Fang' zhi nu." In
Qingzhu Su Bingqi kaogu wushiwu nian lunwenji, pp.
381–85. Beijing: Wenwu Press, 1989.

CHANG KWANG-CHIH 1980
Chang Kwang-chih. *Shang Civilization.* New Haven
and London: Yale University Press, 1980.

CHANG PING-CH'ÜAN 1986
Chang Ping-ch'üan. "A Brief Description of the Fu Hao Oracle Bone Inscriptions." In *Studies in Shang Archaeology*, edited by K. C. Chang, pp. 121–40. New Haven: Yale University Press, 1986.

CHEN FANGMEI 1991
Chen Fangmei. "Palace Museum Collection of Alien-Style Weapons from Late Yin to Early Chou Dynasty: Part II of Bronze Weapons of the Shang and Chou Dynasties." In *International Colloquium on Chinese Art History: Antiquities,* 1: 257–306. Taipei: Palace Museum, 1991.

CHEN MENGJIA 1977
Chen Mengjia. *Yin Zhou qingtongqi feilei tulu.* 2 vols. Tokyo: Kyuko Shōin, 1977.

CHEN RENTAO 1952
Chen Rentao, ed. *Jin Gui lun gu chuji.* Hong Kong, 1952.

CHENG DONG AND ZHONG SHAOYI 1990
Cheng Dong and Zhong Shaoyi. *Zhongguo gudai bingqi tuji.* Beijing: Chinese People's Liberation Army Publishing House, 1990.

CHENG TÊ-K'UN 1963
Cheng Tê-k'un. *Archaeology in China.* Vol. 3, *Chou China.* Cambridge: W. Heffer and Sons, 1963.

COHN 1940–41
Cohn, W. "The Deities of the Four Cardinal Points in Chinese Art." *Transactions of the Oriental Ceramic Society* 18 (1940–41): 61–75.

CREEL 1965
Creel, Herrlee G. "The Role of the Horse in Chinese History." *American Historical Review* 70, no. 3 (April 1965): 647–72.

CREEL 1970
Creel, Herrlee G. *The Origins of Statecraft in China.* Chicago and London: University of Chicago Press, 1970.

CRUMP 1979
Crump, J. I., trans. *Chan-kuo Ts'e.* San Francisco: Chinese Materials Center, 1979.

CSORBA 1995
Csorba, Mrea. "Frontier Culture of China's Bronze Age Northern Zone: The Non-Chinese Face on the Frontier." Forthcoming.

CUTTER 1989
Cutter, Robert Joe. *The Brush and the Spur.* Hong Kong: Chinese University of Hong Kong, 1989.

DAVIS-KIMBALL 1991
Davis-Kimball, Jeannine. "With the Saka on the Soviet Steppe." *Minerva* 2, no. 3 (1991): 18–20.

DEVLET 1980
Devlet, M. A. *Sibirskie poyasnye azhurnye plastinki* (Siberian Open-Worked Belt Plates/Buckles). Moscow, 1980.

DEWOSKIN 1982
DeWoskin, Kenneth J. *A Song for One or Two: Music and the Concept of Art in Early China.* Ann Arbor: University of Michigan Center for Chinese Studies, 1982.

DI COSMO 1994
Di Cosmo, Nicola. "Ancient Inner Asian Nomads: Their Economic Basis and Its Significance in Chinese History." *Journal of Asian Studies* 53, no. 4 (November 1994): 1092–1126.

EGAMI AND MIZUNO 1935
Egami Namio and Mizuno Seiichi. *Inner Mongolia and the Region of the Great Wall.* Tokyo and Kyoto: Far-Eastern Archaeological Survey, 1935.

ELIADE 1964
Eliade, Mircea. *Shamanism: Archaic Techniques of Ecstasy.* New York: Bollingen Foundation, 1964.

ERDBERG 1978
Erdberg, Eleanor von. *Chinese Bronzes from the Collection of Chester Dale and Dolly Carter.* Ascona, Switzerland: Artibus Asiae Publishers, 1978.

ÉRDY 1995
Érdy, Miklos. "Hun and Xiongnu Cauldrons: Finds Throughout Eurasia." *Eurasian Studies Yearbook* 67 (1995): 5–94.

FRANCFORT ET AL. 1990
Francfort, Henri-Paul, Daniel Klodzinski, and Georges
Mascle. "Petroglyphes archaiques du Ladakh et du
Zanskar." *Arts Asiatiques* 45 (1990): 5-27.

FRYER 1975
Fryer, Jonathon. *The Great Wall of China.* London:
New English Library, 1975.

FU TIANQIU 1985
Fu Tianqiu, ed. *Zhongguo meishu quanji, diaosuo bian
(2), Qin Han diaosuo.* Beijing: Wenwu Press, 1985.

GAI SHANLIN 1986
Gai Shanlin. *Yinshan yanhua.* Beijing: Wenwu Press,
1986.

GAI SHANLIN 1989
Gai Shanlin. *Wulanchabu yanhua.* Beijing: Wenwu
Press, 1989.

GALE 1931
Gale, Esson M., trans. *Discourses on Salt and Iron.*
Translated from the Chinese of Huan K'an. Leyden:
E. J. Brill, 1931.

GIMBUTAS 1989
Gimbutas, Marija. *Language of the Goddess.* London:
Thames and Hudson, 1989.

GOODRICH 1984
Goodrich, Chauncey S. "Riding Astride and the Saddle
in Ancient China." *Harvard Journal of Asiatic Studies*
44, no. 2 (1984): 279-306.

GRIAZNOV 1984
Griaznov, Michael Petrovic. *Der Grosskurgan von Arzan
in Tuva, Sudsibirien.* Munich: Verlag C. H. Deck, 1984.

GRIESSMAIER 1936
Griessmaier, Viktor. *Sammlung Baron Eduard von der
Heydt.* Vienna: Krystall-Verlag, 1936.

GRIFFITH 1963
Griffith, Samuel B., trans. *Sun Tzu: The Art of War.*
New York and Oxford: Oxford University Press, 1963.

GUO BAOJUN 1964
Guo Baojun. *Xun Xian Xincun.* Beijing: Science Press,
1964.

GYLLENSVÄRD 1953
Gyllensvärd, Bo. *Chinese Gold and Silver in the Carl
Kempe Collection.* Stockholm: Nordisk Rotogravyr,
1953.

HAN AND BUNKER 1993
Han Rubin and Emma C. Bunker. "The Study of
Ancient Ordos Bronzes with Tin-Enriched Surfaces in
China." *Wenwu* 9 (1993): 80-96.

HASKINS 1963
Haskins, John. "Eighteen Refrains to a Barbarian Flute."
Bulletin of the Museum of Far Eastern Antiquities 35
(1963): 141-60.

HASKINS 1988
Haskins, John. "China and the Altai." *Bulletin of the
Asia Institute* 2 (1988): 1-9.

HAYASHI 1972
Hayashi Minao. *Chūgoku In Shū jidai no buki.* Kyoto:
Kyōto Daigaku Jimbun Kagaku Kenkyūjo, 1972.

HAYASHI 1985
Hayashi Minao. *Sengoku jidai shutsudo bunbustu no
kenkyū.* Kyoto: Kyōto Daigaku Jimbun Kagaku
Kenkyūjo, 1985.

HEARN 1987
Hearn, Maxwell K. *Ancient Chinese Art: The Ernest
Erickson Collection.* New York: Metropolitan Museum
of Art, 1987.

HO P'ING-TI 1975
Ho P'ing-ti. *The Cradle of the East.* Hong Kong:
Chinese University of Hong Kong, 1975.

HÖLLMANN 1992
Höllmann, Thomas O. "Social Structure and Political
Order as Reflected in the Maoqinggou Burials: A Few
Preliminary Remarks." Paper presented at the
International Conference of Archaeological Cultures of
the North Chinese Ancient Nations, Huhehot, Inner
Mongolia, August 1992.

HÖLLMANN AND KOSSACK 1992
Höllmann, Thomas O., and Georg W. Kossack. *Maoqinggou.* Mainz am Rhein: Verlag Philipp von Zabern, 1992.

INNER MONGOLIA 1987
Neimenggu lishi wenwu. Inner Mongolia: Inner Mongolia Museum, 1987.

JACOBSEN 1984
Jacobsen, Robert Dale. "Inlaid Bronzes of Pre-Imperial China: A Classic Tradition and Its Later Revivals." Ph.D. dissertation, University of Michigan, 1984.

JACOBSON 1984
Jacobson, Esther. "The Stag with Bird-Headed Antler Tines: A Study in Image Transformation and Meaning." *Bulletin of the Museum of Far Eastern Antiquities* 56 (1984): 113–80.

JACOBSON 1985
Jacobson, Esther. "Mountains and Nomads: A Reconsideration of the Origins of Chinese Landscape Representations." *Bulletin of the Museum of Far Eastern Antiquities* 57 (1985): 133–61.

JACOBSON 1988
Jacobson, Esther. "Beyond the Frontier: A Reconsideration of Cultural Interchange Between China and the Early Nomads." *Early China* 13 (1988): 201–40.

JAGCHID AND SYMONS 1989
Jagchid, Sechin, and Van Jay Symons. *Peace, War, and Trade Along the Great Wall.* Bloomington and Indianapolis: Indiana University Press, 1989.

JANSE 1935
Janse, O. "L'Empire des Steppes et ses relations." *Revue des Arts Asiatiques* 9, no. 1 (1935): 9–39.

JAPAN 1992
Dai Kōga, Orudosu hihoten: Chūgoku Neika kodai bijutsu no sui. Edited by NHK Chūgoku Sofuto Puran. Japan: NHK Chūgoku Sofuto Puran, 1992.

JETTMAR 1967
Jettmar, Karl. *Art of the Steppes.* New York: Crown Publishers, 1967.

JETTMAR 1985
Jettmar, Karl. "Cultures and Ethnic Groups West of China in the Second and First Millennia B.C." *Asian Perspectives* 24, no. 2 (1985): 145–62.

KARLBECK 1955
Karlbeck, Orvar. "Selected Objects from Ancient Shou-Chou." *Bulletin of the Museum of Far Eastern Antiquities* 27 (1955): 41–130.

KARLGREN 1948
Karlgren, Bernhard. "Bronzes in the Hellström Collection." *Bulletin of the Museum of Far Eastern Antiquities* 20 (1948): 1–38.

KARLGREN 1966
Karlgren, Bernhard. "Chinese Agraffes in Two Swedish Collections." *Bulletin of the Museum of Far Eastern Antiquities* 38 (1966): 83–159.

KARLGREN 1968
Karlgren, Bernhard. "Early Chinese Mirrors: Classification Scheme Recapitulated." *Bulletin of the Museum of Far Eastern Antiquities* 40 (1968): 79–95.

KEIGHTLEY 1990
Keightley, David N. "Early Civilization in China: Reflections on How It Became Chinese." In *Heritage of China,* edited by Paul S. Ropp, pp. 15–54. Berkeley: University of California Press, 1990.

KRIUKOV AND KURYLEV 1992
Kriukov, Michael V., and Vadim P. Kurylev. "The Origins of the Yurt: Evidence from Chinese Sources of the Third Century B.C. to the Thirteenth Century A.D." In *The Nomads Trilogy 3, Foundations of Empire: Archaeology and Art of the Eurasian Steppes,* edited by Gary Seaman, pp. 143–56. Los Angeles: Ethnographics Press, University of Southern California, 1992.

LA PLANTE 1958
La Plante, John D. *Arts of the Chou Dynasty.* Stanford: Stanford University Museum, 1958.

LALLY 1990
Lally, James J. *Arts of Ancient China.* Sale and exhibition catalogue published by J. J. Lally & Co., Oriental Art, New York, 1990.

LATTIMORE 1940
Lattimore, Owen. *Inner Asian Frontiers of China.*
Boston: Beacon Press, 1940.

LAWERGREN 1980
Lawergren, Bo. "Reconstruction of a Shoulder Harp in
the British Museum." *Journal of Egyptian Archaeology*
66 (1980): 165–68.

LAWERGREN 1984
Lawergren, Bo. "The Cylinder Kithara in Etruria,
Greece, and Anatolia." *Imago Musicae* 1 (1984):
147–74.

LAWERGREN 1988
Lawergren, Bo. "The Origin of Musical Instruments
and Sounds." *Anthropos* 83 (1988): 31–45.

LAWERGREN 1990
Lawergren, Bo. "The Ancient Harp from Pazyryk."
Beiträge zur Allgemeinen und Vergleichenden Archäologie
9–10 (1990): 111–18.

LAWERGREN 1993
Lawergren, Bo. "Lyres in the West (Italy, Greece) and
East (Egypt, the Near East), ca. 2000–400 B.C."
Opuscula Romana 9, no. 6 (1993): 55–76.

LAWTON 1982
Lawton, Thomas. *Chinese Art of the Warring States
Period: Change and Continuity (480–222 B.C.).*
Washington, D.C.: Freer Gallery of Art, Smithsonian
Institution, 1982.

LAWTON ET AL. 1987
Lawton, Thomas, Shen Fu, Glenn D. Lowry, Ann
Yonemura, and Milo C. Beach. *Asian Art in the
Arthur M. Sackler Gallery: The Inaugural Gift.*
Washington, D.C.: Arthur M. Sackler Gallery,
Smithsonian Institution, 1987.

LEGGE 1935
Legge, James. *The Chinese Classics.* Vol. 4, *The She
King.* 1893–95. Reprint, Shanghai: Oxford University
Press, 1935.

LEWIS 1990
Lewis, Mark Edward. *Sanctioned Violence in Early
China.* Albany: State University of New York Press,
1990.

LI XUEQIN 1985a
Li Xueqin. *Eastern Zhou and Qin Civilizations.*
Translated by K. C. Chang. New Haven and London:
Yale University Press, 1985.

LI XUEQIN 1985b
Li Xueqin, ed. *Zhongguo meishu quanji, gongyi meishu
bian (4), qingtongqi (1).* Beijing: Wenwu Press, 1985.

LI XUEQIN 1986
Li Xueqin, ed. *Zhongguo meishu quanji, gongyi meishu
bian (5), qingtongqi (2).* Beijing: Wenwu Press, 1986.

LI XUEQIN 1991
Li Xueqin. "Chu Bronzes and Chu Culture." In *New
Perspectives in Chu Culture During the Eastern Zhou
Period,* edited by Thomas Lawton, pp. 1–22. Princeton:
Princeton University Press, 1991.

LIN YÜN 1986
Lin Yün. "A Reexamination of the Relationship
Between Bronzes of the Shang Culture and of the
Northern Zone." In *Studies of Shang Archaeology,*
edited by K. C. Chang, pp. 237–73. New Haven: Yale
University Press, 1986.

LINDUFF 1994a
Linduff, Katheryn M. "Early Bronze Age in the
Northeast: Xiajiadian and Its Place in the Network."
Paper presented at the annual meeting of the
Association for Asian Studies, Boston, April 1994.

LINDUFF 1994b
Linduff, Katheryn M. "Here Today and Gone
Tomorrow: The Emergence and Demise of Bronze
Producing Cultures Outside the Central Plain." Paper
presented at the Conference on Chinese History and
Archaeology, Academia Sinica, Taipei, Taiwan, January
4–8, 1994.

LIPPE 1950
Lippe, Aschwin. "A Gift of Chinese Bronzes."
Metropolitan Museum of Art Bulletin 9, no. 4
(December 1950): 97–107.

LOEHR 1948
Loehr, Max. "The Earliest Chinese Swords and the Akinakes." *Oriental Art* 1 (1948): 132–42.

LOEHR 1949
Loehr, Max. "Ordos Daggers and Knives: New Material, Classification, and Chronology. First Part: Daggers." *Artibus Asiae* 12, nos. 1/2 (1949): 23–83.

LOEHR 1951
Loehr, Max. "Ordos Daggers and Knives: New Material, Classification, and Chronology. Second Part: Knives." *Artibus Asiae* 14, nos. 1/2 (1951): 77–162.

LOEHR 1955
Loehr, Max. "The Stag Image in Scythia and the Far East." *Archives of the Chinese Art Society of America* 9 (1955): 63–76.

LOEHR 1956
Loehr, Max. *Chinese Bronze Age Weapons.* Ann Arbor: University of Michigan Press, 1956.

LOEHR 1965a
Loehr, Max. "Ordos." *Encyclopedia of World Art* 10 (1965): 774–82.

LOEHR 1965b
Loehr, Max. *Relics of Ancient China from the Collection of Dr. Paul Singer.* New York: Asia Society, 1965.

LOEHR 1975
Loehr, Max. *Ancient Chinese Jades from the Grenville L. Winthrop Collection in the Fogg Art Museum, Harvard University.* Cambridge, Mass.: Fogg Art Museum, 1975.

LONDON 1978
Frozen Tombs: The Culture and Art of the Ancient Tribes of Siberia. London: British Museum Publications Limited, 1980.

LONDON 1989
Chinese and Korean Art from the Collections of Dr. Franco Vannotti, Hans Popper, and Others. London: Eskenazi, 1989.

MA CHENGYUAN 1986
Ma Chengyuan. *Ancient Chinese Bronzes.* Edited by Hsio-yen Shih. Hong Kong and Oxford: Oxford University Press, 1986.

MÄENCHEN-HELFEN 1944
Mäenchen-Helfen, Otto. "Are Chinese *hsi-p'i* and *kuo-lo* I. E. Loan Words?" *Language* 21 (1944): 256—60.

MAIR 1990
Mair, Victor H. "Old Sinitic *Myag, Old Persian Maguš, and English 'Magician.'" *Early China* 15 (1990): 27–47.

MAIR 1994
Mair, Victor. "The Mummies of Xinjiang." *Discover,* April 1994, pp. 68–77.

MAJOR 1993
Major, John S. *Heaven and Earth in Early Han Thought: Chapters Three, Four and Five of the Huainanzi.* Albany: State University of New York Press, 1993.

MAYOR 1994
Mayor, Adrienne. "Guardians of the Gold." *Archaeology,* November/December 1994, pp. 52–58.

MIAMI 1978
The Art of the Oriental Bronze Metallurgist: China, Korea, Japan (1500–1911). Miami: Lowe Art Museum, 1978.

MINNS 1942
Minns, E. H. *The Art of the Northern Nomads.* Proceedings of the British Academy 28 (1942): 47–99. Reprint, London: Humphrey Milford, 1942.

MINYAEV 1992
Minyaev, S. S. "On the Origin of the Hsiung-nu." Paper presented at the International Conference of Archaeological Cultures of the North Chinese Ancient Nations, Huhehot, Inner Mongolia, August 1992.

MIZUNO 1959
Mizuno, Seiichi. *In Shū seidōki to gyoku.* Tokyo: Nihon Keizai Shimbunsha, 1959.

190

MOOREY 1967
Moorey, P. R. S. "Some Ancient Metal Belts: Their Antecedents and Relatives." *Iran* 5 (1967): 83–99.

NAGAHIRO 1943
Nagahiro, Toshio. *Taiko no kenkyū (Die Agraffe und Ihre Stellung in der Altchinesischen Kunstgeschichte)*. Kyoto: Tōhō Bunka Kenkyūjo, 1943.

NELSON 1994
Nelson, Sarah M. "Hongshan Connections." Paper presented at the annual meeting of the Association for Asian Studies, Boston, April 1994.

NELSON 1995
Nelson, Sarah M. ed. *The Archaeology of Northeast China*. London and New York: Routledge, 1995.

NEW YORK 1970
Masterpieces of Asian Art in American Collections II. New York: Asia Society, 1970.

NEW YORK 1980
The Great Bronze Age of China. New York: Metropolitan Museum of Art and Alfred A. Knopf, 1980.

O'DONOGHUE 1990
O'Donoghue, Diane M. "Reflection and Reception: The Origins of the Mirror in Bronze Age China." *Bulletin of the Museum of Far Eastern Antiquities* 62 (1990): 5–183.

OSAKA 1987
Kinryu kinba to dobutsu kokuhoten. Osaka: Osaka Municipal Art Museum, 1987.

OSAKA 1991
Chūgoku Sengoku jidai no bijutsu. Osaka: Osaka Municipal Art Museum, 1991.

OSAKA 1992
Chūgoku no kin, gin, garasu ten: Shōsoin no sato. Osaka: NHK Ōsaka Hōsōkyoku, NHK Kinki Media Puran, 1992.

PALMGREN 1948
Palmgren, Nils, ed. *Selected Chinese Antiquities from the Collection of Gustaf, Crown Prince of Sweden*. Stockholm: Generalstabens Litografiska Anstalts Förlag, 1948.

PIGGOTT 1992
Piggott, Stuart. *Wagon, Chariot and Carriage: Status and Symbol in the History of Transport*. London: Thames and Hudson, 1992.

PIOTROVSKIJ 1987
Piotrovskij, Boris B., ed. *Tesori D'Eurasia: 2000 anni di Storia in 70 anni di Archeologia Sovietica*. Milan: Arnoldo Mondadori Editore S. p. A., 1987.

POLOSMAK 1991
Polosmak, Natalya. "Un nouveau kourgane a 'tombe gelee' de l'Altai (rapport preliminaire)." *Arts Asiatiques* 46 (1991): 5–13.

PORADA 1965
Porada, Edith. *The Art of Ancient Iran: Pre-Islamic Cultures*. New York: Crown Publishers, 1965.

PRŮŠEK 1966
Průšek, Jaroslav. "The Steppe Zone in the Period of Early Nomads and China of the 9th–7th centuries B.C." *Diogenes* 54 (1966): 23–46.

PRŮŠEK 1971
Průšek, Jaroslav. *Chinese Statelets and the Northern Barbarians in the Period 1400–300 B.C.* Dordrecht, Holland: D. Reidel Publishing Company, 1971.

PULLEYBLANK 1966
Pulleyblank, E. G. "Chinese and Indo-Europeans." *Journal of the Royal Asiatic Society*, April 1966, pp. 9–39.

PULLEYBLANK 1983
Pulleyblank, E. G. "The Chinese and Their Neighbors in Prehistoric and Early Historic Times." In *The Origins of Chinese Civilization*, edited by David N. Keightley, pp. 411–66. Berkeley and Los Angeles: University of California Press, 1983.

RAWSON 1987
Rawson, Jessica. "Animal Motifs on Early Western Zhou Bronzes." *Orientations,* September 1987, pp. 54–65.

RAWSON 1990
Rawson, Jessica. *Western Zhou Ritual Bronzes from the Arthur M. Sackler Collections.* Cambridge, Mass.: Harvard University Press, 1990.

RAWSON AND BUNKER 1990
Rawson, Jessica, and Emma C. Bunker. *Ancient Chinese and Ordos Bronzes.* Hong Kong: Oriental Ceramic Society of Hong Kong, 1990.

ROSSABI 1983
Rossabi, Morris, ed. *China Among Equals: The Middle Kingdom and Its Neighbors, 10th–14th Centuries.* Berkeley, Los Angeles, and London: University of California Press, 1983.

ROSTOVTZEFF 1929
Rostovtzeff, Mikhail. *The Animal Style in South Russia and China.* Princeton Monographs in Art and Archaeology 29. Princeton: Princeton University Press, 1929.

RUBINSON 1990
Rubinson, Karen S. "The Textiles from Pazyryk: A Study in the Transfer and Transformation of Artistic Motifs." *Expeditions* 32, no. 1 (1990): 49–61.

RUBINSON 1992
Rubinson, Karen S. "Tillya-Tepe and the Yuezhi (Rouzhi): A Look at the Evidence." Paper presented at the International Conference of Archaeological Cultures of the North Chinese Ancient Nations, Huhehot, Inner Mongolia, August, 1992.

RUDENKO 1958
Rudenko, S. I. "The Mythological Eagle, the Gryphon, the Winged Lion, and the Wolf in the Art of the Northern Nomads." *Artibus Asiae* 21, no. 2 (1958): 101–22.

RUDENKO 1962
Rudenko, S. I. *Sibirskaia kollektsiia Petra I.* Moscow and Leningrad, 1962(1).

RUDENKO 1970
Rudenko, S. I. *The Frozen Tombs of Siberia: The Pazyryk Burials of Iron Age Horsemen.* Translated by M. W. Thompson. Berkeley and Los Angeles: University of California Press, 1970.

SALMONY 1933
Salmony, Alfred. *Sino-Siberian Art in the Collection of C. T. Loo.* Paris: C. T. Loo, 1933.

SARIANIDI 1985
Sarianidi, Victor. *The Golden Hoard of Bactria.* New York and Leningrad: Harry N. Abrams and Aurora Art Publishers, 1985.

SCHAFER 1950
Schafer, Edward. "The Camel in China down to the Mongol Dynasty." *Sinologiya* 2, no. 3 (1950): 174–92.

SCHMIDT et al. 1989
Schmidt, Erich F., Maurits N. van Loon, and Hans H. Curvers. *The Holmes Expedition to Luristan.* Chicago: Oriental Institute of the University of Chicago, 1989.

SHAANXI 1992
The Shaanxi Provincial Museum. *The Gems of the Cultural Relics.* Xi'an: Shaanxi Travel and Tourism Press, 1992.

SHANXI 1980
Shanxi chutu wenwu. Shanxi: Shanxi wenwu gongzuo yiyuanhui, 1980.

SHAUGHNESSY 1988
Shaughnessy, Edward L. "Historical Perspectives on the Introduction of the Chariot in China." *Harvard Journal of Asian Studies* 48, no. 1 (June 1988): 189–237.

SHAUGHNESSY 1989
Shaughnessy, Edward L. "Western Cultural Innovations in China, 1200 B.C." *Sino-Platonic Papers* 11 (July 1989): 1–8.

SHI YONGSHI 1980
Shi Yongshi. "Yanguo de hengzi." In *Zhongguo kaogu xuehui di'erci nianhui lunwenji,* pp. 172–75. Beijing: Wenwu Press, 1980.

SHI YONGSHI 1987
Shi Yongshi. "Xiadu: Beijing's Twin Capital in Warring States Times." *China Reconstructs,* December 1987, pp. 57–59.

SINOR 1990
Sinor, Denis, ed. *The Cambridge History of Early Inner Asia.* Cambridge: Cambridge University Press, 1990.

SIRÉN 1929
Sirén, Osvald. *A History of Early Chinese Art: The Prehistoric and Pre-Han Periods.* London: Ernst Benn, 1929.

SMITH 1970
Smith, Cyril Stanley. "Art, Technology, and Science: Notes on Their Historical Interaction." *Technology and Culture* 11, no. 4 (October 1970): 493–549.

SMITH 1973
Smith, Cyril Stanley. "Bronze Technology in the East." In *Changing Perspectives in the History of Science,* edited by Mikulas Teich and Robert Young, pp. 21–32. London: Heineman, 1973.

SO 1993
So, Jenny F. "A Hongshan Jade Pendant in the Freer Gallery of Art." *Orientations,* May 1993, pp. 87–92.

SO 1995
So, Jenny F. *Eastern Zhou Ritual Bronzes in the Arthur M. Sackler Collections.* New York and Washington: Arthur M. Sackler Foundation, Harry N. Abrams, and Arthur M. Sackler Gallery, 1995.

SO AND STRAHAN 1995
So, Jenny F., and Strahan, Donna. "A Tinned Bronze Belt Plaque in the Walters Art Gallery." *Bulletin of the Walters Art Gallery.* Forthcoming.

STURMAN 1985
Sturman, Peter C. "Wild Beasts and Winged Immortals: Early Portrayals of Landscape in Chinese Art." Parts 1 and 2. *National Palace Museum Bulletin* 20, no. 2 (May/June 1985): 1–17; 20, no. 3 (July/August 1985): 1–12.

SUN JI 1981
Sun Ji. "Tangdai di maju yu mashi." *Wenwu* 10 (1981): 82–96.

SUN JI 1987
Sun Ji. "Wo guo gudai de gedai." In *Wenwu yu kaogu lunji,* pp. 297–321. Beijing: Wenwu Press, 1987.

SUN JI 1994
Sun Ji. "Xian Qin, Han, Jin yaodai yong jinyin daikou." *Wenwu* 1 (1994): 50–64.

SWANN 1950
Swann, Nancy Lee, trans. *Food and Money in Ancient China: The Earliest Economic History of China to B.C. 25—Han Shu 24 with Related Texts, Han Shu 91 and Shih-Chi 129.* Annotated by Nancy Lee Swann. Princeton: Princeton University Press, 1950.

TAKÁCS 1929
Takács, Zoltan von. "Some Irano-Hellenistic and Sino-Hunnic Art Forms." *Ostasiatische Zeitschrift* 15 (1929): 142–48.

TAO 1988
Tao Jing-shen. *Two Sons of Heaven: Studies in Sung-Liao Relations.* Tucson: University of Arizona Press, 1988.

TAO ZHENGGANG 1983
Tao Zhenggang. "Shanxi chutu de Shang dai tongqi." In *Zhongguo kaogu xuehui disici nianhui lunwenji,* pp. 57–64. Beijing: Wenwu Press, 1983.

TATE 1947
Tate, G. H. H. *Mammals of Eastern Asia.* New York: Macmillan Company, 1947.

TCHLENOVA 1963
Tchlenova, N. L. "Le Cerf Scythe." *Artibus Asiae* 26, no. 1 (1963): 27–70.

TIAN AND GUO 1986
Tian Guangjin and Guo Suxin, eds. *E'erduosi shi qingtong qi.* Beijing: Wenwu Press, 1986.

TOKYO 1983
Chūgoku naimōko hoppō kiba minzoku bunbutsu ten. Tokyo: Nihon Keizai Shinbunsha, 1983.

TOKYO 1992
Rōran Ōkoku to yūkyū no bijo. Tokyo: Asahi Shinbunsha, 1992.

TREGEAR 1965
Tregear, T. R. *A Geography of China.* Chicago: Aldine Publishing Company, 1965.

UMEHARA 1931
Umehara Sueji. "Shina kodai no doriki ni tsuite." *Tōhō Gakuhō* 2 (1931): 1–50.

UMEHARA 1933
Umehara Sueji. *Ōbei Shūcho Shina kodo seika.* Kyoto: Yamanaka, 1933.

UMEHARA 1937
Umehara Sueji. *Rakuyō Kin-son kobo shūei.* Kyoto: Kobayashi Shashin Seihanjo Shuppanbu, 1937.

UMEHARA 1960
Umehara Sueji. *Mokō Noin-ula hakken no ibutsu.* Tokyo: Toyo Bunko ronso, 1960.

VAINSHTEIN 1980
Vainshtein, Sev'yan. *Nomads of South Siberia.* Cambridge: Cambridge University Press, 1980.

VAINSHTEIN AND KRIUKOV 1984
Vainshtein, Sev'yan I., and M. V. Kriukov. "Sedlo e Stremya." *Sovietskaya Ethnografiya* 6 (1984): 114–30.

VISSER 1948
Visser, H. F. E. *Asiatic Art in Private Collections of Holland and Belgium.* Amsterdam: De Spieghel Publishing Company, 1948.

WALDRON 1990
Waldron, Arthur. *The Great Wall of China: From History to Myth.* Cambridge: Cambridge University Press, 1990.

WANG RENXIANG 1982
Wang Renxiang. "Gudai daigou yongtu kaoshi." *Wenwu* 10 (1982): 75–81.

WANG RENXIANG 1985
Wang Renxiang. "Daigou gailun." *Kaogu xuebao* 3 (1985): 267–312.

WATSON 1961
Watson, Burton, trans. *Records of the Grand Historian of China.* Translated from the *Shih Ji* of Sima Qian. Vol. 2. New York and London: Columbia University Press, 1961.

WATSON 1971
Watson, William. *Cultural Frontiers in Ancient East Asia.* Edinburgh: Edinburgh University Press, 1971.

WEBER 1968
Weber, Charles D. *Chinese Pictorial Vessels of the Late Chou Period.* Ascona, Switzerland: Artibus Asiae Publishers, 1968.

WHITE 1939
White, William Charles. *Tomb Tile Pictures of Ancient China.* Toronto: University of Toronto Press, 1939.

WHITE 1956
White, William Charles. *Bronze Culture of Ancient China.* Toronto: University of Toronto Press, 1956.

WHITE AND BUNKER 1994
White, Julia M., and Emma C. Bunker, with contributions by Chen Peifen. *Adornment for Eternity: Status and Rank in Chinese Ornament.* Denver and Hong Kong: Denver Art Museum and Woods Publishing Company, 1994.

WU EN 1985
Wu En. "Yin zhi Zhou chu de beifang qingtongqi." *Kaogu xuebao* 2 (1985): 135–56.

WU EN 1990
Wu En. "Lun Xiongnu kaogu yanjiu zhong de jige wenti." *Kaogu xuebao* 4 (1990): 409–37.

WU HUNG 1984
Wu Hung. "A Sampan Shan Chariot Ornament and the *Xiangrui* Design in Western Han Art." *Archives of Asian Art* 37 (1984): 38–59.

WU HUNG 1986
Wu Hung. "Buddhist Elements in Early Chinese Art." *Artibus Asiae* 47, nos. 3–4 (1986): 263–352.

194

WU HUNG 1989
Wu Hung. *The Wu Liang Shrine*. Stanford: Stanford
University Press, 1989.

XI'AN 1993
Shaanxi xin chutu wenwu jicui. Xi'an: Shaanxi Tourist
Press, 1993.

YABLONSKY 1990
Yablonsky, Leonidi T. "Burial Place of a Massagetae
Warrior." *Antiquity* 64 (1990): 288–96.

YABLONSKY 1994
Yablonsky, Leonidi T., ed. *Kurgany Levoberezhnogo
Ileka*. Moscow: Institute of Archaeology, Russian
Academy of Science, 1994.

YANG BODA 1986
Yang Boda, ed. *Zhongguo meishu quanji, gongyi meishu
bian (9): yuqi*. Beijing: Wenwu Press, 1986.

YANG BODA 1987
Yang Boda, ed. *Zhongguo meishu quanji, gongyi meishu
bian (10): jinyin, boli, falang*. Beijing: Wenwu Press,
1987.

YU XINGWU 1941
Yu Xingwu. *Shuang Jian Chi Yin qi pianzhi xubian*.
Beijing, 1941.

YÜ YING-SHIH 1967
Yü Ying-shih. *Trade and Expansion in Han China*.
Berkeley and Los Angeles: University of California
Press, 1967.

YÜ YING-SHIH 1990
Yü Ying-shih. "The Hsiung-nu." In *The Cambridge
History of Early Inner Asia*, edited by Denis Sinor, pp.
118–49. Cambridge: Cambridge University Press, 1990.

ZAVITUKHINA 1983
Zavitukhina, M. P. *Drevnee Iskusstvo na Enisee*.
Leningrad, 1983.

ZHANG BOQUAN 1989
Zhang Boquan. "'Xianbei geluodai' ji yi xianbie ming-
ming youguan de wenti." *Liaohai wenwu xuekan* 1
(1989): 219–25.

ZHANG CHANGSHOU 1980
Zhang Changshou. "Lun Baoji Rujiazhuang faxian de
Xi Zhou tongqi." *Kaogu* 6 (1980): 526–29.

ZOU HENG 1980
Zou Heng. *Xia Shang Zhou kaoguxue lunwenji*. Beijing:
Wenwu Press, 1980.

Archaeological reports are cited from the following
periodicals:

Beifang wenwu
Kaogu
Kaogu xuebao
Kaoguxue jikan
Kaogu yu wenwu
Neimenggu wenwu kaogu
Wenbo
Wenwu
Wenwu chunqiu
Wenwu ziliao congkan
Zhongguo wenwubao

Lenders to the Exhibition

Anonymous loan

The Art Museum, Princeton University

Buffalo Museum of Science

The Calon da Collection

Dr. and Mrs. George Fan

Freer Gallery of Art (Study Collection)

The Therese and Erwin Harris Collection

Leon Levy and Shelby White Collection

Los Angeles County Museum of Art

Metropolitan Museum of Art

Walters Art Gallery, Baltimore

Xiwenguo Zhai

Index

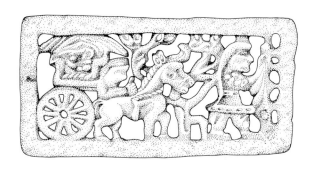

Edited by Ann Hofstra Grogg

Designed by Beth Schlenoff

Typeset in Monotype Bulmer

Printed and bound in Hong Kong